W9-BNM-866

NIGHT AND LOW-LIGHT PHOTOGRAPHY
PHOTO WORKSHOP

Alan Hess

WILEY

John Wiley & Sons, Inc.

Night and Low-Light Photography Photo Workshop

Published by
John Wiley & Sons, Inc.
10475 Crosspoint Boulevard
Indianapolis, IN 46256
www.wiley.com

Published simultaneously in Canada

ISBN: 978-1-118-13822-9

Manufactured in the United States of America

10 9 8 7 6 5 4 3 2 1

For general information on our other products and services or to obtain technical support, please contact our Customer Care Department within the U.S. at (877) 762-2974, outside the U.S. at (317) 572-3993 or fax (317) 572-4002.

Wiley also publishes its books in a variety of electronic formats and by print-on-demand. Some content that appears in standard print versions of this book may not be available in other formats. For more information about Wiley products, visit us at www.wiley.com.

Library of Congress Control Number: 2011940395

About the Author

Alan Hess is a photographer and author based in San Diego, California where he lives with his wife and two dogs. He has written books on both photography and technology including the *Exposure Digital Field Guide, Composition Digital Field Guide, iPad Fully Loaded,* and the *iPad 2 Fully Loaded.* His concert and backstage images appear in numerous online and print publications and they have also been used for promotional purposes, including music packaging.

Alan has been a part of the Instructor Dream Team for Photoshop World where he taught classes on concert and event photography and the basics of Exposure and Composition. He has written articles on concert photography and Photoshop for *Photoshop User Magazine.*

His website is www.alanhessphotography.com where he writes a semiregular blog or you can find him on Twitter as ShotLivePhoto.

Credits

Acquisitions Editor
Courtney Allen

Project Editor
Cricket Krengel

Technical Editor
Haje Jan Kamps

Copy Editor
Marylouise Wiack

Editorial Director
Robyn Siesky

Business Manager
Amy Knies

Senior Marketing Manager
Sandy Smith

Vice President and Executive Group Publisher
Richard Swadley

Vice President and Executive Publisher
Barry Pruett

Senior Project Coordinator
Kristie Rees

Graphics and Production Specialists
Jennifer Henry
Andrea Hornberger
Jennifer Mayberry

Quality Control Technician
Melissa Cossell
Lauren Mandelbaum
Dwight Ramsey

Proofreading
Laura Bowman

Indexing
Potomac Indexing, LLC

Acknowledgments

I would like to thank my wife for enduring yet another book with crazy hours and weird schedules. This time at least it made sense as I was out creating the images for this book mostly at night.

Big thanks go to Courtney for all she does in getting me the right projects and to Cricket for trying her hardest to keep me on track, which is nearly impossible no matter how good my intentions are. Also, a big thanks to Haje for all his work making sure all the numbers and tech stuff are right. If you find something that's wrong, it just means I didn't fix something I should have. You can check out his work at http://kamps.org.

To the great group of photographers who helped with images, I couldn't have done this without you. A huge thanks goes out to all of you:

Kenny Kim for his help with the wedding chapter and all that goes into photographing some of the best weddings ever. You can find out more about Kenny at www.kennykim.com.

Larny Mack for his insight into photographing interiors and the use of his images to illustrate the point. Check out his work at www.larnymack.com.

Jacob Lucas for the use of his great star trails image, I can't thank you enough. His work is at www.jflphotography.com.

E. Howe-Bryne for the star trails image. It is a great shot and I am honored that you allowed me to use it here. For more on E. Howe-Bryne check out http://littleredtent.net/LRTblog.

Ken Toney who supplied the image of the flowing water and the use of the neutral density filter, it's a great photograph and I thank you for its use here. Check out Ken's work here: www.kentoneyphoto.com.

To everyone at Nik Software especially Laurie, Janice, and Kevin, thanks for everything. Working with you and your products is always a joy.

For Nadra

Contents

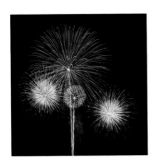

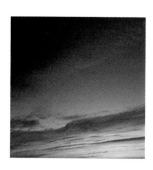

CHAPTER 3 What Gear Is Important

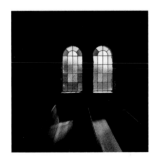

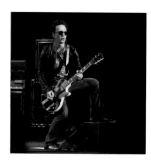

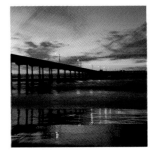

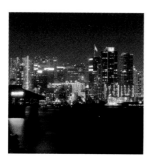

Introduction

It's easy to take photos on a bright sunny day. With plenty of light, it's easy to freeze the action, and you can use low ISO settings and get virtually noise-free images. The real challenge and excitement start when the light goes down.

Digital camera technology has come a very long way since I bought my first camera. The new cameras have more advanced built-in light meters and metering modes that allow photographers to focus more on the composition. The problem is that these advances don't really help when it comes to shooting in very low light or at night. There is no way to use the light meter when photographing fireworks or when painting with light for example.

The good news is that this book deals with all those situations where the camera might not be able to capture the image correctly. This means starting at the beginning and covering the basics of light and exposure settings as well as the importance of understanding the color of light and white balance. Many types of photography can be done with any type of camera and lens, but there are certain types of low-light photographs that are made easier by using a lens with a wide aperture and the high ISO capability of the camera along with the accessories, like a tripod and cable release that make long exposures possible. All this and more are covered in Chapter 3.

Chapters 4, 5, and 6 deal with photographing people in various low-light situations, from portraits to concerts and even sports. This includes dealing with adding your own lighting, freezing fast-moving action, and dealing with scenes that the camera's built-in light meter just can't deal with consistently.

Next up is some of the most enjoyable photography you can do at night, and that is photographing the night sky — from sunsets to the moon, star trails, and fireworks. This is the type of photography that just can't be taken any other time. Chapter 7 is all about photographing the night sky, and Chapter 8 deals with city lights, light trails, and one of my favorite subjects, neon signs.

Chapter 9 covers light painting from the traditional to the experimental and a fun technique that you can do in any darkroom with a flashlight and a piece of string that will amaze people. I don't want to give it away here, but the results of this technique will have people wondering exactly how you did it without a computer.

Chapter 10 is about taking the traditional landscape photography and doing it at night when the long exposures reveal details that you just never see during the day. It also addresses how to deal with the very long exposures that can literally turn night into day. To wrap it all up, Chapter 11 visits the digital darkroom and postproduction using Adobe Lightroom and Photoshop Elements. Topics include adjusting the white balance, dealing with digital noise, and using blend modes.

So turn the page and jump right into the very interesting world of night and low-light photography!

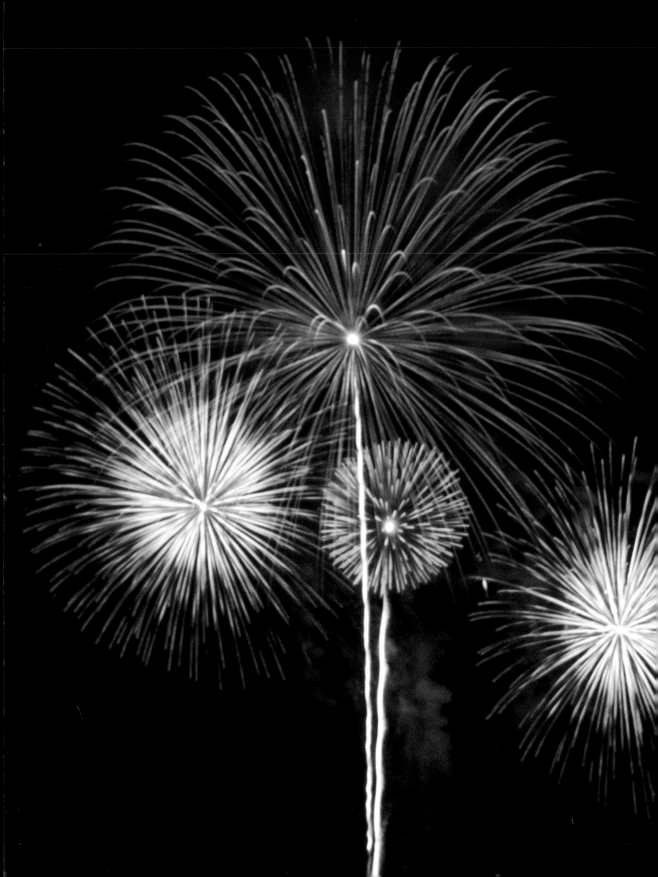

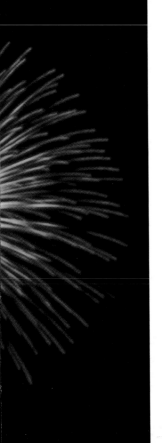

NIGHT AND LOW-LIGHT PHOTOGRAPHY OVERVIEW

Photographing at night is challenging because there is usually less light available, and the less light available, the harder it is to get a proper exposure. This also applies to low-light situations such as shooting indoor events or sports, or even the kids just playing in the living room. The basics of photography don't change when the sun goes down or the action moves inside, but the tradeoffs become much more noticeable.

The lack of light means that you have fewer choices for the settings that you can use to create a photograph, and the challenges of getting the image to look exactly the way you want increase. When it comes to getting the proper exposure, there are only three controls that can be changed: the shutter speed, the aperture, and the ISO. Controlling these settings to get the shot you want in reduced lighting conditions is key. At times faster shutter speeds are needed to freeze movement, and at other times slower shutter speeds are needed to show the full movement. There are times when a wide aperture is needed to allow as much light in as possible, and other times a smaller aperture is needed to create a deep depth of field.

For example, in Figure 1-1, taken from a ferry dock at Coronado Island with the San Diego city lights in the background, I needed to use a setting that exposed the sky and the background, but I also wanted a deep depth of field. I started with a low ISO (100) to keep the digital noise to a minimum, and then set the aperture to f/10, which gave me the depth of field I wanted. Then I set the shutter speed long enough to get the exposure I wanted. Because the shutter speed was 2.5 seconds, I made sure the camera was properly locked down in a tripod and used a cable release. I then corrected the color by adjusting the white balance in postproduction.

SHOOTING CHALLENGES

If you believe the advertisements on television and in magazines, photography is easy: Just point the camera at the subject and press the button. No worries about the amount of light or the movement of the subjects or any of the camera settings. I don't blame the camera manufacturers for making it all look so easy; their job is to sell cameras, not to make sure you get the best results from the camera. Many of the situations they depict — shooting in a crowded, dimly lit restaurant or capturing a touchdown pass using the built-in flash — are not going to yield nicely lit photos because those are both examples of difficult lighting situations.

LACK OF LIGHT

Lack of light is easily the biggest challenge, not only with night and low-light photography, but with most photography.

Many times this lack of light can be frustrating to newer photographers — they see a great scene, whip out the camera, and take the photo, only to look at the LCD on the back of the camera and see an image that is blurry; so they turn on the flash and the results are even worse. This frustration often results in missed photos because the next time a low-light photo-op presents itself, they just leave the camera in the bag. For example, I live in San Diego and spend a fair amount

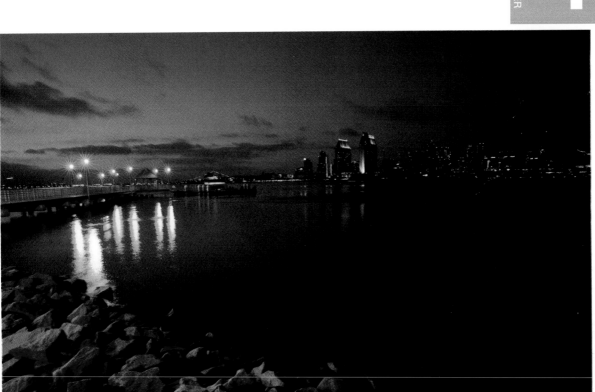

1-1

ABOUT THIS PHOTO *The San Diego skyline in the distance with the ferry dock in the midground and the rocky shore in the foreground taken right after the sun had set. Taken at 2.5 seconds, f/10, and ISO 100.*

of time photographing the beautiful sunsets here, and it never fails to amaze me when I see someone standing with a camera at the water's edge trying to capture the sunset with the pop-up flash turned on. I know that when they get home, they will be disappointed because there is no way that the image will come out as they envisioned.

The solution is to understand how the camera works and which of the settings needs to be adjusted. Many times, the shutter speed needs to be increased, allowing the shutter to remain open for longer, and at the same time the camera needs to be supported so that it doesn't move during the exposure. The surfer sitting on the beach in

Figure 1-2 was photographed using a shutter speed of 1.3 seconds, which allowed enough light to reach the sensor to make a proper exposure. The camera was set on the sea wall to make sure it didn't move during the exposure, and luckily, the surfer didn't move either.

FREEZING ACTION

The only way to freeze action is to use a shutter speed high enough that in the time the shutter is open the subject doesn't move. That is not to say the subject has stopped and is waiting for you, but instead the sliver of time the shutter moves out of the way and allows light to reach the sensor is short enough that the subject looks frozen in place. The shutter speed needed depends on the subject being photographed. For example, a person walking is a lot slower than a horse running, so the shutter speed needed to freeze a horse mid-run is shorter than the shutter speed needed to freeze a man walking. The faster the action, the less time the shutter can be open before the subject starts to blur. The problem with low-light scenes is that with the small amount of light available, using a high shutter speed means that you have to either increase the ISO or open the aperture up as wide as possible — and in most cases, you have to do both. For example, when I photographed the Lipizzaner Stallions, shown in Figure 1-3, I made

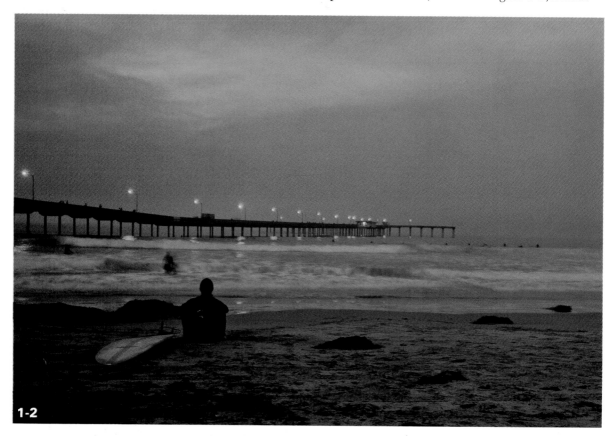

1-2

ABOUT THIS PHOTO *The surfer was sitting on the beach watching the waves right after sunset. I didn't know if he had just come out of the water or was waiting to go in. Taken at 1.3 seconds, f/10, and ISO 100.*

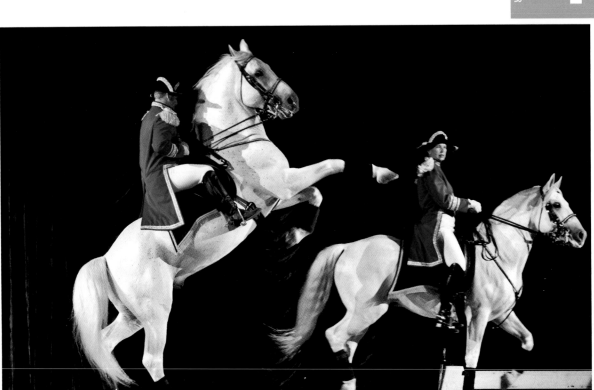

1-3

ABOUT THIS PHOTO *The Lipizzaner Stallions are amazing horses to see and to photograph. To make sure I froze the movement of the horse rearing up, I used a fast shutter speed. Taken at 1/320 second, f/4.0, and ISO 1000.*

sure I was using a shutter speed fast enough to capture the action of the horse rearing up. To do this, I needed to use the lowest aperture available to me — in this case, f/4.0 — and I needed to push the ISO up to 1000 so that the exposure would be correct at the 1/320-second shutter speed.

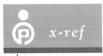 x-ref

> There is a lot more on freezing the action covered in Chapter 5 and Chapter 6.

When it comes to using shorter shutter speeds to freeze the action in low light, one of the other exposure settings needs to change — either the aperture needs to be made larger or the ISO has to be increased. The higher ISO values can cause other problems, however, the biggest of which is the introduction of digital noise.

DIGITAL NOISE

Digital noise is the catchall term for a range of problems that appear in images, especially those taken at high ISOs or when leaving the camera shutter open for a long time. This topic is mentioned so much in later chapters because many images taken at night or in low light require either a high ISO or a slow shutter speed, which creates digital noise in these images. Digital noise

can look like little spots of unwanted color, especially in areas that should have a smooth tone. It can also look grainy when viewed at a distance, and subjects can even look slightly out of focus if the noise is very high in the critical areas of your subject.

On the positive side, for new photographers and especially for those just getting into night and low-light photography, the camera manufacturers, as well as the software developers who create noise reduction algorithms, have really made improvements. The images produced today have far less noise than images produced a few years ago in the same conditions because cameras can now shoot at much higher ISO values and still get relatively noise-free images. And those images that need a bit of help can be fixed in postproduction or using in-camera noise reduction (if your camera offers that feature). For example, the image in Figure 1-4 was photographed at ISO 400 in 2005, and even at that relatively low ISO the noise is really obvious, especially in the shirt and skin tones.

LIGHT

There are really only two types of light in photography: the light that is already in the scene, often called available light, and the light the photographer adds to the scene. Both of these types of light can be used to create great images, and many people will argue about which is better. I believe that the type of light that you use is dependent on the subject and the shooting conditions. It would be great to always have the option of using extra light by adding a flash where needed, but at times that isn't possible.

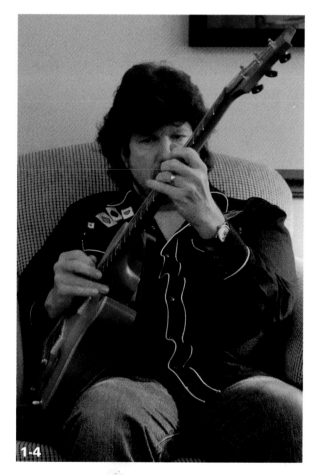

1-4

ABOUT THIS PHOTO *The photograph of guitarist Mark Karan backstage was shot using available light, so the ISO was pushed to 400 and the shutter speed was dropped to the lowest speed I could successfully handhold without motion blur. Taken at 1/20 second, f/3.5, and ISO 400.*

USING AVAILABLE LIGHT

The available light in a scene can be from multiple sources and can be used to create great images if you use it to your full advantage. This can mean just waiting until the light is in the right position, as when shooting a concert by timing the movement of the spotlight, or leaving the

shutter open for a longer time to allow the light to fully illuminate your subject, as with long exposure landscapes. At times, photographing in low-light situations can come with rules that prohibit using an extra light, such as photographing in some wedding venues or photographing some sporting events at night or inside. There are also some locations where it isn't very practical to set up extra lights or where the use of those lights will change the look of the photograph too much. Take the bridge pictured in Figure 1-5, where the light sources are all actually attached to the bridge and the light reflected in the water helps

to illuminate the underside of the bridge. I took this image with the light that was already there in the scene.

Many times, the key to getting great images when shooting in available light is to watch for a few minutes and see how the light is affecting your surroundings. When you can see what the light is actually affecting, you can do a better job of capturing it. For events, such as concerts and weddings, this could be as simple as showing up a little early and watching the area and how it is illuminated. For static scenes like the bridge in

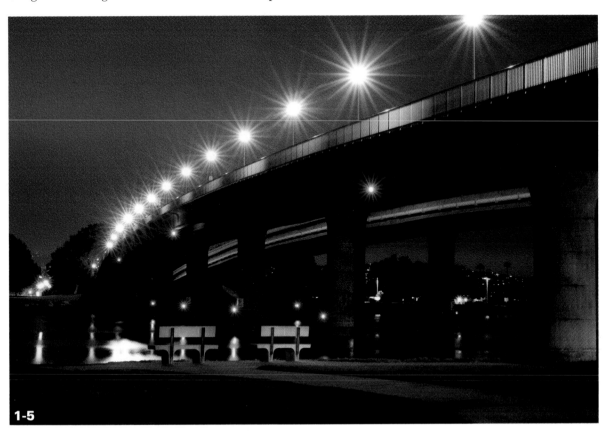

1-5

ABOUT THIS PHOTO *When I took this photograph of the Ingraham Street Bridge late at night, I was limited by the light available from the bridge and needed to use a long shutter speed to capture it all. Taken at 33 seconds, f/20, and ISO 200.*

Figure 1-5, I stood and watched for a few minutes to see what the light would do before picking the spot for the photographs.

x-ref Using available light is covered in many sections of this book including using the window light to take portraits in Chapter 4, weddings, concerts, and other events in Chapter 5, and sports in Chapter 6. Chapters 7, 8, and 10 also discuss the use of available light in the creation of images.

ADDING LIGHT

One solution when faced with photographing in a low-light situation is to add a bit of light to the scene. This could involve just turning on a nearby light or adding an off-camera flash unit or two. The results are best when the new light works with the scene and doesn't try to overpower it. Take the photograph in Figure 1-6, for example. It was taken outdoors right after the sun had set. The added light from the camera-left position helped to make this a better image. Had there been no light added, the model would have been in too low of a light to shoot at these settings and the light would have looked too even and flat.

Adding light to a portrait is not as easy as it sounds because the flash units are usually very small bright lights that create hard light from the camera's position. This can cause your images to look unflattering.

WHAT GEAR IS IMPORTANT

There are a lot of accessories available for your camera. Walk into any good camera store or visit a big online retailer and you will see bags, cases, flashes, cords, cables, straps, remotes, timers, tripods, tripod heads, filters, filter holders…well, you get the idea. Many of these are not necessary

1-6

ABOUT THIS PHOTO *Photographing Sam outside after the sun had set, I added an off-camera flash from the left to add light and definition to his face. The flash was fired using a radio triggering system that fires the flash when the shutter release button is pressed. Taken at 1/60 second, f/6.3, and ISO 200.*

for photographing at night or in low light, but there are a couple accessories that you will want to invest in. The most important of these is a good camera support, followed closely by a cable release or remote. Even with all the advances in camera technology, image stabilized lenses, and high ISO capability, making sure that the camera doesn't move — especially when using longer shutter speeds — is really important, and using a cable release or remote means that you don't have to touch the camera once it has been set up.

CAMERA SUPPORTS

One way to get a proper exposure when shooting in low light is to let the shutter stay open long enough for enough light to reach the sensor. However, when the shutter is open, anything that moves appears blurred in your shot, and if the camera moves, then everything is blurred. The way to counteract this is to make sure that the camera is locked into position and can't move, which means you need a tripod or at least a monopod.

Tripods have a long history, and even with the newer models that are made with space-age materials, the basics are the same. The tripod has three legs that extend downward from a center point creating a stable platform; the camera is attached either to the tripod itself or to a tripod head that allows the position of the camera to be adjusted. All cameras made today either have a threaded tripod mounting hole on the underside of the camera, so the camera can either screw directly onto the tripod or the tripod head, or they can have a mounting plate attached to make putting it on or taking it off the tripod easier. Once the camera is firmly attached to the tripod, it is held firmly in place and won't move during the exposure. Having the camera locked into the tripod also allows you to take multiple photographs of the exact same scene without changing the composition. This is important for HDR photography, capturing star trails, light-painting, and especially time-lapse photography.

The choice of a tripod is a personal one because tripods come in all sizes, materials, weights, and prices. However, the most important factor is choosing a tripod that can support your camera and lens. If the tripod is too light, or the camera and lens are too heavy, then the tripod will not be rock steady, which defeats the purpose. There is another bonus to using a tripod—the time it takes to set up the photograph and make sure the composition and exposure settings are just right. This little bit of extra time makes you think about the photograph more than when you just bring the camera up to your eye and press the button. When it is impossible to use a tripod, either due to the shooting location or because it's against the rules such as when photographing concerts, using a monopod in these cases can help you get better results that just handholding the camera and lens. This is especially true when you are using any of the longer, heavier lenses.

CAMERA AND FAST GLASS

There have been a great many advances made in camera technology. For example, cameras are able to capture usable images in less light than ever before, you can now shoot at higher ISO settings with excellent results, and consumer-level cameras have better ISO capabilities than professional models of just a few years ago. When you combine the advances of the ISO capability with the improved in-camera noise reduction and processing, the results are amazing. There have also been advances in the auto focusing and camera metering systems, making it easier to get proper exposures and in-focus images in a wide variety of situations.

For photography where you need to freeze the action in low light, consider a camera with high-ISO capability combined with a lens that has a very wide maximum aperture like f/1.4 or f/2.8, for

x-ref

You can find much more on tripods and gear in Chapter 3. For more on Star trails and time-lapse photography, go to Chapter 7, where all the techniques require the camera to be held steady during the exposure, and Chapter 9, where a tripod is needed for light painting.

example. Look at the photographers working on the sidelines of a sporting event, especially under the lights at night, or the photographer in the photo pit of a concert, or a wedding photographer in a dimly lit church; the one thing that they all have in common is the types of lenses they are using. Known as fast glass, these lenses allow the maximum amount of light to reach the sensor in the shortest time; this enables you to use faster shutter speeds, which freeze the action. One problem with using wide apertures is that the photographer has very little control over the depth of field. For example, a large majority of my concert images are taken at f/2.8 or wider, which offers a very shallow depth of field. The photo of Anthrax lead guitarist Scott Ian in Figure 1-7 was shot using fast glass and a high ISO so that the shutter speed would freeze the action under the stage lighting.

SHUTTER-TRIGGERING DEVICES

Many times, just having your camera locked into a tripod isn't enough to get razor-sharp images. When you press the shutter release button on the camera with your finger, you can set off small vibrations in the camera that can cause slight blurring. This is why a shutter release cable is a great idea for long exposures. In Figure 1-8, I used a cable release so that I could watch the fireworks and trigger the camera at the right moments without actually touching the camera.

> **note** You can also get remotes for many different camera brands that allow for wireless triggering of the camera shutter release without having to touch the camera.

It is possible to use the self-timer to trigger the shutter release, but you are limited to the maximum shutter speed of the camera (usually 30

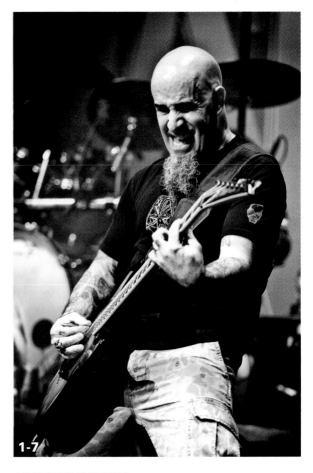

1-7

ABOUT THIS PHOTO *Scott Ian is the rhythm guitar player for the band Anthrax and was captured here in concert at a high enough shutter speed to make sure he was not blurred. That meant a combination of a wide aperture and a high ISO. Taken at 1/500 second, f/2.8, and ISO 1250.*

seconds or less) and you have to think ahead because the shutter will trip 2 to 10 seconds after you press the button.

There are two good reasons to get an advanced shutter release: to be able to lock the shutter open for extended periods using the camera's Bulb mode, and to set up interval shooting like that used for time-lapse photography.

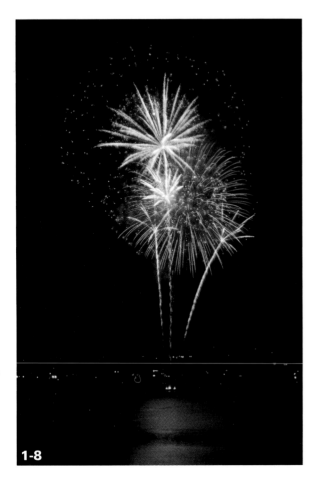

1-8

ABOUT THIS PHOTO *I used a cable release to capture these fireworks. I started the exposure as the rockets flew skyward, and stopped it at the end of the explosion. Taken at 6.5 second, f/22, and ISO 200*

POSTPRODUCTION SOFTWARE

Everyone has heard of Adobe Photoshop, and many people think that it is the magic answer to every photograph. While photo-editing software can do amazing things, it is always best to get the image as close to what you want in the camera. While this isn't a Photoshop or image-editing software book, there are some important things that you can do in postproduction to make your life easier and to get the most out of your images.

Three of the most important adjustments you can make when editing photographs taken in low light and night conditions have to do with reducing the noise in your images, correcting the white balance which controls how the colors in your image are rendered, and adjusting the exposure.

■ **Noise reduction.** Because of improvements in noise reduction in image-editing software, an image taken at night or in low light can have a significant amount of the digital noise removed while keeping the sharpness of the image. These advances make it possible to shoot in lower light, use higher ISOs, or keep the shutter open for much longer than ever before and still get a good shot.

■ **White balance.** When you take a photograph, the color of the light that illuminates the subject can cause the image to look wrong — to have a colorcast. You can usually solve this colorcast by picking the right white balance setting in the camera, but you can also change or adjust the white balance in postproduction, especially if you photograph using the RAW image file type. Take Figures 1-9 and 1-10; these are of the same image but the white balance has been changed. When I took the original photo, I had the white balance set for fluorescent, which gave the image an interesting look but wasn't accurate to the scene.

■ **Exposure.** Every image-editing software program has tools for adjusting the exposure of your images, from slightly increasing the overall brightness and revealing details in the highlights that could otherwise be too bright to increasing the brightness and revealing the details hidden in the shadow areas that otherwise could be too dark. It is possible to adjust both so that the details in the dark areas and the light areas are both visible.

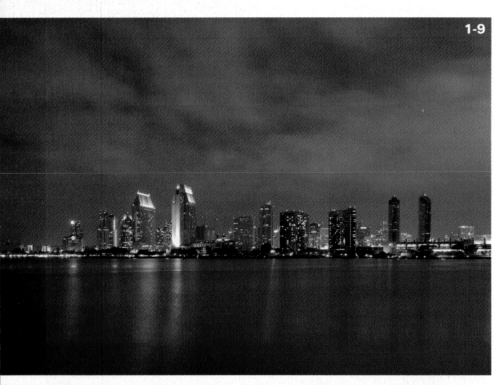

1-9

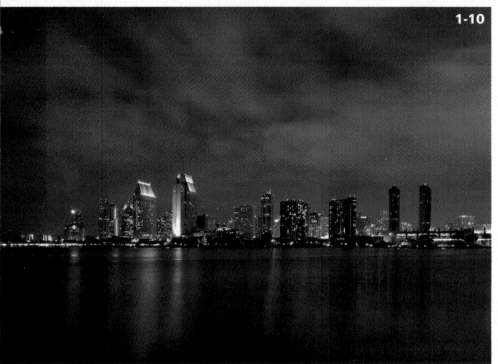

1-10

There are many image-editing software packages on the market, but you don't have to spend a lot of money. Much of the post-processing of the images for this book was done using Adobe Photoshop Lightroom, the Adobe Camera Raw module of Adobe Photoshop and Photoshop Elements. The full version of Adobe Photoshop Lightroom retails for $299.00 but can be found on sale often for less. Abode Photoshop Elements can be bought for $79.00.

CHOOSING YOUR SUBJECTS

What to photograph can be a tough question. For weddings, it's easy; just follow the bride around. For concerts, it's also easy; just follow the spotlight around. But what about other subjects? What good subjects are available to you that lend themselves to night and low-light photography? Since the earliest cave drawings, people have been depicting other people in their art, and photography is no different. Night photography, in particular, offers some really exciting subjects that you just can't photograph during the day. The dark night sky makes a perfect canvas for light trail photography, be it the blending of the car lights as they stream past your camera or the great fireworks displays that have been wowing crowds for years. The stunning vistas as the sun sets (or rises) and paints the sky with color are great to photograph. There are nighttime sporting events and concerts or the kids playing outside that are all great subjects. You can also create time-lapse photographs that show the changing night sky. If you are at a loss for a subject, just point the camera skyward and see what the night sky has to offer.

PEOPLE

I have a theory that the people who don't like to have their photo taken have never had a good photo taken of them. I believe this is because the person taking the photo didn't understand light and how it can make or break an image. This is especially true when the light gets low and a photographer starts to use a flash or tries to compensate in some other way. Many times, just using a simple external flash with the head aimed up or over the subject so that the light bounces down instead of blasting straight forward produces a much more flattering image. For the photo in Figure 1-11, the flash was aimed up ay the ceiling where it bounced down creating a simple portrait of the young Giants fan.

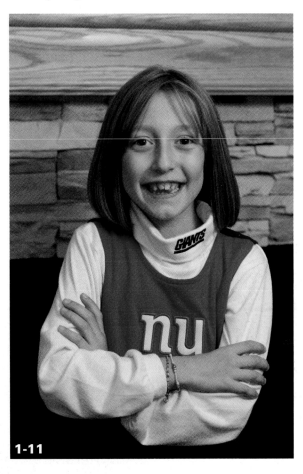

1-11

ABOUT THIS PHOTO *Photographing inside, I adjusted the flash on my camera to point up over the head of the subject at the ceiling, which was white and slightly angled; this created a nice soft light that was pleasing to the eye. Taken at 1/250 second, f/5.0, and ISO 200.*

PLACES

In addition to photographing people, photographing places can be fun and also challenging as the sun goes down. The best part of using a building as a model is that it never moves and never complains, and you can go back and photograph it as often as you want. The look of building exteriors and interiors changes as the light changes. And, during the evening and night, moonlight and artificial light start to illuminate the building, creating interesting textures, shadows, and even patterns that may not be visible during daylight hours.

Photographing at night can also bring out colors not seen during the day because the color of the light often changes as the types of light illuminating the scene change. This can make a room that may appear drab and boring in the daytime look really exciting at night.

EVENTS

I photograph a lot of events. It is the type of photography that I do the most and that I have been doing the longest. The main types of events that I photograph are concerts, and these can range from small, dark clubs to big arena shows. But the one thing that stays consistent is that the lighting is never as bright as I would like it to be. That makes concert photography one of the hardest types to master: There is rarely enough light to freeze the musicians, you are not usually allowed to add any light by using a flash, the light changes from moment to moment, and you usually have to get permission to photograph a concert in the first place. As you can see from Figure 1-12, the concert light can be all over the place, and while it may look bright to you in the photos, it sure doesn't to my camera. I needed to use the slowest

shutter speed possible and still freeze the action, which in this case was 1/100 second. However, that also meant that I needed to use the widest aperture my lens offered (f/2.8) and I had to push the ISO up to 1000 to get the proper exposure. I was able to grab the shot, and within seconds, the lights had changed again.

But when it comes to shooting in low light, there are many other events besides concerts. Often, wedding photographers have to deal with low light at the ceremony, especially if it is being held indoors in a house of worship, where it may be against the rules to use a flash. Receptions are often low-light situations as well, with a lot of action and different types of lighting in the same room, so wedding photographers need to be able to shoot in a variety of lighting conditions.

Another type of event that has lower available light than you would expect is a sporting event held indoors or at night. Because the goal in shooting sporting events is to freeze the action and that action is moving fast, higher shutter speeds are needed. To get those high shutter speeds, you either need a lot of light or you need to raise the ISO and open the lens up wide. While those Friday night lights might seem very bright on television, you need to increase the ISO and open the lens up as wide as possible because they are not bright enough to allow for action-freezing shutter speeds at low ISO and small apertures.

THE NIGHT SKY

Go outside any night of the year and look up. Chances are it will look different than the night before. It might not be very different, but because it is impossible to get the exact same weather patterns with the exact same moon at the exact same

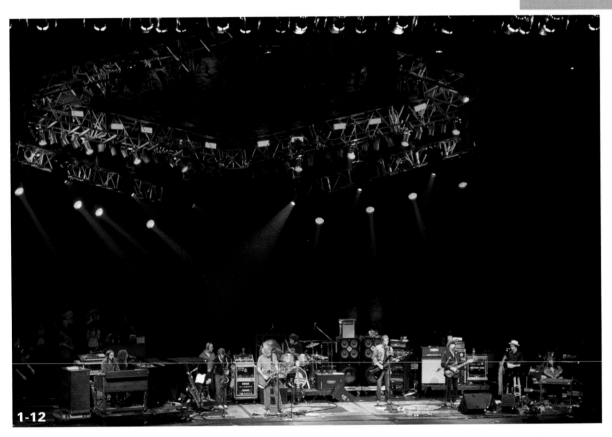

1-12

ABOUT THIS PHOTO *The lights beam down on the stage, illuminating the individual band members. Shot at 1/100 second, f/2.8, and ISO 1000.*

time, it is different. This means that every night you have a new opportunity to make a new image of the same beautiful subject.

Now there are subjects that you can photograph specifically as part of the night sky, including the golden glow of sunrises and sunsets, star trails, and even fireworks displays, but it is important not to forget that the night sky itself can make a great subject. For example, the night sky in Figure 1-13 had these darker clouds that I wanted to capture as they moved across the sky. So I used a long shutter speed — in this case, 55

seconds — which allowed the clouds to have some movement and made them a nice, soft counterpoint to the hard lights from the city.

Photographs of the night sky or objects in the night sky usually need longer shutter speeds to allow enough light to reach the sensor and give you a proper exposure. This means you need to get out the tripod and cable release to help eliminate camera shake during those long exposure times. But in the end, the extra steps are really worth it.

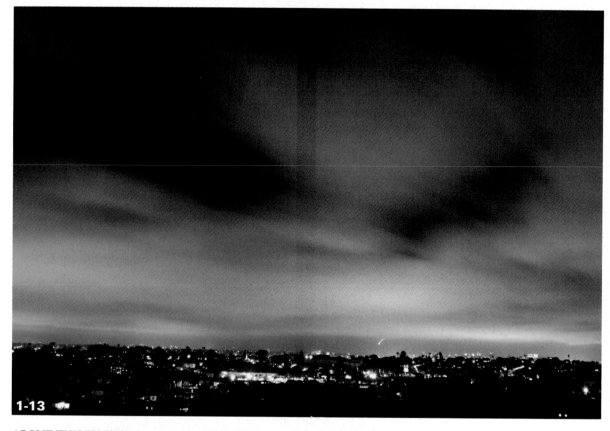

1-13

ABOUT THIS PHOTO *The same night sky I have photographed many times before, but it is always different. Taken at 55 seconds, f/10, and ISO 100.*

CITY LIGHTS AND LANDSCAPES

When you think of landscape photography, you probably think about photographing at the first light of the day and as the sun sets. While this is a great time to photograph, you can often get great images even after the sun has set. The landscape can take on an entirely different look, depending on the amount of illumination and the length of time you leave the shutter open.

Shooting landscapes at night takes patience and a sense of adventure. That is also true when shooting urban landscapes where the subject is often lit mainly by city lights. You must be willing to try a fair amount of experimentation because it is

nearly impossible to read the light accurately in these types of scenes, so you have to try different shutter speed, aperture, and ISO combinations to get results you are satisfied with. For example, consider that long shutter speeds can render a scene in a way that you can never see with the human eye because the camera can take an extended capture and compress it down to a single moment. Items that are moving can virtually disappear from the image, and any light that is moving can be rendered as a trail instead of a point. All these factors combine to make night and low-light photography a really adventurous form of image creation.

Assignment

Capture the same scene during the day and then at night

The assignment for this chapter is to capture an interesting scene during the day and then the same scene at night. You should really look to see what the differences in the lighting and mood are. When you are done, post your resulting images to the website to share with other readers.

The two images here were taken in Balboa Park in San Diego 90 minutes apart. The image on the left, taken at 1/80 second, f/6.3, and ISO 200, shows the reflecting pool and the Prado building in the background. The second image is the same scene but taken at 1 second, f/5, and ISO 200. As you can plainly see, the colors in the image are completely different because the main source of illumination is different.

During the 90 minutes between the two images, the sun set and the electric lights inside the buildings became the main light source. You can tell that there are at least two different types of light in the scene because some of the light is green and some is orange. There are also the last traces of color in the sky, adding a nice blue hue to the sky. If you look closely at the image on the left, many of the lights are already turned on but they are no match for the sun's power so they don't necessarily add to the illumination in the photograph. Look for lights like this when photographing during the day because it usually means that the building will be illuminated at night.

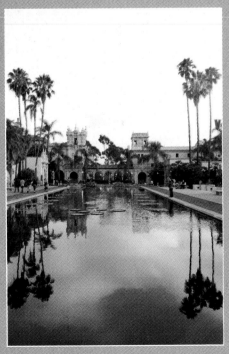 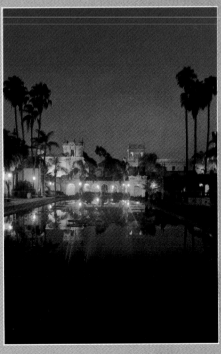

Remember to visit www.pwassignments.com after you complete the assignment and share your favorite photo! It's a community of enthusiastic photographers and a great place to view what other readers have created. You can also post comments and read encouraging suggestions and feedback.

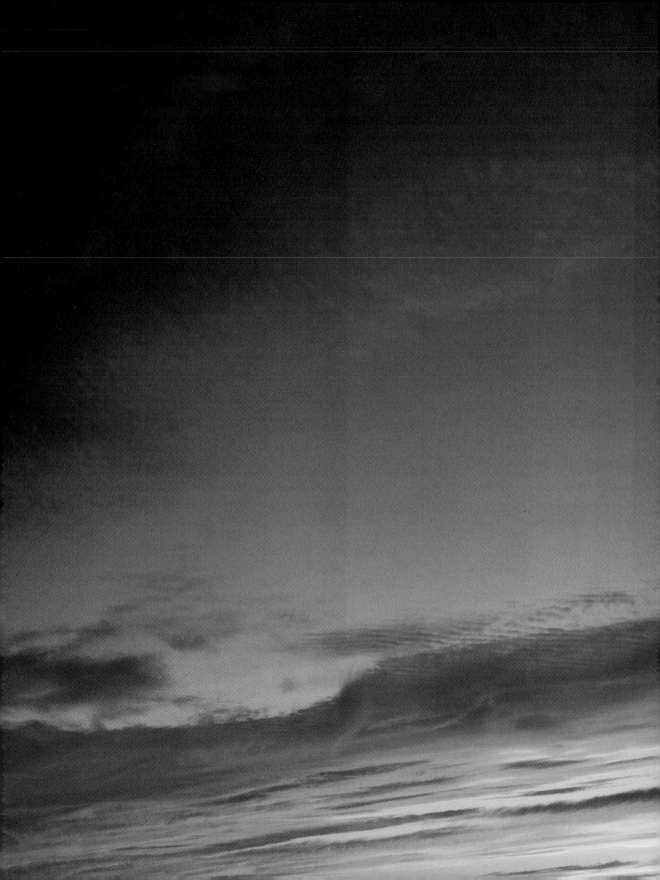

ALL ABOUT LIGHT AND EXPOSURE

Photography is about recording light. It doesn't matter if that is the light present at high noon under a bright sun or if it is in a darkened arena where the only light is from the stage lighting. As a photographer, you have to know where the light is coming from and how bright it really is. That is, you must determine the direction and intensity of the light. Luckily, there are light meters built into the cameras that can read the light present and help to get the right exposure settings. These built-in light meters can be used to measure the light in the whole scene or just in parts of the scene allowing for more control of the exposure readings.

Once you determine the amount of light, you need to be able to control the exposure settings on your camera so that you record the scene in the way you want to. Picking the right exposure mode or taking over full control and using the manual mode are all covered in this chapter. After you determine the settings, you need to take the color of the light into consideration because different light sources have different colors, even though they might look the same to you. Adjusting the white balance in the camera can make all the difference to the final image, and even though the white balance can be adjusted in postproduction, it is always better to try and get it right in the camera first.

DIRECTION AND INTENSITY OF LIGHT

Where the light is coming from (the direction) and how bright it is (the intensity) are the two most important starting points in creating a photograph. These two factors can be intertwined and related to each other, but more on that a little later on. First look at how direction and intensity determine how the subject is lit and how the viewer will react. Take, for example, the

beautiful, soft lighting used in portraits; the light seems to come from all directions at once and doesn't leave any hard shadows, as shown in Figure 2-1. This type of beauty lighting makes everybody look good and is very flattering, leaving a good impression with the viewer, which is why it is used so much in fashion and portraits.

On the other side of the coin is lighting using a small, hard light source that leaves hard shadows and distinct lines. This type of light is not well

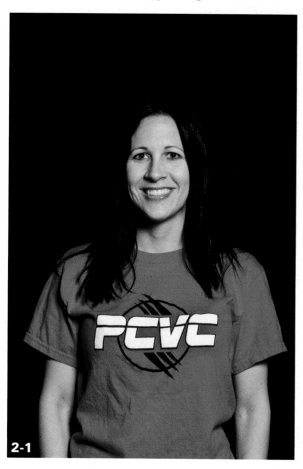

2-1

ABOUT THIS PHOTO *When photographing a series of volleyball team photos, I placed the coach against a black wall in the practice room and used a small softbox on the flash to soften the light as much as possible. You can see that the shadow under the chin does not have a very sharp edge, but fades from light to dark. Taken at 1/200 second, f/7.1, and ISO 200.*

suited for portraits unless you want to portray the subject as hard and angular. This type of lighting is used to great effect in horror movie posters when the light shines up from under the chin causing the face to fall in hard shadows.

DIRECTION

When it comes to the direction of the light, you generally expect it to come from above. The sun is above us with the light coming down, and so is the moon. Most rooms are lit by overhead lights, and even lamps are often placed to shine down. At night, when shooting cityscapes, the light can actually come from below and shine up, creating images that are unique.

> **tip** Looking at the shadows can help determine the direction and intensity of the light. The shadows always stretch away from the light, and hard light makes for hard-edged shadows.

A good way to determine the light's direction is to look at the shadows as they always show the direction the light is coming from. It is the shadows in an image that can help to give it character and interest. For example, landscape photographers usually like to work in the early hours of the morning or the late hours of the evening because not only is the light a great color, but the angle of the sun and the direction of the light cause long shadows to stretch across the landscape away from the sun.

Stop and look around for a moment. What light sources are present right now while you are reading this? Is it the soft glow from the overhead light in your living room or is it the hard, bright rays of the sun? Part of being a good photographer is being able to see the light that is present and understand how it interacts with your subject. Some people can do this without thinking about

it. Others need to practice. I fall into the second category and spend a lot of time practicing looking at the light and working out how it will affect my photography.

Look at the shadows created by the light; the harder the edge of the shadow, the harder the light. One of the situations I constantly deal with is the shadow created on the face of performers when they are illuminated by a spotlight. Take the shadow in Figure 2-2, for example, where the microphone is between the performer and the light source, creating a hard shadow right on his

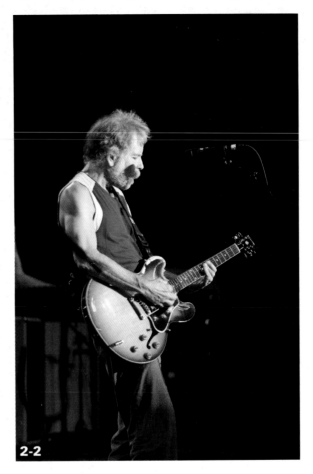

2-2

ABOUT THIS PHOTO *Bob Weir performing in concert. Notice the harsh shadow on his face caused by the microphone in the path of the spotlight. Taken at 1/320 second, f/2.8, and ISO 1600.*

face. Knowing that the light and microphone don't change, I have to wait until the performer moves so that the light striking him does not hit the microphone first, as you can see in Figure 2-3.

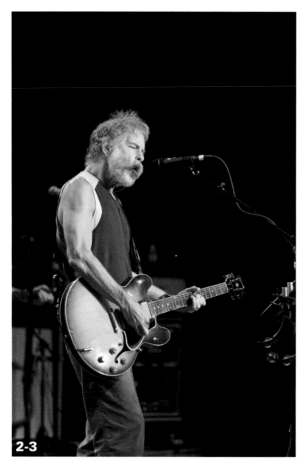

2-3

ABOUT THIS PHOTO *A few seconds after I took the previous image, the performer changed his position, so the light was no longer hitting the microphone first and creating a shadow. Taken at 1/320 second, f/2.8, and ISO 1600.*

INTENSITY

A very important thing to know about light is that the illumination from a light source decreases with distance. Just think of a lamp next to a wall in your house; the light doesn't light up the whole room equally, but instead the objects closer to the light are illuminated more than those across the room. The amount that light falls off as it travels can be determined by using a mathematical equation, one that every photographer should know about. Called the *Inverse Square Law*, this equation states that light drops off in inverse proportion to the square of the distance. I know that sounds complicated, and the natural reaction is to skip to the next section, but if you break it down, it's not that tough. Take, for example, the lamp: at 5 feet the light is pretty strong, but at 10 feet the light is much weaker — it is actually four times weaker than at 5 feet.

The rapid falloff of light becomes important when shooting at night and in low-light situations, especially when using a flash or any of the tools described in Chapter 9. For example, say you want to take a photo of two people, where one is 5 feet from the camera and flash, and the other is 10 feet away. The amount of light that reaches the second person is one-quarter of the light that reaches the first person, which can cause a lot of problems, especially if you don't understand what is happening to the intensity of the light. If you understand what is happening, you can either move the second person closer to the first person or add a second light that is closer to the second person.

LIGHT SOURCES

Many times the light source can help in determining both the direction and intensity of the light. During the day, it is pretty easy — the biggest and brightest light source is the sun, which makes it easy to determine the direction of the light, but that all changes at night. While moonlight (which is technically the reflection of sunlight) can be pretty bright, at night the other light sources are easily seen, too, such as neon signs hanging in store windows or the lights still on in office buildings as employees work into the evening. These different light sources create

very different looks to the same scene and can be one of the more interesting and fun parts of photographing at night. Take an office building that is usually lit from the sun; it is now lit up internally, and instead of the very bright sunlight coming down from above, the combination of different electric lights all mix to create a very different view.

When shooting indoors at weddings, concerts, and even sporting events, the light sources are usually really obvious. Take the lighting in Figure 2-4; it is easy to see exactly where it is coming from and what it is illuminating. This was taken

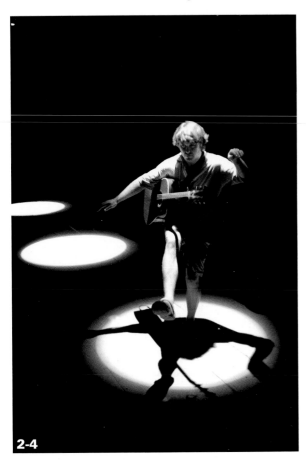

2-4

ABOUT THIS PHOTO *Keller Williams posing under the hard, directional lights in the backstage area of the Los Angeles Greek Theatre. Taken at 1/40 second, f/2.8, and ISO 250.*

backstage when I noticed that the lights coming straight down cast great shadows, so I had Keller Williams pose with his guitar before taking the stage. Of course, it isn't always so clear.

tip It is important to remember that when it comes to long exposures, small sources of light that might often go unnoticed can become significant sources of illumination.

MEASURING THE AVAILABLE LIGHT

To be able to take a good photograph with proper exposure, you have to be able to quantify the amount and intensity of the light present in the scene. Many times your eyes are fooled, and scenes that look bright are really quite dark, while scenes that look normal can be very bright. This is because your brain can adjust the way you perceive the light. While you could purchase a separate light meter to measure the light for you, your camera's built-in light meter does a great job and will serve you well with just a little practice.

THE BUILT-IN LIGHT METER

Your camera's built-in light meter enables the camera to see the light in the scene and, depending on the camera's exposure mode, provides a fairly accurate reading of the light present. The camera reads the light coming through the lens and it determines the correct settings to capture the scene properly. These results are usually pretty good, but the camera has problems when the scene you are shooting is predominantly light or dark. The light meter tries to take all the dark and light areas and average them out to create a scene that is an overall 18 percent gray. This might be great for average scenes, but night and

low-light photography is anything but average. Many of the photo subjects covered in this book are difficult to meter, but you need to know what the different metering modes do.

METERING MODES

The camera has a built-in light meter that reads the light reflected off the subjects in front of the lens, but it doesn't treat the whole scene equally. Digital cameras have at least three different metering modes and, depending on which one you use, the outcome can be very different. Each mode looks at the scene in front of the camera in a different way.

- **Spot metering.** In this mode, the camera's built-in light meter only looks at a small area of the overall scene, usually the area in the center of the frame. It ignores everything else and is really useful for when you have very large areas of light or dark that you don't want to be part of the exposure equation. On many new cameras, the spot metering area is tied to the focus point (the autofocus point on which the camera uses to focus). This allows you to use the spot metering on the subject, even when it isn't in the middle of the frame.

- **Center-weighted metering.** Center-weighted metering looks at the scene and pays more attention to the area in the middle of the scene than it does to the edges; in most of the cameras produced today, you can set the size of the area to be measured. This is really useful when you're taking portraits and you want to make sure the camera's built-in light meter measures the light falling on the subject, rather than the background.

- **Matrix or evaluative metering.** This is the mode that camera manufacturers try to improve all the time because it looks at the whole scene and tries to actually determine what you are photographing. This mode divides the entire scene into different segments and then tries to determine what the proper exposure is for the scene. It is an excellent choice for scenes that don't have big areas of extreme brightness or darkness, like that in Figure 2-5.

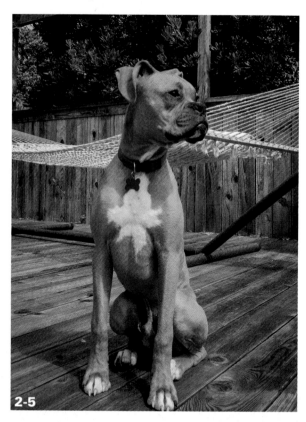

2-5

ABOUT THIS PHOTO *Photographing my dog outside in the shade allowed for the matrix metering to work well because there were no large areas that were very bright or very dark. Taken at 1/1000 second, f/4, and ISO 200.*

EXPOSURE SETTINGS

Setting the exposure on your camera is a very simple process that can take a few minutes to understand and a lifetime to master. There are three settings that you can adjust to control the exposure: the shutter speed, the aperture, and the ISO.

The exposure settings are described mathematically, with the proper exposure having an exposure value (EV) of 0. Images that are too light are *overexposed* and have a positive value, while the images that are too dark are *underexposed* and have a negative value.

The amount an image is over- or underexposed is described in *stops*. A stop is exactly half as much light or twice as much light. If you are wondering how something can be both half and double, it is because a stop is a way to describe the change in the amount of light that reaches the sensor when adjusting the shutter speed or aperture. So, if the image is underexposed by −1, then it is underexposed by 1 stop, and twice as much light would need to reach the sensor to get an exposure value of 0.

When you adjust the exposure, you can adjust the shutter speed, aperture, and ISO by parts of a stop, usually set in the camera as 1/3 or 1/2 of a stop. This allows you to fine-tune the exposure by using small adjustments and not just full stops. You can check your manual to find out how to set this on your camera.

SHUTTER SPEED

The shutter speed setting specifies the amount of time that the shutter is moved out of the way, allowing light to reach the camera's sensor. The longer the shutter is open, the more light is allowed to reach the sensor; the shorter the time the shutter is open, the less light is able to reach

the sensor. The shutter speed is also the setting that is used to show motion in your images. If the subject is moving while the shutter is open, then the subject is blurred.

It is really important to use a shutter speed that shows the movement in the way you want. A fast shutter speed freezes the action. So, for example, to freeze the action of a basketball player dribbling down the court, you will need a shutter speed of at least 1/500 second. To get that shutter speed in low light, the ISO needs to be pushed way up, possibly as high as 3200 (if your camera offers it). You are likely to need an aperture around f/2.8.

tip Can't get the settings you need to freeze the action? Consider that a slower shutter speed will show the motion as a blur and can add a real sense of movement to an image.

The frustrating part of photographing in low light is when you use an exposure setting that gives control of the shutter speed to the camera, such as auto mode or aperture priority mode. In these modes, the camera uses the built-in light meter to determine the shutter speed needed to get a proper exposure, but at times these shutter speeds are not what you want. Many times the shutter speed will be too slow and the image will be blurry and out of focus.

Shutter speeds are usually described as a fraction of a second, like 1/60 second or 1/200 second. When it comes to shooting at night or in very low light, your shutter speed might be described in full seconds or in minutes and seconds.

When you leave the shutter open for a long period of time, not only does it allow more light to reach the sensor, but it can also show how an object moved during that time. This is a key part

to capturing light trails because instead of freezing the subject in one place, you capture the movement of the subject. Take, for example, Figure 2-6, where the 25-second shutter speed allowed the fireworks to render as solid lines of light instead of just points of light.

note

Your camera may have a setting for long exposure noise reduction. While it is useful when taking long exposures, it does mean that you have to wait between photos. So it is not great when shooting fireworks or other events where you don't or can't wait between photos.

The shutter speeds are related to each other in a very important way. Each time you double the shutter speed, you let in exactly twice as much light, and each time you halve the shutter speed, you let in exactly half as much light. Night and low-light photography uses both extremes when it comes to picking shutter speeds. Many times, fast shutter speeds are needed to freeze the action, while at other times, very long shutter speeds are needed to gather as much light as possible.

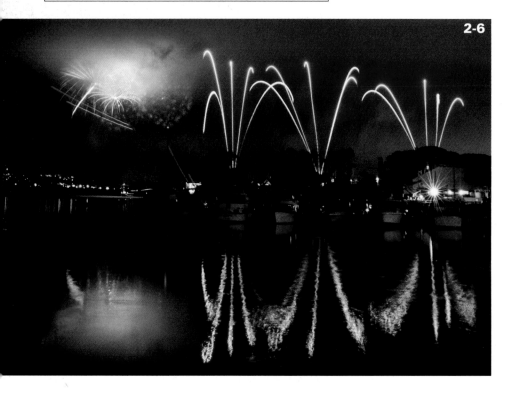

2-6

ABOUT THIS PHOTO
The nightly fireworks display from SeaWorld in San Diego makes it easy to photograph fireworks every night, not just at special events, and shooting them at the water's edge created the reflections seen here. Taken at 25 seconds, f/16, and ISO 200.

STUCK AND HOT PIXELS There is one thing that needs to be addressed when it comes to using very long shutter speeds, and that is a specific type of digital noise. Usually digital noise is only a concern in relation to the ISO setting, but when you keep the shutter open a long time, there is a different type of noise that is introduced. This type of noise is commonly referred to as *stuck pixel noise* or *hot pixel noise,* but the two are not exactly the same. Stuck pixels are actually damaged pixels that are going to show up as spots in any photo no matter the shutter speed, while hot pixels are those that leak over time, showing up in the longer exposure times, but they can look the same. The longer that you leave the shutter open, the more hot pixels you will see. Many cameras have a long exposure noise reduction setting that seems to take as long as the exposure to work. That is because the camera is taking a second photo, just as long as the original but without opening the shutter so that the hot pixels can be determined and removed from the shot. Check your camera manual for this setting for your camera.

APERTURE

The aperture setting controls the size of the opening in the lens that lets light through the lens into the camera. The bigger the opening, the more light is allowed to reach the sensor. The range of openings available is determined by the lens, not the camera body, which is one of the big advantages to using a dSLR — you can change lenses depending on the situation.

The aperture is described using f-stops, which are fractions made by the focal length of the lens and the diameter of the opening. The important thing to know is that the smaller the number, the larger the opening. So an f-stop of f/2.8 lets in more light than an f-stop of f/5.6. Each time the size of the opening is doubled, the lens allows twice as much light (1 stop) in. Each time the aperture is halved, it allows half as much light in. This means that when you change from f/2.8 to f/4.0, you are letting in exactly half as much light, and when you change from f/16 to f/11, you

are letting in exactly twice as much light. The following list of apertures are all exactly 1 full stop of light apart from each other:

f/1.4, f/2.0, f/2.8, f/4.0, f/5.6, f/8.0, f/11, f/16, f/22, f/32, f/45, f/64

Many of the cameras available today allow you to adjust the aperture in 1/3 or 1/2 stops. This gives you much more control over how much light is allowed through the lens.

The f-stops available when using 1/3 stops are as follows:

f/1.4, f/1.6, f/1.8, f/2.0, f/2.2, f/2.5, f/2.8, f/3.2, f/3.5, f/4.0, f/4.5, f/5.0, f/5.6, f/6.3, f/7.1, f/8.0, f/9.0, f/10, f/11, f/13, f/14, f/16, f/18, f/20, f/22

The aperture controls the depth of field in your image. The *depth of field* is defined as the area in front of and behind the subject that is in acceptable focus. The bigger the opening in the lens (aperture), the shallower the depth of field (which means that the area in acceptable focus is very small). Look at

the guitar and the hands in Figure 2-7, and you can see that while the guitar is in focus, the right hand isn't. This is because I used an aperture of f/2.8, creating a very shallow depth of field.

When out photographing subjects that need long shutter speeds or when you need to get the whole scene in focus (as with landscapes), you need to use smaller apertures in order to create deeper depths of field.

ISO

The ISO is the setting that determines how sensitive the camera's sensor is to light. The ISO setting gives you a starting point for the exposure

settings and allows you to have consistency in exposures no matter what camera you use. The ISO setting is based on the film speeds used in traditional photography, giving photographers a constant measurement of how sensitive to light the film was. Because the light sensitivity of the sensor in a digital camera can't actually be changed, the ISO is adjusted by amplifying the signal received by the sensor when light strikes it. The more the signal is amplified, the higher the ISO rating and the less light is needed.

The downside to this amplification is that digital noise can be introduced into the image as the signal is amplified more. Because this book is all

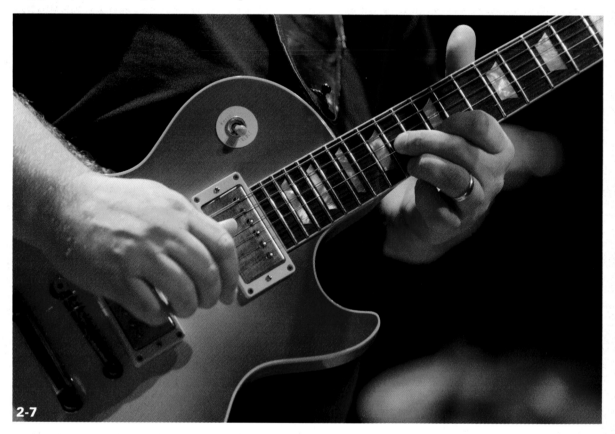

2-7

ABOUT THIS PHOTO *I needed to use a wider aperture to get the most light possible through the lens and freeze the fast fingers of the guitar player. However, at the same time, the shallow depth of field meant that while the guitar was in focus, the right hand that was just in front of it wasn't. Taken at 1/160 second, f/2.8, and ISO 1600.*

about shooting in conditions where there is not a lot of light, choosing the best ISO setting is really important. You control the ISO through a menu setting on your camera. Figure 2-8 shows the ISO choices available on my main camera; your menu will look similar. The ISO settings available to you will depend on the make and model of your camera.

x-ref

For a more detailed look at working with ISO, see Chapter 3.

ISO sensitivity settings

ISO sensitivity

500
640
800 [OK]
1000
1250
1600
2000

2-8

ABOUT THIS FIGURE *The ISO choices on my camera.*

With digital cameras, you can change the ISO whenever you want, and many cameras now have an Auto ISO setting where the camera not only adjusts the shutter speed and/or aperture to get the proper exposure, but also adjusts the ISO. This enables the camera to choose a shutter speed high enough to freeze the action and an aperture with a deep depth of field to show everything that is captured in acceptable focus. However, the result of this feature can be a lot of digital noise in images when you weren't expecting it.

Not all camera sensors are created equal when it comes to high ISO settings and digital noise. The sensor, electronics, and software built into each camera model deal with noise differently, and as technology improves, so does the high ISO/low noise capture ability of the cameras. Camera manufacturers have created cameras that can use ISOs previously unimagined, and while these incredibly high ISOs can still have a great deal of digital noise, the quality of the images captured at the high ISOs (1600, 3200, and even 6400) has increased dramatically as well. For example, the Nikon D2X pro-level camera was released in early 2005 and had a maximum ISO of 800 with the ability to shoot at 1600 and 3200, but those settings were so noisy that they were called H1 and H2. The latest Nikon consumer camera, the D7000, has a high ISO setting of 6400; it still has high ISO settings, but now the H settings represent an unbelievable ISO 12,800 and 25,600. It is now possible to shoot at ISO 1600 and get images with noise levels that just a few years ago would have had to be taken at a much lower ISO.

With all these advances in high ISO capability, the real test of what is acceptable digital noise is what you find acceptable in your own photography. When it came to photographing the marine in Figure 2-9, I had the ISO set to 1250, and while there is noise present in the uniforms, it isn't bad enough to render the image useless. I could even apply noise reduction in post-processing to clean the noise up.

x-ref

Noise reduction is covered in Chapter 11.

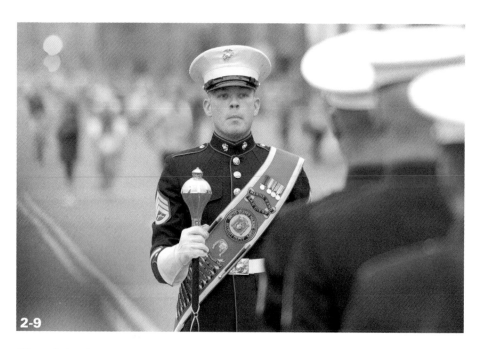

2-9

ABOUT THIS PHOTO
The Marine Color Guard was present at the start of the Rock 'n' Roll Marathon in San Diego, and I needed to push the ISO because it was early in the morning and there wasn't a lot of light present. Taken at 1/60 second, f/3.2, and ISO 1250.

EXPOSURE MODES

Your camera has at least four basic exposure modes and quite possibly many more. The four basic exposure modes are program auto, shutter speed priority, aperture priority, and manual. They are labeled P, S, A and M on Nikon and Sony cameras and P, Tv (for Time value), Av (for Aperture value), and M on Canon cameras. These modes determine what happens when you press the shutter release button.

■ **Program auto mode.** This is the automatic mode of your camera; it gives most of the control to the camera's built-in light meter. When you press the shutter release button halfway down, the camera's built-in light meter reads the light in the scene and picks the best aperture and shutter speed (and in some cases, the ISO as well) so that the image is properly exposed. What makes this different from a fully automatic mode is that you can still adjust the settings before actually taking the photo. If you decide that you need a faster shutter speed to make sure the subject is

frozen in place, then you can increase the shutter speed and the camera will automatically try to open the aperture wider. If you want to adjust the aperture so that you get the desired depth of field, the camera will automatically adjust the shutter speed so that the exposure is correct. Check your camera manual for how to adjust the settings when in program auto mode.

■ **Shutter speed priority mode.** When you use the shutter speed priority mode, you set the shutter speed, and the camera uses the built-in light meter to determine what the best aperture is to get a proper exposure. This is useful if you want to control the shutter speed to get the desired results. For example, if you really want to make sure that you are freezing the action, and the depth of field is less important, then you want to use this setting and set the shutter speed as high as needed. The camera will then try to use the smallest aperture it can to get the proper exposure until it is at the widest aperture for the lens used.

- **Aperture priority mode.** This mode enables you to set the aperture, and the camera uses the reading from the built-in light meter to set the best shutter speed to get a proper exposure. If you have auto ISO capability and have it turned on, the camera will also adjust the ISO accordingly.

- **Manual mode.** This is the mode that gives you complete control over the camera settings because you set both the shutter speed and the aperture. So, while the camera will still use the built-in light meter to read the light in the scene and determine what it believes to be the proper exposure, it has no actual bearing on what is captured. You will use this mode most often when shooting at night or in

low light. Most of the photos in this book were taken using manual mode. In Figure 2-10, for example, there was no way to get this exposure in any of the other modes. In most cameras, the longest shutter speed that you or the camera can use is 30 seconds. There is a special setting called the bulb setting which allows you to use a cable release; as long as the shutter button is pressed, the shutter will stay open. That is what was used here because if the camera had picked the shutter speed and the aperture, it would have used the widest aperture and the longest shutter speed and still wouldn't have been able to expose the scene properly due to the large areas of black and the lack of light.

2-10

ABOUT THIS PHOTO *Mission Bay in San Diego captured late at night. Taken at 61 seconds, f/22, and ISO 200.*

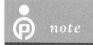
The four modes discussed here are all you need to get the best results in any lighting situation. The trick is to know when to use each one and why.

- Program auto mode is best used in an emergency when you don't really have the time to set the camera exactly the way you like it. I use this as a snapshot mode, and while it is useful, I don't use it very often.

- Shutter priority mode is used when you need to make sure you are using a shutter speed that shows the movement in your images as you want it to be seen. This means that you have set a fast shutter speed to freeze the action or have set a longer shutter speed to show the movement. You can also use the shutter speed to control the aperture because you know the way a camera adjusts the scene. So, if you are shooting in shutter speed mode and want the camera to use a wider aperture, just increase the shutter speed by a stop and the aperture will get bigger by a stop. For example, if you are photographing at 1/250 second and the camera has picked f/4.0, but you want a shallower depth of field, then just change the shutter speed to 1/500 second, which is 1 stop faster, and the camera will change the aperture to f/2.8 (as long as your lens has f/2.8).

- Aperture priority mode can be used when you want to make sure that you are getting the right depth of field, but it can also be used to control the shutter speed. If you are using f/5.6 and the camera has picked 1/60 second as the shutter speed, then if the light stays the same, you can change the aperture and the camera will change the shutter speed. So if you change the aperture to f/8.0, then half as much light is being allowed through the lens, so the shutter speed will double to 1/30 second.

- Manual mode takes some getting used to, and it is easy to make mistakes because you have complete control, which may result in either over- or underexposed images. The camera shows you how much it believes your settings will either over- or underexpose the scene, but it will not adjust anything.

EQUIVALENT EXPOSURES

One of the coolest things about photography is that different settings can result in the same exposure. This means that if you need the same exposure, but want or need a different f-stop or shutter speed, then you can still get the desired result. For example, if you want to use a higher shutter speed to freeze the action, then a wider aperture allows you to do this. Or, if you want to use a very long shutter speed to capture fireworks and the rockets' trails, then using a very small aperture allows you to do this. By being able to use different settings to get the same exposure, you have creative control over your images.

Because an exposure is created when a specific amount of light reaches the sensor, you can change the way that happens. For example, if you increase the amount of time the shutter is open, allowing light to reach the sensor, then you can decrease the size of the aperture so that the amount of light travelling through the lens is reduced. This results in the same amount of overall light, and thus it is an equivalent exposure. What makes this all work easily is that the amount of light is measured using stops, as discussed earlier. Because a stop of light is the same if you adjust the shutter speed, the aperture, or

the ISO, it is much easier to adjust the exposures. Take Figures 2-11 and 2-12 for example. They both have the same exposure but very different shutter speeds and ISO settings. Notice how the longer shutter speed in Figure 2-12 creates a smoother look to the water because the longer exposure time allowed the motion to smooth out the water.

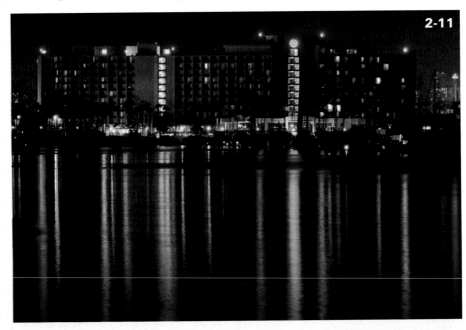

2-11

ABOUT THIS PHOTO
The Hilton Bayfront hotel at night with lights reflecting in the San Diego bay was taken at 4.6 seconds, f/16, and ISO 1600.

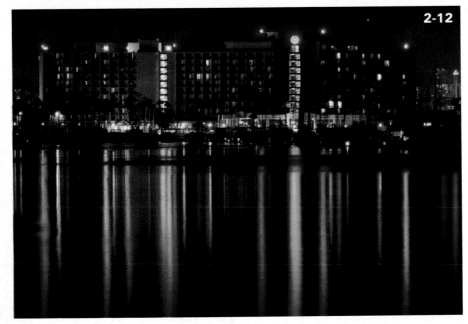

2-12

ABOUT THIS PHOTO
The same scene of the same hotel as in Figure 2-11 but with a much lower ISO which in turn needs a lot longer shutter speed to get the same exposure. Taken at 33 seconds, f/16, and ISO 200.

MULTIPLE EXPOSURES

Many times you will want to take more than one exposure of the scene you are photographing. This could be because the tonal range of the scene is more than your camera can handle in one photograph or because you are having a difficult time deciding what to expose for. Other times it is just because there is no way to accurately measure the light in the scene, and exposures are just a best guess. There are some different ways to easily take multiple images each with a different exposure. The idea of taking multiple exposures of the same scene with different exposures is called *exposure bracketing*.

EXPOSURE BRACKETING

When you bracket your exposures, you take a series of images that have both the properly exposed shot and at least one underexposed and one overexposed image. Many cameras can take this sequence automatically, and you can set the number of shots in the sequence and the amount the exposure is different in each shot from the previous one in the sequence. For example, I can set my camera to take a series of five shots in the following sequence:

- Correct exposure or 0

- Underexposed by 2 stops or –2

- Underexposed by 1 stop or –1

- Overexposed by 1 stop or +1

- Overexposed by 2 stops or +2

Many times, bracketing your exposures helps you get the shot, especially in tough exposure situations, such as the series in Figures 2-13, 2-14, and 2-15. These were taken in Key West, Florida, around sunset. I wanted to make sure I could see the details in the boat, so I photographed

a three-image bracket, with each image 1 stop different. As you can see, the three images are vastly different in the exposure, from too dark (Figure 2-13) to too light (Figure 2-15), with Figure 2-14 being the proper exposure according to the camera. In my opinion, the sky looks better in the technically underexposed image and the boat looks better in the correctly exposed image. Had I just taken the single frame with the camera's suggested settings, I would never have seen how great the underexposed sky looked.

2-13

ABOUT THIS PHOTO *A sunset captured in Key West, Florida. Taken at 1/50 second, f/5.6, and ISO 200 with –2 exposure compensation.*

One of the reasons why bracketing works well is that many cameras have the feature built right in so it can be set up easily. The function is usually called automatic exposure bracketing and can be set in the camera to take a series of bracketed images automatically. Check the manual for information on how to set this feature for your specific camera. If you want a wide variety between the exposures, set the difference between the exposures at 2 stops, but if you want to keep the changes small, set the difference to 1/3 stop.

Many cameras allow you to set this auto bracketing function in the aperture priority and shutter priority modes. This enables you to specify which of the exposure settings will be adjusted. When you use aperture priority as the exposure mode and set the bracketing function, the camera first meters the scene using the built-in light meter, then picks the shutter speed it has determined will produce the proper exposure, and then calculates which shutter speeds will produce the desired under- and overexposed images. This

2-14

2-15

ABOUT THIS PHOTO *The same scene as Figure 2-13, but this time with the proper exposure of 1/13 second, f/5.6, and ISO 200.*

ABOUT THIS PHOTO *The same image was taken with a +2 exposure compensation and the setting ended up at 0.3 second, f/5.6, and ISO 200.*

allows you to make sure that the aperture and the depth of field do not change in the bracketed images.

When you use the shutter speed priority mode, you set the shutter speed and the camera sets the aperture. When you set the bracketing in this mode, the camera first picks the aperture that it determines is the correct exposure, and then it picks the apertures that will under- and overexpose the image. This way, you can make sure that the image has the shutter speed you want, but the depth of field will be different for each shot.

EXPOSURE COMPENSATION

Another way to quickly change the exposure of your image is by using exposure compensation. Exposure compensation is a camera function; not all cameras have this feature, so check your manual. The idea behind exposure compensation is to purposely over- or underexpose the image by a certain amount, no matter what the camera determines the settings should be. The camera first picks the settings that it has determined are correct based on the built-in light meter and the metering mode. Then it sets the values for the shutter speed and/or aperture, depending on the exposure mode. Finally, it adjusts those values, depending on the exposure compensation you picked.

This makes it very easy to quickly make a photo lighter or darker without having to actually set the camera to manual mode and adjust the exposure.

Exposure compensation is set as a relative amount from the proper exposure value, which is 0. So to overexpose the image, you use the exposure compensation controls to set positive numbers, and to underexpose the image, you set it to negative numbers. It may be possible to set the exposure compensation in parts of a stop, depending on the camera. For example, if the scene is just a little bright and you want to darken the whole scene,

then set −1 exposure compensation. If you need the scene to be a little lighter, then set +1 exposure compensation.

Exposure compensation isn't some sort of photography magic; the new exposure settings come from the camera adjusting the current settings, and this adjustment can have unforeseen consequences. If, for example, you decide that the image needs to be a little brighter, then the camera will use either a longer shutter speed or a wider aperture because that's the way to get more light to the sensor and make the image brighter. This means that the shutter speed might drop, causing a moving subject to be blurry or the depth of field to become much shallower.

COMBINING MULTIPLE EXPOSURES

One reason to take multiple exposures is to make sure you get the best exposure for the scene, but there is another reason to take multiple exposures — to combine the images into a single image. To do this, you need an image-editing program, such as Adobe Photoshop or Adobe Photoshop Elements, which allows you to import multiple images and combine them into a single image. One of the more common uses of combining multiple exposures is to manually combine the images to create a composite, as shown in Figure 2-16. This image was created from combining Figures 2-13, 2-14, and 2-15. I used the sky from the first image (Figure 2-13), the water from the second image (Figure 2-14), and parts of the ship from the third image (Figure 2-15). I did this by putting each image on its own layer and masking out the areas that needed to be hidden.

(p) *x-ref* While this isn't a book about how to edit your photos in image-editing software, combining images like this is covered in Chapter 11 in more detail.

2-16

ABOUT THIS PHOTO *The scene from Figures 2-13 to 2-15 combined into a new image.*

HDR

In addition to creating composite images, a very popular way to combine multiple images into a single image is to create a *High Dynamic Range* (HDR) photo. HDR imaging is a process where you take a series of images of the same scene with different exposures and combine them so the final image has a greater tonal range than any of the individual images. This technique takes the set of images that have different exposures and, by using specialized software, creates a single image file.

There are really two kinds of images that you can create using this process: one is a more photo-realistic representation of the scene and more closely resembles what our eyes see, and the other renders the same scene in a much more artistic way with a much higher level of saturation. The latter style isn't an actual representation of the colors present, but a more artistic rendering.

To create an HDR image, you need a set of identical images with different exposures. To get the best results, the following conditions must also be met:

- **The exposures should all have the same depth of field.** This ensures that the final image has the same objects in focus when it is created from the individual files. This means shooting in aperture priority mode or in manual mode so that you can adjust the exposure by adjusting the shutter speed or the ISO, and not the aperture.

- **The images should each have the same composition.** The HDR creation process blends the images together, and any difference in the composition in the individual shots can cause a problem. These differences could be due to the wind blowing the leaves on a tree or a person walking through the scene, and it is best to try to avoid them if possible. It is best to lock the camera into a tripod and not move it at all when shooting the sequence of images.

To combine your images, you need to use a software program that can blend the images together. Programs such as Nik Software's HDR Efex Pro and Photomatix Pro allow for easy HDR creation. The Merge to HDR settings available in Photoshop and Photoshop Elements also work well.

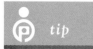
tip For more on HDR, check out *HDR Photography Photo Workshop*, also from Wiley, to learn more about how to work with and create great HDR photos.

Combining photographs using HDR software makes it possible to take a good scene and, with a little patience, make it better and more interesting. For example, an average sunset scene can get a little pop by combining seven different exposures into one image, as I did in Figure 2-17.

THE COLOR OF LIGHT

Different light sources have different colors. This can be obvious, like the deep red and orange glow that the sun gives off at sunrise and sunset, or it can be subtle, like the difference between the incandescent and fluorescent bulbs used indoors. And, while the human brain automatically adjusts for small differences in light color, the sensor in your camera is very different. It records the light that is present in the scene as it is — so that what you see may not really be white at all.

2-17

ABOUT THIS PHOTO *The sun setting over the Pacific captured with the camera on a tripod so that the composition didn't change, but the exposure range is seven full stops of light from –3 to +3 all combined using the Nik Software HDR Pro.*

The Kelvin scale is used to describe the color of the light and the white balance setting on the camera.

> **tip** One of the best reasons to shoot using the RAW file type is so that you can easily fix the white balance in postproduction.

DIFFERENT LIGHT SOURCES

There are a lot of different light sources out there, and while you may think that shooting at night or in low light would reduce the number of sources, it actually increases them. Photograph outside during the day when the predominant light source is the sun, and take the same location at night. The chances are that there will be a variety of different light sources all competing with each other and combining to illuminate the scene. This can include sodium vapor streetlights, newer fluorescent bulbs in signs and buildings, the variety of illuminated building signs, car headlights and taillights, neon, and even the moon. Each of the different light sources has a different color.

COLOR TEMPERATURE AND THE KELVIN SCALE

The Kelvin scale is used to describe the color of a specific light. It gives a constant measurement that can be used to adjust the color of an image either in the camera or in postproduction. The Kelvin scale was created by the British physicist William Thomson in the late 1800s. He heated up a block of carbon and noticed that the block changed colors as it changed temperature. The color started out as a dark red and slowly changed to a blue-white light as it got hotter. This became

the basis for the Kelvin scale: deep oranges and reds are the lower temperatures and bright blue and white are the higher temperatures. Because of the Kelvin scale's standard numerical description, it is possible to tell the camera what the color of the light in the scene is using the white balance setting on the camera.

WHITE BALANCE

Setting the white balance on your camera is the way to get the most accurate color when photographing under any light source. Check your camera manual for the location of the white balance menu or button. Make sure you choose the correct one before taking the photo so you get the most accurate color.

The following list introduces the standard white balance settings:

- **Auto white balance.** Most cameras have an auto white balance setting that allows the camera to set the white balance for every shot. This means that the camera looks at the light present just as the shutter release button is being pressed and tries to get the most accurate results and the truest colors. The downside is that the white balance is different, even if only slightly, for every photograph as the camera makes slight adjustments, depending on the light. If you are taking a series of photos in the same place at the same time, this can cause each of the images to look a little different. I have found that the auto white balance setting works great in most situations, but not all, and when shooting under multiple light sources either indoors or at night, the auto white balance is probably not the best choice.

- **Daylight.** The daylight setting sets the white balance on the camera to around 5000 to 5500K. Although this gives you accurate color in direct noon sun, it can look a little cold or blue. Figure 2-18 shows you an example of a photo with the daylight white balance applied.

- **Cloudy.** The cloudy white balance setting pushes the color temperature a little warmer than the daylight setting, as you can see in Figure 2-19. I use this when shooting in direct sunlight because it adds a little warmth to images that I find to be more pleasing.

- **Flash.** The flash white balance setting is even warmer than the cloudy setting, as shown in Figure 2-20, but these two are usually very close to each other. This setting is used to match the on-camera flash because the flash creates light that is cooler (more blue).

- **Shade.** The shade white balance setting pushes more red and orange into the image because the light in the shade is cool and has a blue cast, as shown in Figure 2-21. This is also a good mode for shooting in very cloudy situations because the light coming through the clouds is much colder than direct sunlight.

2-18

ABOUT THIS PHOTO *David photographed with an off-camera flash using daylight white balance. Taken at 1/250 second, f/5.6, and ISO 200.*

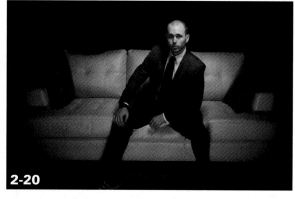

2-20

ABOUT THIS PHOTO *David photographed with an off-camera flash using flash white balance. Taken at 1/250 second, f/5.6, and ISO 200.*

2-19

ABOUT THIS PHOTO *David photographed with an off-camera flash using cloudy white balance. Taken at 1/250 second, f/5.6, and ISO 200.*

2-21

ABOUT THIS PHOTO *David photographed with an off-camera flash using shade white balance. Taken at 1/250 second, f/5.6, and ISO 200.*

■ **Fluorescent.** The fluorescent white balance, as shown in Figure 2-22, starts to push blues into the photo because the color of fluorescent light is usually warmer to start with. This setting is also used to counteract the warmer fluorescent bulbs. Fluorescent lighting can cover a wider range of colors depending on the bulbs, the power consumption, and the shutter speed. The wide variety of fluorescent bulbs makes this setting more of an educated guess than anything else, and when shooting under these lighting conditions, I would rather use a custom white balance setting.

■ **Incandescent/tungsten.** The incandescent or tungsten white balance setting is used in lighting situations where the light is much warmer than sunlight. This setting counteracts the red color in a scene, but can make shots taken indoors look like they were taken in pure white light, which may not actually be a good thing. People's expectations are that photos taken indoors will look warm; if they are too white, then the image will look wrong, as shown in Figure 2-23. I prefer the fluorescent setting, which removes some of the warmth, but not all of it.

■ **Custom white balance.** The custom white balance setting, shown in Figure 2-24, allows the photographer to set the white balance for the exact color of light present in the scene and adds blue or red as needed to even out the light in the scene. Most cameras allow you to take a test photograph to use as a basis for the white balance setting.

2-22

ABOUT THIS PHOTO *David photographed with an off-camera flash using fluorescent white balance. Taken at 1/250 second, f/5.6, and ISO 200.*

2-23

ABOUT THIS PHOTO *David photographed with an off-camera flash using incandescent white balance. Taken at 1/250 second, f/5.6, and ISO 200.*

2-24

ABOUT THIS PHOTO *David photographed with an off-camera flash using a custom white balance. Taken at 1/250 second, f/5.6, and ISO 200.*

ⓟ **x-ref** The white balance can also be used to change the color of your image, in some cases pretty drastically, in postproduction. There is more on that in Chapter 11.

Assignment

Capture the same scene using equivalent exposures

For this assignment, choose a scene and photograph it twice using equivalent exposures. Share your results with other readers on the website. When you photograph the same scene using different shutter speeds, apertures, and ISOs, you can really get a feel for what each does. The same scene photographed with a long shutter speed and a short shutter speed look very different even though exposure is the same. These two photographs were taken at the same place at the same time with the same overall proper exposure, but they look different due to the changes in the shutter speed, aperture, and ISO settings between them.

By using a short shutter speed of 1/60 second in the left image, the cars that are driving down the road are frozen in place and you can distinctly see each one. The photo on the right was taken with a shutter speed of 1 second and the cars became streaks of light. To keep the exposure the same, I also had to change the ISO and aperture. The image on the left was taken at 1/60 second, f/2.8, and ISO 1600 while the image on the right was taken at 1 second, f/5.6, and ISO 100.

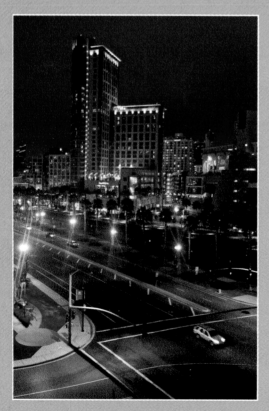 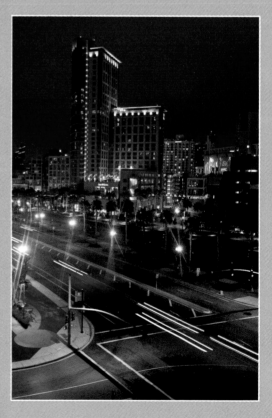

Remember to visit www.pwassignments.com after you complete the assignment and share your favorite photo! It's a community of enthusiastic photographers and a great place to view what other readers have created. You can also post comments and read encouraging suggestions and feedback.

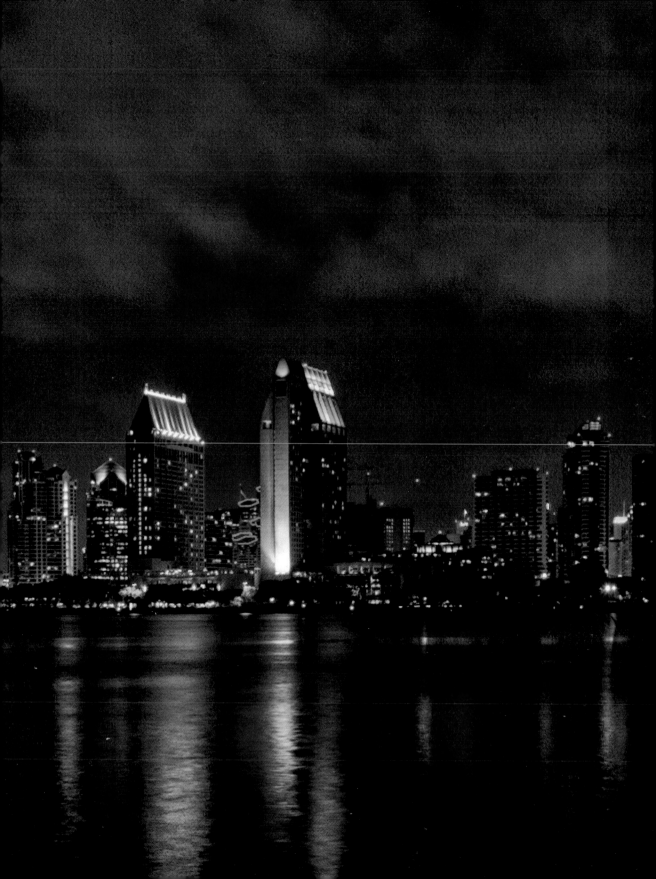

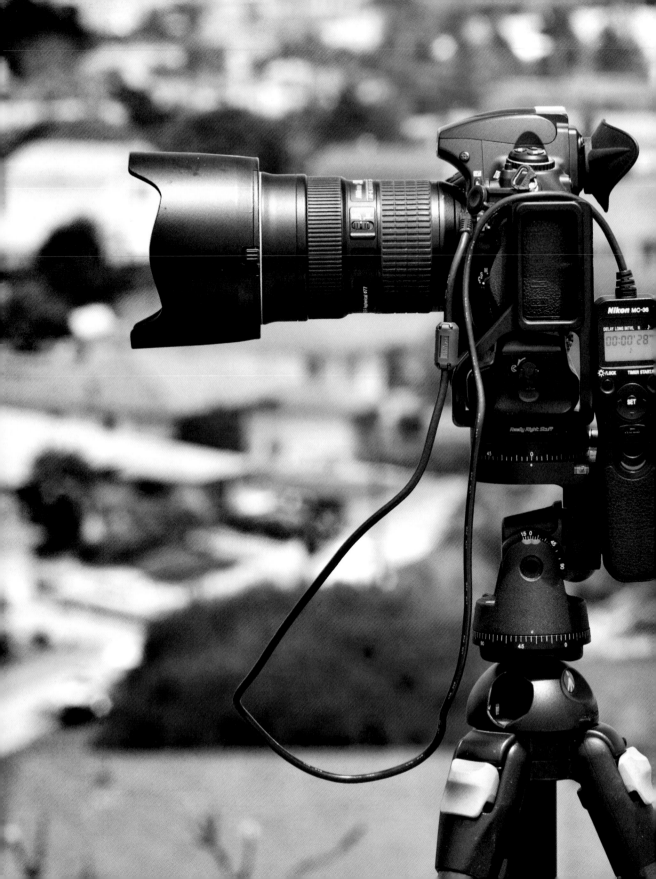

Already a daunting task, photographing in low light can be made so much more difficult without the right gear. You must consider the camera's ability to shoot in low light with low noise, and whether it has the ability to keep the shutter open for extended periods of times. You have to consider the ability of your lenses, what the range of apertures are, and whether you will be able to zoom in an out and what effect that may have on the available apertures.

When it comes to shooting in low light, especially when using long shutter speeds, you need to keep your camera rock steady, so you have to

have a tripod or, at the very least, a monopod. Another very useful piece of equipment you must consider is a cable-release remote control that allows you to trigger the shutter release of your camera without actually touching the camera. There are also some remotes that allow you to keep the shutter open for extended periods of time when using the Bulb feature of your camera. These tools make it possible to capture images that need longer exposure times than the camera can do without them. For example, in Figure 3-1 I needed to keep the camera steady for 50 seconds to get the correct exposure of the San Diego

3-1

ABOUT THIS PHOTO *The San Diego skyline looks beautiful when photographed from Coronado Island. Taken at 50 seconds, f/22, and ISO 200.*

skyline, something that couldn't be done without a tripod and using the bulb mode because the longest exposure without the bulb mode on my camera is only 30 seconds.

UNDERSTANDING THE CAMERA'S CAPABILITIES AND LIMITATIONS

Any camera can be used for night or low-light photography, but there are some features that can make the task easier. The first is the ability to produce image files that contain low digital noise at higher ISO settings. In Chapter 2, I explained that you could increase the ISO to make the camera sensor seem more sensitive to light, which allows you to photograph in lower-light situations. The downside to the increased ISO setting is the increase in digital noise. The good news for photographers who want to shoot in low light using high ISOs is that camera manufacturers have really improved the capabilities of their cameras, and while there is still noise present, it is greatly reduced compared to cameras that are only a few years old.

 x-ref

Boosting the ISO is only one way that digital noise is created in your image; the sensor heating up when using very long shutter speeds can also create digital noise. Although that cannot be helped, I talk about how you can reduce exposure times in order to avoid overheating your camera sensor for certain types of long exposure subjects in Chapter 7.

The type of low-light photography that can really benefit from the advances in the low-noise, high-ISO capability of newer cameras is when you need to use higher shutter speeds to freeze the action in low light. This includes weddings, concerts, and indoor or nighttime sporting events.

x-ref

For more information on capturing great shots in these low-light situations, see Chapters 5 and 6.

THE HIGH ISO AND DIGITAL NOISE PROBLEM

It's important to know how much noise is created when you use higher ISO settings and what you can do about it. Because this chapter is all about gear, the first thing to do is to see what range of ISO settings is available on your camera. The usual range of ISO settings is between 100 and 6400, and some cameras, like the Nikon D3S, go all the way to 102,400. Now that doesn't mean that the there is low noise at these higher settings; quite the contrary — there is a lot of noise but not as much as was produced by cameras manufactured five years ago.

The real question you need to ask yourself about your camera (or one you are planning to buy) is what the usable ISO range is; this is the range of ISO settings that produce images with acceptable noise. I have found that I can push the ISO to 3200 and higher and still get results that I am happy with, like the image in Figure 3-2.

BULB MODE AND LONG SHUTTER SPEEDS

When camera manufacturers talk about the shutter speed of their cameras, they usually focus on the fastest possible speed that the camera has available. For example, the Nikon D700, which I use a lot, has a top shutter speed of 1/8000 second, which is really fast. The Canon EOS T3 has a top shutter speed of 1/4000 second, which is still plenty fast to freeze the action on even a very fast-moving subject. However, when it comes to shooting using very long shutter speeds, both of these cameras — in fact, most cameras — can be set to a speed of 30 seconds. While 30 seconds might seem like an eternity when taking a photograph, what do you do if you need a longer shutter speed, such as 90 seconds? This is where the bulb (often called B) setting on your camera comes into play. The bulb setting keeps the shutter open as long as the shutter release button is pressed (either the one on the camera or the one on a cable release or remote). Some cameras have a two-press bulb mode where the first time you press the shutter release the shutter opens, and the second time you press it, the shutter closes.

3-2

ABOUT THIS PHOTO *To get the photo of David Hinds, best known as the lead singer of the band Steel Pulse, I needed to use a high ISO of 3200. This was the only way to get the proper exposure with the very low lighting on the stage. Taken at 1/160 second, f/2.8, and ISO 3200.*

The bulb setting is only available when shooting in manual mode. Check your camera manual for how to access the bulb mode.

If you are wondering when you might use a shutter speed longer than 30 seconds, think about fireworks, star trails, and light painting. I used the Bulb mode and a cable release to photograph the fireworks in Figure 3-3 instead of a set shutter speed because it made it much easier to time the fireworks. I just held the shutter release button on the cable release when the fireworks explosions started and released it when I saw the explosions had finished.

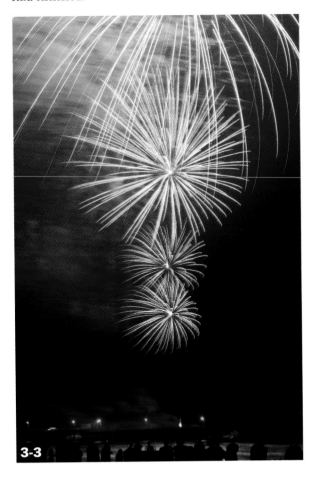

3-3

ABOUT THIS PHOTO *This was taken using a Nikon D700 set on Bulb mode, allowing me to watch the fireworks and decide when to start the exposure and when to end it. The long exposure also allowed me to capture some of the movement in the smoke as the wind blew it to the left. Taken at 6.3 seconds, f/16, and ISO 200.*

LENSES

One of the big advantages of using a digital Single Lens Reflex (dSLR) camera is that you can change the lens that is attached to the camera, which gives you an unlimited choice of focal lengths. The lens choice is critical when you are planning on photographing fast-moving subjects in low light. You want to choose lenses with a wide maximum aperture. You must pay attention to what happens to that aperture when using zoom lenses that have variable apertures because as the lens changes focal length, the widest aperture changes as well.

You might also consider a lens that has vibration reduction, as this technology can help you get a sharp image when used correctly. All these factors go into choosing the right lens for the job.

FOCAL LENGTH

The focal length of a lens is the distance between the center of the lens and the sensor; it is usually shown in millimeters. That's really accurate but doesn't tell the whole story. The focal length measurement can be used to determine how much of the scene in front of the lens is captured and what effect it has on the subject. The focal length can be translated into a measurement called the angle of view, which describes the amount of the scene in front of the lens that is captured. The shorter the focal length the wider the angle of view, the longer the focal length the smaller the angle of view. For example, in Figure 3-4 I used a 17mm focal length to capture as much of the stage as I could from where I was standing, while in Figure 3-5 I used the longer focal length to only capture a small part of the scene, in this case a close-up of Bob Weir, the leader of the band. The longer the focal length,

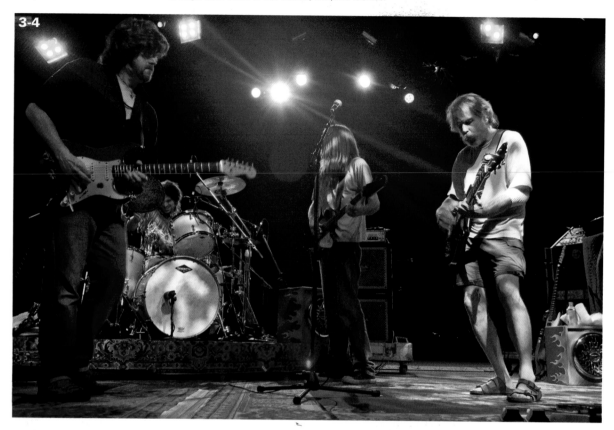

3-4

the less of the scene in front of the lens is recorded and the smaller the angle of view. So a lens with a focal length of 35mm captures more of the scene than a lens with a focal length of 200mm. Lenses with short focal lengths are considered wide-angle lenses, while those with long focal lengths are considered to be telephoto lenses.

Lenses can be divided into two categories: those with a single focal length (called prime lenses) and those that have a range of focal lengths (called zoom lenses). Prime and zoom lenses both have strengths and weaknesses.

The advantages of prime lenses are that they can have a wider maximum aperture than a zoom lens, can be cheaper than their zoom equivalent, and can be smaller and lighter than zoom lenses. The disadvantage of using a prime lens is that it only has one focal length, so to change the focal length, you either have to change the lens or physically move.

When it comes to zoom lenses, the main advantage is that you can change focal lengths without having to change lenses, and that makes it easy to change the composition of the image without having to move. The downside of zoom lenses is that they are larger and heavier than prime lenses.

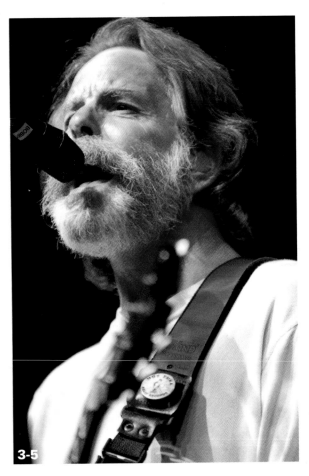

ABOUT THIS PHOTO *I used an 80-200mm lens at the 200mm focal length to really get in close for this shot of Bob Weir, former guitarist for the Grateful Dead. Taken at 1/160 second, f/2.8, and ISO 500.*

So which type of lens is right for you? That depends on two things: your photography needs and your budget. As I mentioned before, prime lenses can be much cheaper than zoom lenses, especially zoom lenses with a wide maximum aperture. For example, the Nikon 50mm f/1.8D lens sells for $135, while a 17-55mm f/2.8G IF-ED lens sells for $1,540. That's a huge price difference, especially when you take into account that the 50mm prime lens has a wider maximum

aperture than the 17-55mm zoom lens. Of course, not all primes are cheaper than their zoom equivalent lenses. For example, the Nikon 200mm f/2 prime lens costs $6,000, while the Nikon 70-200mm f/2.8 zoom lens costs $2,400. (I know that is still a lot of money.) If you need to have the widest opening possible, then you will have to use a prime lens because the one real advantage is that they can have much wider apertures than the zoom lenses. For example, in Figure 3-6

ABOUT THIS PHOTO *Because of the very low light on stage, I used an 85mm f/1.4 lens to get this shot. While the lens could open all the way up to f/1.4, I needed to use it at f/2.0 since the depth of field at f/1.4 would have been too shallow. The f/2.0 aperture is still wider than any of the zoom lenses available. Taken at 1/160 second, f/2.0, and ISO 3200.*

I wanted to get a photograph of Jackie Greene's guitar before he took the stage, and, because the light was really low, I needed a lens with a very wide maximum aperture to get the most light possible. I used an 85mm f/1.4 lens combined with an ISO of 3200 to get the shot.

One advantage that zoom lenses have over prime lenses, when it comes to photographing at night, is that you can create some very cool effects by zooming in or out while the shutter is open. For example, when photographing lights, a zoom lens can create great light trail effects, as shown in Figure 3-7.

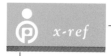

x-ref

More on creating light trails with zoom lenses can be found in Chapter 8.

MAXIMUM APERTURE

The maximum aperture of the lens tells you how big the biggest opening is. The bigger the opening, the more light can reach the sensor. In low-light situations where you need to have a fast shutter speed to freeze the action, the more light that can reach the sensor through the lens, the better. When you look at a lens, you see that it

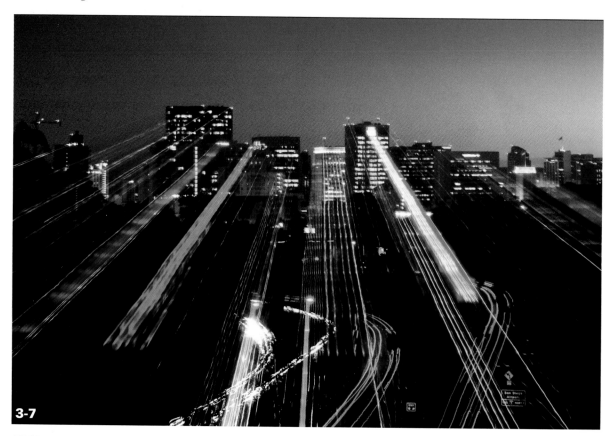

3-7

ABOUT THIS PHOTO *By zooming out while taking the image, the light trails seem to stretch from the edges to the cityscape. Taken at 15 seconds, f/9.0, and ISO 100.*

has some descriptive numbers engraved or printed on the lens barrel. These should include the focal length and the maximum aperture, as shown in Figure 3-8.

3-8

ABOUT THIS PHOTO *The information plate on the 300mm f/4.0 lens showing the focal length and the maximum aperture.*

CONSTANT- AND VARIABLE-APERTURE LENSES

There are two different types of zoom lenses: those that have a constant maximum aperture and those that have a variable maximum

aperture. Lenses that have a variable maximum aperture are those where the widest aperture available changes, depending on the focal length. When the lens is at the shortest focal length, it has the widest aperture; as the focal length gets longer, the aperture gets smaller. These lenses are very popular because they are much cheaper, smaller, and lighter than equivalent lenses that have a constant aperture. The downside to these lenses is that as you zoom out, you have to change the shutter speed or ISO settings because the aperture setting is changing automatically.

Consider a 17-55mm f/2.8 lens. It has a range of focal lengths from 17mm to 55mm and a maximum aperture of f/2.8 at all of these focal lengths. So no matter what focal length you are using, the maximum aperture available is f/2.8. An 18-55mm f/3.5-5.6 lens, on the other hand, might be much less expensive than its f/2.8 counterpart, but there is a really big difference in the size of the maximum aperture. The 18-55mm lens has a range of maximum apertures that goes from f/3.5 to f/5.6 depending on the focal length. At the shortest focal length, 18mm, the maximum aperture is f/3.5, and as you change the focal length, the maximum aperture changes. By the time the focal length is at 55mm, the maximum aperture is f/5.6. This change is more than a full stop of light, so at the longest focal length, there is less than half the amount of light reaching the sensor as there is at the shortest focal length. So when you use one of these lenses you need to adjust the shutter speed and or the aperture when using the longest focal length compared to the shortest focal length.

One lens I use for all my outdoor shooting is the 80-400mm f/4.5-5.6 lens, shown in Figure 3-9. This lens is great for long exposures, and the wide

range of focal lengths makes it very versatile; however, this lens isn't great for shooting sports or events in low light because at the 400mm focal length the widest aperture available is f/5.6 which isn't very wide when shooting in low light.

There is nothing wrong with variable-aperture lenses, and many times they can be just as sharp as any other lens. The smaller size and weight make them much easier to carry around, but it is important to know what their limitations are, especially when shooting in low light. The lenses are great for those situations where you can use

3-9

ABOUT THIS PHOTO *The description on the lens shows that the maximum aperture is 1:4.5-5.6 or f/4.5-f/5.6, meaning that at 80mm the widest aperture is f/4.5 while at 400mm the maximum aperture is f/5.6.*

longer shutter speeds and smaller apertures, but they don't do so well in situations where you need to use faster speeds to freeze the action.

VIBRATION REDUCTION AND IMAGE STABILIZATION

Camera and lens manufacturers have developed technologies that help reduce image blur that comes from camera shake. Camera shake is caused by the small camera movements that can happen when using a long lens and slower shutter speed, photographing from an unsteady position, or using a shutter speed that is too long to hand-hold the camera steady. Each camera and lens manufacturer has a slightly different method with a different name.

The types of vibration reduction and image stabilization can be broken down into two categories: in the lens and in the camera. The lens-based system has the stabilization technology built into the lens, and the control to turn the system on or off is on the lens itself, while the camera-based system has the technology built into the camera body and works with any lens attached to the camera. For example, Nikon and Canon use a lens-based system, while Sony uses a camera body-based system.

The vibration reduction systems work best when photographing static scenes with little subject movement; they originally were meant to be used when handholding a camera and not when the camera is mounted on a tripod. Some of the newer vibration reduction technology has now been designed for use with the camera mounted on a tripod and may have a special tripod setting. It's best to check the manuals for your camera and lenses. As you can see in Figures 3-10 and 3-11, where the same sign was photographed at 1/8 second in both images, a slow shutter speed is

3-10

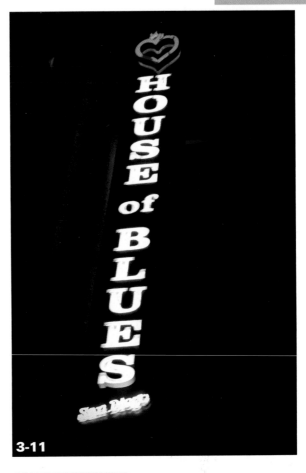

3-11

ABOUT THIS PHOTO *The House of Blues sign makes a nice example of the differences in using and not using the vibration reduction technology that is in my Nikkor 70-200mm f/2.8 lens. This photo was shot without using the vibration reduction technology at 1/8 second, f/6.3, and ISO 500.*

ABOUT THIS PHOTO *The House of Blues sign again but this time the photo was shot using the vibration reduction technology at 1/8 second, f/6.3, and ISO 500.*

nearly impossible to hold steady. In Figure 3-10 the vibration reduction feature was turned off and in Figure 3-11 it was turned on. You can see that there is a difference in how sharp the two images are compared to each other.

There are also times when this technology should not be used because there is a brief lag time between pressing the shutter button and the actual image being captured. This is because it

takes a moment for the vibration reduction or image stabilization feature to read the movement in the scene and counteract it. This slight lag can cause problems when photographing moving subjects because the subject can change position by the time the shutter is actually released. If possible, it is always better to use a tripod to keep the camera steady.

FLASH UNITS

One of the easiest ways to deal with a low-light situation is to just add some light of your own. That's where the flash comes into play. Using the flash allows you to add a little or a lot of light to a scene that might be too dark to photograph any other way. Most dSLR cameras come with a built-in flash (top-end pro cameras do not), but the light produced from that little pop-up flash isn't very flattering, and many times you are probably better off not using it at all. The larger, more powerful and adjustable flash units are a better solution since they allow you to not only add light to a scene but control the direction and the intensity. Camera and flash technology has advanced to the point where you can now easily use a dedicated flash unit on or off your camera. You can even expand and use multiple flashes as well.

USING A SINGLE FLASH

The easiest way to use a dedicated flash unit is to just slide it onto the hot shoe (sometimes called the accessory shoe) on the top of your camera,

turn it on, and start taking photographs. Because the camera and the flash are meant to be used together, the information from the camera is sent to the flash controlling the flash output, and the information from the flash is sent to the camera, allowing the camera to know that a flash is being used. This makes the flash behave as if it were the built-in flash but with better results. One of the immediate results is the increase in distance between the flash and the lens. This alone helps to reduce any red-eye when photographing people because the light is not as easily reflected back from the back of the eye through the pupil, which causes red-eye. The real advantage to the dedicated flash unit on the camera is the ability to adjust the angle of the flash head. Many of the flash units can not only angle the flash head up, but they can also rotate the flash head so it points at an angle, as shown in Figure 3-12.

The other advantage to the dedicated flash unit is that you can use a small diffusion dome on it that will make the small, harsh light more diffused and softer. If the flash didn't come with a diffusion dome, then you can buy one made by Sto-Fen at

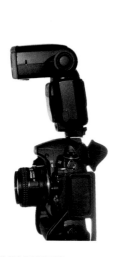

3-12

ABOUT THIS PHOTO *The Nikon SB-900 can be angled from straight forward to straight up, and the flash head can also be rotated left or right.*

any good camera shop. There are also a lot of third-party light-modifying tools available from companies such as Gary Fong, LumiQuest, and Honl. These just attach to the head of the flash and can really change the light that is produced. They work both when the flash is attached to the camera and when it is used off camera.

The easiest way to produce a more flattering light when using a flash on the camera is to angle the flash head at a nearby surface to bounce the flash back at the subject. A nice white ceiling or wall does this really well and turns a small, hard flash into a large, soft light source. The difference is noticeable, as shown in Figures 3-13 and 3-14.

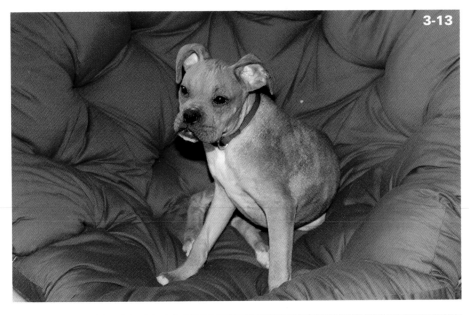

3-13

ABOUT THIS PHOTO
This photo was taken with the flash pointed forward, and while it isn't a bad photo, you can see the harsh shadows right behind the puppy's chin. Taken at 1/30 second, f/5.0, and ISO 200.

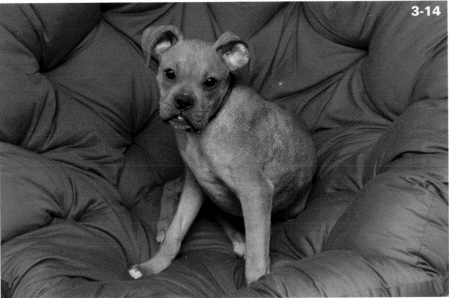

3-14

ABOUT THIS PHOTO
This photo, taken just after Figure 3-11, had the flash aimed up at the white ceiling; this bounced the light, making it much softer and eliminating the hard shadow behind the puppy. Taken at 1/30 second, f/5.0, and ISO 200.

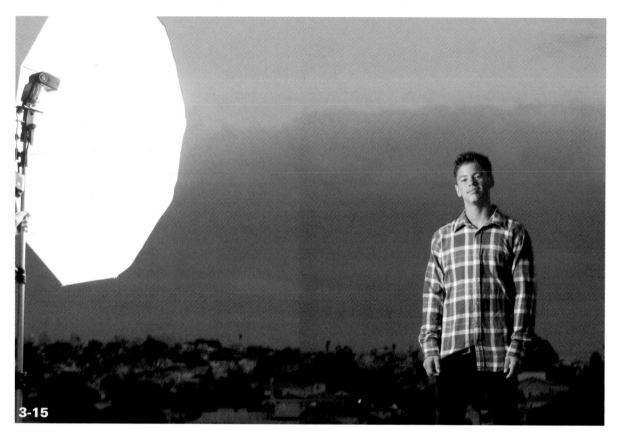

3-15

OFF-CAMERA FLASH

Using an accessory flash off camera can make a dramatic improvement in a photo because you can place the flash exactly where you want the light and you are not limited to the position on top of the camera.

Most accessory flash units come with a small stand that allows the flash to stand upright. These little stands have a threaded mounting hole in the bottom and can usually be attached to a tripod or a light stand using a mounting screw. There are also a wide range of flash holders that make it easy to position the flash just about anywhere. One of the most useful is the Manfrotto 175F Justin Clamp, which when attached to the flash allows the flash to be clamped to nearly anything. For example, I have used this clamp to

attach the flash to a bookshelf, a table edge, and even the back of a chair. Once the flash is in position, you must trigger it from the camera. Currently, there are three different methods:

- **Remote Triggers.** Remote triggers are where one unit attaches to the flash and the other attaches to the camera. Then when you press the shutter release button, the flash gets a signal from the camera and fires. This method works really well, but you do have to buy extra gear, including a set of Radio Poppers or Pocket Wizards. I used a Pocket Wizard to fire the off-camera Nikon SB900 Flash through a light-modifying umbrella in Figure 3-15 to create a softer, bigger light source from the side instead of from the camera direction.

■ **Built-in trigger.** The ability to use this method depends on what camera and flash system you are using. This system allows the camera to trigger the external flashes by either using the built-in flash or a flash unit mounted on the camera. The advantage to this type of system is that the camera and the flash units are communicating with each other and can adjust the amount of light produced by the flash depending on the scene. This type of triggering is usually line-of-sight triggering meaning that the off-camera flashes need to actually see the on-camera flash to work.

■ **Slave trigger.** The third method depends on the type of flash you have, and whether it can be set to fire when using a slave trigger. A slave trigger just fires the flash when it sees another flash fire. This can be an external slave trigger, or it can be built right into the flash. Check your flash's manual to find out if it has this capability. This type of technology is also line-of-sight as the slave flash unit needs to see the main flash to fire.

USING MULTIPLE FLASHES

Using multiple flashes is just as easy as using one off-camera flash, except you now have multiple light sources. If you are triggering the external flash units with a remote trigger such as a Pocket Wizard or Radio Popper, then you need a unit for each of the flashes that you want to trigger.

If the method you use to trigger the external flashes is a line-of-site solution like the Nikon CLS or Canon system, then you need to make sure that the sensor on the flash that needs to see the light from the master flash is visible. I used two off-camera Nikon flash units to light the portrait of Nicole in Figure 3-16. I wanted to have a main light to the left of the camera and a less powerful light to the right of the camera to even out the light.

3-16

ABOUT THIS PHOTO *I shot this portrait of Nicole after the sun set, and because the natural light wasn't helping, I used two flashes — one on either side of the camera — to add the light I wanted. Taken at 1/50 second, f/7.1, and ISO 200.*

TRIPODS

In night and low-light photography, one of the most important accessories you can have is a tripod. It is impossible to hold your camera absolutely steady when using long shutter speeds. The longer the shutter is open, the greater the chance that the camera will move during the exposure, and the resulting photo will be out of focus or, at the very least, a little blurred. To counteract this camera movement, the camera needs to be locked into a tripod to keep it steady during the exposure.

There are many tripods available today in a wide variety of materials, weights, heights, and price points. Tripods are actually made up of two different parts: the tripod legs and the tripod head. Some of the less expensive tripods come as one piece, but the more advanced tripods come as separate pieces, which means you can mix and match the legs and the heads to make your perfect tripod. You must consider the weight that the tripod you choose can support — will it be enough for your camera and the largest lens you work with? For example, I need a solid tripod to hold my camera, and the model shown in Figure 3-17 is a great combination of weight and stability. It is light enough to carry easily and still holds my camera steady.

TRIPOD LEGS

Picking out the perfect tripod should be a very personal experience. What is perfect for me might not be the same for you, but there are some things to keep in mind when choosing a new tripod.

Not all tripods are created equally, and it is often a case where you get what you pay for. If you are serious about taking long-exposure photographs with the shutter open for seconds or minutes at a time, then you need a very steady tripod. There are a variety of tripod materials, all of which can affect weight, price, and stability.

The first thing to consider is the type of material that your tripod legs are made out of:

- **Wood.** Wood is an excellent material for tripod legs because the wood has a natural ability to dampen any vibrations, which keeps the camera very steady. You can still buy wooden tripod legs, but they are not very common anymore. The downside to wooden tripod legs is that they are very heavy and expensive.

- **Aluminum.** Aluminum is an inexpensive alternative to wood and is very common in tripod leg construction. Using aluminum

3-17

ABOUT THIS PHOTO *A tripod is only useful if you are willing to carry it with you. This tripod is not so heavy that I never want to carry it to the shooting location and it is still steady enough for my camera and lens.*

allows manufacturers to create a lightweight, stable, and durable tripod. One downside to aluminum legs is that they can be very cold to the touch when shooting in cold climates.

- **Carbon-fiber.** Carbon-fiber tripod legs are made from layers of carbon fibers, creating legs that are lighter than wood and aluminum and can be as stable as, or even more stable than, wooden legs. The downside to these tripod legs is that they can be very expensive.

- **Other materials.** Some manufacturers are now creating tripod legs using newer and more exotic materials such as basalt and titanium.

The goal is to create tripod legs that are light-weight and stable and in some cases less expensive than the carbon-fiber legs. Tripod legs using these materials can range in price from the very affordable to the very expensive. One of the real advantages of the basalt tripod legs is that they are light and very durable and can weigh as little as 5 pounds for a full size tripod.

> **note** When it comes to Manfrotto tripods, it can be difficult to tell the difference between the aluminum and carbon-fiber legs because they can look the same; check the model number. The X in the model number means aluminum, while a CX stands for carbon-fiber construction.

Here are some other important considerations:

- **Height.** The maximum height of the tripod without taking the center column into account should be comfortable for you to use. If the tripod isn't tall enough, then you will be crouched over in very uncomfortable shooting positions, which can hinder you from getting great compositions.

- **Weight.** Because you will likely need to carry your tripod around with you when shooting at least part of the time, weight is an important consideration. You need to be honest with yourself about how much weight you are willing to carry with you, because if the tripod is too heavy, then you are not likely to use it as often as you should.

- **Leg-locking mechanism.** One of the great things about tripod legs is that they collapse and extend so that they can be stored and transported easily. There are two different types of mechanisms used to lock the legs in place: locking levers and twist locks. Make sure that the locking mechanisms work and will keep the tripod legs locked into place on any tripod you consider.

- **Feet.** Many people don't look too closely at the tripod feet, but they are important, especially if you want to use your tripod in certain areas when the feet can either be helpful or hurtful. For example, some tripods come with spiked tripod feet, which are great on rocky or sandy surfaces, while others come with rubber feet that work great on smooth surfaces. Other tripods have feet where the rubber feet can be screwed off or retracted allowing the spiked feet to be used. When I am shooting on the beach and the tripod is on the sand, I use the spiked feet and I make sure that the tripod is firmly pushed into the sand to make it as stable as possible.

TRIPOD HEADS

The tripod head is the part that actually holds the camera steady and allows you to fine-tune the camera placement. You can usually purchase it separately from the tripod legs. Because each type of tripod head works a little differently, it pays to look at them and determine which one works the best for how you shoot. The three most common types of tripod heads are as follows:

- **Ball head.** The ball head is basically a ball that connects to your camera and that can move in any direction. It has a locking mechanism that allows you to lock the ball exactly where you want it. The ball head allows you to adjust and lock the camera into place with one control, making it very easy to rapidly change the position of the camera. The bigger your camera-and-lens combination, the bigger the ball head you need to support the weight.

- **Three-way pan head.** This is the more traditional tripod head, with separate controls for each of the three axes. You can adjust the horizontal and the vertical, and switch between landscape and portrait orientation, with each of the adjustments having its own controls.

The advantage to this type of tripod is that you can adjust each of the controls without changing the others. So, for example, if you just want the camera to be moved up or down, then all you have to do is adjust that control without having the camera move on any of the other axes. This is not as easy to do with a ball head.

- **Smooth panning head.** This is used more for video than still photography, but because many of the dSLR cameras now shoot video, this tripod is becoming more popular for people who want to get the most bang for their tripod-purchasing money.

EXTRAS

Many tripods and tripod heads come with some cool extras. These extras can be important, depending on what you use them for, and you should consider whether your photography might benefit from one of them before investing. Here are a few of the more common ones:

- **Bubble level.** Many tripods and tripod heads have built-in bubble levels, giving you a quick way to make sure that everything is level. When working at night or in low light, you will need a small flashlight to check the levels.

- **Quick release plate.** A quick release plate allows the camera to be mounted and removed from the tripod quickly and securely. The plate screws into the tripod mounting hole on the bottom of the camera (or lens collar) and then the plate is attached to the tripod head with some sort of quick release mechanism. Different manufacturers use different types of plates; usually they can't be mixed. There are some industry standards, such as the Arca Swiss-type release clamps. I use an L bracket from Really Right Stuff that fits in an Arca Swiss clamp on my tripod, which allows me to easily mount the camera in either a horizontal or vertical orientation. In addition to making it easy to attach the camera to the tripod, having a quick release plate on each camera means that you can switch cameras easily. The Induro tripod head shown in Figure 3-18 uses the Arca Swiss quick release system.

- **Center-column weight hook.** Some tripods have a hook that comes out of the bottom of the center column, which allows you to hang a weight from the tripod to give it extra support. This can really help to keep the tripod rock steady, especially if it is windy out.

MONOPODS

A monopod is basically a stick that you can attach to your camera to help steady it. It usually looks like one leg of a tripod and screws directly into the tripod screw of the camera or lens. Monopods are often used by sports and event photographers to help support and steady those very long (and heavy) lenses they use. Monopods can be an invaluable tool for shooting in low light, especially in areas where tripods are not allowed, because they allow you to steady the camera while using shutter speeds that would cause blurring if the camera was handheld.

3-18

ABOUT THIS PHOTO
One tripod head that I use is made by Induro, and I love all the extras, including a set of built-in levels and the angle grid, which allows me to set it exactly the way I want to.

Picking out a monopod is very similar to picking out a tripod, and you will find that monopods are made and sold by the same companies that make tripods. Here are some things to take into account when buying a monopod:

- **Height.** Is the monopod tall enough to use comfortably? Because the monopod is designed to be used to support a camera at the eye height of the photographer, make sure that the monopod you pick is tall enough for you.

- **Strength.** Monopods are designed to support cameras and long, heavy lenses, but make sure that the model you pick can support your camera now and any gear you plan on buying in the near future.

- **Weight.** Monopods are much lighter than tripods but can still add a fair amount of weight to your camera bag. If the monopod is too heavy, then you are not likely to carry it with you, and so you won't use it.

- **Material.** Just like tripods, monopods come in a variety of materials that can affect the weight and price.

I use a monopod when shooting with long lenses, 300mm or more, because it adds a level of stability that I don't get when handholding the same lenses, even in bright light.

SHUTTER RELEASES AND REMOTES

Shutter releases and remote controls allow you to trigger the shutter release on the camera without physically pushing down on the shutter release button with your finger. This is important when you want to get the sharpest possible image, especially when using long shutter speeds. When you press down on the shutter release button, it is possible and likely that the pressure of your finger will cause small vibrations to move the camera, which can cause the image to be slightly blurred. The simplest of the shutter releases and remotes

just have a button that, when pressed, triggers the camera's shutter release. Some remotes allow you to lock the button in place so that when used with the camera's bulb mode, the shutter will stay open as long as the remote button is locked. The Nikon MC-36, shown in Figure 3-19, has a shutter release button that can be locked open just by sliding the lock up when pressing the button.

The difference between a shutter release (also called a cable release) and a remote is that a shutter release is usually attached to the camera physically while the remote is a wireless trigger. For example, the Nikon ML-L3 remote has a single

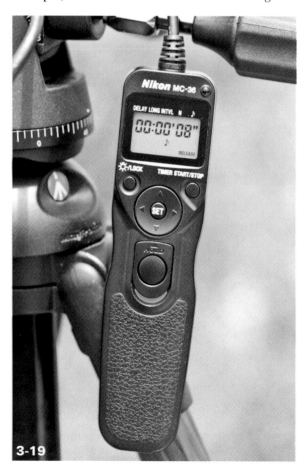

3-19

button that you can press to trigger the shutter release on a wide range of Nikon cameras. This single-function remote retails for about $20. Even though this remote only has one button, it does lock the shutter open when you set the camera to bulb mode. Press the button once to open the shutter, and press it again to close the shutter. The Canon RC-6 Wireless remote triggers the shutter on a host of Canon cameras. This remote has a single button and works by line of site from the remote to the front of the camera, so when the camera is mounted on a tripod and you are trying to trigger the shutter release from behind the camera, you might have to adjust where you aim the remote to get it to work.

The simplest Nikon shutter release is the MC-DC-2 Remote release cord, which is compatible with the newer consumer-level cameras. It is just a simple button that can be locked open; when you press the button, it triggers the camera. If you are a Canon user, check out the Canon Remote Switch RS60 E3, which brings the single button remote to the Canon line of cameras.

Regardless of what type of camera you have, you should check your camera manual to find out which remote triggers are compatible before purchasing one.

TIMERS

Chances are your camera has a built-in timer that can trigger the shutter release a few seconds after you press the shutter release button. This was created so that you could set the camera down, press the shutter release button, and run back to get in your own photo. It also offers the advantage that, by using the timer, the camera doesn't have anything touching it before the shutter is moved, which reduces the small vibrations that can be

ABOUT THIS PHOTO *The Nikon MC-36 is a remote trigger that can keep the shutter locked open.*

caused by your finger pressing the shutter release button. Check your camera manual for the self-timer directions.

Another type of timer you can get for your camera can be part of the shutter release remote. This type of timer can lock the shutter open for a predetermined length of time. You can also set it to go off after a certain length of time or to take a series of exposures over a length of time. This timer is indispensible for extremely long exposures and critical for time-lapse exposures. The type of timer that can be set to go off for predetermined amounts of time over a period of time is called an intervalometer; some cameras have this built in. Check your camera manual to see if you have this built in or need to buy it as an extra.

 note

These types of shutter releases are referred to as intervalometers because they can set the camera to fire at predetermined intervals.

Assignment

Use the bulb mode to get a very long exposure

It is fun to experiment with very long shutter speeds, which is when the bulb mode is your best option, especially when combined with a shutter release cable. The assignment for this chapter is to use the bulb mode to take a very long exposure — try for one over the usual 30 second limit on the camera and don't forget to upload your results to the website.

For this assignment, I set up my camera and tripod on the sea wall facing the cove inlet that I wanted to photograph. I used a wide-angle lens to get both the skyline and the cove entrance in the frame. I started by setting the ISO to the lowest setting available on the camera (ISO 100) and the aperture at the smallest opening available on the lens (f/22) to get the deepest depth of field. Using this combination to get a proper exposure, I made an educated guess that I would likely need a shutter speed of 10 seconds or more. So, I started at 10 seconds, which was not nearly enough time. I added 10 seconds and tried again until I reached 40 seconds. It still wasn't quite what I wanted, so I adjusted the shutter speed in 1-second increments. I took several shots between 40 and 45 seconds to make sure I was happy with the results. My favorite was at 41 seconds — I really liked the way the water looked soft, but there was still detail in the rocks, cliff, and seawall.

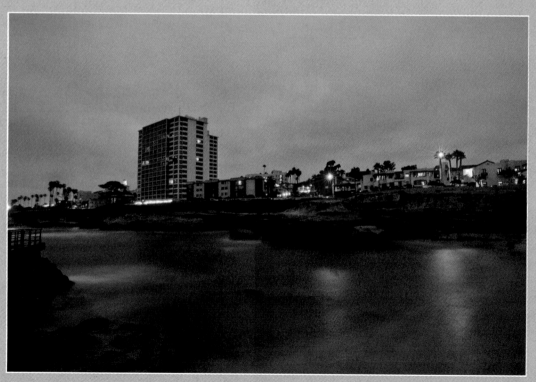

Remember to visit www.pwassignments.com after you complete the assignment and share your favorite photo! It's a community of enthusiastic photographers and a great place to view what other readers have created. You can also post comments and read encouraging suggestions and feedback.

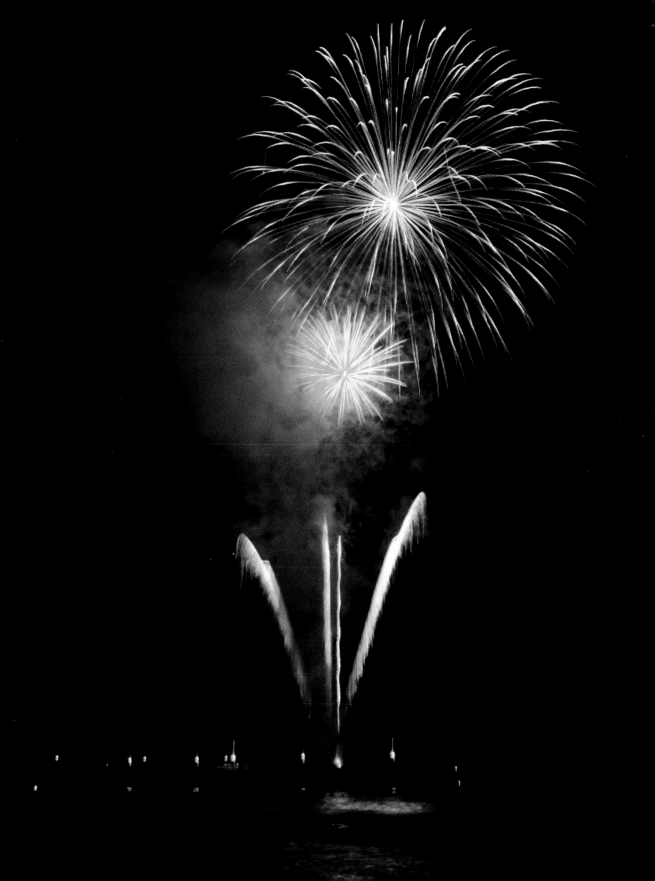

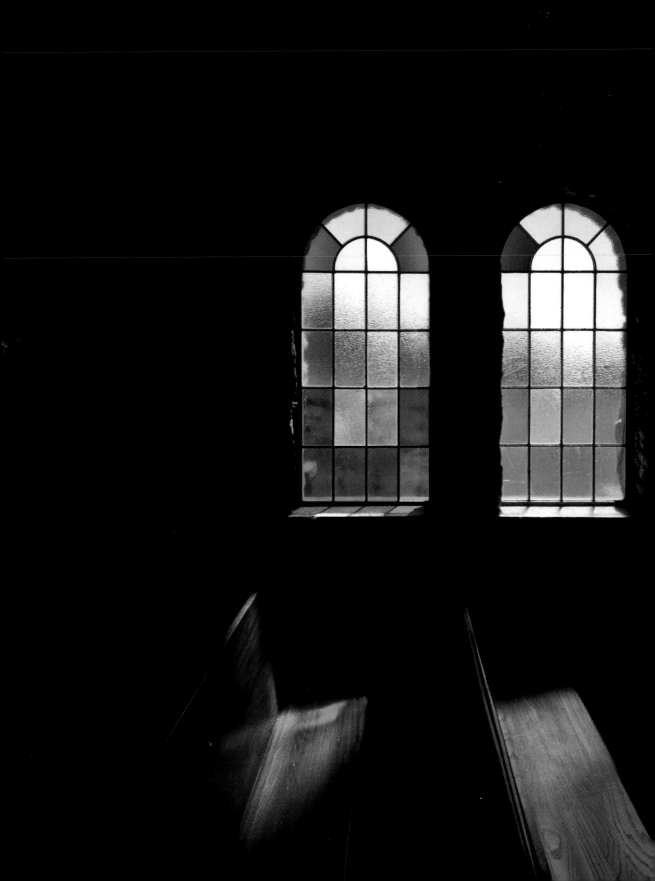

PEOPLE AND PLACES INDOORS

Photographing People Indoors

Building Interiors

Shooting indoors presents several different challenges. Often, there isn't a lot of light, and many times the light is mixed — that is, there are two or more different types of light with different colors. You can easily overcome the low-light conditions by adding an accessory flash or two or by using the available light to your advantage. To be clear, this chapter is not about setting up a whole studio's worth of lights or spending a lot of money, but instead, it's about how to look for the available light and successfully get the most out of minimal accessory lighting. Take Figure 4-1, for example: I just used a single flash mounted on

my camera with the flash head adjusted so it aimed over the heads of Jerry and Nydia to get this portrait of Robin and Catwoman at the San Diego Comic-Con 2011. This chapter also covers photographing whole rooms and the problems that can arise from the various mixed lighting that can be present. The best angle and composition are covered as well as adding your own light to help illuminate the space and still have it look natural.

PHOTOGRAPHING PEOPLE INDOORS

There are many opportunities to photograph people indoors, from taking a quick photograph of your children playing in the family room to taking a portrait of a bride before her wedding.

I talk a lot in this chapter about both the size and relative size of the light source used to take photos indoors. When it comes to taking flattering photographs of people, the bigger the light source, the better. This is because a bigger light source creates a more diffused light that looks more flattering when illuminating the subject.

When talking about the size of the light source, you are actually talking about the relative size of the light source because distance and intensity play a big roll. If you consider the sun as the light source, for example, it is a huge light source. However, because it is so far away, it does not create soft, flattering light — as you likely know

ABOUT THIS PHOTO *Costumes are a big part of the fan participation at the San Diego Comic Convention every year, and 2011 was no different. I photographed my friends in costume against one of the backgrounds that were set up at the convention. I used a single accessory flash mounted in the camera's hot shoe that had an adjustable head aimed high and at a 45-degree angle. Taken at 1/30 second, f/5.0, and ISO 200.*

if you have ever tried to photograph outdoors under noonday sun. Now, when that hard, small light source shines through a window, especially one with some type of diffusion material on it, like thin drapes or a sheet or even a store-bought diffuser, the light is diffused in the same way the light from a flash is when bounced off of a ceiling. The photograph of the bride and her bridesmaids in Figure 4-2 was taken using just the light coming in from the left of the camera through a large window.

The softer light creates much softer shadows, making for a better portrait, and one of the most common ways to get a nice, soft light is to use window light.

WINDOW LIGHT

One of the easiest and most effective methods of illuminating a person indoors is to use the natural light available during the day, by placing the subject in the light coming in through a window.

4-2

ABOUT THIS PHOTO *The soft light coming in through the large window to camera left was diffused by the transparent material used in decorating the room. There are no harsh shadows on any of the faces. Taken at 1/80 second, f/4.5, and ISO 500.*

When used correctly, the window light acts like a large studio softbox, producing a very flattering, even light. And with a few accessories, just about any window with light coming through it can be used to create great portraits.

The basics are very simple:

- Pick a window that is large and unobstructed.
- Place the subject next to the window, but not in the direct path of the light.
- Watch the light as it plays across the subject.
- Take the photo.

Shooting a quick portrait using the light coming in through the window doesn't have to be a complicated affair. A blank wall and some light coming in through a window was all that was needed in Figure 4-3.

The two extra pieces of equipment that can be especially useful for natural light portraits are a diffuser and a reflector. The diffuser reduces the intensity of the light, while the reflector redirects the light to where you need it.

There are many different types of diffusers available for photographers, from handheld models to big screens, but when it comes to turning a too-bright window into a softer light source, you can really use any material, including a sheet. Just remember to use a white sheet, as the color of the light will be changed by any material it travels through.

Because the source of the light is actually the sun — a small, hard light source — anything that you put between the light and the subject can change that light. For example, change the angle of the blinds in the window and you can create patterns with that light. The hard light streaming in through the window blinds created the pattern

4-3

ABOUT THIS PHOTO *Mia was waiting to get back to the photo shoot when I saw that the light coming in from the window to her left was as good as any studio light that I could have set up. Taken at 1/60 second, f/5.6, and ISO 800.*

in Figure 4-4. With the model posed against the wall, the light was streaming across her face from left to right. I photograph using the light from this particular window a lot because of the soft late afternoon sunlight that passes through it. Usually the blinds are pulled up and I diffuse the light more with a handheld diffuser, but in setting up this photograph, the pattern the blinds made seemed to fit the mood. You can use anything to create patterns with the light.

4-4

ABOUT THIS PHOTO *I first noticed the pattern of light from the blinds against my office wall late one afternoon and was reminded of it when I neglected to pull the blinds out of the way when setting up this model shot. This was not taken in a studio or with a complicated setup, but against my office wall with the photos removed. Taken at 1/160 second, f/5.6, and ISO 200.*

One last word: When using window light, keep a lookout for how you can use it in all types of situations. I saw my nephew sitting down in a big green chair being lit by a window as the light played across the scene from right to left. Instead of trying to set up a photograph, grab a flash, and have him turn this way or that, I just framed the image and took the photograph, which you can see in Figure 4-5. I don't think he even knew I took a photograph.

USING A FLASH OR FLASHES

When there is not enough window light (or other light) in the room, the best solution is to add some of your own. The dedicated flash units that are available today are really great for this type of work. They are small, light, and powerful, and the light can be changed easily with a variety of small flash modifiers. The dedicated flash units can be mounted on your camera's hot shoe and will fire when you press the camera's shutter release button. Now when the flash is mounted on the camera and aimed straight towards the subject, there really isn't much improvement over the built-in flash, but you can adjust the flash unit to fire at different angles, allowing the light to bounce off of nearby surfaces. Flash units can also be fired when not mounted on the camera, either by using a built-in controller or a third-party trigger. Once you position the flash away from the camera, the creative possibilities really open up.

But first I need to talk about some limitations and settings that come into play when using a flash. The first is called the flash sync speed, and it has to do with the shutter speeds that are available when using a flash. The flash sync speed is the highest shutter speed that you can use a flash with, and it usually isn't that high. You can check your camera manual, but the usual sync speed is around 1/250 second.

To understand this, you need to know what exactly happens when you press the shutter release button to take a photo. Most digital cameras have what is called a focal plane shutter that is made up of two shutter curtains. When you press the shutter release button, the first shutter curtain moves out of the way and starts to expose the sensor. When the amount of time that is set

ABOUT THIS PHOTO
My nephew kicking back in the big green chair at his grandparent's house. Taken at 1/40 second, f/2.8, and ISO 320.

by the shutter speed has passed, the second, or rear shutter, curtain closes. The sync speed is the shortest amount of time that the shutter is open and the flash can fire before the rear curtain starts to close. As you can see in Figure 4-6, the first shutter moves out of the way, then the whole image is exposed and the second shutter starts to close.

Most dSLRs have a built-in or pop-up flash. Actually, the only cameras that don't have a built-in flash are the top-of-the-line professional models. It might seem odd that the most expensive cameras don't have a built-in flash, but it isn't; no professional photographer is going to use that light to illuminate someone in a portrait. The light produced by these flashes really is that bad, making anyone who is photographed with one look like they are getting a driver's license or passport photo. This has to do with two factors: the direction of the light and the distance of the flash from the lens.

4-6

ABOUT THIS FIGURE *When the shutter release button is pressed, the first shutter starts to move out of the way (image at left), the whole image is exposed (center image), and the second shutter moves to block the light (image at right).*

The built-in flash is usually right above the lens and is aimed directly at the subject. This straight-ahead direction means that the flash illuminates the subject straight on and there are no shadows, meaning no detail. There is also the problem of red eye which is more common when the flash and the lens are very close to each other. Because the flash and lens are close, the angle that the light travels when it bounces back from the subject when the flash is fired is close to straight at the lens. The light from the flash bounces off the back off the eye and the red blood vessels can be seen through the wide-open iris in the photo. Some cameras have a red-eye reduction feature that fires a series of flashes before the main flash to try and get the iris of the subject's eye to contract in response to the bright light. This works sometimes, but, more often than not, after the first pre-flash goes off, the subject moves thinking the photo has been taken, and by the time the actual flash goes off and the image is recorded, the subject has moved or is no longer in the right pose or smiling. It is also impossible to take a candid photo with the red-eye reduction setting turned on as the pre-flashes give you away. The only real advantage to the built-in flash is that it is built-in and always available.

If you plan on photographing indoors a lot, then a dedicated flash unit is the best way to go. They are relatively inexpensive and you can use them both on and off the camera. Many of the flash units have adjustable heads that allow you to aim the flash in different directions, and because they have their own power supply, they don't use any of the camera's battery power. You can also get battery packs for the flash that increase the recycle time and increase the amount of flashes before you need new batteries.

The advantage of the flash unit comes from its ability to bounce the flash. This technique works great indoors, where there is a nearby wall or ceiling that you can bounce the light off of. The idea is that the light no longer comes directly from the flash, but comes indirectly from the bounce surface. Here are some of the advantages of bouncing the flash:

- The light is softer and more even because the light source is now much bigger.

- There is less of a chance of any red eye because the light is no longer as close to the angle of the lens.

- There are fewer hot spots, or areas that are overexposed. These hot spots can be really distracting because the eye is drawn to the brightest part of the image.

- There are fewer harsh shadows because the light is effectively much larger than the small flash head.

To do a basic light bounce using the flash unit, just do the following:

1. **Mount the flash on the camera.**

2. **Adjust the flash head so that it is angled at 45 degrees and aimed over the head of the subject, instead of at 90 degrees.**

3. **Use the scene metering mode.**

4. **Use the auto exposure mode.**

5. **Take a photo.**

As you can see from Figures 4-7 and 4-8, there really is a big difference between the straight flash and the bounced flash. If you look at the wall in the background, you can really see the hard shadows and the soft shadows.

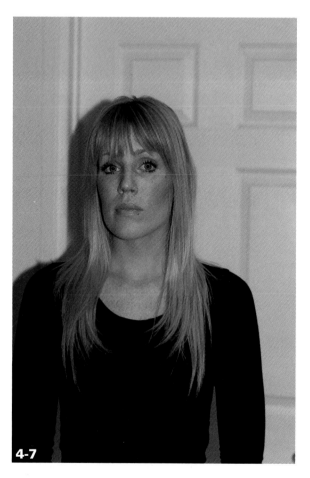

4-7

ABOUT THIS PHOTO *This photo of Nicole was taken with the flash pointed straight at her; you can see the hard-edge shadow on the left side of the image. Taken at 1/30 second, f/3.5, and ISO 200.*

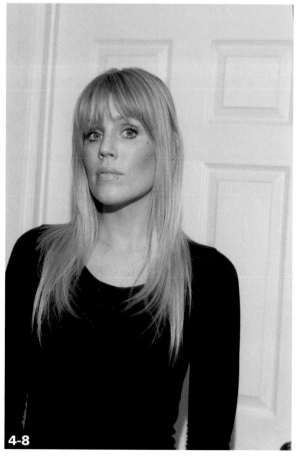

4-8

ABOUT THIS PHOTO *The same location and subject as in Figure 4-7 but with the flash aimed over her head and bounced off the ceiling. Notice that the shadows on the wall are gone and now there is a softer shadow under her chin. Taken at 1/30 second, f/3.5, and ISO 200.*

The accessory flash unit, especially when used to bounce the light, will achieve a better result than using the built-in flash every time. The key is to know what to bounce the flash off of. Your choices are to:

■ **Bounce the light off the ceiling.** This is the basic bounce, and it works best when the ceiling is white and not too high. The ceiling acts as a big reflector so that the small, hard light of the flash turns into a huge, softer light. The only downside of this method is that the light

coming from the ceiling can cause shadows under the eyes. You can just aim the flash head straight up at the ceiling and the light bounces down at the subject from the ceiling. You can also aim the flash at an angle over the subject so that the light bounces down on the subject.

■ **Bounce the light off the ceiling and a wall.** If you can adjust the angle of the flash head and rotate the flash head, then you can aim the

flash head at the ceiling and at the wall behind you. Instead of being aimed straight up or over the head of the subject, just rotate the flash head 180 degrees so that it is aimed over your head. This works when you have your back close to a wall and a lower white ceiling, and it also helps to reduce the shadows under the eyes that can be caused by the previous method. With the light bouncing off the ceiling and the wall, the subject is more evenly lit.

- **Bounce the light off a wall.** Bouncing the light off a nearby wall turns that wall into a light source and can really make for some great portrait light. This is because the light comes from the side and gives the subject some shadow and character, more than the ceiling bounce. This works when the wall is nearby and white. All you need to do is rotate the flash head to the side 45 or 90 degrees instead of up.

There will be some situations where bouncing the light will not be possible:

- **There are no nearby walls or ceilings to bounce the light off of.** Bouncing the light only works if there is something to bounce it off of, so if the ceilings are really high or you are photographing in the middle of the room and there are no walls nearby, then this just won't work.

- **The walls or ceilings are a different color, which will introduce a colorcast.** Light picks up the color of any surface it is bounced off of, which can cause the light to have an unwanted color. For example, if the ceiling or walls are red, then the light that bounces off the red surface will cause the subject to have an unwanted red cast.

- **The wall or ceiling is too far away and there isn't enough light reaching the subject.** This happens a lot, especially if you are moving around while photographing. While the small flash is pretty powerful, light still loses its illuminating power really quickly as it travels, so trying to bounce a light off a wall that is too far away will result in an underexposed image.

- **The flash unit isn't adjustable.** Some flash units do not have adjustable flash heads and cannot be adjusted at all. These cannot be used to bounce the light.

Because bouncing the flash will not work in all situations, some clever designers came up with flash modifiers that will help to give you a better light from the flash unit attached to your camera. These light modifiers can be used both with on-camera and off-camera flashes and the basic idea is the same: to take the small, hard light from a flash and turn it into a bigger, softer light.

The first solution is the simplest, and that is to put a diffuser dome on the flash. This is just a piece of plastic that fits over the head of the flash, and instead of the light coming straight out of the flash head, it bounces around inside the dome, diffusing the light. This diffuser comes standard with many Nikon flash units, but if your flash doesn't include one, then you can get one from Sto-Fen called the Omni-Bounce. To use the diffuser, just place it over the flash head, then angle the flash head at 45 degrees over the subject and take your photos. Because the light no longer comes out in a tight beam but instead as a larger, diffused light, it reduces harsh shadows and your subject is illuminated more evenly.

A second solution is to use a bounce card, such as the LumiQuest Promax System. This is a device that attaches to the head of your flash and mimics

a ceiling by allowing part of the light to go straight up and the rest of the light to be bounced at the subject. The advantage of this system is that it comes with different color screens that allow you to match the color of the ambient light or just color the light as you want to. A third solution is to use a softbox that is made for your flash unit. These devices mimic the bigger softboxes used in studio photography, and they can be used right on the camera; however, their real power comes into play when you use them off camera. The softbox attaches to the head of the flash and turns the small light of the flash into a bigger light. By using a small SoftBox III from LumiQuest on an off-camera flash, I was able to get this great light for a quick shot of Sam in Figure 4-9.

One advantage of the flash unit is that you can use it off-camera. There are four different ways that the flash can be fired when off-camera:

- **Cord.** The easiest way to fire a flash that is not in the hot shoe of your camera is to use a special cord, where one end slides into camera's hot shoe and the other end has a hot shoe for your flash. The downside is that the flash is still attached to the camera by this cord. This means that the placement is limited to the length of the cord. The advantage is that the camera just thinks that the flash is on the camera and fires it automatically.

- **Built-in trigger.** Many of the camera systems used today have a built-in external flash system. This usually means that a flash on the camera triggers an external flash. Some of the cameras are able to use the built-in pop-up flash as a controller for the external flash. The

4-9

ABOUT THIS PHOTO *The LumiQuest SoftBox III attaches to the flash with the use of an included Velcro strap, making it easy to put on and take off. As you can see, it produces a nice light. Without the softbox, the light would have been much harder creating harsh shadows. Taken at 1/5 second, f/5.6, and ISO 200.*

Nikon system is called the Creative Lighting System, or CLS for short, and the Canon system is the EX Flash System. This allows a flash on the camera to tell the off-camera flash not only when to fire, but also what power to use. These systems work well most of the time.

■ **Radio controlled.** There are systems that allow you to trigger the flash from your camera using radio signals. The Pocket Wizard is one of the most popular types. A radio transmitter is attached to the camera hot shoe while a receiver is attached to the flash, and when you press the shutter release button, the flash fires. This allows you to place the flash pretty much anywhere and trigger it from the camera. The downside to this system is that it can be expensive because each flash needs its own receiver. Triggering the off-camera flash in Figure 4-10 was easy using a pair of Pocket Wizards. Keep in mind that the exposure information is not transmitted to the flash, and any adjustments need to be made on the flash.

■ **Slave mode.** Some flashes can be set to fire when they see a flash of light. This slave mode just fires the flash when another flash is fired. This allows you to trigger a second (or third or fourth, and so on) flash from a flash on your camera. This is also often referred to as an optical trigger since the flash needs to see the light to trigger.

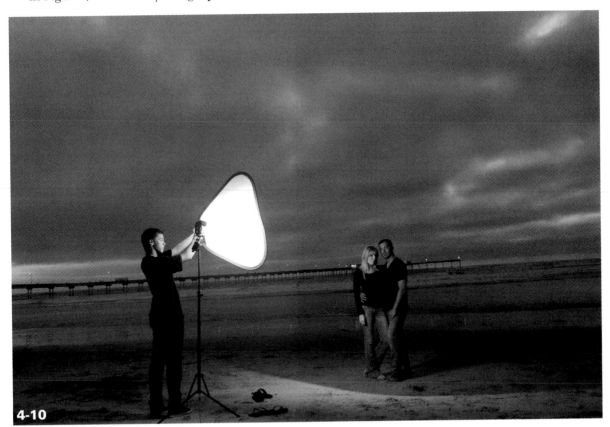

4-10

ABOUT THIS PHOTO *Photographing after sunset requires longer shutter speeds and extra lights — in this case, a Nikon SB-800 speedlight fired with a Pocket Wizard off to the camera's left. The light was diffused using a Lastolite diffusion panel held by an assistant. Taken at 1/6 second, f/7.1, and ISO 400.*

When photographing people indoors, especially when using a flash, let the camera do some of the work. This is a great time to use the aperture priority mode and allow the camera to pick the best shutter speed. The key is to use the correct metering mode for the situation. That means looking at the scene and determining whether there are very bright or very dark areas that could cause the scene metering to be fooled into over- or under-exposing the image. If, for example, there is a very dark area behind the subject, the camera might try to use a shutter speed that will overexpose the subject, while if the background is very light, the camera could try to underexpose the subject.

Digital cameras use a TTL, or Through The Lens, system to control the output of the on-camera flash. The camera takes the information about the scene, including how far away the subject is, and uses it to control the flash. These systems are really very good and will, in most circumstances, give you a great exposure without much effort. For example, if you pick an aperture that gives you the desired depth of field, the camera picks the shutter speed and controls the power of the flash, and it only outputs the light needed to get a proper exposure.

To successfully photograph people, there are times when you will need to pose them to get the best image. These posing tips will help you get your subjects looking their best:

■ **The eyes are important.** The most important part of a portrait is the eyes. Make sure you focus on the eyes and ensure that they are positioned correctly; even if the rest of the image is pretty plain, as in Figure 4-11, the attention will go straight to the eyes. Make

sure you control the direction of your subject's eyes. People want to look at the camera and will shift their focus towards it, even if that isn't the look you are going for. Here are some eye directions and how they work:

> **Looking directly at the camera.** This is a very powerful look, and having the subject look directly into the camera can help the viewer connect with the subject.

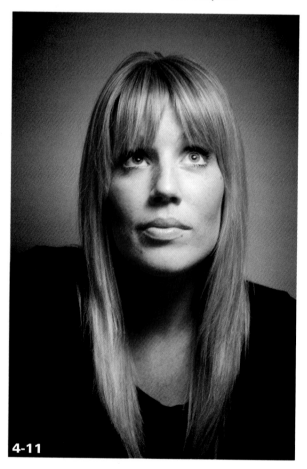

4-11

ABOUT THIS PHOTO *This photo was taken with a simple flash set on the camera, with the light bounced off the ceiling. Taken at 1/30 second, f/5.6, and ISO 400.*

> **Looking off camera.** Having the subject look off to the side or just past the camera can create a sense of mystery in the photo. The viewer will wonder what the subject is looking at. Here is the important part: Make sure that the subject is actually looking at something and not just staring into space because it will show in the image.

> **Eyes closed or looking down.** If the subject is looking down or has her eyes closed, you still need to focus on the eyes. This look can be really intimate, but make sure that you don't capture the subject with her eyes half open — that doesn't look very good.

> **See the whites of the eyes.** A way to make the eyes look more open and larger is to have the subject look slightly up so that the whites under the iris are visible. This works well when you have the subject tilt her head down slightly while looking up slightly. The key word there is slightly. A little tilt goes a long way.

■ **Control the tilt of the head.** Everybody's head tends to lean to one side or the other when they are relaxed. Make sure that, as your subjects get comfortable, they don't suddenly start to lean to the left or right.

■ **Turn the body.** Turning the body slightly towards the camera makes the distance between the shoulder blades narrower, which makes the subject look slimmer. Conversely, when the subjects are square to the camera, they seem wider and more aggressive.

■ **Watch the legs.** Make sure that the knees are not locked out. This can make the pose look very stiff and unnatural. Have the subject shift weight from one leg to the other, and see how it changes the composition.

■ **Hands can be a problem.** The side of the hand looks thinner and therefore better than the front or back of the hand. Try not to have the hands too far forward in the frame, as this can draw the eyes away from the rest of the image by drawing attention to the hands.

■ **Sitting or standing.** When your subject is sitting in a chair, angle the chair slightly and have your subjects sit forward, as shown in Figure 4-12.

4-12

ABOUT THIS PHOTO *After a long day of posing for photos, a glass of wine is not a bad idea. This was lit with a single flash bounced off the ceiling; you can see the soft shadow on her neck. Taken at 1/30 second, f/4.0, and ISO 100.*

This helps to keep them upright and avoids the dreaded slouched look. The light used here was a single on-camera accessory flash bounced off the ceiling. If the model is standing, let her relax between shots. Have her take a couple of deep breaths and then return to the pose.

Photographing people outside at night in low light is the same as photographing them indoors under low light, but there can be more space to work and some more interesting backdrops. The one thing to keep in mind is that the lighting conditions outdoors can change as the sun sets and the moon rises. That just means that you need to check the settings between the exposures more often and will probably need to make more adjustments.

In Figure 4-13, the sun had set and the sky was turning dark, but with two external flashes aimed at the subject and fired remotely with Pocket Wizards, the image wasn't that hard to capture. When trying to balance the ambient light with the flash — even an off-camera flash — the shutter speed controls the ambient light and the f-stop controls the amount of light from the flash. This is because the light from the flash is all output in a single burst that lasts a split second, so it makes no difference to the flash whether the camera's shutter is open for 1/200 second or 1/4 second; all the light from the flash is discharged. However, the aperture does matter. The wider the aperture, the more light reaches the sensor; so set the shutter speed to capture the ambient light (in Figure 4-13, that would be 1/4 second), and then set the aperture to capture the flash light (in Figure 4-13, that was f/5.6).

4-13

ABOUT THIS PHOTO *Nicole photographed on the beach 45 minutes after the sun had set and the very last of the daylight was leaving the sky. Taken at 1/4 second, f/5.6, and ISO 400.*

BUILDING INTERIORS

Photographing the interior of a building might seem straightforward, but there are some concerns when shooting interiors, chiefly, using proper focal lengths and dealing with multiple light sources all on top of the basic low-light concerns. When photographing inside, there is usually not a great amount of light and the light that is there can at

times be more of a hindrance than a help. When the existing light just doesn't cut it, you can use a flash to add light as and where you need it.

CHOOSING THE BEST LENS FOR THE SPACE

When you look at any of the top architectural magazines and see those amazing layouts, chances are they used a specialized wide-angle lens called a perspective control or tilt-shift lens. These lenses correct for the distortion that happens when you point a lens at an upward angle as you try to get the whole room in the frame and can't go any farther back. This specific distortion appears when the vertical lines in the image tend to curve towards each other as they near the edges of the frame. It is really noticeable when using fisheye lenses, but all wide-angle lenses can have this problem, especially if you tilt the camera up or down. The perspective control lenses fix this, but at a pretty hefty price tag.

> **tip** It is possible to rent perspective control and tilt-shift lenses, allowing you to try before you buy, which is something I suggest you do as purchasing one is a substantial investment.

If you are going to just try taking some interior photos, then there are other less-expensive options. The good news is that because the interiors of a building don't move while you are taking photos of them and you no doubt want a deeper depth of field to get as much in focus as possible, you don't need to have a lens that has a very wide aperture. This means that the lens that came with your camera will work just fine — at least until you want to invest in a specialized lens later on.

For full-frame-sensor cameras, look at lenses that start at the 24mm focal length, which give you a view wider than the 50mm normal view, and which give the room a feeling of space, as you can see in Figure 4-14. For the cropped-sensor camera, you want to use the 18mm focal length, and the good news is that it is usually the widest angle on the kit lens that comes with a lot of cameras, so chances are you already have it. You can use a super-wide or fisheye lens, but you either have to live with the lens distortion or use software to correct for the distortion. In Figure 4-14 I really wanted the room to look bright, so I purposely exposed the scene so that the lights were rendered pure white by using a high ISO and slower shutter speed.

CROPPED VERSUS FULL-FRAME SENSORS There are two sizes of sensors used in dSLR cameras: a full-frame sensor, which matches the size of a 35mm frame of film, and a cropped sensor, which is smaller. The size of the camera's sensor impacts the effective focal length of the lens. The smaller sensor in the cropped sensor cameras doesn't record the same amount of the scene as a full-frame sensor, it records less. The easiest way to determine what the equivalent focal length is between a lens on a cropped sensor and a full-frame sensor camera is to multiply the focal length by 1.5 or 1.6 depending on the sensor in the camera. Your camera manual will have this information. In practical terms, a wide-angle lens isn't as wide on a cropped sensor, but a telephoto lens will seem to reach further.

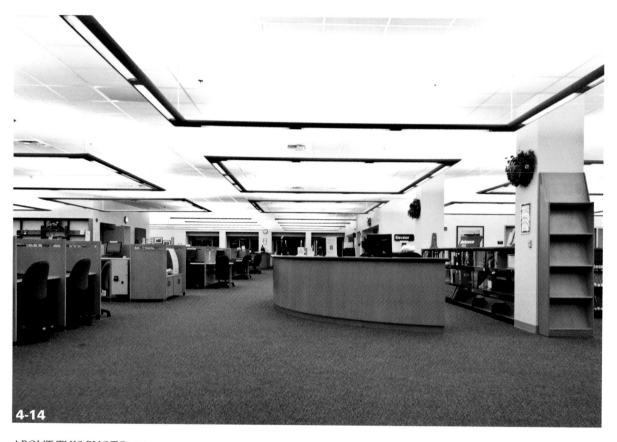

4-14

ABOUT THIS PHOTO *Using a wide-angle lens — in this case, 24mm — gives the room a sense of space that is wider than the normal view lenses. That makes items in the foreground seem a little larger and makes the background recede into the distance. Taken at 1/20 second, f/8.0, and ISO 800.*

Once you have the right lens for the job, the next part is to place it at the proper spot and angle. Because each room is different, there is no hard-and-fast rule for exactly what to do because the furniture, architecture, and other features need to be taken into consideration. But there are general guidelines that can help:

■ **Compose the image showing only two walls to give it a sense of being big.** The minute the third wall is shown in a room, the space seems to be a little smaller than it really is. This also allows you to place any extra lighting off to the side and out of the image if needed.

■ **Photograph from eye height.** Shooting at a height of 5 to 6 feet from the ground lets the viewer see the room from a natural angle. (Figures 4-14 and 4-15 were shot at normal height.)

■ **Watch for reflections.** This is especially true when shooting in rooms with large windows or actual mirrors, but it can also be caused by televisions, artwork under glass, and even framed artwork hanging on the walls. This is really important when using a flash or flashes to add light because you can't see the reflection until the flash fires. Make sure that you

take a test shot first to see if the flashes show up as reflections in the image; if they do, reposition the camera or the flash until the reflection is gone.

■ Watch the edges when shooting with a super wide-angle lens. The distortion created by this lens type can make objects at the edges of the frame look curved when they should be straight.

If you look at Figure 4-15, you will see that the room looks nice and big and bright, and while there is a slight convergence of the verticals in the display case, the room looks relatively normal.

As an example, Figure 4-16 shows all the things that can go wrong when photographing inside what should look like a great kitchen. Here, the reflection of the flash in the window to the right, along with the bad angle and severe distortion

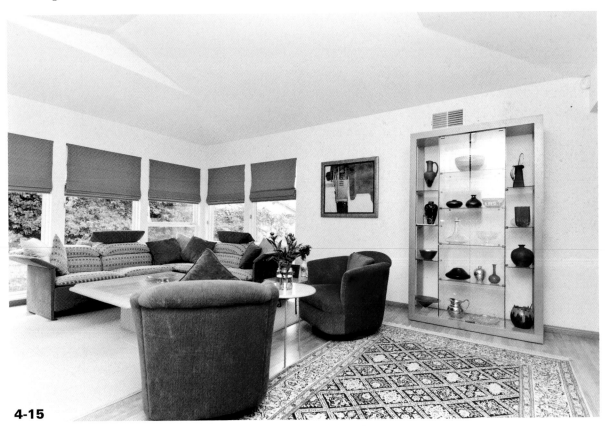

4-15

ABOUT THIS PHOTO *This living room was photographed with a 12mm lens on a cropped sensor camera, and then the lens was corrected using the lens correction tool in Lightroom. This helped to keep the vertical lines looking straight and true. The room was lit by a combination of light coming in from outside and an off-camera flash set up on camera left and aimed at the ceiling and triggered with a Pocket Wizard radio controller. Taken at 1/60 second, f/4.0, and ISO 100.*

4-16

ABOUT THIS PHOTO *The kitchen photographed at a downward angle might help to show off the counter, but it really made the rest of the room look wrong. The lens choice was also not right for the situation as the 10.5mm fisheye lens caused the walls to look bowed. The room was lit with a combination of natural light through the window and a flash on the camera that can be seen as the bright spot in the widow. Taken at 1/60 second, f/4.0, and ISO 100.*

from the fisheye lens, make this a prime example of what *not* to do. As you can see from Figure 4-17, just changing the view, doing a little cropping in postproduction, and using a different lens can really help to clean up the image. The room was lit by a combination of the light coming in through the window and a flash unit mounted on the camera. The flash was aimed at the ceiling to provide bounce light.

DEALING WITH MULTIPLE LIGHT SOURCES

When photographing a room interior, the first thing to do is determine the light source or light sources that are present. Unless the room is pitch black, there is at least one light source, and maybe more. The room or part of the room may be lit by sunlight coming in through the windows, or maybe by a few lamps placed in the corners, but more likely it is both.

4-17

ABOUT THIS PHOTO *The same kitchen photographed at a different angle and from a lower perspective using a 12mm lens instead of a 10.5mm fisheye lens; this improved the look and feel of the image. The flash reflection can no longer be seen in the image. Taken at 1/60 second, f/4.0, and ISO 100.*

> **note** Your brain and eyes automatically adjust to different light sources and can even adjust to mixed light sources, while your camera doesn't.

As the photographer, you need to make a decision: which of the light sources do you set the camera to in order to record correctly, and which do you ignore. It is not possible to set the camera for two different white balances at the same time. To see the different colors of light in the same room, set the white balance on your camera to Auto and just take a photo of a room with mixed light sources, and then check the image on the back of the camera. You will see that the different light sources color the different areas and they don't match, especially when you add fluorescent lights into the mix.

A well-lit room can have a mix of light that can look natural, especially if the lighting is all close in temperature on the Kelvin scale. An example of this is shown in Figure 4-18 where there is

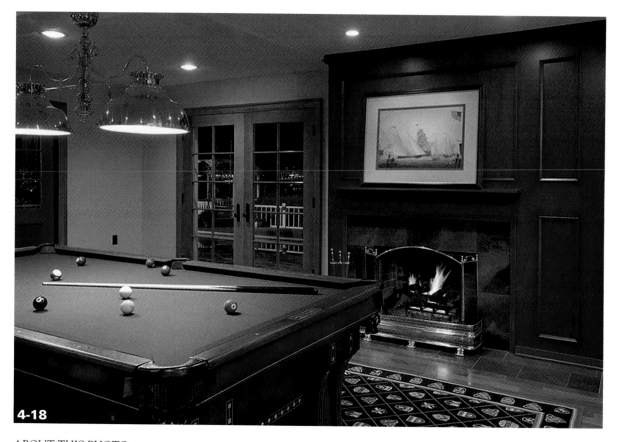

4-18

ABOUT THIS PHOTO *The pool room was shot to show the table and fireplace along with the view out the doors. The lights in the image focus your attention on what's important. Taken at 13 seconds, f/14, and ISO 100.* © Larny Mack

light from the ceiling and the lamp over the pool table, as well as from the fire. To successfully photograph this room, all the different lights needed to be close to the same type or at least close to each other in temperature. That means that the lights in the ceiling and the lights over the table were close to each other on the Kelvin scale and both were close to the color of the fire. This image looks brightly lit; it took a 13 second exposure for all the details to be captured properly.

Here are some ways to get the best results when you photograph in mixed lighting:

■ **Make the lights the same.** The first step is to see which light sources can be eliminated or easily changed. Is it possible to turn off the lights or change the bulbs so that all the lights are the same type?

■ **Gel the lights.** Some lights can't be changed or turned off, so another option is to change the color of the light by putting a gel over it. A gel is a piece of colored material that is

placed in front of a light to change it's color. The color of the gel is important, as it needs to turn the current color of the light into the color that matches the other light in the room. The most common use is to neutralize the off-putting green cast produced by fluorescent bulbs by covering them with magenta gels. The addition of the magenta to the green creates a more even white light. The magenta gel needs to be covering the tubes, so before setting out to gel the lights, make sure that you can actually get to the bulbs.

- **Create a custom white balance.** If the lights are close in terms of color, then you can create a custom white balance. Check your camera manual for the directions on how to save a custom white balance. Just make sure that the area you use is illuminated by all the lights present and is not just directly under one type of light.

- **Know which lights work together.** Lights that are close together on the Kelvin scale can be used together and will look fine. That means that sunlight and warmer incandescent lights, including the light from a flash, are similar enough to be used together. The white balance you use should match the dominant light source. If there is more sunlight, then the white balance should be set to daylight. If there is more light coming from the incandescent bulbs, then set the white balance for incandescent, and if the flash or flashes are the predominant light, then set the white balance for flash.

- **Postproduction fix.** It is possible to adjust the white balance using software, but this usually takes a lot of work, as you will most likely have to adjust each part of the image separately and then try to rebuild it; as a result, you should only use this as a last resort.

Not all mixed lighting is bad; actually, some of it can be used to great effect. The different light can actually draw your eye to different areas of the image. When it comes to looking at a room, the lights that are present are important, and they were most likely placed carefully to create a mood and feeling. Keep this in mind and try to make sure that you don't ignore the lights that are present; work with them instead.

The image in Figure 4-19 is an example of not only gelling the lights correctly, but also of adding some lights to the scene to get the best look. The room looks simple enough, but photographer Larny Mack had to do a lot of work to get it just that way. The ceiling lights in the room are tungsten lights so the camera's white balance was set to tungsten, which caused the late evening light to look very blue outside; then a couple of extra lights were brought in to help add some light to the room. If you look at the shadow on the wall behind the plant in the center of the room, you will see a distinct shadow of the plant, which could only be made from a light coming in from the far left. The strobes used were covered with a gel that turned the light into one that had the Kelvin temperature of a tungsten light. This made the additional light the same color as the built-in lights and it rendered correctly as the camera's white balance was set to tungsten. To gel a flash so that the color matches tungsten lighting, you add an orange gel, usually called a CTO or Color Temperature Orange. This is one of the most useful gels to have because it turns the color of the light from your flash the same as that from a regular tungsten household lightbulb.

4-19

ABOUT THIS PHOTO *The living room has a great blue, late-evening sky outside and a warmer feel to the inside, making it cozy and inviting. Taken at 6 seconds, f/18, and 100 ISO.* © Larny Mack

The nicest thing about architectural photography is that your model doesn't get up and walk away or need to stretch. The house or building will be there today and most likely tomorrow as well. They never have an itch or complain, and you can take your time when photographing them. When you get to Chapter 9, where I talk about light painting, try to use those techniques when it comes to painting a room. The results might just surprise you.

Assignment

Shoot a portrait in available low light

The assignment for this chapter is to take a portrait in low light and share it on the website. It is actually easy to shoot a portrait using window light. It sometimes takes a little planning, but the results can really make it look as if there was a full light setup.

Photographer Rick Sammon was giving a talk in San Diego, and I wanted to get him to pose for a portrait. Knowing that there was not going to be a lot of time and no way to bring in a lot of lights, I opted to take the portrait using the available evening light that was coming in through the glass entryway to the building. The setup was perfect with two glass walls and a white wall across the way that could act as a reflector. I placed Rick with his left shoulder close to one window and had him turn his head towards me as I watched the background and the light that was coming in from the other window. I chose matrix metering so that the light in the whole scene was taken into account. I set the exposure mode to aperture priority and used an f-stop of f/4.5 to get a shallow depth of field.

I set the ISO to 400, which was high enough that I could get a shutter speed of 1/30 second. I took four quick shots, confirming after the first two that the exposure was correct.

 Remember to visit www.pwassignments.com after you complete the assignment and share your favorite photo! It's a community of enthusiastic photographers and a great place to view what other readers have created. You can also post comments and read encouraging suggestions and feedback.

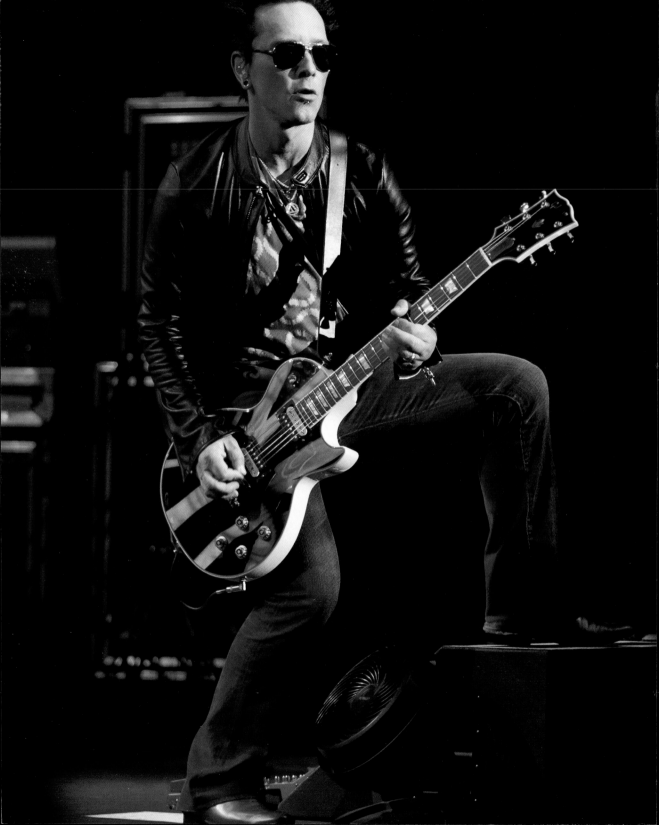

WEDDINGS

PHOTOGRAPHING CONCERTS AND EVENTS

AT THE FAIR

There is certainly a thrill to capturing live events as they unfold right in front of you (as in Figure 5-1) — be they weddings, concerts, plays, or even the action at the local fair. However, these events are likely to take place at night or in low-light situations. Often photographers become frustrated when trying to shoot these types of events for the first time and the results are not what they expect. The problem is that these events take place in venues where the amount of light is deceptively low. What happens is that your eyes adjust to the amount of light and the scene looks well lit to you, but the camera doesn't adjust to the light automatically and has to work with what is there. This chapter shows you how to work with the available light and get the results you want including when to push the ISO higher and when you can use slower shutter speeds.

WEDDINGS

Being a wedding photographer is a tough combination of jobs. You need to be able to shoot portraits and events, and stay organized, friendly, and outgoing the whole time. You also have to deal with multiple subjects in multiple locations and

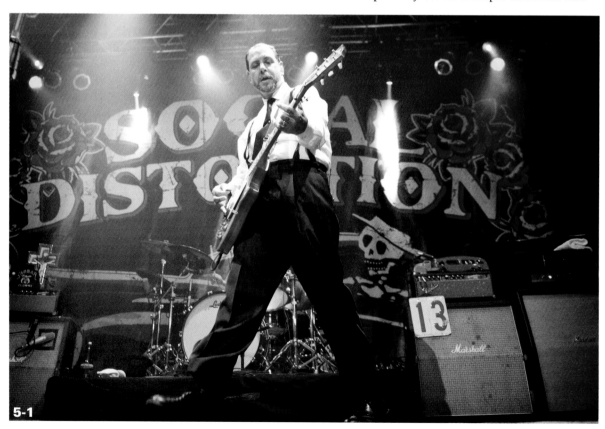

ABOUT THIS PHOTO *Social Distortion front man Mike Ness performing. While photographing at clubs can be really tough work with the changing lights and restricted access, with the right settings and good timing, you can capture great images. Taken at 1/160 second, f/2.8, and ISO 1600.*

you don't get a second chance at capturing some of the most memorable moments in a couple's life, including the bride walking down the aisle, the exchange of vows and rings, the first kiss, and the celebration that follows. Great wedding photographers make this all look effortless and the couple never has a moment of doubt. In reality, photographing a wedding takes a lot of planning and practice and shouldn't be undertaken lightly. The tips can help you become a better wedding photographer and a better photographer in general, especially when working in situation where the light is low.

Weddings are usually all-day affairs, with the bride and groom getting ready, the ceremony, and then the reception, a time to cut loose. Many times most of this takes place indoors and under less-than-optimal lighting conditions. Even when the ceremony is outdoors, it may be later in the day or timed with the sunset. Because portraits and photographing people indoors and in low light are covered in Chapter 4, this section concentrates on getting the best images during the ceremony and reception.

THE CEREMONY

The wedding ceremony is the most important part of the wedding day. It is when the actual marriage happens and can go by really fast. All that planning and preparation culminate in a ceremony that not only joins a bride to her groom but also combines two families. This gives you many subjects for the limited time you have to shoot during a wedding ceremony.

When a wedding ceremony happens in a place of worship, it is often not a well or evenly lit space. Additionally, you may be asked not to use a flash or any type of extra lighting during the ceremony as it can be very distracting to the bride, groom,

and guests. The combination of low light and restrictions on flash can be really stressful especially when you realize that there are no second chances when shooting a wedding ceremony. The wedding party are not going to stop the ceremony to make sure that you are in the right spot or that the lighting is right. The wedding in Figure 5-2 took place in a synagogue. While the overall light was rather low, requiring me to use a high ISO of 1600, a relatively slow shutter speed of 1/60 second, and a wide f/2.8 aperture, the light never changed in direction or intensity, making the settings I used consistent as long as the subjects didn't move much.

Before the ceremony even starts, it pays to make sure that your cameras are set up right. Having the cameras ready to go with the right ISO, aperture, and shutter speed before the ceremony starts will allow you to focus on the composition instead of the exposure when the ceremony starts. This also includes knowing which lenses you will need and if and when you can use a flash. The key to getting your cameras ready with the right settings and with the right lenses is to get to the wedding site before the wedding starts.

Before the ceremony gets under way, check out the location and, most importantly, check out the locations you are going to be photographing from and how much light will be on the subjects. This preplanning allows you to be ready with the right lens and right setting during the ceremony. If there is not enough time during the wedding day, then make a point to check out the site before the wedding, preferably at the same time of day so that you can see where the light is. Fortunately, most places of worship are designed for the congregants to be able to see the front clearly. This means that there is more light in the front of the venue, where you need it.

ABOUT THIS PHOTO *For this photograph I used a relatively slow shutter speed of 1/60 second, which allowed me to freeze the action because the bride and groom were stationary. I still needed a rather high ISO of 1600 and a wide aperture of f/2.8. Taken at 1/60 second, f/2.8, and ISO 1600.*

5-2

The key to getting good wedding images, especially during the ceremony, is to make sure that you are using a shutter speed that is fast enough to freeze the action so there is no blur. The good news is that the subjects during a wedding ceremony don't really move very much. This means that you can use slightly slower shutter speeds and still get sharp images. Because you have limits on what shutter speeds freeze the action, you have to adjust the aperture and ISO to get a proper exposure. That is to say that you can't drop the shutter speed so low that the subject's movement causes blur or the camera movement causes blur. Once you have set the shutter speed

as low as you feel it can go and still freeze the subject, you have to adjust the ISO and the aperture. To capture the scene in Figure 5-3, wedding photographer Kenny Kim used a shutter speed of 1/80 of second, which froze the action, but in doing so he then needed to use a high ISO of 3200 and a wide aperture of f/2.8 because the light in the church was quite low.

> **tip** It is better to raise the ISO so that you can use a shutter speed fast enough to freeze the action (and deal with the digital noise later) than to get blurry shots with low noise.

5-3

ABOUT THIS PHOTO *It's a good thing that the bride and groom were not moving much because the low-light conditions in the church cre-ated a situation where photographer Kenny Kim needed to use a wide aperture and very high ISO. Photographed at 1/80 second, f/2.8, and ISO 3200.*
© Kenny Kim

The basics of exposure allow you to change the shutter speed, the aperture, and the ISO. However, to set the shutter speed high enough to freeze the action, you need to adjust the aperture and ISO.

The range of apertures is a function of the lens, not the camera. The maximum aperture is the widest that the aperture in a lens can open allow-ing more light to reach the sensor, so for weddings in low-light situations, the bigger the opening, the better. When it comes to zoom lenses, the biggest opening is f/2.8 and the most popular lens for getting in close is the 70–200mm f/2.8 zoom lens, a staple for wedding and event photogra-phers. This lens allows you to use any of the focal lengths between 70 and 200mm at the wide f/2.8, allowing in a lot of light. There are other options such as using cheaper prime lenses that have even wider maximum apertures but don't have the same focal length range. Lenses like the 50mm and 24mm can usually be purchased for a few hundred dollars.

Prime lenses can have even wider maximum apertures, allowing in even more light. These wide apertures are great for the low-light part, but because you are using them at such wide

apertures, the depth of field is very shallow. You have to be aware of this as it won't look that way through your viewfinder, but subjects that are not on the same focal plane will not be in focus. What this means in practical terms for you is that if you are shooting from an angle at the bride and groom, then you need to be sure that you are focusing on the subject of your photo. The rest of the image will fall out of focus, depending on the distance of the camera from the subject and the distance of the rest of the scene from the subject. You can use this effect creatively, as shown in Figure 5-4 where wedding photographer Kenny Kim kept the focus on the groom watching his

wife-to-be make her way down the aisle. The shallow depth of field created by using the f/2.8 makes the groom really pop out of the photo. Knowing that a wide aperture would cause a shallow depth of field, Kenny made sure that the subject of the photo was in focus. Because he was already using as slow a shutter speed as possible and a very high 2500 ISO, he used that shallow depth of field to his advantage.

The other exposure adjustment you can make is to raise the ISO so that the signal captured by the sensor is amplified, allowing captures in lower light. This means that you can increase the ISO until the chosen shutter speed and the maximum

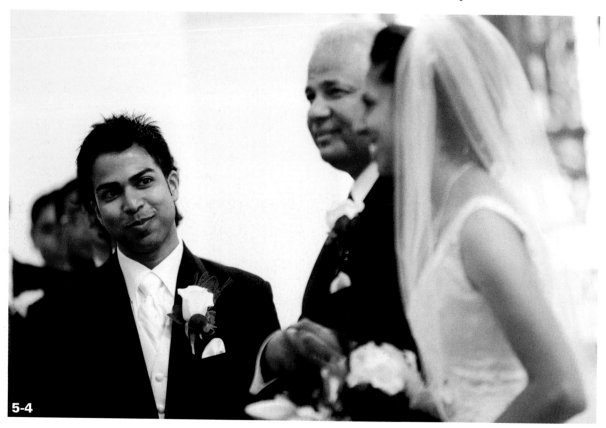

5-4

ABOUT THIS PHOTO *For this photograph, the shallow depth of field works well in making the viewer's eye go directly to the groom. Taken at 1/80 second, f/2.8, and ISO 2500.* © Kenny Kim

aperture on the lens equal a proper exposure. Remember, however, that the higher you set the ISO, the more digital noise is present, so you need to know the highest that you can go on your camera and still get images that are usable. As you increase the ISO, you can start adjusting the other settings to make sure that the shutter speed really is fast enough or make the aperture smaller to increase the depth of field.

During wedding ceremonies, the light usually doesn't change much. So once I have the settings dialed in, I can focus more on composition than on exposure.

Here are some initial settings that I use as a starting point to determine exposures:

- Set the shutter speed to 1/125 second.

- Set the aperture to the widest possible setting on the lens, hopefully at f/2.8.

- Spot meter the area where the bride and groom are going to be standing.

- Adjust the ISO high enough to get a proper exposure.

If I use a longer lens, then I increase the shutter speed so as not to get any lens shake in the images. I make a note of the settings so that I can set my camera before the actual ceremony even starts.

The last part of the puzzle for the ceremony is to know when and where things are going to happen beforehand. It helps to make a list of the key moments in the ceremony so that you can be prepared with the best camera settings and also be in position for them.

- **Bridal party walking down the aisle.** You need to be in position to catch them as they start down the aisle, and pay attention to the camera metering if they are coming in from outside or through a door with a brighter background. You will need to meter for their faces and not have the brighter background turn them into silhouettes.

- **Bride walking down the aisle.** The bride usually wears a white or very light colored dress, which can cause the built-in light meter to underexpose the scene, so make sure that you are letting enough light reach the sensor to render the dress the right shade of white.

CAMERA SHAKE Camera shake has to do with the minimum shutter speed needed to make sure that the slight movements when holding the camera don't affect the sharpness of the photo. The rule of thumb is that the shutter speed needs to be 1/focal length used. That means that if I am using a 24mm focal length, then the minimum shutter speed is 1/24 second or more likely 1/30 second, and if I am using a 200mm focal length then I need a 1/200 second shutter speed. When you start out, these are probably good guidelines, but after you have practiced holding the camera steady for a while, you may be able to use lower shutter speeds on longer focal lengths. I routinely shoot a 200mm lens at 1/100 second and get sharp images. Note that although you don't get lens shake at 1/30 second with a 24mm lens, if the subjects are moving, they will still be blurred because 1/30 second is a pretty long shutter speed.

- **The first look.** There is a very special moment when the groom sees his bride for the first time. The problem is that often the groom is standing forward of where he will be standing during the ceremony, which may have even less light than his position during the ceremony. The only real advantage you have is that he will not be moving, so a slower shutter speed is an option.

- **Ceremony.** Knowing when the vows and ring exchange are going to take place will allow you to be in position to capture these important parts of the ceremony. If you have a lens in the range of a 70-200mm f/2.8, then you can zoom in and still use a wide aperture to help in the low light. If you don't and only have a prime lens with a shorter focal length, then you will need to physically move in closer to the couple to be able to get the details of the ring exchange.

- **The first kiss and walk up the aisle as husband and wife.** Many ceremonies end with a first kiss and the newly married couple leaves together. Using a longer focal length will allow you to capture the kiss, but many couples practically run down the aisle. This is also the time when you may be able to start using a flash, so it is possible to have one ready to help illuminate the scene if needed, but make sure you check with the venue before using a flash.

If possible, try to also get photos of the wedding party and the guests during the ceremony. It shouldn't take more than a few seconds but can really help tell the story of the day. There will be a chance to do this later, but it never hurts to get a few during the ceremony. The challenge here is that many times the lighting is lower on the guests and the wedding party than it is on the couple. When this happens, it is fine to overexpose the couple, especially the white dress, to get the wedding party or the guests in proper exposure. You just don't want to forget to switch the settings back for when you are photographing the couple again. Using a wide-angle lens allowed photographer Kenny Kim to capture not only the bride and groom but the wedding party as well in Figure 5-5. Notice how the detail in the dress is lost as it goes very close to pure white. The windows in the background and the lights in the ceiling are already pure white with no detail, but since they are actually sources of light that is just fine.

THE RECEPTION

Wedding receptions are celebrations — a celebration of the couple starting their life together — one that they want to share with their close friends and family. The reception offers a great many photo opportunities, from the entrance of the couple as husband and wife to the couple leaving to spend their lives together and everything in-between. There are fewer rules when it comes to using a flash at receptions, and many times it is a good idea to use not one, but multiple flashes to light up the subjects and the room.

Shooting with a single accessory flash is a great place to start, and once you are comfortable with that, adding a second (or third) flash is easier. A downside with using a flash is that the images all look like they were taken with a flash and the light source was right at the camera. This can leave the images looking more like snapshots than great photographs. There are some things that you can do to make these images look better:

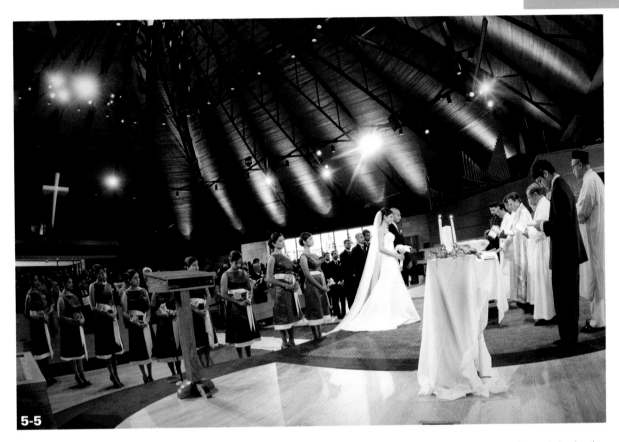

5-5

ABOUT THIS PHOTO *For this photograph Kenny Kim used a wide-angle lens to capture the wedding party as well as the couple by shooting from the side of the venue, a location he scouted earlier in the day. Shot at 1/250 second, f/4.0, and ISO 1600. © Kenny Kim*

■ **Use a diffuser.** A diffuser is a plastic dome that goes over the head of the flash and creates a softer light. Many external flash units come with a diffuser, and you can get one for those that don't from a company like Sto-Fen. There are also more advanced diffusers with specialized shapes that go a step further than a simple dome and create a softer more controlled light source. The leading diffuser in this group was designed by wedding photographer Gary Fong and is one of the most popular diffusers being used today.

■ **Change the angle of the flash head.** Because the problem of the on-camera flash is the angle of the light, use an accessory flash head where you can change the angle. When you aim the light over the heads of the subjects, the light hits the ceiling and bounces back down, which in practice turns the ceiling into a big, soft light source, instead of a small light source like the flash. You will need to adjust the power of the flash, depending on the distance to the ceiling.

 x-ref

For more on bouncing the light, see Chapter 4.

■ **Use a flash bracket.** Getting the flash as far away from the lens as possible is really helpful in getting good portraits. This can be done by placing the flash off camera, on a light stand for example, but it is not practical when you have to move around and take photos. Another option is a flash bracket that attaches to the camera using the tripod screw at the bottom. It uses an articulated arm to place the flash up high over the camera. Many flash brackets can also be quickly adjusted so that the flash is always above the camera, no matter what orientation the camera is in.

■ **Rear curtain sync.** Many cameras allow you to set when the flash fires during the exposure — at the start, when the first shutter curtain starts to move, or at the end, right before the rear curtain starts to close. If you use the rear curtain sync and longer shutter speeds, the ambient light present in the scene is captured, and the subjects are frozen not by the shutter speed but by the flash. This can add a sense of movement to an image but only works well when you have the flash light freeze the subjects. This can be seen in Figure 5-6, where photographer Kenny Kim captured the movement of the first dance by using a slow shutter speed and having the flash fire at the end of the exposure.

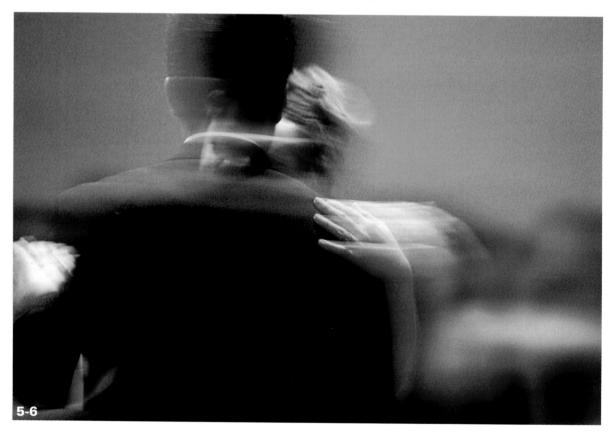

5-6

ABOUT THIS PHOTO *The first dance was captured to show movement in the image by using a rear curtain sync. Taken at 1/2 second, f/2.8, and ISO 1600. © Kenny Kim*

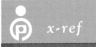 **x-ref** | Sync speed is covered with more detail in Chapter 4.

All these methods work great with a single accessory flash attached to the camera, and they work great if you add another flash off the camera to act as a room fill light. Because the photos at the reception are usually taken from a variety of places, the ideal setup is a second flash on a light stand that can be placed off to the side, aimed at the ceiling or the background and fired remotely from the camera. This second flash can be placed in the best possible position when you know what is going to happen and when.

The following list outlines some of the moments that you should set up to capture. Each likely takes place in a specific area, so you can set up before they happen and be ready with the right lens and camera settings:

- **The first dance.** During this dance, the couple is usually surrounded by the guests on the dance floor, but with enough space to get a nice clean shot. This is also a perfect time to use the rear curtain sync with a longer shutter speed to show the emotion of the couple dancing. The longer shutter speeds enable the dancing couple to move a little in the frame, then the flash fires at the end freezing their last movement. This can give them a purposely blurred edge and show the movement of the dance. Angling the flash at the ceiling or over their heads creates a more natural-looking effect than if the flash was just aimed directly at them.

- **Toasts.** During the toast, you should make sure to capture the person giving the toast, the bride's and groom's reaction, and the guests' reactions. As the wedding photographer, it is tough to get in position to capture all three, but you need to be able to at least capture the person making the toast and the couple. A zoom lens works great in this situation because you can get in close and get a wider view without having to change position. When changing what the subject of the image is, for example from the person giving the toast to the reaction of the guests, make sure you adjust the exposure settings as well. You can easily do this by increasing or decreasing the ISO. In Figure 5-7, the groom is toasting his bride to the great joy of the guests. I used a flash to add fill light to the scene, as well as a slower shutter speed of 1/50 second so that some of the background could be seen.

- **Cake cutting.** The cake cutting is actually one of the easiest parts of the reception to photograph, as long as you have set up for it and are ready. It is important to be positioned so that you can get the cake and the couple in the frame, which usually means using a wider focal length and being in close so that none of the guests get between you and the subjects. This means that the angle of the flash needs to be adjusted so that the light doesn't hit the cake and subjects straight on. Making sure that the white balance is set correctly here ensures that the wedding cake looks the right color in the final photos. Many times the cake is white or close to it, so it picks up the color of the light used to illuminate it. An off white ceiling can cause the cake to look off white instead of white. Or using rear curtain sync can let the ambient light influence the cake's color. For example, if the light in the room is tungsten and you use a slow shutter speed, then the light in the photo will be a combination of tungsten and flash and it becomes very difficult to make the photo look good later.

5-7

The solution is to gel the flash to the same color as the ambient light so that all the light sources are the same.

x-ref For more information on using gels with flash, see the section in Chapter 4 discussing lighting a room with multiple light sources.

■ **Garter and bouquet toss.** The garter and bouquet tosses can be a bit of a challenge because they happen really fast. Try to set up so that you can capture the subject making

the toss and then be able to very quickly rotate to capture the catch. If you are using an accessory flash for this, and I suggest that you do, make sure that the batteries are fresh and increase the ISO on the camera so that the flash doesn't have to work as hard. This will enable you to get a sequence of shots like Figures 5-8 to 5-10 of the single women vying to catch the bride's bouquet. This was taken using an on-camera flash unit to light up the scene. The flash was aimed over the heads of the women and bounced off the relatively low ceiling. The flash is actually so bright that in Figure 5-9 the light is causing the bride's dress

ABOUT THIS PHOTO
The single women gather for the tossing of the bride's bouquet. Taken at 1/250 second, f/2.8, and ISO 200.

ABOUT THIS PHOTO
The bride throws the bouquet to the waiting women. Taken at 1/250 second, f/2.8, and ISO 200.

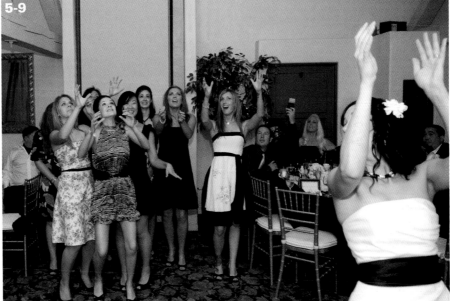

to be overexposed. The flash loses a slight amount of power each time it is used in quick succession, so the amount of light is slightly less in Figure 5-10.

When shooting the reception, remember that this is a party and a celebration, so go with the flow and watch for those special moments between the bride and groom and the guests. A rule of thumb is to just follow the bride because she really is the center of attention and nothing will happen without her. Pay attention to the various types of light present and how different areas of the same room can have different intensities of light.

> **tip** At wedding receptions, use a flash when needed. The basics of photographing people with a flash from Chapter 4 can really help.

PHOTOGRAPHING CONCERTS AND EVENTS

Concert and event photography can be some of the most challenging types of photography to master, and while it can be frustrating, it can also be a whole lot of fun. Being in the photo pit at a concert as the house lights go down and the band takes the stage to the roar of the crowd is exhilarating, but being able to capture a few friends playing at a party in the backyard with the final rays of daylight and a few household lights can be just as fun and even more challenging.

When it comes to concert and much event photography, it is the low-light conditions combined with limited access and restrictive shooting times that make it a very tough job. It doesn't matter if I am shooting a local band at a small bar or the headlining act at a big arena, the techniques are

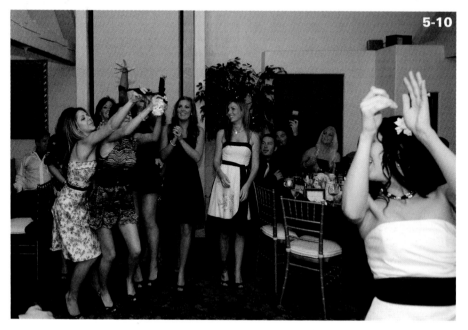

5-10

ABOUT THIS PHOTO
Victory for one woman as she manages to win the toss, reaching for the bouquet as it comes down. Taken at 1/250 second, f/2.8, and ISO 200.

the same. You may be surprised to find that it is actually much more difficult to shoot in a small venue because the light is lower and the stage is smaller. But if you start with the most difficult lighting situations, then as you get to shoot bigger and better-lit shows, it actually gets easier.

When it came to photographing Billy Idol and his band during their 2010 winter tour, the venues were medium-sized clubs with pretty good lighting, allowing me to use higher shutter speeds to make sure I captured every snarling minute, as you can see in Figure 5-11.

There are some factors to take into consideration when trying to determine what shutter speed to use to freeze the action in your images.

■ **The direction of the movement.** If the object is moving toward or away from the camera, then you can get away with a slightly slower shutter speed, as the movement is actually very small. If the object is moving across the frame, then you will have to use a faster shutter speed, as any movement will be noticeable.

■ **The speed of the movement.** You have to actually start to judge how fast something is moving, and that takes practice. It is easy to think of a car going fast, but what about the hand of a guitar player during a fast solo? The more you photograph these types of events, the easier it becomes to judge this.

5-11

ABOUT THIS PHOTO *Billy Idol photographed during the opening number on the southern California leg of his 2010 winter tour. Taken at 1/320 second, f/2.8, and ISO 1600.*

- **The distance of the movement.** If the object is far away and only a very small part of your frame, then you can get away with a slower shutter speed, as it won't travel very far in the frame.

- **The importance of the movement.** This is a judgment call every time you take a photo. Is it important to freeze everything in the frame or just the main part? Is it important to freeze the guitar and the hand, or does a little blur add to the image as long as the rest is sharp.

In the end, it is practice that will enable you to pick the right shutter speed for action stopping in a variety of situations, but it is important to check the results at 100 percent on the back of the camera and not just by looking at the thumbnail. Learn how to view the images at 100 percent using your camera manual.

KNOW YOUR GEAR

One thing that doesn't change, no matter what size show you are photographing, is that the gear does matter. That doesn't mean you have to go and buy the newest camera and lenses as they come out (even though I'm sure the camera and lens manufacturers would disagree), but you do need to choose your camera and lenses wisely.

tip If you want to try some of the gear before you buy it, then consider renting from your local camera store or one of the online camera rental services like www.lensprotogo.com or www.borrowlenses.com.

The two pieces of gear that are most important to concert photographers are cameras with high ISO and low-noise capability and lenses with a wide maximum aperture.

x-ref Gear is covered in detail in Chapter 3.

Concert and event photography lenses are often referred to as "fast glass," meaning lenses with maximum apertures of f/2.8 or wider. There are some situations where a lens with a maximum aperture of f/4 or smaller might work, but to be able to use shutter speeds high enough to freeze the action, at times pretty fast action, you need to use lenses that can open up really wide. The two most common zoom lenses for concert and event work are the 70-200mm f/2.8 lens and the 24-70mm f/2.8 lens. Every camera and lens manufacturer makes a version of these lenses, and for good reason — they are incredibly useful for just about all types of photography. If I went back and looked at all my concert images, I would estimate that more than 70 percent of them were taken with the 70-200mm f/2.8 lens or its predecessor, the 80-200mm f/2.8 lens. The combination of a wide aperture and long focal length makes this the perfect lens for getting in close and getting wider shots without having to change lenses.

Many times photographing concerts or events in really low light calls for lenses that can open up to even wider apertures; this is when you need a prime lens that can open up to an amazing f/1.4, f/1.8, or f/2.0. These lenses allow you to get up to a full stop of light over the zoom lenses, which can mean the difference between getting the shot and missing it. The good news is that many of the prime lenses are actually cheaper than zoom lenses but usually at much shorter focal lengths; however, this is a great place to start. The longer focal lengths, those over 50mm, usually demand a premium price tag; for example, I have an older 85mm f/1.4 lens that has really saved me in some of the dimly lit bars I have shot in, but it cost

quite a bit when I bought it and the newer versions available now cost even more. When photographing the Jackie Greene band, the lights were extremely low so I needed to use an 85mm prime lens opened all the way to f/1.4 and an ISO of 1600, as you can see in Figure 5-12.

Many full-time concert and event photographers use two camera bodies at the same time. It is much faster to change cameras than it is to change lenses, so using two camera bodies with two different lenses enables you to capture the show with the most versatility and different looks, all in the allotted time. Most of the time you are only allowed to photograph concerts for a very

limited amount of time; usually the first three songs or less. The most common setup is to have one camera with a longer lens, like the 70-200mm f/2.8, and the other camera with a shorter lens, like the 24-70mm f/2.8. This allows coverage from 24mm to 200mm, all at the same aperture and all accessible at any given moment. A second bonus to having two cameras is that if you fill the buffer on the first you can easily switch to the second while the data writes to the card.

Depending on the band and venue, the time rule might be flexible, but so many bands and venues use the three-song rule, it is definitely the norm when shooting concerts. The one really big

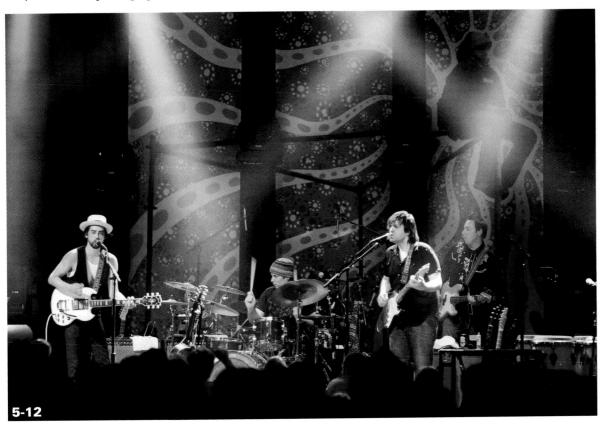

5-12

ABOUT THIS PHOTO *A prime lens can really help when the light is low, especially a lens that opens up to a maximum aperture of f/1.4. This is what I needed to capture the Jackie Greene band. Photographed at 1/125 second, f/1.4, and ISO 1600.*

exception is when shooting in bars, and then there is usually no limit, making it possible to get a lot of practice in during a single show. When it comes to general events, this could mean photographing a parade or a birthday party, or red carpet arrivals. Now, while all these might seem very different, they all have certain time restrictions on the photography. Take a parade, for example; it moves down the parade route and usually doesn't stop much, and even if it does, it usually gets moving pretty quickly. That means that the subjects are not in front of the camera for very long, giving you a limited time to shoot.

Photographing a birthday party might seem like you have a lot of time, but similar to weddings, there are certain moments that you want to capture and they come and go quite fast. For example, there is only one shot at getting the birthday boy or girl blowing out the candles on their cake. As for red carpet events, they move really fast, with the celebrities being ushered along at a good clip. At the most, you might get from 30 seconds to a minute with the subject in front of you, and then you are competing with a group of other photographers who are all trying to get the same shot. When I photographed actor Ron Perlman at the arrivals for the Syfy/Entertainment Weekly party (see Figure 5-13), the average time each star was in front of the cameras was about 30 seconds, which meant making sure that the camera settings were dialed in before the first arrival.

STAGE LIGHTING

A great light show can greatly enhance the entire concert experience. Many bands put a lot of thought into their light shows, and the bigger bands and shows may even have a dedicated lighting director who handles the lights during

5-13

ABOUT THIS PHOTO *When photographing red carpet arrivals, I made sure that my exposure settings were set before the first actor stepped in front of the camera. The settings never changed because the light never changed, but the shooting time was very limited. Taken at 1/250 second, f/5.0, and ISO 1250.*

the show. The lighting director can be your best friend or your worst enemy because he or she is the person in control of the lighting. The lighting director is only interested in creating the right lighting for the band and giving the audience something interesting to look at. For example, in Figure 5-14, the lighting was interesting enough that I chose to make it the subject of the image.

5-14

ABOUT THIS PHOTO *The lights gave the stage a great look and enhanced the show. Photographed at 1/30 second, f/2.8, and ISO 800.*

These are great shots to work on getting for two reasons; the first is that they can really look great, and the second is that lighting directors really like to see their work, so showing them that you can capture it could lead to more work or at least more opportunities to photograph concerts. When working on getting these types of shots, you will have to drop the shutter speed a little to let the lights look like solid beams of light instead of just capturing what the lights are illuminating. Work with shutter speeds around 1/30 second to keep the musicians from blurring too much, and practice hand holding the camera so that there is

no camera shake. Since each show is different, you will have to adjust the settings to match the lighting and check the LCD screen on the back of your camera often to see if you are getting the effect you want.

As a concert photographer, you need to watch the lights and look for patterns in the way they move. This enables you to time your photographs to shoot when the best light is on the subject.

Most stage lighting can be broken down into two parts: front lighting and back lighting. When done right, a combination of slightly brighter

front lighting and some back lighting can result in great lighting to photograph in. The subject pops out and the entire scene looks great. However, chances are this is not going to happen often — either the front lighting or the back lighting will be too bright. The performer is likely to either have no background details and will look solid black or will be silhouetted against a very bright background.

At times, there will also be a follow spot, which is a spotlight that is aimed at the main performer or performers on stage. While it is much easier to photograph a performer when he is lit by the bright light of the follow spot, it can also lead to rather plain photos as the follow spot is usually white. Additionally, when shooting a performer who is illuminated by a follow spot, the rest of the stage can look very dark.

METERING MODES AND MANUAL EXPOSURES

The difference between an amateur and a professional is that a professional can replicate his results time and time again while an amateur may get a lucky shot. The key to getting consistent results is to set the shutter speed, aperture, and ISO yourself, and use the spot metering mode as a guide to getting the proper exposure. For photographing concerts and events indoors or at night, the following settings are a good place to start:

- **ISO set to 1600.** On the camera I use, the ISO setting of 1600 gives me an image that has an acceptable amount of digital noise to me. Older cameras might not be able to shoot this high, and some newer cameras can shoot even higher; it is a choice that you will have to make, depending on the camera you have.

- **Aperture at f/2.8.** Most of the time, for events like this, you want a lens that can open up to f/2.8 and sometimes even wider. Having the aperture set here allows you to concentrate on the other settings.

- **Shutter speed 1/160 second.** This is an arbitrary shutter speed that I use as a starting point every time. If I know where my shutter speed is to start with, I know which direction I need to turn the dial. For example, when photographing a solitary figure giving a speech, 1/160 second might be just fine and will freeze the subject, but when shooting the rock band Metallica, that shutter speed is just too slow. Because I know my starting shutter speed, I also know that if I rotate the rear dial of my camera three clicks I am at 1/320 second. From there I can start to work out what else I might need to adjust to get the proper exposure.

- **Manual exposure mode.** This is the key to getting consistent exposures because in manual mode, the camera doesn't change the exposure at all. It doesn't matter if the exposure settings you use will create a completely underexposed image that looks solid black or a completely overexposed image that is pure white; all the camera can do is meter the light and tell you if it believes the image will be under or overexposed. I will continue to discuss shooting in this mode later in the chapter.

- **Spot metering mode.** When you shoot in manual mode, the camera doesn't change any of the settings, so the metering mode doesn't have any effect on the exposure settings, but it can help you get close to the proper exposure. Take the scene in Figure 5-15, where the dark background and the bright white shirt of the keyboard player in the background could

have thrown off the metering if the whole scene was taken into consideration and not just the area of the visor of the lead singer.

■ **High speed advance / High speed continuous.** Setting the camera to high speed advance lets you shoot in burst mode, where instead of taking one shot at a time, you take three or four shots in quick succession. The camera keeps taking images as long as the shutter release button is held down or until the buffer gets full and the card runs out of space. Try shooting bursts instead of single shots when shooting a concert; this increases the odds of getting the perfect moment.

■ **Auto white balance.** This is one time that I don't worry too much about the white balance and I let it just run on automatic mode. The colors of the lights will keep changing, and many times the colorcasts that are present in concert photography look great. I do photograph using the RAW file type so that if I do need to fix the white balance in postproduction it is easier.

■ **Continuous autofocus.** There are usually three different focus modes on a dSLR, but the one that you want for concert and event photography is continuous autofocus — it is the best mode to use when shooting musicians who always seem to be on the move.

5-15

ABOUT THIS PHOTO *For this photograph of David Hinds and Selwyn Brown of Steel Pulse, I made sure that the spot meter was on the underside of David's visor, which gave me a good starting point for the exposure. I didn't want the built-in light meter to use the very dark background or Selwyn's white shirt. Taken at 1/200 second, f2.8, and ISO 3200.*

See Chapter 11 for more on fixing the white balance and working with RAW files.

Photographing in manual mode gives you complete control over your camera and works best when photographing concerts and events.

To help you better understand why using manual mode is your best option when shooting at a concert, consider the basics of the other settings you could use. When you photograph in aperture priority mode, the camera sets the shutter speed based on the meter reading. When you shoot in shutter speed priority mode, the camera sets the aperture based on the meter reading. In full auto or programmed auto mode, the camera sets both the shutter speed and the aperture based on the meter reading. What all these modes have in common, other than that the camera changes the setting, is that the camera uses the built-in light meter to do it.

The light meter looks at the scene in front of the camera and then works out the best settings to achieve proper exposure. But what happens if the lights are changing rapidly? For example, say you are photographing a band and the lights behind the performer suddenly get much brighter but the lights striking the performer from the front don't change. If it were up to the camera, the sudden influx of bright light would cause the meter to read the scene as brighter and increase the shutter speed (or use a smaller aperture depending on the mode), causing the subject to be underexposed. The same thing happens if the lights in the back suddenly become dark; the camera thinks that it needs to use a slower shutter speed or a smaller aperture, depending on the mode, and overexposes the subject.

If you use the spot metering mode and place it on the performer's face, then the changes might not be that severe and you will probably get some pretty cool results, but if you shoot in manual mode and use the spot metering mode to give you an idea of where your exposure is, this will result in more consistent images.

Here's the process:

1. **Set the camera to the initial settings: ISO 1600, 1/60 second, f/2.8, manual mode, and spot metering.** Check to see if the spot metering reading is close to what the exposure settings are.

2. **Take a photograph and check the results.** I check the photo on the back of the camera by making sure the highlight warning is on, which causes any areas that are totally white to blink. I don't bother checking the background, but instead check the exposure on the subject.

3. **Adjust the ISO if you need to make the image brighter.** If the image is too dark, I increase the ISO from 1600 to 3200 and try again. If at 1/160 second, f/2.8, and ISO 3200 the image is still too dark, then I consider switching to a prime lens that can open up wider than f/2.8, and I also consider decreasing the shutter speed as long as the subjects are not moving fast. I never want the shutter speed to be so slow that the subject is blurred.

4. **Adjust the shutter speed to make it darker.** If the image is overexposed, then I increase the shutter speed.

5. **Check to make sure that the shutter speed is freezing the action.** I make sure to use the 100 percent preview on the camera back to check the focus and to see if there is any motion blur from using too slow of a shutter speed.

6. **Watch how the lights change.** Now as you shoot the show, watch the lights, specifically the ones that are actually illuminating what you are photographing. It doesn't matter exposure-wise if the background or foreground lights change, unless they are illuminating the subject. If they are not, then they don't have to be dealt with. Take, for example, the lights that are behind guitarist Billy Morrison in Figure 5-16. They were solid white as they pointed forward, but because they were not affecting the light on Billy, I didn't worry about them.

7. **Double-check the images.** Periodically, check to see if the images are being recorded as you want them to be using the LCD on the back of the camera.

Knowing how your camera operates makes this process a lot easier. Because you are working in the dark and time is of the essence, knowing how to change the ISO, shutter speed, and aperture by touch saves time. Practice by holding your camera up to your eye and adjusting the ISO from 1600 to 3200 without looking, and then practice adjusting the shutter speed.

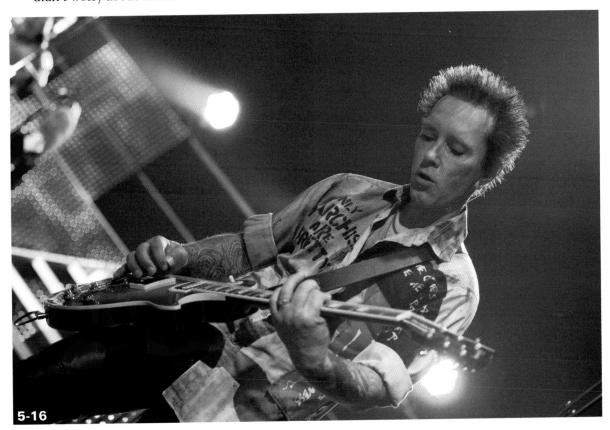

5-16

ABOUT THIS PHOTO *Billy Morrison on guitar during the Billy Idol concert. He is being lit from the front, and those spotlights in the background don't matter. Taken at 1/160 second, f/2.8, and ISO 1600.*

CAPTURE THE MOMENT

The goal behind all concert and event photography is to capture the moment. This is a combination of making sure that you have the exposure correct, have the timing down, and recognize the moments that matter. There are five different elements that can help you capture the perfect moment:

■ **Timing.** To get great concert photos, you need to practice your timing so that when a moment unfolds in front of your camera, you are ready to capture it. This could involve watching how the subject interacts with the fans or other band members, or how the light changes on the stage at any given moment. It helps familiarize yourself with the music before shooting a band because that really helps you with the timing. Is the music fast and frantic or slow and melodic? Does it sound like there are lots of music solos which might mean that the lights will be brighter on a musician when performing live? Most people get into concert photography due to the love of live music and photography, so just consider listening to the band before the shoot as a form of homework, and fun homework at that.

■ **Emotions.** As you watch the musicians through the viewfinder, watch for the emotions that can take an average photo and make it great. Just watch the face and be ready to press that shutter release button. Watching guitarist Steve Stevens rip out a solo, you can just feel the energy and power, mainly due to the facial expression he has, as shown in Figure 5-17.

■ **Backgrounds.** It is easy to focus on the performer and get so caught up in the music that you don't notice what's going on in the background. Many times you are not able to change your position much so you either need to wait for the subject to move or you need

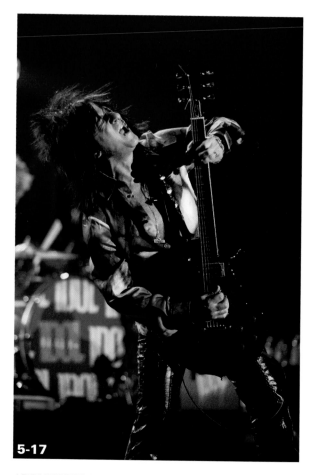

5-17

ABOUT THIS PHOTO *Steve Stevens performing live is a true joy to watch. His love of the music he plays is clear from his facial expressions. Taken at 1/320 second, f/2.8, and ISO 1600.*

to try changing your angle if at all possible. Distracting elements such as people, gear, wires, rigging, even ladders on the side of the stage can ruin a concert photo.

■ **Instruments.** It's important to take the musical instruments being used into consideration when framing your images. My personal preference is to not cut the instruments off with the edge of the frame if I can help it. So, for example, make sure you don't cut off the neck and bottom edge of the guitar or bass. When it comes to photographing drummers, time the shots on the upbeat instead of the downbeat, as this gets the drumsticks in the image. For piano and keyboards, see if you can find a downward view from a balcony or, if a downward angle isn't an option, at least get a side angle so you can photograph the hands on the keys. For the vocals, it can be tough as the microphone can really get in the way of a performer's face, so a side-view angle is a good way to start.

■ **Interaction.** Watching for and capturing the interaction between the band and the audience can make for some of the best photographs. Getting these shots requires a little planning and a lot of luck. If you are photographing from the photo pit, ideally you need to be off to the side and shooting across the front of the stage, hoping that the performer will reach out and interact with the audience in the front row. In Figure 5-18, I was watching as Rivers Cuomo, lead singer of the rock band Weezer, kept moving closer to the crowd and finally reached out with a single finger.

5-18

ABOUT THIS PHOTO *The rock band Weezer put on a private show in the parking lot of a Los Angeles motel. I made sure that I was focused on the lead singer as he walked back and forth across the front of the stage until he finally reached out to the fans. I also made sure that the focus was on the fingers touching so that they would be in focus. Taken at 1/400 second, f/2.8, and ISO 1600.*

AT THE FAIR

Fairs and amusement parks are exciting, vibrant, and often crowded places that make for great photographic opportunities, especially as the sun sets and after dark. There are thousands of different-colored light bulbs on the rides, attractions, and games at fairs that make them come alive at night. Photographing at fairs is a combination of shooting events and photographing light trails and gives you multiple opportunities to create all kinds of low-light images.

Fairs usually last for a week or more, allowing you to visit multiple times at different times with different lighting conditions and even different weather, all in a short period of time. For example, the San Diego County Fair lasts for 18 days during June and July, and with an unlimited entry ticket, it is very affordable to shoot just about every night. However, it is easy to get caught up in the excitement of the fair and forget to look for photo opportunities.

When photographing an event such as a fair, try to get overall scene setting images, along with mid-range views to show the people, the animals, the rides, the entertainment, and even the food vendors, then get some close-up detail shots to help round out the photo story. At times the overall shot is the hardest to get and you need to start looking for a vantage point to capture the lights from a distance. An overview shot can be taken before even entering the fairgrounds just as long as you have a view of the rides and lights. For Figure 5-19, I stayed back from the main midway and looked for any vantage point that would allow me to see the lights. Once I found a good location to shoot from, I wanted a longer shutter speed to get the rides in motion, so I needed to make sure the camera didn't move and used a tripod and cable release.

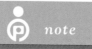

note

Before going, check with any fair at which you plan to photograph about using a tripod. Many times they are allowed but with restrictions usually to do with the safety of the crowds.

The best time to show up at the fair is before the sun has set so that you can scout the areas that you want to photograph before it is actually time to take the images. This prep time allows you to be prepared as the sun sets and the sky starts to turn dark, when the lights from the fair begin to stand out against the night sky.

There is one more point to go over before getting into the exposure settings and the fun subjects to photograph, and that is your safety. Fairs are open to the public, and there may be some people who do not have your best interests at heart and decide that a big camera bag is a worthy prize. Be aware of your surroundings and make sure that you don't get so caught up in taking photographs that you stop paying attention to what is going on around you. I suggest going with a friend so that there is someone else to help keep an eye on activity around you; it can also be more fun to shoot with a friend.

EXPOSURE CONSIDERATIONS

Because of the difference between the very bright lights and the very dark sky, getting the exposure right when photographing at the fair can be a challenge. A solution to the tricky exposure situation is to bracket your exposures; in other words, take multiple shots of the same scene using slightly different exposure settings to make sure you get the one you want.

For photographs taken at the fair, set the camera to aperture priority mode and pick one of the metering modes, depending on the subject:

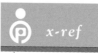

x-ref

Bracketing the exposures is covered in detail in Chapter 2.

ABOUT THIS PHOTO *The fair looks appealing from up high with the bright lights and fun rides, including the giant Ferris wheel. Taken at 5 seconds, f/22, and ISO 100.*

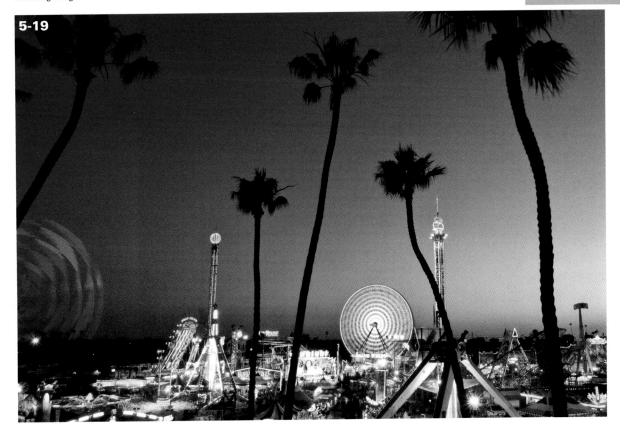

5-19

■ **Matrix metering.** This is the smart metering mode and takes the whole scene into consideration. Use this when there are elements throughout the frame that need to be taken into consideration. This is great for photos where there is something going on in all of the frame like close ups and images without a lot of night sky or bright indoor lights.

■ **Center-weighted metering.** The center-weighted metering option looks at the center of the frame, and just a little from the edges, for most of the data used to determine the exposure settings. This is great for scenes where there are areas of light or dark on the edges of the frame that you don't want to be considered as part of the exposure settings.

This is great for taking photos of the people and animals where the background, especially the really dark night sky, is around the edges of the scene.

■ **Spot metering.** This mode just looks at a small area usually tied to the focus point. It ignores everything else and is best used when the critical part of the exposure is surrounded by areas that are either too light or dark. This is great for taking photos on the midway where the mix of the bright lights and night sky can cause problems getting the right exposure. Try to make sure that the spot metering area is on something that is not too bright or too dark.

Each situation requires you to decide which mode is the right one, but because you are working with digital photography, I would suggest trying different modes and seeing what the differences are. For those situations where none of the exposure modes seems to be giving you the best results, consider bracketing your exposures. This way you can get slightly different exposures for the same scene and decide which one works best for you later when reviewing the images on the computer screen.

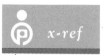

x-ref

Bracketing was covered in Chapter 2.

You can also combine differently exposed photos of the same scene to get one that is more representative of what you saw or just more interesting using HDR. For example, Figure 5-20 shows an HDR image created from seven separate exposures of the same scene that ranged from −3 to +3. The one that was the closest to what I wanted was actually the −1 exposure, but combining them gave me a better image than any of the separate images did.

If you are not happy with the results using any of the exposure modes, and would rather not auto bracket the exposures, you can also use exposure compensation to fine tune the exposure to get the result you want. Taking the photo of the carousel

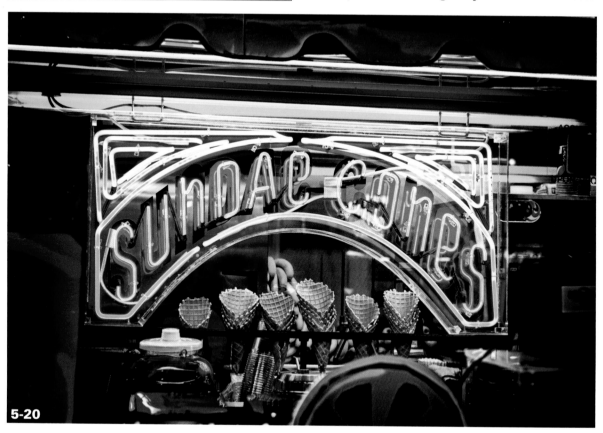

5-20

ABOUT THIS PHOTO *The Sundae Cones neon sign drew my eye at the food court at the fair. I believe it might have been the healthiest option, and it sure was one of the more colorful ones. This was a seven-image HDR created using Nik Software's HDR Efex Pro. The shutter speeds were 1/1250 second, 1/640 second, 1/320 second, 1/200 second, 1/125 second, 1/50 second, and 1/25 second, all at f/4.5, and ISO 250.*

was a little more of a challenge as the amount of light and bright areas had the camera underexposing the image as it tried to counteract the bright parts. I purposely wanted to overexpose the image to get an accurate representation of how bright it appeared to me. To do this, I started by adjusting to a +1 for the exposure compensation and then checking the results on the LCD on the back of the camera. I looked to see that the areas of solid light were rendering pure white. After checking the exposure and making sure it was correct, I could focus on the composition. In Figure 5-21, I pushed the exposure to +2 to get the lights right, and then I focused on the horse right in front of me.

It is a good thing that the San Diego fair lasts for 18 days. This enabled me to make several visits — getting the exposures perfect takes a lot of practice and experimentation.

THOSE GREAT RIDES

The best part of the fair for many is those great rides, the ones that flip you upside down and spin you around. However, when I say that the rides are great, I mean to photograph, not to actually ride.

The most iconic ride at the fair is the big Ferris wheel, and part of what makes it so great to photograph is the pattern of lights on the spokes. As the Ferris wheel slowly rotates, these lights create

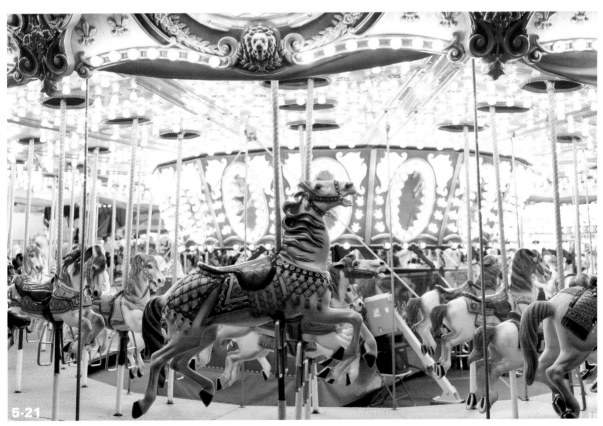

5-21

ABOUT THIS PHOTO *The carousel is a great subject, with the bright, white lights and the expressive wooden horses. For this photo, I overexposed the image by two full stops to get the look I wanted. Taken at 1/60 second, f/2.8, and ISO 800.*

a pattern with really interesting designs. When shooting a Ferris wheel, follow these steps as a starting point:

1. **Find a good location and set up your tripod.** Look for a location where you are allowed to set up the tripod and you have a clear view of the Ferris wheel. Pay attention to the area where you set up so you aren't in anyone's way.

2. **Compose the image.** You can frame the Ferris wheel any way you want, in Figure 5-22 I wanted the whole wheel in the image, but feel free to try different things. A zoom lens is really helpful here, allowing you to try different compositions without having to move the tripod.

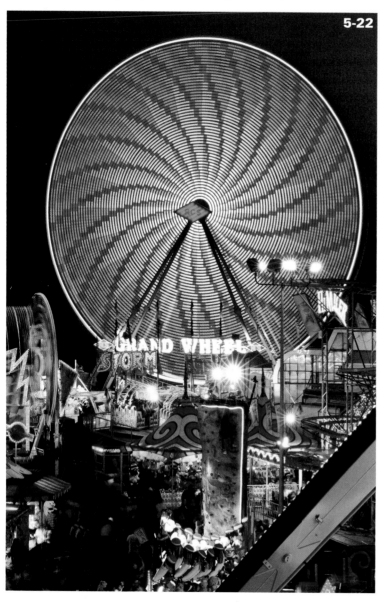

5-22

ABOUT THIS PHOTO *A giant Ferris wheel outlined against the dark sky. I wanted the lights to be captured making a solid pattern, so the Ferris wheel needed to be in motion during the image. Taken at 5 seconds, f/22, and ISO 100.*

3. **Set the ISO to 100.** The lowest ISO possible allows for slower shutter speeds, which will get you the motion in the image.

4. **Set the aperture to f/16.** This is just an arbitrary starting point, as you have to start somewhere. This f-stop allows you to get a deep depth of field, with little light coming through the lens which allows for the slower shutter speed needed to get light trails.

5. **Set the shutter speed to 5 seconds.** This is just a starting point and you can adjust it depending on the results.

6. **Wait for the Ferris wheel to be moving and take the photograph.** Check it on the LCD for both exposure and composition:

 > If the scene is too bright, then reduce the aperture and try again.

 > If the scene is too dark, then open the aperture and try again.

 > If the scene has too little movement, then decrease the shutter speed and the aperture and try again.

 > If the scene has too much movement, then increase the shutter speed and the aperture and try again.

7. **Take another photograph and keep adjusting the exposure until you are satisfied with your results.** I took several shots before I was happy with the photo shown in Figure 5-22. I was photographing just after the sun set and was using a telephoto lens because tripods were not allowed in the middle of the crowds. By moving further away, I could use a tripod, allowing me to get the longer exposure I needed, but I had to use a telephoto lens.

note If you are looking to get a photo with the just the lights on the Ferris wheel and not the pattern when they are in motion, then instead of waiting for the wheel to move in step 6, just wait until it has stopped.

Another ride that made a good photo subject in the same way as the Ferris wheel can only be described as a tall post with a single arm attached that spun in a giant circle. As you can see in Figure 5-23, by zooming in close, I could fill the frame with the pattern made by the arm as it rotated around the center point.

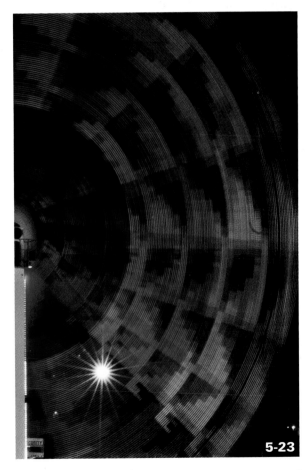

5-23

ABOUT THIS PHOTO *The giant arm rotates slowly around in a big circle. By using a slow shutter speed, the lights are turned into a pattern. Taken at 10 seconds, f/22, and ISO 100.*

For rides that move in a very easily defined pattern, the slower shutter speeds help to create a great image of the lights. However, for rides that move in multiple directions or lack a specific pattern, including the Sky Flyer, shown in Figure 5-24, you have to get the shutter speed just right. Rides like this are more difficult to shoot to capture the motion and make it possible to see that there are people on the ride. To get a great photo that freezes the action, it is all about the timing and watching how the ride works. I noticed that the ride seemed to go slower at the start as the riders got up to speed and at the end as they slowed down. By using a shutter speed of 1/50 second, I was able to freeze the motion and still show the lights of the ride against the darkening sky.

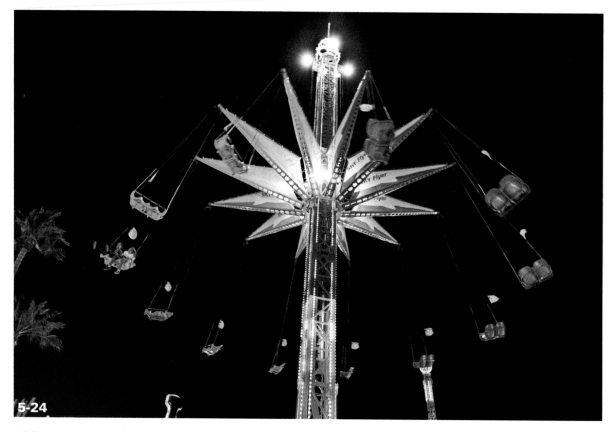

5-24

ABOUT THIS PHOTO *The Sky Flyer photographed against the setting sun. Taken at 1/50 second, f/3.2, and ISO 1600.*

Assignment

Freeze the action

This assignment is about using a shutter speed that is high enough to freeze the action, so I decided to use this image of guitarist Mark Karan playing at a local club as my example. Once you complete the assignment, don't forget to post your image on the website to share.

Getting a shutter speed high enough to freeze the action is challenging in very low-light situations, which was the case at the club where I took this photo. I waited until Mark pulled the guitar up and held the note for a moment, which allowed me to use a slower shutter speed of 1/100 second because he was not moving very much during that moment. Because flash was not allowed and a tripod would have been in the way, I handheld this shot, pushed the ISO to 1600, and opened the lens up to f/2.5. The lens had a maximum aperture of f/2.0 but I felt that the depth of field at f/2.0 would have been too shallow. This image was converted to black and white in postproduction because the high ISO caused the image to look murky and the conversion helped to alleviate the negative effects of the digital noise and the odd colored lights.

Remember the factors that go into picking the right shutter speed to freeze a moment: the direction of the movement, the speed of the movement, the distance of the movement, and the importance of the movement.

 Remember to visit www.pwassignments.com after you complete the assignment and share your favorite photo! It's a community of enthusiastic photographers and a great place to view what other readers have created. You can also post comments and read encouraging suggestions and feedback.

Many of the images in this book were taken at long, sometimes very long, shutter speeds. These long shutter speeds allowed enough light to reach the sensor to make a proper exposure. This chapter ventures in the opposite direction — all the shutter speeds used here are fractions of a second to freeze the action. To get a motion-stopping shutter speed in low light, the other exposure settings have to be pushed, sometimes to their limits. For example, many times the ISO was pushed to 3200 and the aperture was wide open at f/2.8. Even with these settings, the highest shutter speed I was able to use and still get a properly exposed image was only 1/320 second. The 1/320 of a second shutter speed is enough to freeze a basketball player as he rolled the ball off his hand into the net but not fast enough to freeze a hockey puck flying across the ice. Had I needed a faster shutter speed, I would have had to push the ISO even higher because I was already using the widest aperture available for that lens. There are times part of the scene is in focus because it isn't moving as much as other parts of the scene. For example, when photographing a boxing practice in Figure 6-1, I used a shutter speed that froze the defender while the woman throwing the punch is moving faster and is therefore blurred.

6-1

ABOUT THIS PHOTO *Photographing a boxing practice allows me to not only practice photography but to also learn more about how boxers move, allowing me to anticipate the action. Taken at 1/60 of a second, f/1.8, and ISO 400.*

SPORTS VENUE LIGHTING

Regardless of whether it is an indoor venue or an outdoor venue at night, the lighting is deceptive because it looks bright. When you actually try to freeze the action, you realize how hard it is to get a proper exposure. The following sections go into the specific lighting types used and the best way to get the images you want when working with them. Each type of lighting needs to be dealt with slightly differently, but in all cases the main goal is getting a fast enough shutter speed to freeze the action.

INDOOR LIGHTING

There are three types of lighting that may be available when shooting sports photography indoors: available artificial light, natural light, and electronic flash.

Consider available artificial light first. The lights in the building that are used to illuminate the sporting event can range widely in both type and power. However, these lights are most often in the ceiling, providing even illumination to the entire sports area with no shadows or dark spots. This makes it easy for the players and spectators to participate and observe the game without any deep shadows appearing in the playing area.

Overhead lighting is great for watching a game and can be good for photographing if it is bright enough. Many times in smaller gyms and venues the lighting is low, making it tough to get a high enough shutter speed to freeze the action without using very high ISO settings and having to deal with a lot of noise or using a prime lens with a very wide aperture. The real plus when it comes to photographing under these lights is that because the intensity of the lights and the illumination is constant, once you have set the shutter speed fast enough to freeze the action and the aperture and ISO, you don't have to change the settings much — you can set it and forget it.

A concern when shooting under these lights is the color of the light and the white balance setting. The best thing to do is to set the white balance in the camera to a setting that looks good when you check it on the camera's display. Chances are you will have to adjust the white balance using software later, but it pays to get it as close as possible in the camera. If possible,

create a custom white balance for the venue so that the color is as close to true as possible. For directions on creating a custom white balance for your camera, check the camera manual.

To get the proper exposure in this type of lighting, just do the following:

1. **Set the camera to the manual exposure mode.**

2. **Set the shutter speed at a setting that you believe can stop the motion.** I usually start at 1/500 second.

3. **Open the lens up to the widest aperture it offers.**

4. **Set the ISO to 1600.**

5. **Take a photo and check the exposure on the camera's LCD.** If the image is underexposed, you have to either increase the ISO, open the aperture up wider, or reduce the shutter speed.

For example, the light in the gym in Figure 6-2 was constant but low. I needed an ISO of 2000 to get the shutter speed up to an action freezing 1/400 second. I started at 1/500 second and ISO 1600 at f/2.8, but the image was underexposed. I increased the ISO from 1600 to 2000 and tried again and the image was still underexposed. So I switched to a lens that had a wider aperture and finally dropped the shutter speed to 1/400 second. I was able to now concentrate on the sport and capturing the moment instead of worrying about the exposure settings.

Natural light is any light that may be filtering in from outside through windows or doors, or that is mainly available at smaller halls and gyms.

6-2

ABOUT THIS PHOTO *The lighting in the school gymnasium might have been great for the spectators, but it really didn't help with the photography. Luckily, it was consistent, allowing me to concentrate on the composition and the timing. Taken at 1/400 second, f/1.4, and ISO 2000.*

However, the lighting is now mixed lighting, combining the artificial light of the building and the natural light from outside. This type of lighting is actually the hardest light to photograph in because the intensity of the light changes, depending on where the outside light is coming in from and what time of day it is. Additionally, the color of the sunlight is a different color than

the lights in the building. In this type of mixed lighting the auto white balance is your best bet as it can adjust nearly instantly in the changing light as you track the play through your camera. It is also possible to adjust the white balance in postproduction if needed.

As you can see in Figure 6-3, there is a lot of light coming in through the door on the other side of the gym as my nephew practices his basketball skills. To make sure that the exposure was correct in the different lights, I set the exposure mode to shutter speed priority and chose a shutter speed high enough to freeze the action of the sport I was shooting. For example, the kids playing basketball needed about 1/320 of a second to freeze, while adults playing the same game might need a higher shutter speed if they move faster. I then focused on the darkest area of the gym where action was going to take place and set the ISO so that the camera selected the widest aperture available to get a proper exposure. As the action moves and the light increases and decreases, so does the aperture resulting in a proper exposure at all times.

An electronic flash can be fired remotely when needed. This type of light is the main reason why the images you see in Sports Illustrated and other sports magazines look so crisp and clear. The photographers who shoot for those publications set up remotely triggered lights. These remote flash units are triggered when the photographer presses the shutter release. Because the flashes are usually placed right next to the lights that are illuminating the game, the direction of the flash light is the same as the other lights and the flash doesn't have to do all the work, just add to the existing light. Most of the time, the flash goes completely unnoticed because they fire from high up and are

not distracting to the players or the fans. These photographers must really be able to time their shots carefully because the flashes need time to recharge between firing and can't just be used continuously. In reality, unless you get permission to try this at the local gym, you will not be working with this lighting, but just know that it is out there.

6-3

ABOUT THIS PHOTO *My nephew learning the ins and outs of basketball at the local recreation center. He is lit by both the ceiling lights and the light coming in through the open door. As he dribbled up and down the court, the exposure changed. Taken at 1/320 second, f/2.8, and ISO 500.*

OUTDOOR LIGHTING

Many sports, ranging from American high school football to little league to soccer or rugby, are played outdoors in the evenings under artificial lights. Those lights look very bright, especially against a darkening sky, but when you start to measure the light, you will find the levels to be lower than you expect.

The lighting outdoors is also different because instead of coming from directly above, it comes from the side of the venue and can cause shadows to fall across the field. Because the lights are around the field and not over it, there are places where the light is brighter than others. This change is not huge, but it can cause slight discrepancies in the exposure. For these situations, using the shutter priority mode enables you to keep the shutter speed high enough to freeze the action and still make sure that any differences in the light are accounted for. In these cases, I usually use a spot-metering mode so that the black night sky backgrounds are not taken into consideration when determining the exposure. Even the stands full of fans can be considered dark backgrounds and need to be avoided.

Because all the light is coming from the same type of light, even if it does vary in intensity, you can either let the camera pick the white balance by using the Auto setting or create a custom white balance setting.

FREEZING THE ACTION

The goal is to freeze a moment in time, that split second that sums up the whole game — the moment the receiver catches the ball or dives over the goal line for a touchdown, the moment

the basketball player goes in for the slam-dunk or makes the game-winning three-point shot. It can also be the expression on a player's face as the ball doesn't go the way it should, or the fingers of the receiver who doesn't quite get there in time. But the one thing all these moments have in common is that they should be sharp and not blurry. The key to getting the images sharp is to use the right shutter speed for the situation.

THE RIGHT SHUTTER SPEED

Picking the right shutter speed depends on the speed of the action you are trying to freeze. For example, there is a big difference in the speed of play between a kids' basketball game and an NBA team driving down the hardwood. A good starting point is to determine the highest shutter speed you can use under the light. You can do this before the actual event starts, as long as the light doesn't change. An easy way to do this is as follows:

1. **Set the camera to manual mode.**

2. **Set the ISO as high as you can stand.** This takes a little testing on your part, but you can do it anytime. Set the camera to auto mode and take a photo. Then, raise the ISO and take the same photo and keep doing this until you have roughly the same photo at all the ISO settings that your camera has. Then download these images to your computer and look at them at 100%. Find the ISO at which you can't tolerate the amount of noise and step back one ISO. This is the highest ISO setting you are willing to use.

3. **Set the aperture at the widest f-stop the lens offers.** This is determined by the lens you are using. For example, a 70-200mm f/2.8 lens will be set at f/2.8 while a 50mm f/1.4 will be set to

f/4. When using variable aperture lenses, make sure that you set the aperture for the focal length that you will be using; for example, if I had the 70-300mm f/4.5-5.6 Nikon lens, and I knew I was going to be shooting all the way zoomed to 300mm, then the widest aperture would have to be f/5.6.

> *note*
>
> As technology improves, cameras will continue to offer higher and higher ISO settings. So, if you get a new camera, you should run this test again. The highest ISO you are comfortable with is likely to be different on a different camera.

4. **Pick a shutter speed you believe will freeze the motion.** This is a best guess and can be changed later, but as a starting point I most often use a shutter speed of 1/500 second.

5. **Take a photo of a neutral object in the middle of the light, preferably a player or an official waiting for the game to start.**

6. **Check the exposure on the LCD.** If the frame is underexposed, increase the shutter speed; if the frame is overexposed, decrease the shutter speed and try again.

Once you find the settings you are happy with, you know the highest possible shutter speed that will be available to you during play. That doesn't mean you actually have to use these settings, but it is very good to know what they are.

When shooting at night or in low light, you must consider what direction the action is moving and then how fast the movement is. The most important concept to remember is that subjects moving toward or away from you can be frozen with a longer shutter speed, while subjects moving across the frame need higher shutter speeds to freeze

them. This has to do with the amount the subject actually moves in the frame. For example, in Figure 6-4 the kicker is frozen in place at the end of the kick but the ball is not frozen in place, as it is moving fast, much faster than the players. The shutter speed of 1/320 second was not enough to freeze the ball, but it did come close. If you can't see the ball, it is the blurry, brown object next to the helmet of the player in the white uniform. The football was moving across the frame from the right to left meaning that I would have needed a faster shutter speed to freeze it.

When the subject is traveling towards the camera, or away from it, you can freeze the action with a much slower shutter speed. Take the player in Figure 6-5; it was easier to freeze him coming at me than it would have been if he were moving across the screen. The same shutter speed that could not freeze the ball in Figure 6-4 was more than fast enough to freeze the runner in Figure 6-5.

Obviously, the shutter speed you pick must actually freeze the action. Check the images on the LCD on the back of your camera at 100 percent

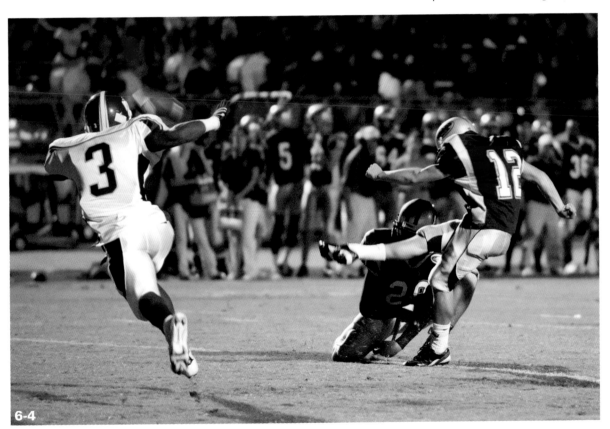

6-4

ABOUT THIS PHOTO *The shutter speed used here froze the kicker but was too slow to freeze the ball in the air. Taken at 1/320 second, f/2.8, and ISO 2500.*

preview. It is critical that you zoom in to look at the image at 100 percent. Just seeing the thumbnail view does not allow you to see any of the slight fuzziness that might be in your image. Check your camera manual for how to preview at 100 percent, and when you do, make sure that the area you are previewing is the area that you need to have in focus.

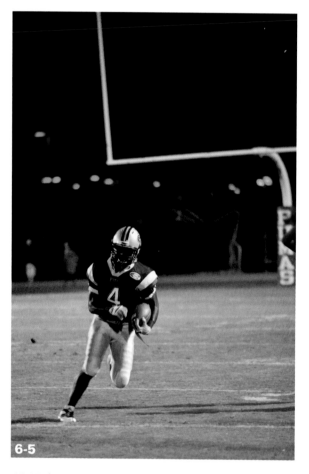

6-5

ABOUT THIS PHOTO *Because the action was coming right at me, I was able to use a slower shutter speed and still freeze the action. Taken at 1/320 second, f/2.8, and ISO 1600.*

PUSHING THE ISO

Using high ISO values creates images with digital noise, but how much noise can you stand before the image is unusable? This is a personal preference and can be influenced by the final use. If the images are for the Web, just to be e-mailed among family members, or printed at 4 × 6, then you can use a higher ISO and more noise reduction. If the images are to be printed on glossy paper at 8 × 10 or larger, then you might not want to go as high with the ISO.

You should decide beforehand the highest ISO that you are comfortable with for your camera. For example, I know that I can use ISO 3200 on my Nikon D700 and get a usable file that doesn't have too much noise in my opinion. The amount of noise that you are willing to put up with in your images may be different.

KNOW THE SPORT

Knowing how to adjust the setting on your camera and what the best exposure settings are is only part of the equation. The rest is all about knowing the sport so that you can anticipate where the action will be and capture it successfully — you have to know what is going on.

STUDY THE SPORT

One of the best ways to improve your sports photography is to know as much about the sport as possible before trying to photograph it. I don't mean that you need to know all the rules and regulations, but you need to understand how the game works, where the players are going to be, and what their purposes are.

Consider basketball, for example; it is usually played indoors and there are five players on each team, which means that there should be ten

players on the court at any one time. The goal is to pass and move the ball down the court until it is possible to throw it through the hoop on the opposing team's end of the court. You are also not allowed to walk or run while holding the ball — the players must bounce it when moving. This doesn't give you all the rules of the game or any real detail, but it does allow you to make some decisions about where to photograph from and what to look for. For example, knowing that the scoring takes place on the ends of the court, you could try to get in the middle so that you can see both ends equally or you could decide to pick one of the ends for a close view of at least some of the shots, and a wide view of the other end.

I practice the martial arts and understand the techniques and styles used in most martial arts, but I had never seen the Brazilian martial art of Capoeira. To successfully capture the action in Figure 6-6, I first watched the performers warm up and practice their moves. This allowed me to have the camera ready and the setting high enough to capture the amazing aerial maneuvers.

Another way to study up on sports that you might not be familiar with is to use the Internet to view other photographers' images of those sports. This can help you to understand the angles that work and don't work before you even have to raise the camera to your eye.

ABOUT THIS PHOTO *Capoeira is a martial art created in Brazil with some very complex moves including kicks, aerial acrobatics, and knee and elbow strikes. Martial arts are tough to photograph (not as tough as it would be to actually be fighting, though). Taken at 1/250 second, f/2.8, and ISO 1600.*

TIME YOUR SHOTS

When photographing sports, you have to anticipate the action and get the timing just right. If you see the action that you want to photograph through the viewfinder, then it is too late to actually capture it. In Figure 6-7, I made sure that my focus was on the ball because it was the center of all the action. I also knew I would need a shutter speed that would freeze the ball in mid-air, so I upped the shutter speed to freeze the action and upped the ISO to compensate. The key is to keep an eye on the ball and where the ball is going. Then all I had to do was watch for the players to interact and start photographing.

For the sports where there is no ball, or for sports like ice hockey where the puck moves so fast it's hard to keep track of, you need to watch the way the players move. This is where knowing the sport can really pay off because you will be able to recognize the body movements and anticipate where the action is going to be. The more you watch or play a sport, the better you become at knowing where the action will take place. That is not to say you get every shot — chances are you won't — but the more you do it, the more likely you will be to capture those important moments.

6-7

ABOUT THIS PHOTO *When it comes to photographing kids' sports, just follow the ball. Taken at 1/500 second, f/2.8, and ISO 800.*

Assignment

Freeze the action successfully

This assignment is about pushing the settings on your camera and capturing and freezing fast action. Once you capture a photograph of action you are happy with, share it on the website.

As you prepare for this assignment, remember that the controls for setting the exposure are always the same: shutter speed, aperture, and ISO. When two are unchangeable, you have to adjust the third. In low light, to freeze the action, the shutter speed can't be changed as it needs to be high enough to freeze the action, and the aperture should be set at the lens's widest allowing the maximum light to reach the sensor. That just leaves the ISO, so it has to be the one that you adjust.

For this assignment, I decided to photograph a local high school football game from the sidelines, and with the bright lights on the field, exposure didn't look like it would be a problem. However, when the players began to run, I noticed that the shutter speed I started out with was too slow. My aperture was already at the maximum for the f/2.8 lens I was using. That only left the ISO, which I raised until I could use a 1/500 second shutter speed and still get a good exposure.

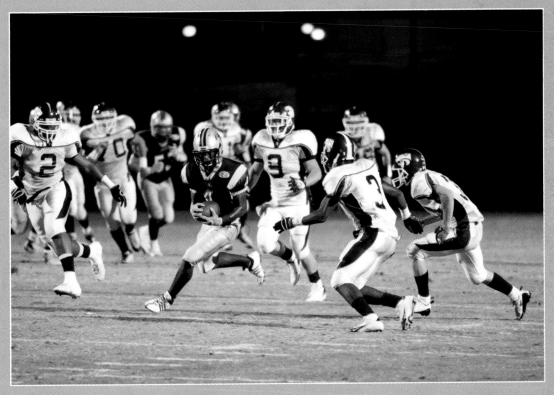

 Remember to visit www.pwassignments.com after you complete the assignment and share your favorite photo! It's a community of enthusiastic photographers and a great place to view what other readers have created. You can also post comments and read encouraging suggestions and feedback.

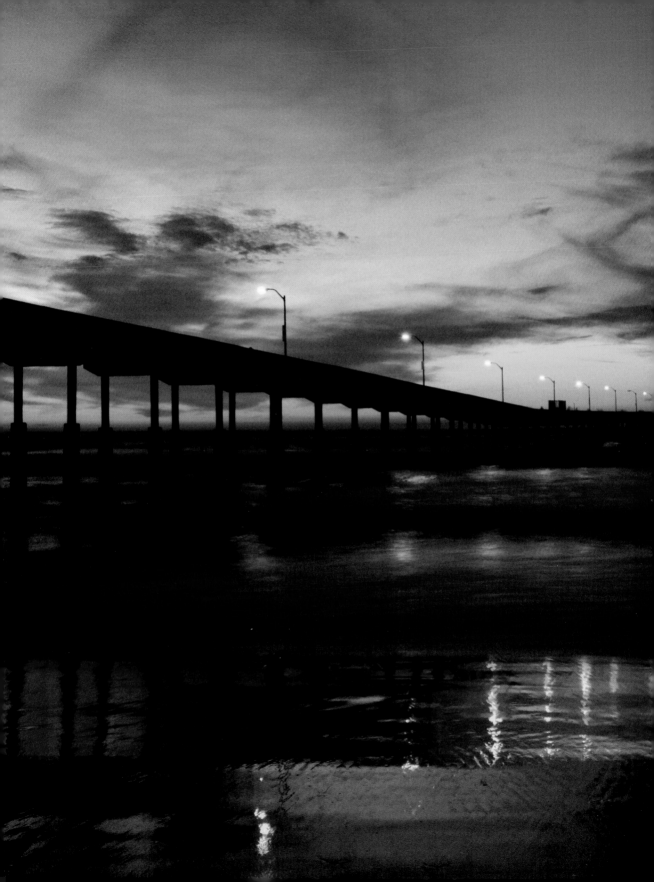

It might seem a little obvious, but one of the great subjects for night photography is the sky. The daytime sky is only really a great photography subject when it is filled with clouds to give it some type of interest, but the nighttime sky can be photographed with clouds or on a clear, starry night, and it often is used as a canvas for subjects that just don't work in the daytime like fireworks and star trails. There are also those great times at the beginning and end of the day. The morning is the time from right before the sun rises to when the first light starts to reveal the details of the landscape. At the end of the day, the sun makes its way below the horizon, the sky starts to change from light to dark, and the night lights start to appear. Photographing at sunrise and

sunset can produce some of the best-looking images because the quality of the light is just so good. I took the sunset photo in Figure 7-1 while on vacation in Florida. This chapter is about the subjects that you can photograph in the night sky, including the moon, star trails, and even time lapse. It also covers photographing fireworks, one of my favorite subjects, and how to get the best results every time.

SUNRISE AND SUNSET

The beautiful reds, oranges, and yellows of the setting (or rising) sun can make any location look good, and if done right, they can make any

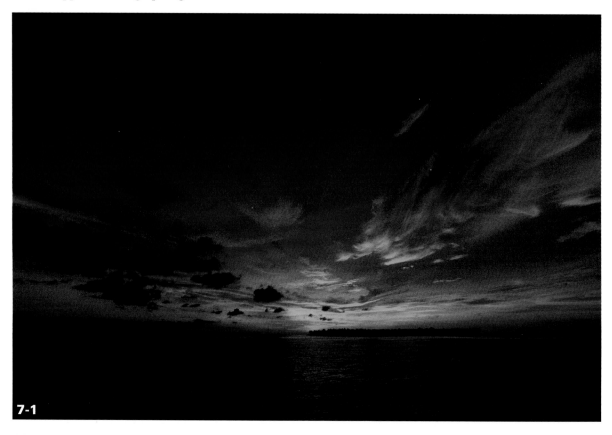

7-1

ABOUT THIS PHOTO *The sunrises and sunsets in Florida's Key West are known around the world. Crowds gather each night to watch the sun set. Taken at 1/250 second, f/5.6, and ISO 200.*

location look great. There is very little difference between taking a great sunrise and sunset photo other than that the timing is reversed, but the results can be quite different depending on the location. Because I live on the West Coast of the United States, the sunset happens over the Pacific Ocean, creating classic sunset photos. There are amateur and professional photographers down at the beach just about every evening of the year trying to capture that perfect sunset.

The colors that are produced at the first light and the last light of the day differ from the light at midday because of the angle of the sun and the way the light waves travel. Light is made up of different wavelengths, and as the rays of light travel through the atmosphere, the different wavelengths are dispersed at different rates. The shorter wavelengths, which have blue and green, disperse more quickly than the longer wavelengths of red and orange. This means that at sunrise and sunset, when the ray of light has the farthest to travel, the light is more red and orange. Any particles in the air can exaggerate this effect. Usually, the sunset colors are more vibrant than the sunrise colors because there are more particles in the sky at sunset than at sunrise, but that is not always the case. Many times, city pollution can cause fantastic sunrises, as shown in Figure 7-2 — a sunrise shot from a hotel in Miami, Florida — and while pollution is bad, it did make for a stunning image.

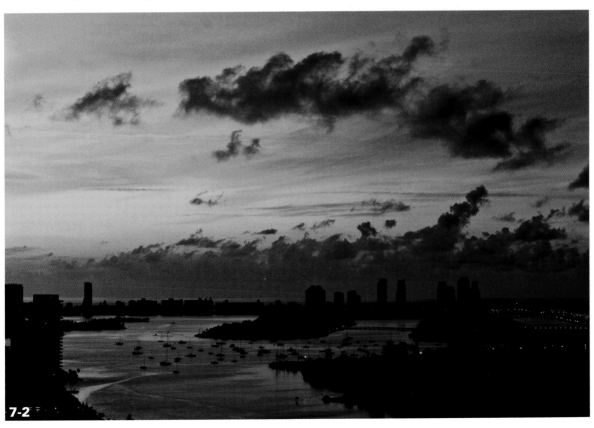

7-2

ABOUT THIS PHOTO *This photo of a Miami sunrise has a lot of red and orange. Taken at 1/250 second, f/5.6, and ISO 200.*

SETTING THE EXPOSURE CORRECTLY

The most disappointed I am as a photographer is when I see a great sunset and fail to capture it, not because I don't have a camera with me, but because when I get the images into the computer, the exposure is off and the colors look washed out and flat. Setting the exposure for sunsets and sunrises is a little more difficult than you might realize.

The correct exposure settings depend on the way you want to depict the sunrise or sunset. You can set the exposure to render the darker areas in the scene, especially those between you and the sun, totally black, which creates great silhouettes. Or, you can set the exposure to capture the drama in the scene, keeping the details visible. Another option is to set the exposure to shoot the detail in the scene as it's bathed in the great first light of the morning or the last light of the day. The light is so good for photography at these times that they are referred to as the golden hour.

■ **Shooting silhouettes.** The idea here is to underexpose the image enough to render the subjects between you and the sun totally black. This works best when the subject has very clearly defined shapes that are recognizable without the details being visible. To do this, you need to expose for the brightest area so that the subject that you want is underexposed by at least two stops rendering it close to pure black. The pier pilings in Figure 7-3

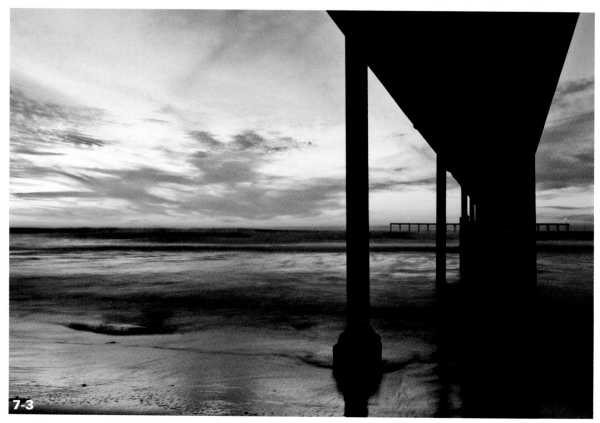

7-3

ABOUT THIS PHOTO *The pier pilings have been rendered pure black. Taken at 3 seconds, f/16, and ISO 100.*

are pure black as the image was exposed for the sky where there is no pure white. Having a big range of tones helps you achieve this effect. Had the pier been properly exposed, there would be large parts of the sky rendered as pure white.

■ **Exposing for the details.** Many times there is no way to expose for both the details in the shadows and the details in the bright parts of the image. When you have this situation you have to make a decision on which to expose for, or you can take two photos, one that exposes for the shadow details and one that exposes for the highlight detail, then you decide later which is better or combine the images in software. The key is to use the spot meter on the area that you want to make sure is exposed correctly.

■ **Using the golden hour light.** Look at what the light is illuminating as the sun rises or sets, because that could be the better image. This is when you are not shooting the actual sunrise or sunset but using the sunrise or sunset light to illuminate your subject. One reason why photographers love this golden hour light is because it takes the ordinary and makes it look better. The color of the light is red to orange, which makes people look like they have a healthy tan and adds a great color to everything else. Even the flock of seagulls in Figure 7-4 looks good as they try to get food from the people on the beach.

7-4

ABOUT THIS PHOTO *The seagulls come to the beach when people feed them. Taken at 1/180 second, f/4.5, and ISO 100.*

The exposure settings used when shooting sunrises and sunsets have a direct effect on the colors in the image. Slightly underexposing the image intensifies the colors, while overexposing the scene washes out the colors. Too much in either direction and the image becomes either dark and muddy or totally washed out. The easiest way to get great photos is to do the following:

1. **Set the camera to spot metering mode.**

2. **Set the exposure mode to program auto.**

3. **Aim the camera at an area of the sky that does not include the sun.**

4. **Press the shutter release button halfway down.**

5. **Make a note of the settings shown by the camera.**

6. **Switch from program auto mode to manual mode.**

7. **Enter the settings from step 5 into the camera.**

8. **Reduce the exposure by 1 stop by increasing the shutter speed or using a smaller aperture.**

9. **Take a photo and check the exposure by looking at the LCD on the back of the camera.**

10. **Adjust the exposure as needed and shoot again.**

As you photograph sunsets, the amount of light starts to drop off, but as you photograph sunrises, the amount of light increases; in both cases, you need to adjust the exposure as you shoot.

START EARLY AND STAY LATE

As Galileo discovered, the Earth revolves around the Sun and never stops moving. When using the sun as a light source in your images, you have to keep in mind that your position in relation to the light source is constantly moving, and this is especially noticeable at sunrise and sunset. So it is best to make sure that you are ready to capture those great colors before they actually appear, and then stay a little while longer to see what the rising sun might reveal or what the setting sun might hide. Many times, I see photographers packing up their gear right after the sun sets and missing that great red glow as the last of the sunlight is reflected in the sky.

The first step in photographing the sunrise or sunset is to know exactly when it is going to happen. Because the Earth revolves around the Sun on a 365-day cycle, the location of the sun and the sunrise and sunset times differ each day of the year. The following website and smart phone apps will all give you the exact time of the sunrise or sunset for every day of the year.

■ **Sunrisesunset.com.** (www.sunrisesunset.com) This website allows you to print a full calendar that lists the sunrise and sunset times. You can also add the moonrise and moonset times.

■ **Timeanddate.com.** (www.timeanddate.com) This Web site has a great sunrise and sunset calculator at www.timeanddate.com/world-clock/sunrise.html. It allows you to enter the location, and then gives you the sunrise and sunset times for the current date. It also allows you to pick any month and year so you can really plan ahead.

■ **Naval Oceanography Portal.** This Web site is great for getting the complete moon and sun data for U.S. cities and towns. Just go to www.usno.navy.mil/USNO/astronomical-applications/data-services/rs-one-day-us and enter the year, month, day, city or town name, and state or territory. If you are not in the United States, you can go to www.usno.

navy.mil/USNO/astronomical-applications/data-services/rs-one-day-world and enter the specific longitude and latitude.

- **Sunrise.** This app, created by Adair Systems for the iPhone, costs $0.99 and can calculate the sunrise, solar noon, and sunset times, as well as the phases of the moon. It shows the current day by default, but can be used to calculate the data for any day in the future (or the past). The app uses your current location by default, but can be set for a wide variety of locations around the world.

- **LunaSolCal.** This app for the Android smart phone operating system gives you the sunrise and sunset information, along with the moonrise and moonset times, for any date between January 1, 1901, and December 31, 2099. It uses the current location or allows you to pick from a list of 30,000 cities from over 200 countries.

Once you know exactly what time the sun rises or sets, you can plan your shoot accordingly. I usually plan to be in position and ready to shoot at least an hour before the sun rises or sets. This allows me to work out the exact composition of the shot and make sure that the tripod is set up, the camera is set in the tripod, I have the lens I want to use attached, and, if it is a zoom lens, I have it set to the focal length I want.

When planning a sunrise shoot, it does help to go to the location during the day and see where you will be shooting from, as well as make sure that you have a composition in mind before the actual photograph. For example, you may be shooting a brand-new location, and you get there in plenty of time to set up your camera on a tripod and start to photograph first as the sky starts to lighten and then as the first rays of sunlight illuminate the scene. As the scene becomes lighter, however, you see that there is a trash can in the middle of the scene that you never noticed before because everything was dark. That's when you either have

to recompose or move to a different location, which means wasting time and wasting the morning light. This doesn't happen with the sunset shoots, as you can see the area in front of the camera clearly, and instead of things becoming more visible, they become less visible, like the graffiti on the rocks in Figure 7-5.

SHOOT THE MOON

The moon makes a great photography subject. It really isn't very difficult to photograph if you keep in mind that it is very far away, is very bright compared to the sky around it, and moves all the time. The moon is not a direct light source, but is actually the light of the sun reflected back. Of course, with the distance involved, the moon is a lot dimmer than the sun — about 18 stops of light dimmer during the full moon compared to the noon day sun — which means that to use the moon as a light source, you would need to change the setting by 18 stops compared to the sun during the full moon.

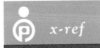

x-ref More on using the moon as a light source can be found in Chapter 10.

PICKING THE RIGHT FOCAL LENGTH

The moon is approximately 238,857 miles away. That is a very long distance, and when you start to aim your camera skyward, you see that the moon will take up a very small part of the frame unless you have a very long lens. For example, at 80mm, the moon will be a tiny white spec in a sea of black. Even at 100mm, it is still going to be too tiny to see any detail at all. When you get to 400mm, as in Figure 7-6, it starts to appear big enough to see some detail. At 600mm, shown in Figure 7-7, you can see some real detail. Unless

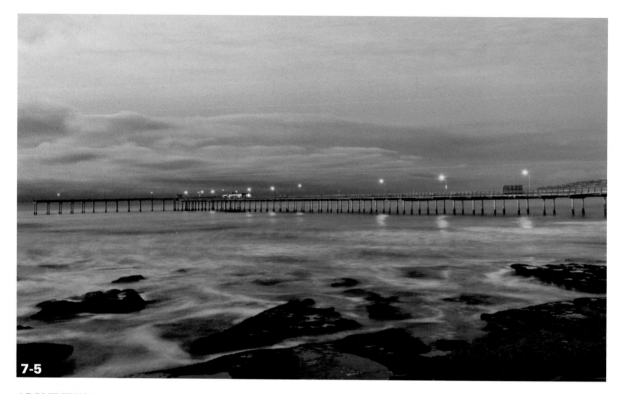

7-5

ABOUT THIS PHOTO *The sunset had a lot less red than usual, and by adjusting the white balance, I was able to make the blues and purples stronger. The rocks in front of the camera have been carved in by people for years, leaving them covered in graffiti that can't be seen because it has been hidden by the reduced light. Taken at 6 seconds, f/19, and ISO 100.*

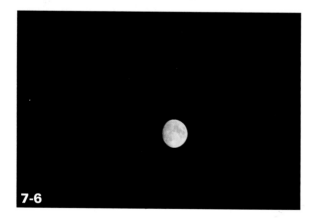

7-6

ABOUT THIS PHOTO *The moon at 400mm.*

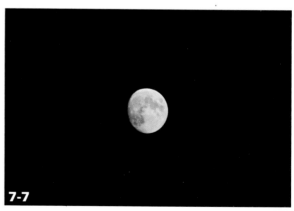

7-7

ABOUT THIS PHOTO *The moon at 600mm.*

you shoot the moon with a long lens or as part of an overall night sky composition, the images will usually be a little disappointing.

To get the moon looking as big as possible, you need to use as long a focal length as possible, and it does help to wait for the perigee (the time when the moon is closest to earth on its elliptical journey). There is a great Web site that calculates the date and time of the perigee for each month at www.fourmilab.ch/earthview/pacalc.html. If you really want to fill the frame with the moon, you will need to have a very long lens, a great tripod, and the right date and time.

When photographing with very long lenses — 400mm and longer — a tripod, or at least a monopod, is important to use because the length and weight of the lens make it very difficult to handhold steady enough to get a sharp image. The length of the lens magnifies the slightest movement.

EXPOSURE SETTINGS

Compared to star trails and other celestial photography, photographing the moon is easy, especially if you keep in mind that it is a lot brighter than you think. If you are using a very long lens and the moon actually fills the frame, then the built-in metering might work, but if you allow the camera to pick the settings, you will be disappointed. In Figures 7-8 and 7-9, I photographed the same moon with the same camera. However, in Figure 7-8, I allowed the camera to pick the settings and in Figure 7-9 I used manual settings. The auto settings rendered the moon very bright and the sky a blue instead of black, while the manual settings gave me the look I was going for: a black sky and a clearly visible and detailed moon.

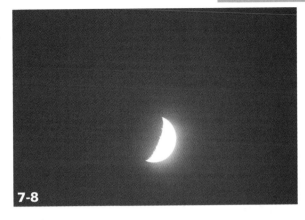

7-8

ABOUT THIS PHOTO *The moon photographed using the auto mode of the camera did not properly expose for the details because the vast areas of sky threw the metering off. Taken at 1 second, f/8.0, and ISO 200.*

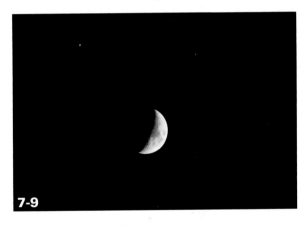

7-9

ABOUT THIS PHOTO *Using the manual mode I was able to get a better photo of the moon with much more detail. Taken at 1/250 second, f/8, and ISO 1250.*

The problem is that the moon takes up too little of the frame to meter correctly, and even at 600mm, the spot-metering circle doesn't get enough of the moon alone to accurately judge the exposure. The following is a good starting place to capture the moon correctly; however, you need to keep in mind that the moon does not have a standard brightness and is affected by the atmospheric conditions where you are photographing.

The initial settings I use are 1/250 second at f/11 and ISO 400. Then I shoot the moon and check the exposure by using the LCD on the back of the camera. I zoom in to look at the edge of the moon as this is where you will most likely see the exposure problems. This instant feedback allows you to make adjustments until you get the exact exposure you want.

DOUBLE EXPOSURES

A double exposure is a single image created by combining two different photographs. This was done on film by taking a photo, then without advancing to the next piece of film, you took a second photograph, creating a single image from two exposures. If the moon is only a part of your composition, then its brightness can be a real problem compared to any other elements in the scene. There are two different solutions, but they both involve using two different exposure settings to capture the scene: double expose the image in the camera or combine two images using photo-editing software.

To create a double exposure in the camera, you first need to know if your camera can do this, so check the camera manual. The setting is usually a menu choice or a combination of buttons on your camera. This type of photography can be a lot of fun, but it can also be a little frustrating because it can be difficult to visualize the final outcome. And, if you are double exposing in the camera, the frame is set with the final image and you lose the two individual shots that make up the double exposure. Remember, however, that if you have a scene with a foreground element and the moon in the same frame, getting the right exposure correct for both elements is impossible. The best way to deal with this problem is to create two images with different exposures and combine them in postproduction.

1. **Pick the subjects you want to photograph.** Obviously, in this case, the moon is one and the other can be anything that will take up the lower half of the frame, such as a cityscape.

2. **Get the exposure settings for both subjects.** If the exposure settings for the foreground object need a slower shutter speed, then use a tripod that can be angled to get the moon in the shot easily.

3. **Choose any white balance setting except auto.** You want to make sure that the white balance stays the same in both shots, so you don't want the camera to choose for you.

4. **Set the camera to manual and enter the exposure settings for the foreground object.**

5. **Turn on the double exposure setting.**

6. **Take the photograph of the foreground object.**

7. **Change the exposure settings to properly expose the moon and take the second part of the double exposure.**

8. **Check the results on the LCD on the camera.**

Once you have the basics down, you can start to explore the composition. With practice you will get better at achieving the results you want. For example, zoom in as close to the moon as possible and as wide for the foreground element as possible to make the moon look big in comparison, or change the order of the images and shoot the moon first.

To create a double exposure using two separate exposures you combine using photo-editing software, make sure the camera is on a tripod and doesn't move. Then, then take an image that is exposed for the moon (Figure 7-10), and take a second image that is exposed for the foreground element (Figure 7-11), which will likely

ABOUT THIS PHOTO
The nearly full moon photographed with an 800mm focal length at 1/400 second, f/8.0, and ISO 500.

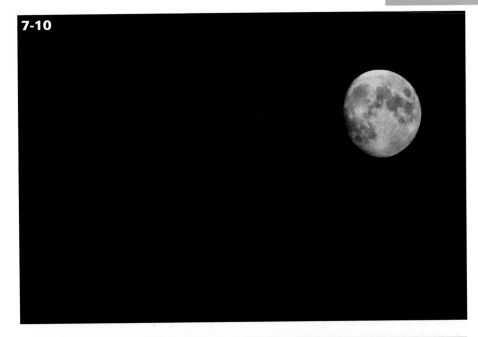

ABOUT THIS PHOTO
The San Diego skyline photographed at 5.4 second, f/10, and ISO 200.

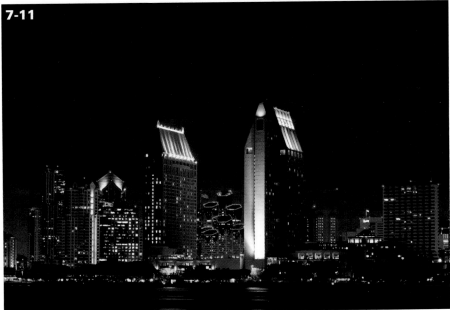

overexpose the moon. To combine them, load the images as layers in the image-editing software, with the correctly exposed moon on the bottom and the overexposed moon on the top, and then mask out the overexposed moon to allow the good moon to show through. With some practice in the software, you can get results like the image shown in Figure 7-12.

x-ref

There is more information on masking in Chapter 11.

TIME-LAPSE PHOTOGRAPHY

Time-lapse photography is a technique where you take a series of images of the same scene spread out over a period of time, and then put them together into a video that compresses the time. The steps are pretty simple: Just pick a subject, set the camera and the remote control, take the photographs, edit the images if needed, and create the video.

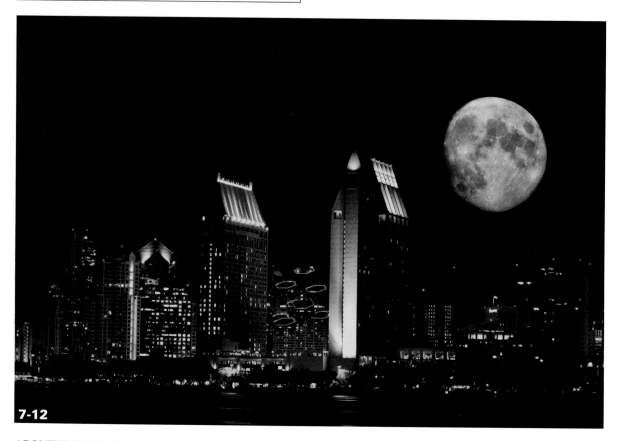

7-12

ABOUT THIS PHOTO *The moon from Figure 7-10 was overlaid with the city from Figure 7-11 and a layer mask was used to show the mooon rising over the San Diego skyline.*

THE GEAR YOU NEED

There are two pieces of equipment needed to take time-lapse photography: a tripod and a remote that allows you to set the number of shots and the interval between them automatically. Some cameras have this functionality built right in, so before buying anything, check your camera manual. For the time lapse to work, the camera needs to be stationary, which means using a tripod.

The remote that triggers the shutter release needs to be able to fire the camera on a set schedule with a programmable interval between the photographs; this remote is usually called an intervalometer. For example, the Nikon MC-36 multi-function remote cord allows you to set the shutter time as well as the interval and the number of shots, thus allowing for an easy setup for time-lapse photography. The Canon TC-80N3 camera remote control cable allows you to set the interval easily with a thumb dial. These remotes are not cheap, with the Nikon costing about $130 and the Canon costing about $150, but if you want to do this type of photography, then you will need to get a remote, as doing this manually is difficult. Another option is the Triggertrap (www.triggertrap.com) that can be used for time-lapse photography.

PICKING THE RIGHT SUBJECT AND SETTINGS

One of the keys to a successful time-lapse photo shoot is picking a good subject and the best length of time to shoot that subject. For example, if you want to do a time lapse of a sunset, then the time of the shoot needs to be from 30 minutes to a few hours at the most. However, if, for example, you want to show a building under construction, then the time frame might be a month or even a year. The key to an effective time lapse is that the subject moves enough during the time frame to keep it interesting. It's no fun watching a movie where nothing happens, and the same is true for time-lapse movies.

There are many fantastic time-lapse movies done of the Milky Way, star trails, and other great nighttime subjects, but before venturing out into the desert to make your time-lapse masterpiece, study the basics and do some tests closer to home. One subject that makes for an interesting shoot is the sunrise or sunset, not only because it can be really fun to watch, but also because it brings up some important exposure and white balance considerations.

When you combine the images into a movie, it really works best if the white balance for all the images is the same. By setting the white balance to an actual numerical value and not the auto white balance, you will ensure that the entire movie has a consistent look, and you won't get color shifts between each frame. When you use the auto white balance, the camera looks at the color of the light and tries to determine the white balance; it usually does a great job, but the problem arises because, as the sun moves, the temperature of the light changes and that change causes the auto white balance to change as it tries to correctly read the light illuminating the scene.

Usually I do not worry about the white balance very much because I generally shoot RAW files and can easily adjust the color in postproduction; however, for time-lapse photography, there can be thousands of images and so I never shoot them in RAW. This is one type of photography where RAW files are not a good option because they are just way too big for what's needed. You can change the size of the file as you are creating the movie, but if the final product is to be a movie, then there is no reason to record the giant RAW files in the first place. This also allows you to get

more images on a single memory card, which is important because of how many images you need to take to make a movie. It's a lot.

Looking at HD television, the highest resolution of the screen is 1920 × 1080 pixels, which is not a very big image file. With the Nikon D7000, for example, the smallest JPEG file is 2464 × 1632, which is still bigger than you need for HD television. The Canon Rebel T3i allows you to pick a resolution of 1920 × 1280, and even better, it has a widescreen mode of 1920 × 1080.

Because you only need to use a small JPEG image, you must set the white balance correctly before taking the first image; this keeps the color consistent for the whole movie. It is possible to use the Adobe Photoshop Camera Raw module or the Adobe Photoshop Lightroom Develop module to adjust the white balance of JPEG files, but it takes a lot of time and computing power, so if you can avoid it, all the better.

The next step is to set the focus, and manual is a good way to go, especially if there is a chance that the focus could change during the exposure. For example, as the image is being taken, a person moving across the frame will cause the focus to shift because the camera's auto focus will shift focus to any subject that is closer to the camera.

The best bet is to set the focus manually. The easiest way to do this is to pick a spot and focus using the built-in auto focus, and then, without touching the lens focus ring, switch the focus to manual.

The last setting is the most important and the hardest to deal with: the exposure setting. The exposure of a single image is easy, but how should you decide what settings to use when the light will change over the period of the time lapse? This is easier when the light change is minimal, but a situation like a sunset takes a little more guesswork. To make things clear, I did not want the exposure to adjust for the changing light conditions as that would not look natural, but instead I wanted the scene to change from light to dark. The question is, how much lighter than a proper exposure do I start at and how much darker than a proper exposure do I end at? I set the camera to manual and set the shutter speed and aperture to overexpose the scene by a full stop. When the time-lapse was done, the camera was recording the scene as underexposed by two stops. This gave me a very nice movie that starts very bright and slowly goes dark, as if you were at the actual scene. As you can see in Figure 7-13, there is a great difference between the first and last frames.

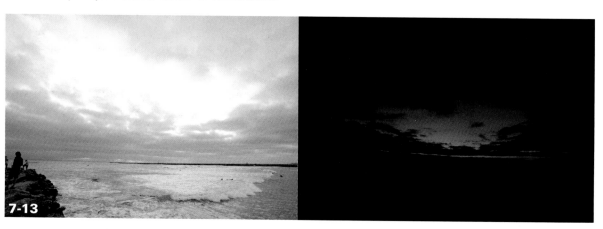

7-13

ABOUT THIS PHOTO *The first and last frames of the time-lapse. All the frames in the movie have the same exposure; it is the fading light that changes the look. 1/125 second, f/7.1, and ISO 500.*

WORKING OUT THE MATH

I am sorry to say that this part has math, but the good news is that the math is actually pretty easy. The key to the math is to know how video works. Most film movie clips are usually around 24 frames per second (digital footage is usually 29.9 frames a second so if you want that, work the math out with 29.9 instead of 24), so if you work with that number as a basis, you will need 720 frames for a 30-second video clip, 1,440 frames for a minute, or 43,200 frames for a 30-minute movie. The next step is to take the length of the event and divide it by the number of frames needed to get the interval between the images. So, for example, if you want to capture the sun setting over a 30-minute period of time and create a 30-second movie, then you will need to take 720 individual images during 1,800 seconds of the event.

The basic equation is:

Length of event in seconds / length of movie in frames = interval between frames

So, in this example, 1,800 seconds (length of the event) divided by 720 frames (length of the movie) equals an interval of 2.5 seconds between photographs.

If you want to shoot a 4-hour time lapse of the night sky and create a 10-minute movie, then you take 4 hours (or 240 minutes multiplied by 60) to get 14,400 seconds as the length of the event. Then you divide that by the 14,400 frames (10 minutes or 600 seconds multiplied by 24 frames equals 14,400 frames), which creates a 10-minute movie with 1 frame for every second:

14,400 seconds / 14,400 frames = 1-second intervals between frames

That works out really nicely, except that you need to take 14,400 individual frames to create the movie at 24 frames per second. So the problem becomes how to get 14,400 images on a single memory card without running out of power. Here are some solutions:

- **Big memory cards.** Memory card sizes seem to go up every year, with Compact Flash cards now in the 32GB range and SD cards reaching 128GB, which is a lot of space, especially for the smaller JPEG files mentioned in the previous section. Some cameras also have two card slots and allow you to shoot until one is full, and then start to fill the second card. Another option is to use a product such as the Eye-Fi, which wirelessly transmits the images to a nearby computer, allowing you to take an unlimited number of photos.

- **Tethered shooting.** You can attach your camera to a computer and allow the computer to store the image files automatically as you take them. This solution is great when you are close to home or where there is a source of power, but not so great on location, as you now have to keep the laptop and the computer running off a separate power source.

- **Power cords.** A fully charged battery might last the full time needed, but if you can plug your camera into a power source, that might be a better idea. For example, the Nikon EH5a Adaptor allows you to plug the Nikon D700 into an outlet so that you don't have to worry about running out of battery power.

Before you go and purchase any of these items, make a small test movie to see if this is actually something you want to take further. Just follow these steps:

1. **Pick a scene.**

2. **Do the math.**

3. **Program the remote.**

4. **Set up the tripod and camera.**

5. **Compose the scene and set the focus to manual.**

6. **Set the white balance.**

7. **Set the exposure.**

8. **Fire the remote and make sure the tripod doesn't move.** You can see how the tripod is set up with the remote attached in Figure 7-14.

That's it for the photo side of things; now you have to put it all together and create an actual movie.

7-14

ABOUT THIS PHOTO *The tripod is firmly planted on the rocks by the beach, ready to start capturing a sunset. Taken at 1/80 second, f/4.5, and ISO 500.*

CREATING THE MOVIE

Once you have the set of still images, the final piece of the puzzle is to create a movie to show the time-lapse. The movie is made by using software that combines the individual images as a movie file, with each image becoming a frame of the movie. It is helpful to have the files ready to go before actually creating the movie. The key is to keep the images in sequential order with sequential filenames. When I download the images from a time-lapse into my computer, I place them into a separate folder. That means that only the files that will be used to create the movie are there and they are in sequence. You should also change the name on import into something a little more meaningful. For example, I might change the name to Sunset_TL_(date)_ (sequence #) so that I know that these are the files for the sunset time-lapse taken on a specific date, as well as the order of the files. As you can see in Figure 7-15, this allows me to keep all the files together.

The next step is to combine these images into a movie, and one of the easiest ways to do this is with the full version of Adobe Photoshop. (Adobe Photoshop Elements doesn't have this capability.) If you have the full version of Photoshop, just do the following to create your movie:

1. **Open Photoshop.**

2. **Choose File ⇨ Open.**

3. **Navigate to the folder that contains your time-lapse images and click the first image.**

4. **Click the check box that says image sequence.**

5. **Click Open.** A pop-up menu appears and asks you for the frame rate.

6. **Enter the frame rate from the calculations you made when capturing the image.** I usually use 24 frames per second. The image opens.

Name	Date Modified	Size	Kind
Sunset_TL_7122011-1.JPG	7/12/11	3.6 MB	Adobe Photoshop JPEG file
Sunset_TL_7122011-2.JPG	7/12/11	3.6 MB	Adobe Photoshop JPEG file
Sunset_TL_7122011-3.JPG	7/12/11	3.7 MB	Adobe Photoshop JPEG file
Sunset_TL_7122011-4.JPG	7/12/11	3.7 MB	Adobe Photoshop JPEG file
Sunset_TL_7122011-5.JPG	7/12/11	3.7 MB	Adobe Photoshop JPEG file
Sunset_TL_7122011-6.JPG	7/12/11	3.7 MB	Adobe Photoshop JPEG file
Sunset_TL_7122011-7.JPG	7/12/11	3.7 MB	Adobe Photoshop JPEG file
Sunset_TL_7122011-8.JPG	7/12/11	3.7 MB	Adobe Photoshop JPEG file
Sunset_TL_7122011-9.JPG	7/12/11	3.7 MB	Adobe Photoshop JPEG file
Sunset_TL_7122011-10.JPG	7/12/11	3.7 MB	Adobe Photoshop JPEG file
Sunset_TL_7122011-11.JPG	7/12/11	3.7 MB	Adobe Photoshop JPEG file
Sunset_TL_7122011-12.JPG	7/12/11	3.7 MB	Adobe Photoshop JPEG file
Sunset_TL_7122011-13.JPG	7/12/11	3.7 MB	Adobe Photoshop JPEG file
Sunset_TL_7122011-14.JPG	7/12/11	3.7 MB	Adobe Photoshop JPEG file
Sunset_TL_7122011-15.JPG	7/12/11	3.7 MB	Adobe Photoshop JPEG file
Sunset_TL_7122011-16.JPG	7/12/11	3.7 MB	Adobe Photoshop JPEG file
Sunset_TL_7122011-17.JPG	7/12/11	3.6 MB	Adobe Photoshop JPEG file
Sunset_TL_7122011-18.JPG	7/12/11	3.6 MB	Adobe Photoshop JPEG file
Sunset_TL_7122011-19.JPG	7/12/11	3.6 MB	Adobe Photoshop JPEG file
Sunset_TL_7122011-20.JPG	7/12/11	3.6 MB	Adobe Photoshop JPEG file
Sunset_TL_7122011-21.JPG	7/12/11	3.6 MB	Adobe Photoshop JPEG file
Sunset_TL_7122011-22.JPG	7/12/11	3.7 MB	Adobe Photoshop JPEG file
Sunset_TL_7122011-23.JPG	7/12/11	3.6 MB	Adobe Photoshop JPEG file
Sunset_TL_7122011-24.JPG	7/12/11	3.7 MB	Adobe Photoshop JPEG file
Sunset_TL_7122011-25.JPG	7/12/11	3.6 MB	Adobe Photoshop JPEG file
Sunset_TL_7122011-26.JPG	7/12/11	3.5 MB	Adobe Photoshop JPEG file
Sunset_TL_7122011-27.JPG	7/12/11	3.6 MB	Adobe Photoshop JPEG file

7-15

ABOUT THIS FIGURE *The folder of images for the time-lapse, all with a descriptive name and information.*

7. **Choose File ⇨ Export ⇨ Render to Video.** The Render Video dialog box consists of four parts, as shown in Figure 7-16:

> **Location.** This is where you specify a location to save your completed video.

> **File Options.** This is where you can set the type of movie and, very importantly, the size of the movie.

> **Range.** This is where you pick the first and last frames of the movie.

> **Render Options.** This is where you change the frame rate, if needed.

8. **Click Render and wait until the process is complete.** The longer the movie, the longer it takes to render.

Another good option is to use QuickTime 7 Pro from Apple, which works on both the Mac and PC. It is available at www.apple.com/quicktime/extending and can create a time-lapse with a few easy steps:

1. **Open QuickTime 7.**

2. **Choose File ⇨ Open Image Sequence.**

3. **Navigate to the files for the time lapse and select the first image.**

4. **Click Open.**

5. **Choose the frame rate from the menu that opens.**

6. **Click OK.**

7. **Click Export and type the filename of the movie.**

ABOUT THIS FIGURE
The Render Video dialog box in Photoshop CS5.

8. **Select the movie type and options, including changing image size from the export menu.**

9. **Click save to have QuickTime render the movie.**

I recommend working on smaller movies and experimenting with the frame rates and other settings before trying a very long movie where you have a lot of time invested. You can see one frame from the final sunset movie as it is playing on my computer screen in Figure 7-17.

note You can see the actual time-lapse movies at www.alanhess photography.com.

STAR TRAILS

Look up on a clear night and you can see that the night sky is filled with thousands of points of light. All those stars up in the night sky make for a great photo, especially when you use a technique to create star trails. Star trails are created by leaving the shutter open long enough for the rotation of the earth to create light trails from each star. The key here is to have a nice clear night to capture the stars, and something in the foreground to keep the image grounded. In Figure 7-18, the stars' light trails are easily seen and the reflection of the sky in the water and the big rocks in the background help to keep the image grounded.

ABOUT THIS FIGURE *A screen capture of the time-lapse movie playing.*

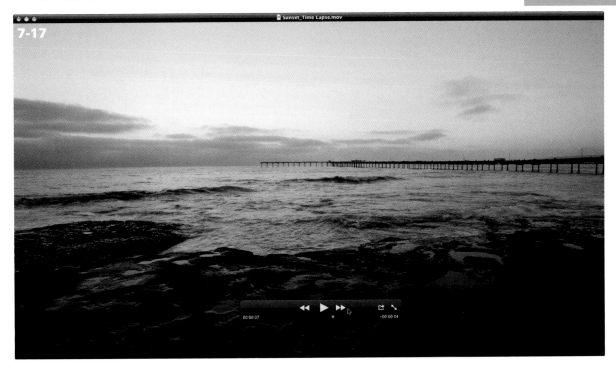

There are two methods used to capture the very long exposures needed to produce star trails. The first is to just set the camera up, open the shutter with a cable release, and leave it open for the length of the capture. The problem is to determine exactly how long to keep the shutter open and what aperture and ISO to use to get a proper exposure. A good method is to use equivalent exposure math to your advantage. By using a fast shutter speed, a middle aperture, and a high ISO, you can get a good starting exposure. From there, you can change the shutter speed and ISO until you have the length of the exposure you want. Here are the basic steps (but keep in mind that your starting numbers will be different from mine):

1. **Set the camera to manual mode.**

2. **Set the ISO to 1600.**

3. **Set the aperture to f/5.6.**

4. **Compose the image through the viewfinder.**

5. **Set the shutter speed to bulb.**

6. **Use the cable release to take a 90-second exposure.**

7. **Check the exposure on the back of the camera.** If the image is underexposed, try twice as long. If the image is overexposed, halve the shutter speed and try again.

Once you have determined the proper exposure using a high ISO of 1600, you can start to work out what the exposure settings need to be for ISO 100, and in doing so this will give you a lot slower shutter speed which will allow for the movement needed to capture the star trails.

x-ref

Equivalent exposures are discussed in Chapter 2.

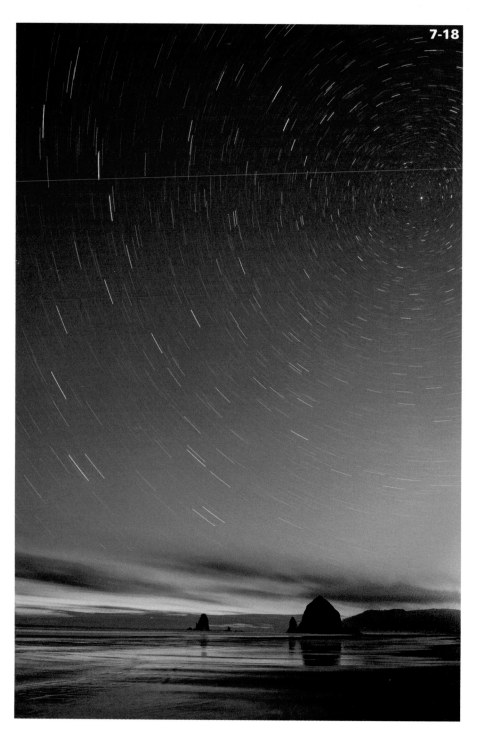

ABOUT THIS PHOTO
An exposure time of 1,128.2 seconds, just over 18 minutes, was needed to get this star trail image. Taken at 1128.2 seconds, f/8, and ISO 800. © Jacob Lucas

This takes a little math. Each time you halve the ISO, you let in half as much light, and each time you double the shutter speed, you let in twice as much light. Based on starting with an ISO of 1600, moving to an ISO of 100 is four full stops of light. This means you can take the shutter speed that gave you the right exposure and double it four times.

For example, if the shutter speed that gave the right exposure was 45 seconds, then the equivalent would now be 720 seconds (12 minutes).

Here's how it works: The ISO goes from 1600 to 800 to 400 to 200 to 100, which halves the amount of light each time; then you take the shutter speed of 45 seconds, and you double it four times: double 45 to get 90 seconds, double 90 to get 180 seconds, double 180 to get 360 seconds, and double 360 to get 720 seconds.

So at this point, you have a shutter speed of 12 minutes (720 seconds) and an ISO of 100. However, the slower the shutter speed, the easier it is to get the motion of the stars in the frame, so it is time to adjust the aperture. Adjusting the aperture works in the same way as adjusting the ISO and shutter speed: You take the original aperture setting and make it smaller, letting in less light, and decrease the shutter speed to end up with an equivalent exposure. In this example, the aperture started at f/5.6. You can halve it to f/8, then halve it again to f/11, and then halve it again to f/16. This is another three full stops of light that you can make up by increasing the shutter speed. To get the equivalent shutter speed with the new aperture, you will need to decrease the shutter speed by three stops. A shutter speed of 720 seconds doubles to 1,440, then again to 2,880, and again to 5,760 (1 hour and 40 minutes).

So to get the proper exposure and the effects of the light trails, the shutter needs to stay open for a very long period of time and this can cause digital noise due to the length of the exposure. The longer the exposure, the more digital noise there will be. There is another method that you can use that doesn't create as much digital noise since there is no single long exposure, but it does take more work later in postproduction. This method is called stacking.

WHAT IS STACKING?

Stacking is a technique where, instead of one long exposure, you split the exposure up into smaller pieces and then recombine them later using software. This helps to greatly reduce the digital noise in the image because the sensor is not subjected to the extremely long exposure time when the star trails are done as a single exposure. The idea is simple, but to do it correctly, you need a programmable interval timer (intervalometer) set up to take a series of images. Each of the images will be combined to make a final single image, and the exposure settings are worked out the same way as the single image in the previous section; however, instead of a very slow shutter speed, the exposure time should be in the 3- to 5-minute range.

> **note** Turn off the camera's long exposure noise reduction; otherwise, it will cause gaps in the image because it causes a lag between exposures.

The key to stacking is in how the images are processed after the shoot. The images need to be loaded into a software application and combined

to create a single file, and the best solution to this is to use Adobe Photoshop Extended and the built-in Image Statistics script. This script makes the stacking process very easy, but at this point is only available in the Adobe Photoshop Extended version. Just do the following:

1. **Open Photoshop Extended.**

2. **Click File ⇨ Scripts ⇨ Statistics.** This opens a dialog box that allows you to select the files to combine, as shown in Figure 7-19.

3. **Change the stack mode to Maximum.**

4. **Select the images you want to stack.**

5. **Click OK.** The file is then opened in Photoshop, but it needs to be converted from a smart object to a regular layer.

7-19

ABOUT THIS FIGURE *The statistics script displays a dialog box in Photoshop Extended.*

AMBIENT LIGHT

One of the most important factors in getting a good light trail image is the location of the shoot. The best areas to take these types of images are where there is as little ambient light as possible because of the really long exposures. The longer the shutter is open, the more light is allowed to

reach the sensor, and that includes the ambient light that is present in all cities at night. This light pollution can really be a problem when it comes to photographing star trails because the light from the cities is so much brighter and it can cause areas of the image to be overexposed.

PUTTING IT ALL TOGETHER

Here are some of the things that will make your star trails work out better, and give you the long, curved trails that many agree look best:

- **Point north.** If you point your camera north, or when in the Northern Hemisphere at the North Star or Polaris, you will create the circles that many feel are the best-looking star trails, as can be seen in Figure 7-20.

- **The length of the exposure.** It doesn't matter if it is a single exposure or a stacked exposure, the total exposure time needs to be long enough to show the movement. That means 30 minutes or longer to get some good trails going.

- **Focal length.** The wider the angle of view, the more the lines will curve, and if you have a fisheye lens, that works even better. Keep in mind that the fisheye also distorts anything in the foreground that is close to the edge of the frame.

- **Location.** The clearer the sky, the easier it is to see the trails, and the farther away from the city, the less ambient light bleed there will be. If you live away from a city, then you can go out and just try the long exposures needed, but if you live in a city, you might not have a clear sky, so I suggest that you practice with getting the right settings and taking some long exposures close to home before heading out and away from the city to capture a star trail.

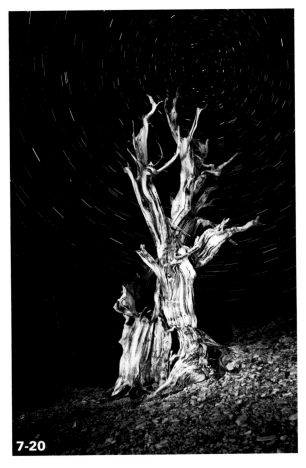

7-20

ABOUT THIS PHOTO *At times, the colors can seem washed out in these very lengthy exposures, so converting the image to black and white creates a better-looking image. Here, the star trails work really well anchored by the tree in the foreground. Taken at 1080 seconds, f/3.5, and ISO 200.* © E. Howe-Byrne

PHOTOGRAPHING FIREWORKS

Photographing fireworks can be really rewarding, and while it isn't very difficult to get good results, there are some things that you need to set up before the first rocket takes flight. You need the following equipment to successfully capture fireworks:

- **Tripod.** To get a sharp image with the long exposures needed to capture the light trails from the fireworks, you need a stable shooting platform, and the best way to do that is with a good tripod.

- **Cable release.** Using a cable release allows you to watch the fireworks and time the exposures as they happen. While it isn't imperative to have one, it will make life much easier.

- **Flashlight.** A small flashlight comes in handy when setting up or breaking down your camera setup.

- **Small piece of matte black board.** This can be used to cover the lens between explosions, allowing for multiple bursts in the same frame without having extra light reach the sensor between the color bursts.

The first thing is to make sure that the camera is set on a sturdy tripod so that it doesn't move during the exposure. This can't be stressed enough, as any movement of the camera will cause the fireworks to blur. For Figure 7-21, a strong wind started blowing, making a sturdy tripod even more critical, and I added a sandbag to the center column to keep it from moving at all.

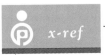 *x-ref*

Tripods and weights to make them sturdier are covered in Chapter 3.

Because the camera needs to be locked into a tripod, you will need to determine where to shoot from before the fireworks start, and you need to check whether a permit is required to set up a tripod in that location. For example, there was no permit required to shoot the local Fourth of July fireworks display in my neighborhood, as the best

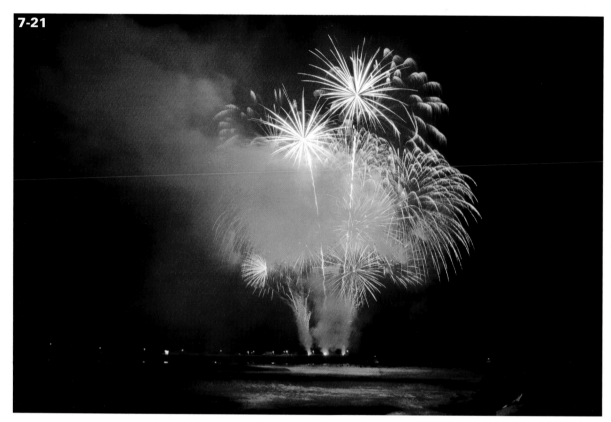

7-21

viewing was from the beach. But if you were going to shoot the fireworks display at the county fair on the Fourth of July, you likely need to get permission to set up a tripod on the fairgrounds. It is best to find out beforehand so you are not prevented from setting up for the shoot.

Composing fireworks photographs is harder than it sounds, as there is nothing to look at before the display starts and many times the entire show only lasts about 15 minutes (even the big shows rarely last more than 30 minutes). Here are some ways to compose the image to get the best shots from the short time available:

■ **Watch for the first burst.** The fireworks will usually start with a nice volley of color bursts to set the tone of the show. Watch where the shells are launching from and where they are bursting. This is the best time to make sure focus is set to manual and the distance is correct.

■ **Ground the show.** Include an element that gives the show a context. For example, in Figure 7-22, I was photographing on the beach and made sure that the other viewers and the launching point on the pier were included in the frame.

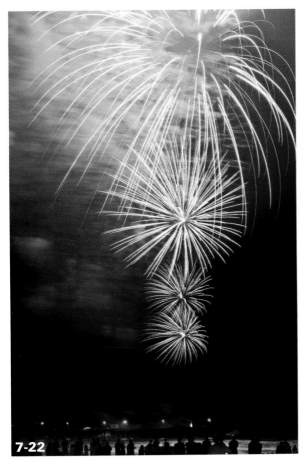

7-22

ABOUT THIS PHOTO *The fireworks going off from the pier with the crowd in the foreground. Taken at 6.3 seconds, f/16, and ISO 200.*

■ **Fill the frame with the color.** Using a longer lens allows you to fill the frame with color if you want the actual color to be the subject of the photo.

■ **Horizontal or vertical.** This one is a personal choice, but keep in mind that vertical framing can give the fireworks some height, while a horizontal composition can help to add a sense of place to the image.

■ **Leave a little room.** I recommend shooting a little wide and cropping in later in postproduction so that you don't end up with lines of light leaving the top of the frame and drawing the viewer's eye right out of the image.

ADJUSTING THE EXPOSURE

How do you set the exposure for a fireworks display? You really don't. Photographing fireworks can't be done successfully with any of the automatic or semi-automatic modes on your camera. The light changes constantly, and the camera will more than likely try very hard to give you settings that will overexpose your image. The basic steps for capturing the fireworks are as follows:

1. **Set the camera to Manual exposure mode.**

2. **Set the ISO to 200.**

3. **Set the aperture to f/11.**

4. **Set the shutter speed to bulb.** If your camera doesn't have a bulb mode, don't worry; I address that a little later on.

5. **Use the cable release to trigger the shutter as the fireworks streak skyward and keep the shutter open as the fireworks explode and fill the sky with colors.** This can range from a few seconds to more than 15 seconds, depending on the number of rockets fired at any given time.

6. **View the camera's LCD screen to check the composition.**

7. **Repeat as needed.**

If your camera does not have a bulb mode, then you can set the exposure for 20 seconds and use a piece of black paper or even a piece of matte black poster board (which is easier to use one-handed and stays rigid) to cover the front of the lens between explosions. The downside to this method is that you can't actually time the start and finish of the explosions because you are limited to the shutter speed of the camera. By using the bulb mode in Figure 7-23, I could start the exposure when the rockets fired and stop the exposure after they burst, so I kept the shutter open for 3.8 seconds, not a setting that exists on the camera.

If you are finding that the fireworks are very bright or there are a lot of multiple bursts of color, then you can always adjust the aperture to f/16 and still be able to use longer shutter speeds to get all the light trails in the image. The companies that run fireworks shows all try to end with a massive display of their craft. In practical terms, the end of the fireworks show is going to be brighter than the start. And because that usually means that they have to get a lot of launch tubes ready to fire in quick succession, there is a lull before the finale. If you watch for this, you can decrease the aperture and still use long shutter speeds to catch the multiple fireworks used for the finale.

WHY MANUAL FOCUS IS THE WAY TO GO

The autofocus capabilities of today's cameras are really very good. In fact, they are so good that in certain circumstances it can be a problem. Photographing fireworks is a great example of where manual focus is a much better choice.

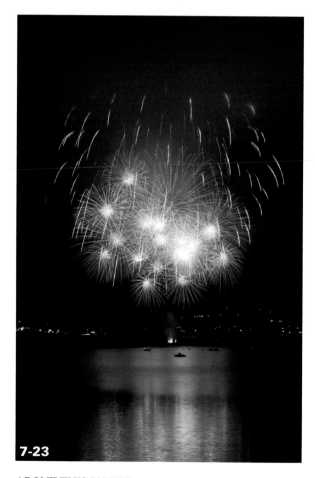

7-23

ABOUT THIS PHOTO *The fireworks' reflection in the water turned everything blue. Taken at 3.8 seconds, f/16, and ISO 400.*

To get the best results, you need to set the focus mode to manual (either on the camera body or on the lens depending on your camera) so that the camera doesn't try to refocus every shot. Take Figure 7-24: if set to autofocus, the focus point could easily have switched between the explosions in the air and the smaller flares being fired off the pier.

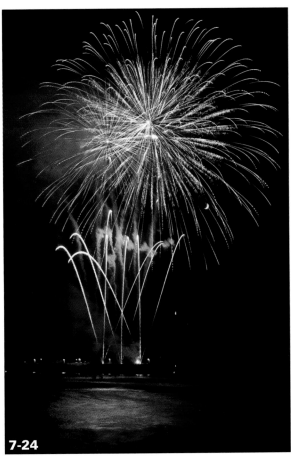

7-24

ABOUT THIS PHOTO *The Fourth of July fireworks display in Ocean Beach, California, where the fireworks are set off from the pier. Taken at 1/250 second, f/5.6, and ISO 200.*

The best way to achieve focus for the fireworks is to use the first explosion to set the focus and the composition, and then change to manual focus without moving the lens focusing ring. Just aim at where you think the fireworks are going to go off and wait until you see the first rocket launch; then adjust where the camera is aimed so that the composition is what you want and press the shutter release button halfway down to activate the auto focus while making sure the auto focus point is on the right spot of the explosion.

The fireworks might go off in different parts of the sky, but because you are usually quite far away and the depth of field is very deep with an aperture of f/10 or smaller, the area of acceptable focus is quite broad and you should be good to go.

Every once in a while, I check the focus on the camera's LCD and make sure that at 100 percent preview, the light trails are sharp. If the focus is off, I wait until the next explosion and adjust the focus manually.

Assignment

Capture fireworks successfully

Successfully capturing fireworks can take some practice, but the results are worth the effort as you will see once you complete this assignment and share your favorite image on the website.

Living in San Diego has the advantage of year-round fireworks displays. For example, SeaWorld has brief nightly shows all summer long and at many other times throughout the year. To capture this image, I checked the SeaWorld schedule and waited for a clear night; then, I went to an area where I knew there would be an uninterrupted view of the fireworks.

By photographing from a bridge, I was able to capture the fireworks display and the reflection of the fireworks in the bay. Once I found my location, carried up my gear, and set up my tripod, I still had to wait for the fireworks to start before I could compose the image. I used a cable release to time the explosions. This worked well as it allowed me to keep an eye on my surroundings because I was on the side of the road. The shutter speed for this image was 6.6 seconds with an aperture of f/16 and ISO 400.

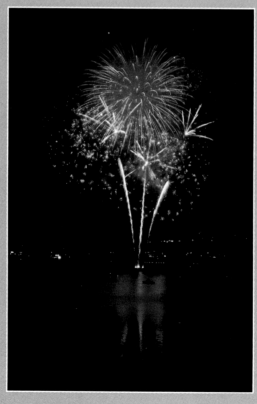

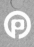
Remember to visit www.pwassignments.com after you complete the assignment and share your favorite photo! It's a community of enthusiastic photographers and a great place to view what other readers have created. You can also post comments and read encouraging suggestions and feedback.

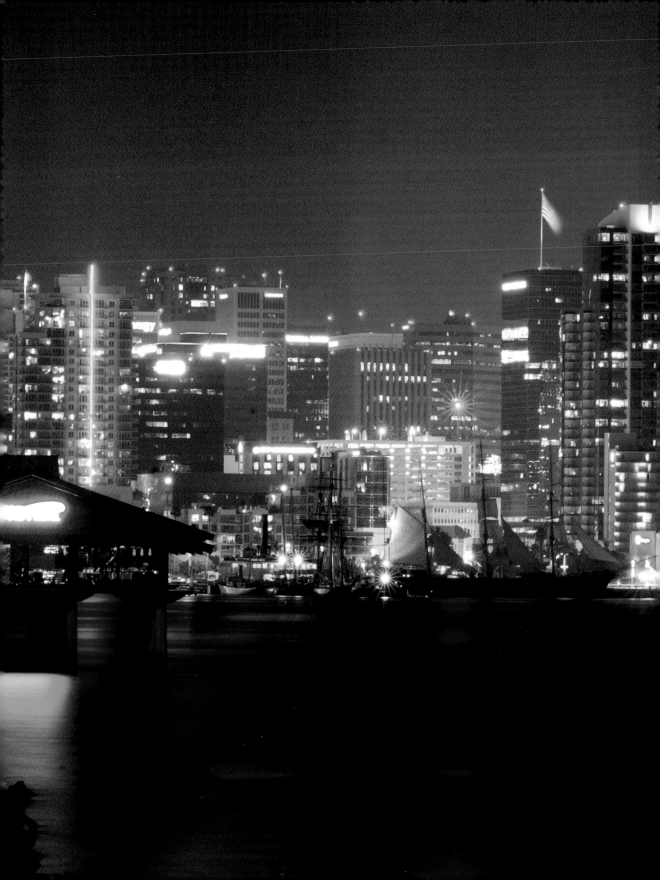

When the sun sets and the city lights start to come on, it looks like the city is waking up and coming to life. The drabness of the day is slowly replaced by an energy that is most evident in the way the city is lit. Think of the city as a one-stop show for night photography, as it offers a huge variety of different subjects. These can include the street scenes, light trails, bright neon lights, and the cityscapes themselves. There is also a lot of fun to be had photographing the same scene in both day and night and comparing them. One of the biggest differences is the direction of the light. When the scene in Figure 8-1 is lit during the day, the sun is the main light source and the light comes from overhead, but at night, the light comes from within the scene, from the lights used to illuminate the memorial from the ground up, which creates a look that does not exist during the day.

STREET SCENES

Big cities are a great place to capture street scenes after dark. This is because there are people, activities, and enough light sources to make all these scenes relatively easy to capture. The bigger

8-1

ABOUT THIS PHOTO *The memorial shot at 40 seconds allowed me to capture the detail in the stone, yet the people visiting it look a lot like ghosts. Taken at 40 seconds, f/22, and ISO 100.*

the city, the more action there is, and the better your chances of finding something worth photographing. If you are not in a big city, then the best bet is to go out looking on a Friday or Saturday night.

The best time to photograph street scenes is right after the sun has set, while there is still some ambient light in the sky. If you are in your hometown, then you will already know where the center of the nightlife is, and will most likely know how to get there and back home. If on vacation or visiting a new area, it is a good idea to check out the area during the day if possible. The more

you know the area, the easier it is to get the images you want. The activity around shopping areas and tourist attractions makes them good subjects to try. Just pick a spot and let the action flow around you, as I did in Figure 8-2 when I photographed outside the downtown mall. I used a relatively fast shutter speed and a high ISO to freeze the cars in place and make the pedestrians visible.

When shooting street scenes, there are two main points of view to try. The first is a street-level view where the camera is set up so that the action flows around it and everything looks as if it was

ABOUT THIS PHOTO *Outside the Horton plaza center in San Diego. Taken at .4 second, f/2.8, and ISO 800.*

taken at the street level. This can give your images a sense that the viewer is part of the scene, as everything looks in the proper perspective.

The other point of view is to look down on the scene from a higher vantage point, such as from a balcony, deck, hillside, or bridge that overlooks the scene. For example, the shopping mall in Figure 8-2 is built to allow views out to the surrounding streets, which provides multiple angles and views of the same scene. When photographing down from the higher levels, a longer focal length is better because the compression can make elements at various distances seem to be close together, even when they are far apart.

SAFETY FIRST

As much fun as photographing is at night, it can also be a very dangerous thing to do. No matter what else is going on, your safety needs to be the most important consideration when you are out shooting. Remember to use your common sense, and don't put yourself in danger just to get a photograph. It isn't worth it. Here are some of the things you need to look out for:

- **Cars and traffic.** The biggest danger when taking night photographs in the city is passing cars. Most drivers can't see you most of the time, and by the time they do, it can be too late. Make sure that you stay off the road and on the sidewalk when shooting. Be careful where you set up your tripod to make sure it doesn't impede the flow of foot traffic.

> **tip** A blinking bicycle light or other type of high-visibility clothing can help you be seen by cars and other pedestrians at night.

- **Shady characters and neighborhoods.** There are some places where having a camera out in the open is a bad idea, and having it out at night is a worse idea. Pay attention to the neighborhood and don't put yourself in any danger. If you have any doubts, don't photograph there, or ask people who know the area; the best thing to do is to make sure you pay attention to your surroundings. It is very easy to get caught up in capturing an image, and people can walk right up to you before you realize they are there. Bringing along a friend can provide an extra pair of eyes looking out while you set up and take the photos.

- **The weather.** Getting caught outdoors in the rain is one thing, but getting caught out in the rain with your camera gear is a whole other story. Not only do you have to protect yourself, but you also need to protect your camera gear. Wearing appropriate shoes and making sure you have the proper rain gear is important; check out the camera rain covers from Think Tank Photo, which are designed with photographers in mind.

- **Let someone know where you are.** The most important safety measure is to let someone know where you are and when you plan on being back. I make sure that my wife knows where I am shooting and when I plan on being done, and I check in if any of those plans change. Just make sure that you check in when you are done. It would not be a good thing for the person awaiting your call to be up all night worrying; they might just call the police.

Follow these precautions in order to stay safe when out photographing in the city at night, especially if you are in an unfamiliar city or are

on vacation. If you are on vacation, check with the hotel staff on the best places to go and those to avoid.

USING DIFFERENT SHUTTER SPEEDS

The longer the shutter is open, the more light is allowed to reach the sensor in your camera. However, the shutter speed also controls *how* time is captured in your images: Open the shutter speed for a tiny fraction of a second and you can freeze a moment forever; allow the shutter to open for a little longer and the razor-sharp scene starts to blur; keep the shutter open for a long time and items in motion can actually disappear from your photo. When it comes to photographing city lights, there are no right or wrong shutter speeds; just know what the approximate results will be before taking the photo. When photographed with long shutter speeds, areas with a lot of foot traffic will look empty and lifeless because the moving figures will not be recorded. For areas where there is car traffic, the cars are frozen when using a fast shutter speed or rendered as light trails with a slower shutter speed, as shown in Figures 8-3 and 8-4.

It is impossible to give you the right settings to use for street photography because the lighting is different every time. It just takes a little experimentation. I suggest that you start on shutter speed priority so that you can decide how to portray the passage of time in the scene. Depending on how much of the scene is lit, the better choices for metering modes are spot metering or center-weighted metering. If the edges of the frame are really dark, using these modes stops the light meter from taking that darkness into account and overexposing the resulting photo.

8-3

ABOUT THIS PHOTO *Using a shutter speed 1/40 second actually froze the traffic into individual cars. Taken at 1/40 second, f/2.8, and ISO 1600.*

One way to increase your chances of getting the image you want is to use the auto bracketing feature of your camera. You set the auto bracketing function on your camera so that it takes a series of photos each time you press the shutter button — one with a –1 exposure value, one normal, and one with a +1 exposure value. Bracketing can help you get the image you want. If your camera doesn't have auto bracketing, you can use the exposure

compensation to take a frame that is underexposed by one stop and a frame over exposed by one stop, along with the frame that is properly exposed. It is also a good idea to shoot in RAW mode so that any color correction can be done using as much information as possible.

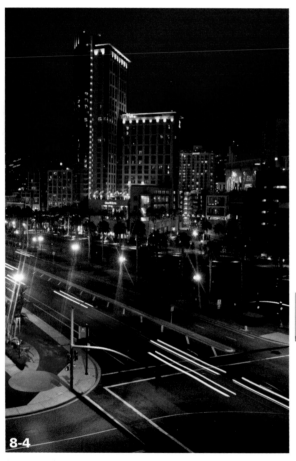

ABOUT THIS PHOTO *Using a shutter speed of 1 second rendered the moving cars as streaks of light. Taken at 1 second, f/5, and ISO 100.*

LIGHT TRAILS

The basics of photographing light trails are simple: Use a shutter speed long enough that the lights in question turn from points of light into trails as they move through the frame. There are three different types of captures in this section: the first is where the camera is stationary and the subject is moving, the second is where the camera moves along with the subject creating a background that seems to be made up of streaks of light, and the third is to use the zoom on a lens to create trails from a stationary light source.

CAPTURING TRAFFIC FLOW

Living in Southern California, one thing that I can count on is that there will be traffic every night. This means that I can capture the light trails produced by the cars' headlights and taillights. The idea is pretty simple: Leave the shutter open long enough that the camera records the lights from the cars as they drive by.

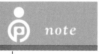 *note* Make sure that you stay safe when taking these types of photos, as you are shooting around moving cars.

To capture the light trails produced by traffic, you need a good view of the traffic where you can set up a tripod and stay safe. It is best to scout out the locations during the daylight hours so that you can see exactly what is around you. It takes a little more imagination to picture the scene without the headlights visible, but just watch the flow of the traffic. Look for roads that lead to or away from something so that the light trails created

from the cars can be used to lead the eye around the photo. Take the trails in Figure 8-5, where I photographed the cars heading to and from downtown San Diego, from a pedestrian overpass. Because it was taken late, I needed to leave the shutter open for a long time in order to get enough cars to make a good design.

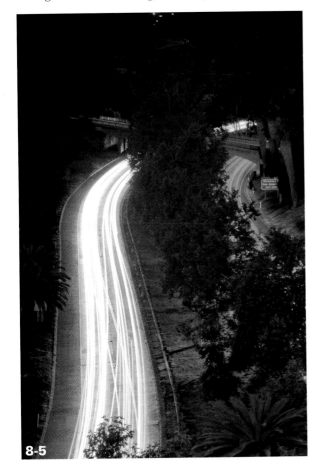

8-5

ABOUT THIS PHOTO *The bright white lights are the headlights as the traffic flows under a pedestrian bridge. The 30-second exposure allowed the light from the headlights to illuminate the surrounding area. Taken at 30 seconds, f/14, and ISO 100.*

To capture the light trails from the cars, just follow these directions:

1. **Set the camera on your tripod.**

2. **Compose the photo and switch the focus to manual mode and don't touch the focus ring on the lens.**

3. **Set the exposure mode to manual.**

4. **Set the ISO to 100.**

5. **Set the aperture to f/10.**

6. **Set the shutter speed to 10 seconds and take a shot.**

7. **Check the exposure and the look of the image on your camera's LCD.**

 > If the image is too bright but the trails look good, then use a smaller aperture.

 > If the image is too dark but the trails look good, then use a larger aperture.

 > If the trails are too short, then use a longer shutter speed.

 > If the trails seem overexposed, then use a shorter shutter speed.

8. **Take another photograph.**

If you start to take your images right after sunset, the sky will get darker and the headlights and taillights will get brighter in relation to their surroundings. You will have to adjust the exposure as the sky gets darker.

One of the more interesting areas to photograph the light trails created by traffic is from a bridge overlooking the traffic. As you can see in Figure 8-6, the view makes for some great motion in the images; however, on the downside, I had to photograph through a fence that is set up to stop people from falling into traffic. If you face a similar situation, the key is to get the front of the lens as close to the fence as possible and try to use the widest aperture that you can.

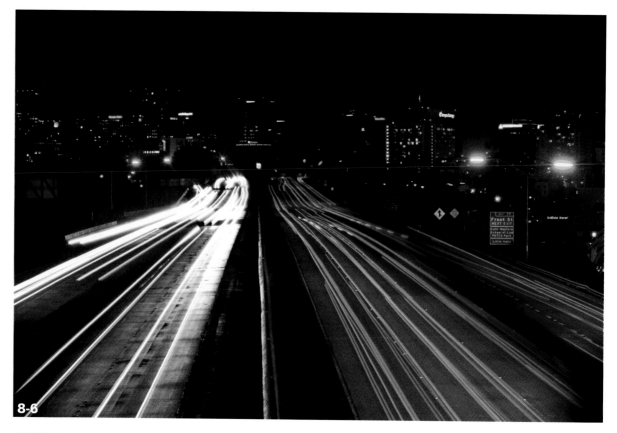

ABOUT THIS PHOTO *Traffic on Interstate 5 streams to and from downtown San Diego. The camera was set on a tripod right up against a safety fence and the live view function was used because I could not get my eye close enough to the viewfinder. Taken at 10 seconds, f/14, and ISO 100.*

MOVE THE CAMERA

When photographing the lights of moving traffic, the camera generally stays stationary and the lights move; however, you can also do it the other way, with the lights stationary and the camera moving. This works best if you have a subject that you can follow with the camera.

This technique is commonly known as *panning*, where, with the shutter open, you follow along with the subject and keep the subject in focus while the background blurs. When you do this at night, any lights in the scene that are stationary become streaks of lights. The key is to follow the subject while the shutter is open and match its movement. This works best with subjects that are moving across the frame. Start with the subject in focus and track the movement; then press the shutter release button and keep moving at the subject's speed. This can take multiple tries to get right, but that's half the fun. The taxi in Figure 8-7 was moving across the frame from left to right, but what really makes this image work is that the background is nice and bright and blurred.

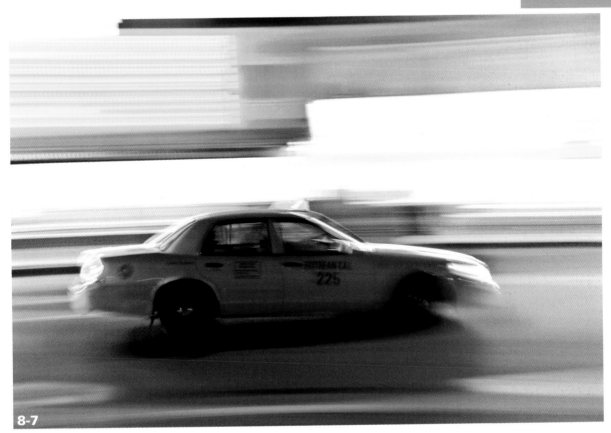

8-7

ABOUT THIS PHOTO *One of the best cars to follow when panning is a taxi cab. They are easily recognizable and the light on the roof makes them easy to follow. Taken at 1/2 second, f/2.8, and ISO 200.*

USE THE ZOOM

One technique that can give you some unusual effects when shooting light trails is to change the focal length during the exposure. To do this, you need to be photographing with a zoom lens and you need to be using at least the widest aperture that the lens has on the longest focal length. For example, if you have a lens that goes from 28mm to 300mm and from f/4.5 to f/6.3, then you need to make sure that you are using at least f/6.3 or smaller when you start photographing. This is so that the aperture doesn't change during the

exposure. For example, I zoomed from 135mm to 70mm during the exposure to get the light trails you see in Figure 8-8.

I achieved this effect by pressing the shutter release button, waiting 4 seconds, and then slowly zooming out for the other 4 seconds. As you can see from Figure 8-9, if you start out wide and zoom in, the look you get is really different — well, maybe not really different, but different enough that you should just try it both ways and see which one you like better.

You can use this technique with any light source, but those that are easily recognizable make really great subjects.

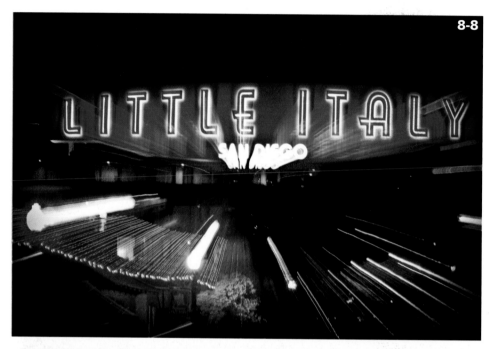

8-8

ABOUT THIS PHOTO *Many of the neighborhoods in San Diego have their own signs. This one in Little Italy is a real treat to photograph, and when shot while zooming out, you can get a really neat effect. Taken at 8 seconds, f/16, and ISO 200.*

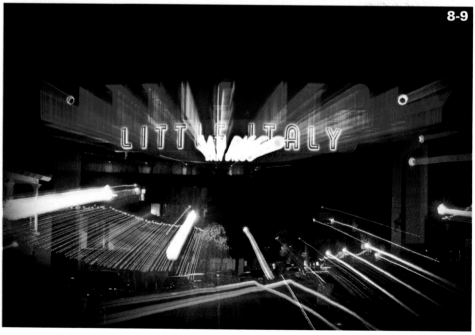

8-9

ABOUT THIS PHOTO *The exact same subject as in Figure 8-8, but instead of zooming from 135mm to 70mm, this was zoomed from 70mm to 135mm. Taken at 8 seconds, f/16, and ISO 200.*

NEON

In urban areas, it seems that everywhere you look there is a neon sign, especially if you walk around any city center where there are restaurants and bars. This is because there is a lot of neon used in business signs, beer signs, and food signs, as well as open or closed signs.

Many times you will see multiple neon signs in the same location as they fight for your attention. Figures 8-10 to 8-13 all show examples of neon signs; as you can see, the differences can really make them interesting to photograph.

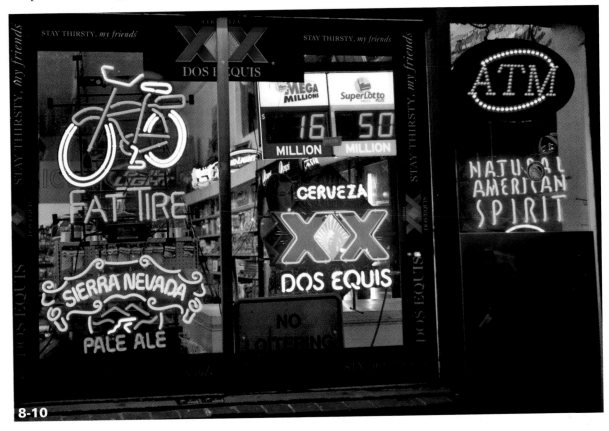

8-10

ABOUT THIS PHOTO *Neon signs in a liquor store window. Taken at 1/100 second, f/2.8, and ISO 400.*

NEON MUSEUM If you have ever wondered what happens to the neon signs when they are no longer in use, then you need to know about The Neon Museum in Las Vegas, Nevada. The Neon Museum was established in 1996 as a place to collect and display neon signs because neon was used a great deal in Las Vegas. If you want to visit the museum, you need to make an appointment as it is not open to the general public. The information can be found on their website at http://neonmuseum.org.

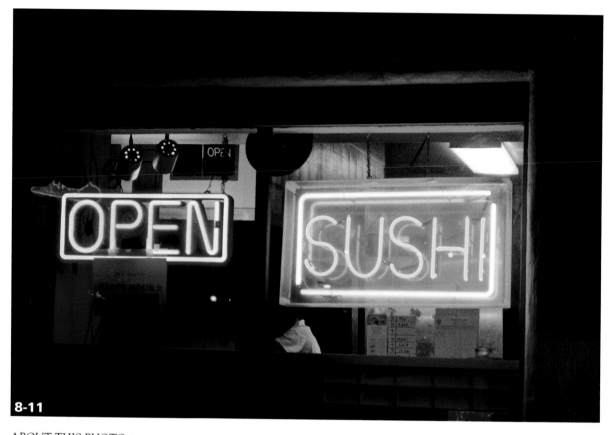

8-11

ABOUT THIS PHOTO *My local sushi restaurant, making sure that people know what they serve and that they are open. Taken at 1/160 second, f/2.8, and ISO 400.*

EXPOSURE CONSIDERATIONS

Neon signs are bright; that is part of their charm and part of their usefulness. The brightness also makes it more difficult to shoot the sign than it would seem. You do have choices: You can expose for the whole scene, which will most likely overexpose the neon; you can expose for the sign, which can underexpose the rest of the scene; or you can combine different exposures into a single frame to get the exposure right for both the scene and the neon sign. The aperture that you use will also affect the way the light bleeds on a neon sign. This bleeding of the light is called *halation*

and it relates to how the light can spread beyond the proper boundaries in a photographic image. As you change the aperture, the spread of the light changes; there are no right or wrong apertures, and knowing this means you can change the look of the light and the image by using different apertures.

To get the neon sign to stand out against the background, just follow these steps to underexpose the image slightly. The first step is to find a sign that is relatively isolated so that the composition will allow the sign to stand by itself.

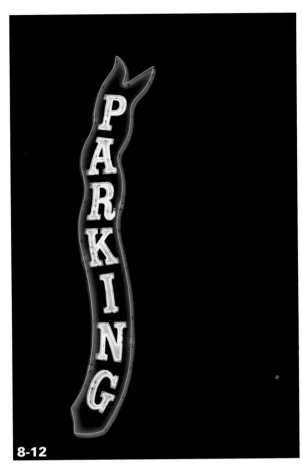

8-12

ABOUT THIS PHOTO *At times, a sign can serve two purposes: to tell you what the product or service is and where to get it, like this parking sign in downtown San Diego. Taken at 1/320 second, f/2.8, and ISO 800.*

1. Set the camera on a tripod.

2. Compose the image and lock the camera into place.

3. Set the camera to aperture priority mode and pick an aperture that you like.

4. Set the camera to spot metering mode.

5. Take a photo and check the exposure on the camera's LCD.

6. **Adjust the image by using exposure compensation.** I have found that, depending on the brightness of the sign, I usually need to underexpose by at least a full stop.

7. **Take another photograph and make adjustments if needed.**

The neon sign for the Arizona Café seems to float against a black background, but if you look closely, you can see the brick wall to the right of the sign in Figure 8-13.

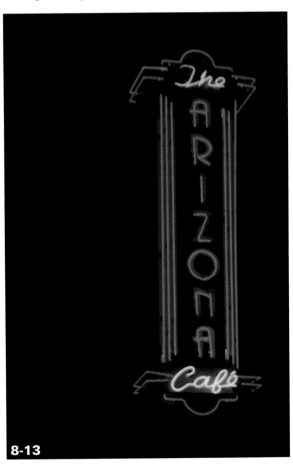

8-13

ABOUT THIS PHOTO *The Arizona Café sign seems to hang in space. Taken at 1/800 second, f/2.8, and ISO 400.*

To capture a scene that has neon in it, without underexposing the rest of the image, you will have to overexpose the neon. The idea is to strike a balance where the neon is not pure white and the overall scene is not too dark. Just follow these steps:

1. Set the camera on a tripod.

2. Compose the image and lock the camera into place.

3. Set the camera to aperture priority mode and pick an aperture that you like.

4. Set the camera to matrix metering mode or scene metering mode.

5. Take a photo and check the exposure on the camera's LCD.

6. **If needed, adjust the exposure by using exposure compensation.** In these situations, I find overexposing by 1/3 to 2/3 stop by reducing the shutter speed seems to work well, but it depends on the brightness of the other lights in the scene. If the shutter speed is now too slow to freeze the action, then you have to adjust the aperture or increase the ISO instead.

7. **Take another photograph and make adjustments if needed.**

The scene in Figure 8-14 and 8-15 is filled with neon light. I wasn't sure if I wanted to be able to see the people clearly, which meant exposing for the overall scene and not the neon, or if I wanted to expose for the neon, making the outside

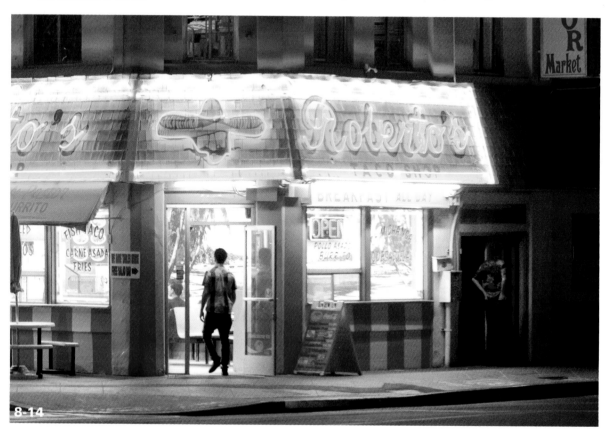

8-14

ABOUT THIS PHOTO *A local Mexican fast-food restaurant. Taken at 1/80 second, f/2.8, and ISO 1600.*

ABOUT THIS PHOTO *A local Mexican fast-food restaurant. Taken 1/250 second, f/2.8, and ISO 1600.*

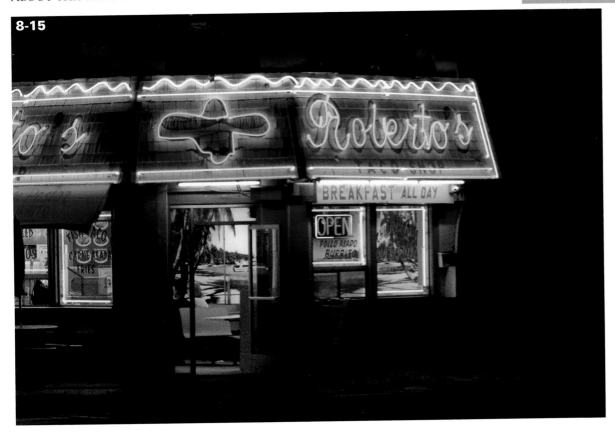

8-15

darker. So, I took shots of the building using both methods so I could decide which one I liked better later.

HDR

Photographing neon signs offers a great opportunity to use High Dynamic Range photo processing, called HDR. By taking a series of exposures and combining them into one, you can get both the neon and the surrounding areas in the same exposure without over- or underexposing either. The only problem is that the image might start to take on a fake look if the processing is pushed too far.

The key is to get a good middle starting point, then get a series of exposures that purposely over- and underexpose that middle exposure. The way to do this is to set the camera to aperture priority mode and the metering to matrix metering. Once you have the exposure that you want, adjust the settings to a –3 exposure and take a shot, then –2 and take a shot, then –1, and so on until you have seven images. Then create an HDR image using one of the software packages available. In Figure 8-16, I used Nik Software's HDR Efex Pro to create the final image from the seven exposures that I took of the sign.

x-ref

HDR is covered in more detail in Chapter 2.

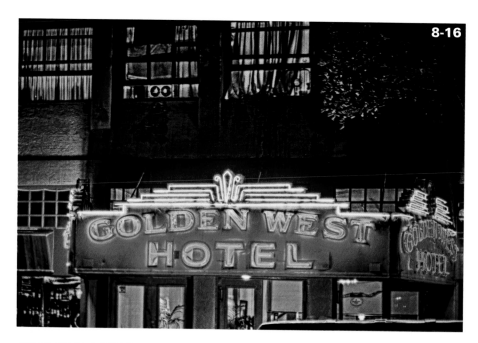

8-16

CITYSCAPES

There is nothing quite like a great nighttime cityscape image; the lights of the city make everything just look magical. The bigger and busier the city, the easier it is to get a good cityscape mainly due to the amount of light present. I have often been amazed at the actual amount of light available when looking out at San Diego. A lot goes into getting good cityscape photographs, including choosing a fantastic location, the best time, and the ideal exposure.

LOCATION, LOCATION, LOCATION

There is a saying in the real estate business that the three most important things are location, location, and location. Well, that holds true for capturing cityscapes as well. There are two distinct views to look for: the first is to get as high above the city as possible, and the second is to get away from the city and shoot from a distance.

To shoot down on a city, look for the highest point that gives you the view you want. Check to see if the location allows visitors — specifically, photographers — and tripods instead of just showing up and hoping for the best. Of course, if you are on vacation, then you have nothing to lose, so just go for it.

In the busiest areas of most cities, some of the tallest buildings are hotels, usually upscale hotels, and a lot of them have bars or restaurants on the upper floors, taking advantage of that view that you want to photograph. Many times you can just call and ask if it is possible to take photographs from that area. It really doesn't hurt to ask.

When shooting down from a high vantage point, wide focal lengths work really well. The wider focal lengths allow you to capture the grand vista of the whole scene. The twinkling lights in the offices and the traffic patterns rendered as light trails make the whole scene worth capturing. Take the cityscape in Figure 8-17 and the way the

city looks alive with the lights twinkling in the scene. I took this image from the 40th floor of a hotel in downtown San Diego with a 24mm lens.

The other option is to photograph the cityscape from a distance at ground level. This works really well when you have an unobstructed view of the skyline, and it is even better if the city is on a body of water. Many times this approach requires a longer focal length to focus in on the buildings because of the distances involved. The added advantage to this type of shot is that the longer focal length causes compression in the image, making things appear to be closer to each other than they really

are, as you can see in the San Diego skyline shown in Figure 8-18. These buildings appear to be much closer together than they actually are.

THE BEST TIME TO SHOOT

In the winter and fall, it is easier to get great cityscapes because the sun sets earlier. Offices are lit up as many people are still at their desks with office lights on, which provides more available light for your photo.

In the summer months, with the sun setting after most people leave their offices, the amount of light available is reduced. That isn't to say that

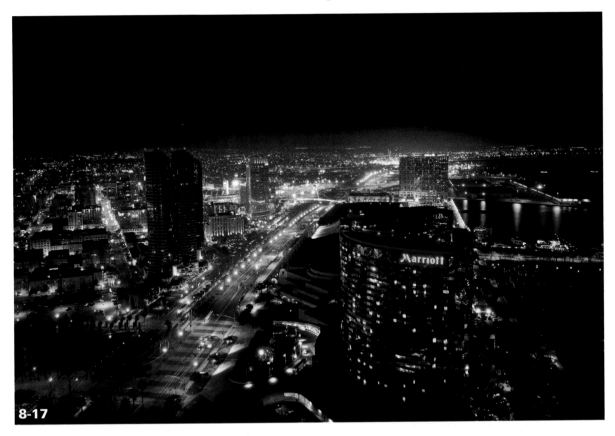

8-17

ABOUT THIS PHOTO *The city looks alive with all the lights, which add a glow to the sky. Taken at 5 seconds, f/7.1, and ISO 400.*

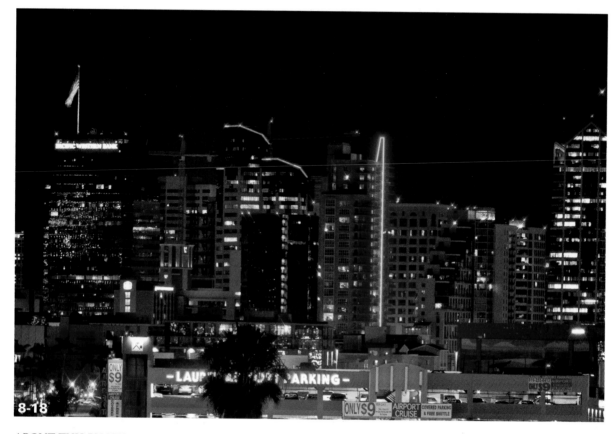

ABOUT THIS PHOTO *The San Diego skyline photographed with a long lens makes the buildings look like they are closer together than they really are. Taken at 5 seconds, f/7.1, and ISO 100.*

you should forget shooting at any other time of the year except winter and fall, but just realize that the images might not have as much light.

The direction that you photograph in also makes a difference in the final image. Facing west will catch the most color in the sky as the sun sets, while facing east could allow you to catch the reflections of the setting sun's colors in the glass buildings and make the photos something special.

The best time to photograph is right after the sun sets, when some of the colors of the day are still bleeding into the sky. Take the photo of the San Diego skyline that I shot from Coronado Island (shown in Figure 8-19); you can see that the sky

hasn't gone completely dark yet, and the clouds are starting to take on the color of the sky and the city.

EXPOSURE CONCERNS

Metering a changing sky with the gradually increasing brightness of the city lights can be tough. This is one of those scenarios where practice can really pay off, but to ensure the closest starting point, do the following:

1. **Set the camera on a tripod.**

2. **Compose the image and lock the camera into place.**

ABOUT THIS PHOTO *The San Diego skyline photographed from Coronado Island. I took this picture in the winter months so that the office lights were still on and the sun had already set, even though it was only 5:30 pm. Taken at 10 seconds, f/10, and ISO 100.*

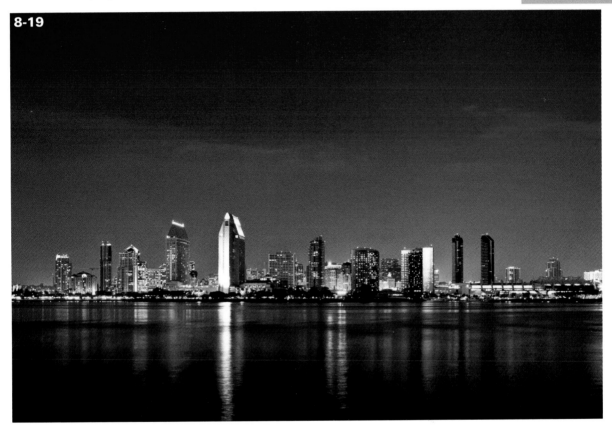

8-19

3. Set the ISO to 100.

4. Set the exposure mode to auto.

5. Set the metering mode to matrix or scene metering.

6. Press the shutter release button halfway down to get a light meter reading.

7. Change the exposure mode to manual and apply the settings shown in the previous step.

> Either increase the shutter speed or reduce the aperture by 1 stop and take a test photo.

> If the image is too light, increase the shutter speed or decrease the aperture by another stop.

> If the image seems too dark, decrease the shutter speed by 1/3 stop or open the aperture up 1/3 stop.

Once you have the settings that give you the proper exposure, you have to keep adjusting them as the scene changes and the sky gets darker, as I had to do to capture the image in Figure 8-20. When photographing the San Diego skyline, I needed to constantly make adjustments to the exposure. Because the light is constantly changing, there is no single setting that will work all the time. Shoot the scene, check the LCD display on the camera, make adjustments, and try again.

ABOUT THIS PHOTO *The San Diego skyline with the ferry in the foreground. The light rapidly changes right around sunset, and a couple of minutes can make quite a difference. Taken at 2.5 seconds, f/10, and ISO 100.*

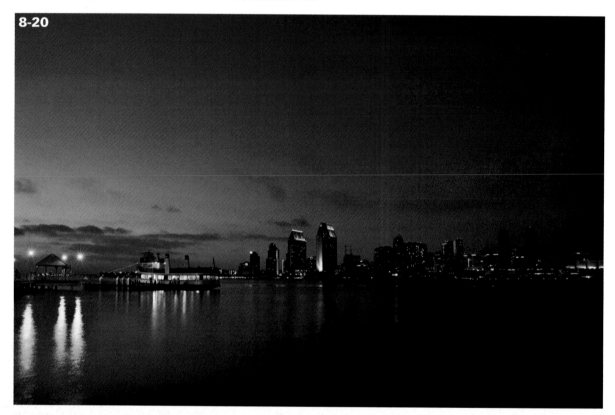

8-20

STORM LIGHT AND LIGHTNING. Storm lighting and lightning make for stunning photos. However, photographing lightning is tough for a very simple reason: You never know where or when it will strike. Some areas of the world get many more lightning storms than others, and if you do live where there are a lot of storms, then your chances of capturing this phenomenon increase.

When trying to photograph storms and lightning, absolutely do not put yourself in harms way trying to get a photo. That said, there are two ways to capture the lightning: Use a tripod, the Bulb mode, and a cable release to keep the shutter open. In this method, you set the ISO as low as you can, set the aperture to a small opening like f/11, and start taking photos of the area where you think the lightning may strike. If the lightning is very close, you may want to try a smaller aperture, and if it is far away, you may want a bigger aperture. The second method is to use a trigger device that takes a photo when lightning strikes. This method can be very useful if it isn't very dark out and you can't do long exposures hoping to capture the lightning randomly. I would still suggest a longer shutter speed to give the rest of the scene some time to be captured. A device like the Triggertrap (www.triggertrap.com) would be an example of a triggering device you could use for this.

Assignment

Capture a cityscape at night

This assignment for this chapter is to capture a cityscape at night and then post your favorite image to the website.

Where you shoot from is important when planning a cityscape photo. To get this photo, I set up on Coronado Island before the sun set, and with plenty of daylight left, I set up my tripod in an area that would not interfere with any pedestrians and wouldn't be blocked by the ferry when it pulled into port. As the sun set, I started to take a series of photos, adjusting the exposure each time; I needed to use longer and longer shutter speeds to get a proper exposure. As I moved into the very long exposures, I noticed that the images were losing their sharpness, so I increased the ISO so that I could use faster shutter speeds and hopefully keep the image sharp. This is my favorite of the series I took. It was taken at 2 seconds, f/10, and ISO 1600.

To keep the image as sharp as possible, and to allow me to keep an eye on my surroundings, I used a cable release to trigger the shutter on the camera. This way, I didn't have to touch the camera and move it in any way. I used a long lens to get in close and then cropped the image even more in postproduction. The only real change to the image that was done on the computer was to adjust the white balance of the image to get the colors closer to how I wanted them.

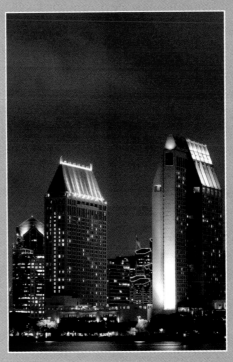

Remember to visit www.pwassignments.com after you complete the assignment and share your favorite photo! It's a community of enthusiastic photographers and a great place to view what other readers have created. You can also post comments and read encouraging suggestions and feedback.

LIGHT PAINTING BASICS

LIGHTING TOOLS

PAINTING WITH LIGHT

ABSTRACT IMAGES

Light painting could be considered the truest form of photography because it is exactly what the word photography means: drawing or painting with light. The idea behind light painting is deceptively simple and the results can be stunning, but it helps to be set up correctly from the start and to have an open mind and some patience. Light painting is not about getting the same image over and over again, but creating an individual piece that can't be replicated. No two light paintings will ever look the same because the way the light is moved when doing the painting will never be exactly the same way twice. Light painting is all about experimentation, so take a deep breath and dive right in.

LIGHT PAINTING BASICS

A dark room or location, a camera, an interesting subject, and a light source are all that you really need to start painting with light. Well, that and a great deal of imagination, patience, and foresight. There are two different types of light painting in this chapter: the type where you use a light to reveal the subject and the type where the light is the subject. Both of these methods usually take place in darkened areas where the camera is set up and the shutter is held open for extended periods of time. This takes a delicate touch and a plan. There is a second type of light painting and that is when the light is the subject. These types of images are more abstract and are really fun to create.

USE LIGHT TO SHOW THE SUBJECT

Light painting takes some imagination because you can't see the effects of the light until after the exposure is completed. The fun part is that you can really control exactly what parts of the subject are lit — the direction and the intensity of the light used — and you can create lighting that would not be possible any other way. Remember

that because you can move the light around, you can really light up any part of the subject and from any angle. The type of lighting tool you use will also affect how the image is illuminated. A flash or large flashlight throws out a large amount of light, a lot like throwing a whole bucket of paint at a canvas. Using a smaller flashlight with a tightly controlled beam of light is more like painting with a small brush.

Deciding how the final image needs to look will keep you focused on where you should paint with the light. You can use the angle of the light to show details or hide them. Take Figures 9-1 and

9-1

ABOUT THIS PHOTO *Using a small flashlight to show the details of this mask from Tahiti really brings out the features in the areas where I painted. Taken at 42 seconds, f/18, and ISO 100.*

9-2, for example: By changing the way the light illuminates the wooden mask, I can create different-looking images of the same subject.

9-2

ABOUT THIS PHOTO *The same mask as in Figure 9-1, but the direction of the light and the areas that are lit are different, rendering a different look to the same subject. Taken at 42 seconds, f/18, and ISO 100.*

USE LIGHT TO FILL IN DARK AREAS

At times, you can use light painting to add a little fill light to a scene and draw attention to a certain area or at least reveal details that would otherwise be hidden. Because this is usually done to an existing scene that is already lit, the idea is to get a proper exposure for the scene, and then add some light to the objects that are a little too dark. To get the best results, you need to follow a two-step process. First, you need to get the proper exposure for the whole scene; then, with those settings in the camera, you add light with one of the light painting tools described later in this chapter. Here are the steps I follow:

1. Set the camera up on a tripod to control the movement of the camera.

2. Compose the image through the viewfinder, or use live view if your camera has that function.

3. Pick the exposure mode you want to use.

4. Pick the metering mode you want to use.

5. Take a photo of the scene.

6. Check the exposure of the overall scene, ignoring the part that you will illuminate later.

7. Once the exposure is set, make a note of the exposure settings.

8. Switch the camera to manual exposure mode and enter those settings from step 7.

9. Use the cable release to trigger the shutter and paint in the area that is too dark with a light.

10. Check your camera's LCD between each image until you have the results you want.

Using the light painting basics in this manner can help you create more interesting images. In the scene in Figure 9-3, by adding the light to the rocks on the right of the image, I was able to bring out the detail in the rocks while keeping the ocean looking smooth.

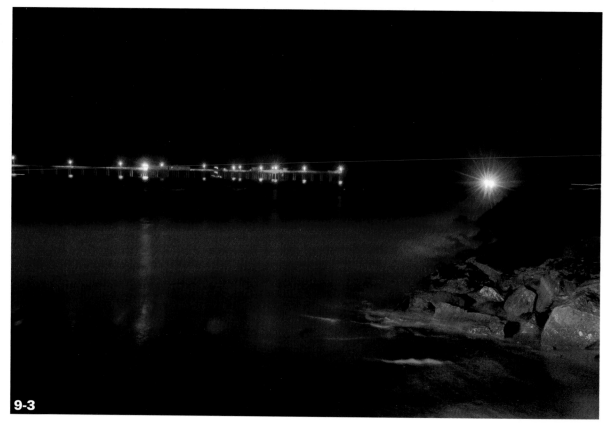

9-3

ABOUT THIS PHOTO *During a long-exposure photograph at the water's edge, I wanted to add some light to the rocks, so I painted in the details using a small but powerful LED flashlight. Taken at 47 seconds, f/14, and ISO 320.*

WHEN THE LIGHT IS THE SUBJECT

Using the light to illuminate the subject is one way to paint with light, but there is another way that you can create interesting images with long shutter speeds and a light source: Have the sensor record the light source itself and the patterns that are created. I captured the pattern in Figure 9-4 by letting the camera record the light created by a couple of sparklers as they were moved through the frame. This is very similar to recording light trails, but because you have control of the light, you can make the light do what you want it to do.

If you don't have any sparklers handy, you can use this same concept to make very interesting patterns with a flashlight and some string. They might not have the same human element as the sparklers, but the symmetry and beauty created by the patterns of light make them enjoyable to view and to create.

ABOUT THIS PHOTO *I handed some sparklers to a couple of assistants and had them draw spirals in the air. This type of photography is fun to create. Taken at 14 seconds, f/10, and ISO 100.*

9-4

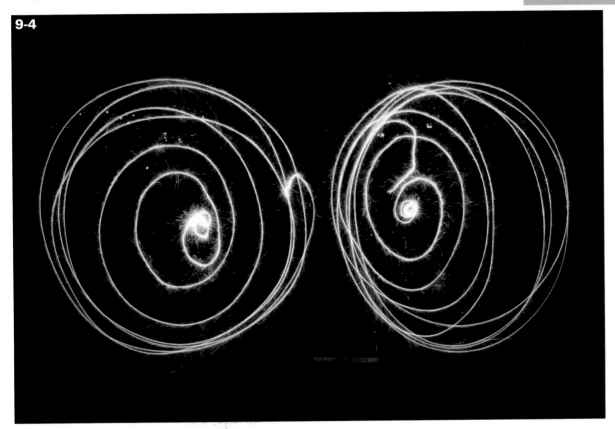

LIGHTING TOOLS

Think of the light as your paintbrush; different sizes of beams are like different sized brushes, and the different powers of the flashlights are like different amounts of paint. You can use anything that produces light as a paintbrush. Some of the more common light "paintbrushes" are flash units, flashlights, and sparklers. They each work in the same way, producing light that is captured on the camera's sensor, but they produce different effects. Of course, you don't have to feel constrained by using these tools; you can actually use anything that produces light, from a cell phone to a car headlight.

THE FLASH

The flash unit is not made for light painting, but it can be used with great success to create cool images. One of my earliest experiments with this type of photography was in college when I would photograph people from my dorm sitting next to themselves. For this type of image, I set the camera on a tripod and locked the shutter open. While the subject was sitting on the left side of the scene, I would trigger the flash from the right. Then, while the shutter was still open, I would have the subject change sides and trigger the flash again, this time from the left. This created a single frame with the same subject in two places.

The best way to use the flash for this type of light painting is to create a snoot for the flash so that you can really control where the light is going. Then all you do is aim and press the test button on the flash. One of the good things about using the flash is that there are a wide variety of small flash accessories, including grids and snoots from LumiQuest and Honl. These accessories can help to mold the light that reaches the subject.

- **Snoots.** A snoot is just a tube that goes over the flash head and helps to contain and direct the light. The snoot can be made with just about anything that you can wrap around the flash head. The Honl Speed Snoot is created out of ballistic nylon and comes in different versions with different-colored insides. The different-colored insides can affect the color of the light, with the gold version adding a little warmth to the light.

tip

A great do-it-yourself project is to create a snoot using an empty pasta box and some black gaffer tape. Just cut the ends off the box and use the tape to make nice edges. Then slide it over the head of the flash.

- **Grids.** Grids are light modifiers that are made to reduce the spread of light by having it go through a bundle of small tubes as it leaves the flash head. The size of the tubes affects the spread of the light — the smaller the grid, the tighter the light.

- **Gels and gel holders.** Gels are small pieces of acetate that go over the front of the flash and change the color of the light that is produced. You can buy gel kits that come with a variety of different colors and usually a way to attach

them to the flash. For example, the LumiQuest gel holders make it easy to add and remove gels from the front of the flash and will work with other accessories at the same time. That means that you could have a gel over the flash and a snoot on at the same time.

- **Softbox.** Softboxes are usually used in portraits and are mainly used with studio strobes, but you can also get a smaller softbox that works on small flash units. These modifiers take the small, hard light source and make it a bigger, softer light source. Because the light has to travel through the softbox material, the light is also less intense. This would give you a very large soft light to use on your light painting, with soft edges. I used this for backgrounds in many of my light painting edges because it gives a muted softer light, and I like that look.

- **Gobo.** Gobo is a catchall term for anything that goes between the light and the camera. This can be a piece of board or cloth or anything. There are some pre-made pieces that attach to the small flash units and stop the light from spilling out to the lens. This allows you to light parts of the scene without the light spilling everywhere.

Your flash can be a very powerful light, and when used really close to the subject, it can easily overexpose the scene. I have found that cupping my hand over part of the flash head, in other words, having my hand act as a gobo, works well, as it did in Figure 9-5. I first lit the background bottles with a burst from my flash from the right with my hand cupped over the flash so the light didn't illuminate the bottle in front, and then I fitted a

ABOUT THIS PHOTO *This bottle of Rhum was purchased in Tahiti many years ago, and I wanted to make it stand out against the other bottles. I used a very shallow depth of field, so I needed to make sure that I didn't use too much light, as it would easily overexpose. Taken at 13 seconds, f/2.8, and ISO 100.*

9-5

snoot on the flash and aimed it at the bottle from the left and fired the flash again. As the room was dark, I was able to leave the shutter open the whole time for a total of 13 seconds.

FLASHLIGHTS

Open up the junk drawer in most kitchens and you will find a flashlight; if you are a little more organized (I'm not), then you might even have the flashlight in an easy-to-find spot if there is a power outage. My point is that most people have at least one flashlight in the house. I find that flashlights are the best light-painting tools for a wide variety of reasons:

■ **Availability of different strengths.** The light output of flashlights is described in a couple of ways; lumens and candlepower. Candlepower is actually based on the light output of a specific candle. The more candlepower, the brighter the light. The other rating is called a lumen and it a measurement of how much illumination a flashlight (or any light) provides. Again, the more lumens, the brighter the light. These measurements are only useful as a guideline because other factors, like the distance between the flashlight and the subject and the strength of the batteries, come into play. The most powerful flashlight with

nearly depleted batteries is not going to be very powerful at all. It is also very easy to judge with your eyes the difference in power once you have the flashlight and can compare it to others you have, so the candle power and lumens ratings are most useful when comparing flashlights in the store. For example, if you compare the E1L Outdoorsman to the E2L Outdoorsman, both by Surefire, you will see that the E1L is 45 lumens and the E2L is 60 lumens, making it brighter. Keep in mind that the more powerful the flashlight, the less time the shutter needs to be open. The power of the flashlight can also be greatly influenced by how new the batteries are.

- **Multiple sizes.** From tiny penlights that take a single AAA battery to giant handheld spotlights, there is a flashlight for every occasion. As you can see from Figure 9-6, not only do I have a variety of flashlights, but I have a handheld spotlight as well, which is how I lit the flashlights for this photograph.

- **Adjustable focus.** Many flashlights have an adjustable focus of the beam of light, which allows for different effects. This feature is found on the Maglite brand of flashlights and many other brands. Adjustable focus allows you to change the size and intensity of the light, making the single flashlight more versatile.

- **LED flashlights.** Many newer flashlights use an LED bulb, which can be a lot brighter and more powerful than the old-style incandescent bulbs; they also come in different light colors.

- **Change the color of the light.** Changing the color of the light beam is easy to do using a colored gel. I just use small pieces of gel and a

9-6

ABOUT THIS PHOTO *These four flashlights all have very different illuminating qualities. The smallest light is the one that I use later in this chapter to produce the physiograms. Illuminated by a handheld spotlight and taken at 2.3 seconds, f/9.0, and ISO 100.*

rubber band to attach them to the flashlight. The thicker the gel, the more the light is diffused.

- **Availability and price.** This is one piece of photography gear that is really inexpensive. You can pick up a decent flashlight for less than $10 at a hardware store.

As you start to experiment with light painting, using a variety of different flashlights is not uncommon. For example, the image in Figure 9-7 was created with three different flashlights; first I used a bigger light to paint in some of the background, and then I used two different flashlights to paint in the subject. These two flashlights had slightly different colors due to the different bulbs, creating different colors in the image.

9-7

ABOUT THIS PHOTO *A Fender leaning up against a wooden fence made for an interesting subject. A powerful LED flashlight illuminated the fence, while the guitar body was painted with a pair of smaller flashlights to control the light. Taken at 18 seconds, f/18, and ISO 100.*

SPARKLERS

Sparklers are great for painting with light and can create great images. However, they are also dangerous. I have included them here because of how nicely they work, but I cannot stress this enough: You need to be very careful when you use them because no matter how safe they seem, sparklers are burning at an extremely high temperature and can cause burns or ignite clothing and other materials. That warning aside, with some practice and some luck, you can use them to create fun images, like the heart in Figure 9-8.

You should follow some precautions when using sparklers to create light painting:

- Don't let young children play with the sparklers, especially if they don't understand that they can cause burns.

- Make sure there are no flammable items in spark range, especially clothing items.

- Use outdoors, but make sure that the area is not too dry, as you do not want to start a fire.

- Make sure that they are legal in your area before using them; it isn't worth breaking the law to get the image.

Sparklers make great tools for writing or drawing with light, where the light trail is the actual subject. It is possible to use them to illuminate another subject, but because the sparklers are really bright, they work best as the subject of the image. However, if you want to use them to illuminate a different subject, it is best to outline the subject with the sparklers and make sure that the subject isn't flammable. Just trace the edges of the subject while the shutter is open, and if it is a big subject, then use a friend with another sparkler to help. While you outline one part, have them outline another at the same time, but again, be careful; the sparklers are extremely hot.

ABOUT THIS PHOTO
Drawing in the air can be a challenge, but this heart came out just right. Taken at 5 seconds, f/10, and ISO 100.

PAINTING WITH LIGHT

To take the actual photograph, you need to set the subject up in an area that is very dark because any ambient light will be picked up by the camera's sensor and will appear in your photo. For small subjects, you can photograph them inside any room that can be made dark. The best time for this is at night, where the ambient light is minimized. To make a room as dark as possible, I use black matte foam board in the windows to block out light from passing cars or neighbors' homes.

When photographing outside and painting with light, you have to take into account the ambient light that may be present from the moon or any other light source. In these situations, you might need to work faster or with a more powerful light so that the shutter does not stay open for too long.

The basic steps for shooting indoors or outdoors are simple: Just set the camera up on a tripod so it doesn't move, aim it at the subject, and adjust your camera settings (with your best guess). Then open the shutter and use a light to paint in the subject. The real challenge with this type of photography is working without a safety net. I know that when shooting regular images, I can always set my camera to one of the automatic modes and probably get a good image, with average exposure, good focus, and a workable white balance. None of that is possible when it comes to light painting. It is a very primitive type of photography that all takes place manually. I created the image in Figure 9-9 by placing the flower against a black background and then painting in the areas using a small LED flashlight. It can take a while to get right. I would be embarrassed to show some of my earlier attempts, but suffice to say that it can take

9-9

ABOUT THIS PHOTO *Flowers make great subjects for light painting, like this sunflower which was painted from the center out, drawing the viewer's eye to the details. Taken at 12 seconds, f/20, and ISO 100.*

more than a few exposures to get the hang of; while I like all the images in this chapter, I am constantly trying to get better. If nothing else, practicing this type of photography can really help you understand the way light works in a photograph as you get complete control over the light.

SHOOTING IN MANUAL MODE

To create a light painting, you have to use the manual exposure and focus modes on your camera. The reason why light painting is impossible to do in any of the exposure modes other than

manual is because there is no way for the camera to read the light in the scene until you apply it, which only happens after the shutter has been opened. The lack of light when pressing the shutter release button is also the reason why the camera's auto focus will not work: There is nothing for the camera to see. To set the focus, you need to do the following:

1. **With your camera securely mounted on a tripod, compose the image with the lights on.** If shooting outdoors, use a flashlight to illuminate enough of the scene to get the proper composition.

2. **With the lights on or with a flashlight, use the camera's auto focus aimed on the subject that you want to have in focus.**

3. **Switch to manual focus either on the lens or the camera body depending on your camera and lens, and don't touch the focusing ring on the lens.** Check your camera manual to find out how to do this.

As long as the camera and the subject remain in the same positions, you now have a properly focused image.

Each time you move the camera or the subject, even a tiny bit, you need to adjust the focus, making sure that the critical element in your image is in proper focus. For Figure 9-10, I made sure that the focus was really on the top part of the peacock feather and checked the focus between each light painting attempt because even moving the flashlight close caused a small breeze that could have moved the feather and made for a blurry image.

9-10

ABOUT THIS PHOTO *This peacock feather was placed against a black background and was painted with a small led flashlight. Taken at 12 seconds, f/16, and ISO 200.*

tip Check the focus every couple of frames by using the LCD screen on the back of the camera zoomed into 100 percent preview and centered on the focus point.

Now that the focus is set, make sure that the exposure mode is set to manual; because the light present in your image only appears after the shutter is opened, there is no way for the camera to accurately determine the white balance of the light. The white balance is one of the things that you can adjust easily in post-processing, but there are ways to get close to the results you want before you ever take a photo. The key is to set the white balance for the light you are going to be using and to not allow the camera to use the auto white balance setting, which will change from image to image, even if only very slightly.

THE PROPER EXPOSURE

Because it is impossible to measure the light in the scene before the shutter is opened, the camera's metering system is useless for this type of photography. There are times when you will add light to a scene that already has ambient light, so you will need to balance the light.

So, if you can't measure the light, then where do you start and what settings should you use? The initial settings that I like to use are ISO 100, f/8.0, and 30 seconds. If your camera has a Bulb mode and you have a cable release, then you can use longer exposure times. However, by using the longest shutter speed available on the camera, you don't actually need to buy any extra equipment.

Check the LCD screen on the back of the camera after you have created each image. This is where you see whether the vision you had while doing the painting actually worked out the way you thought it did. Because the actual light used in the exposure comes from the flashlight or flash, you don't have to change the camera settings much to control the exposure; you can just change the amount of light you used. If the image is too dark, just paint a little longer, if the image is too bright, paint a little less.

When I do this type of photography, I like to use the cable release and the camera set to bulb mode so that when I think I have added enough light I can stop the exposure and don't have to wait for the full 30 seconds. Or sometimes I have found that 30 seconds isn't quite enough, like in Figure 9-11 where I needed a full 31 seconds to paint in the details of the Nikon D3.

At times the area where you practice your light painting may not be completely dark; that's when I use a smaller aperture like f/16 or even f/22 to allow as little unwanted light in as possible during the exposure and I use a more powerful flashlight and a slower shutter speed. I also usually set the ISO as low as the camera goes because I want to really use the light to paint in the photo and don't want the sensor very sensitive to the light. This type of photography is all about experimenting, and part of that is to play with the exposure settings. Try a shallow depth of field and see if that affects the amount of time you can keep the shutter open before being affected by ambient light, or try a very bright flashlight for a short period of time compared to a less intense light for a longer period of time. There is no right or wrong set of exposure settings.

9-11

ABOUT THIS PHOTO *Using a small flashlight, I painted in the details of the Nikon D3 camera, making sure I let the light play over the front of the lens as well. Taken at 31 seconds, f/22, and ISO 200.*

PLAYING WITH THE LIGHT

It is essential, in order to take a good photo, to keep the light moving. If you keep the light aimed at a single spot, then you will end up with an area that is overexposed, or a hot spot, in your image. When you keep the light moving, the light will look softer and more appealing. This gives the image a more painted feeling.

One of the more difficult steps in this process is turning the light on and off, especially when working in the dark. If the light is aimed directly at the subject, then once the light comes on, you have to start moving it immediately. The low-tech method that I have used successfully is to just cup my hand over the end of the flashlight, allowing the small amount of light that escapes to enable me to aim the flashlight where I want to start. It is important to have a plan in mind before you turn on the light. Know where you are going to start and end, and which areas you want to illuminate more and less. For the cowboy hat in Figure 9-12, I knew I needed to get light on the front of the hat to get the detail, and I also knew that I wanted some light in the background to show a little of the colors of the blanket. I started with the flashlight on the background, then came to the front and painted in the details on the hat.

9-12

ABOUT THIS PHOTO *This cowboy hat has seen better days, but it was this characteristic that made me want to photograph it in the first place. Taken at 29 seconds, f/2.8, and ISO 200.*

PHOTOGRAPHING PEOPLE

Light painting can work really well when it comes to photographing people, but you need to make sure you have a model or subject that can hold still during the actual light painting process, as any movement when the light is on could cause the image to look out of focus. There are a few things that you can do to help this process:

■ Start with the face and move down because it is the face that usually moves first.

■ Use a smaller aperture so that the depth of field is deeper, which keeps more of the subject in the zone of acceptable focus. Then, if there is any movement, it might not make as much difference.

■ Practice to get an idea of the amount of time and light needed first, and then have the model get into the pose.

■ Use a pose that is easy to maintain and allow the subject to rest between shots.

When photographing the scene in Figure 9-13, I made sure that the subject was comfortable and I had him angle his head down as I didn't want to shine the light directly into his eyes and possibly cause damage due to the intensity of the light. I took multiple shots of the same image. I liked this one the best even though there is a slight blurring to the head where the model moved.

When photographing people in this manner, don't forget to paint some of the light into the background as well. Because the light can move through the image, you can also add light behind the subject without actually lighting the subject. Just make sure that your subject understands that this is not an exact method and that it might take a couple of tries to get it right.

POSTPRODUCTION AND IMAGE STACKING

The same process that is used to create star trails from multiple images can be used to combine multiple images when light painting. The idea is to take multiple images of the same scene and combine them into a single image using software. There are two different ways to combine the images in postproduction: the first is to use the different layer blend modes to combine a series of images, and the second is to use the Image Statistics script that is built into Adobe Photoshop Extended.

9-13

ABOUT THIS PHOTO *I wanted the guitar to be the focus of the image so I made sure to paint it with a little more light to get it to have the brighest spot in the image. The viewer's eye will always be drawn to the brighest area in the image. Taken at 25 seconds, f/16, and ISO 100.*

x-ref

For more details about creating star trail photographs, see Chapter 7.

When combining multiple images in Photoshop or Photoshop Elements for this technique, it helps if the different images are shot the same way, meaning the camera was locked into a tripod during the different shots. The images then need to be opened in Photoshop and combined into a single file with multiple layers. If you are using Photoshop Lightroom to sort your images, then select all the images that you want to stack together, right-click them, and choose Photo ⇨ Edit in ⇨ Open as Layers in Photoshop. If you are using Adobe Bridge to sort your images, then select the images that you want to combine and click Tools ⇨ Photoshop ⇨ Load Files into Photoshop Layers. When using Elements, you have to manually combine the layers. Just do the following:

1. **Open Elements.**

2. **Open the files that you want to combine.**

3. **Use the Move tool to grab an image and, with the left mouse button held down, hover over the filename on the top bar where you want to drop the file.**

4. **Once the destination is showing on the screen, press Shift and release the left mouse button.**

5. **This automatically aligns the image with the edges of the frame, and because all the images are of the same subject, it aligns properly.**

6. **Repeat for all the files you want to stack.**

In Photoshop and Elements, you can now start to change the layer blend mode to Screen or Lighten. Then you can adjust the layer's opacity and even the order of the layers to get the result you want. Because these adjustments are a personal preference, there are no right or wrong settings. If you find that you like a certain combination of Screen and Lighten modes, then save the file and try a different order or a different opacity. The image will change each time and you will be better able to judge what you like. Figure 9-14 was not the first combination of layers and opacities that I tried, but it was my favorite.

9-14

ABOUT THIS PHOTO
This image is a composite of seven different light paintings of my hiking boots combined in Photoshop using the Screen and Lighten modes and with opacity changes to some of the layers. Each image had a different shutter speed, but the aperture was set at f/13 and the ISO at 100.

The second method of combining multiple light painted images into a single image is exactly the same as described in Chapter 7, but instead of using star trail photos, use a collection of light painted images and see what the results yield.

ABSTRACT IMAGES

Taking painting with light one step further can create some great abstract images. These images include moving the light source in a pattern and recording the results, and randomly allowing the camera to record a long exposure while in motion. Figure 9-15 was created by allowing the camera to record the light, and was a lot easier to create than it looks.

LIGHT PATTERNS

When I was a child, I saw one of those toys where you have a pendulum suspended over sand, you swing the pendulum, and it creates a design in the sand. You can do the same thing

with a flashlight and a string suspended over your camera, and it really is very easy to do. It takes a few minutes to set up, after which you can take multiple images.

The technical term is physiogram, and by following these steps, you can start creating your own in a few minutes:

1. **Place your camera on a tripod facing upward.** If you don't have a tripod that allows your camera to be pointed straight up, then you can set your camera on a table or the floor; just be sure not to move it. Attach a cable release or a remote control to trigger the camera without moving it.

2. **Suspend a light directly above the camera on a piece of string.** A small flashlight works great.

3. **With the autofocus on, hold something bigger than the flashlight where the light source will be, and press the shutter release button until the camera focuses.**

9-15

ABOUT THIS PHOTO *The light from the flashlight creates a pattern as it swings. The pattern is determined by the speed of the flashlight and the arc it is swinging. Taken at 61 seconds, f/10, and ISO 100.*

4. **Without touching the lens or changing the focus, switch the camera or lens to manual focus mode.**

5. **Set the camera exposure mode to manual.** Start with these settings: 30 seconds, f/10, and ISO 100. If your camera has a Bulb mode and a shutter release that locks, then you can go for much longer. I have made many physiograms that range from 60 to 90 seconds.

6. **Start the flashlight swinging in a circular motion (or any motion) and press the shutter release button.**

7. **Check the exposure and focus.** Make any necessary adjustments, and then do it again.

This is one technique where you really can't go wrong. You might really like some of the simple designs or you might want to try some more complex ones. Here are some techniques you can try to create different patterns and effects:

■ **Change the color using a gel.** This is the easiest effect to apply — just hold a piece of colored gel over the lens for all or part of the exposure. The white trails will turn whatever color the gel is, creating more

complex-looking patterns. For Figure 9-16, I changed the color of the light from red to yellow by using colored gels, and then to white for a second or two with no gel to get the colors you see.

- **Change the direction of the light.** This is a great way to get more complex shapes and patterns. You start the flashlight swinging and then start the exposure; when you think it is enough of the first pattern, just put a piece of black board over the lens, start the flashlight swinging in the second direction, and then remove the black board. For Figure 9-17, I not only changed the direction of the swinging light but I changed the color as well.

- **Change the focal length.** If you use a zoom lens, try changing the focal length during the exposure. For example, if you use a 24–70mm lens, then try starting at the 24mm focal length and zoom out as the flashlight starts to lose momentum. This can create different effects, and the pattern seems to either get closer or farther away as the focal length changes.

This is a great photography experiment that you can try any evening, and no two light patterns will ever be exactly the same. Just a quick word of warning: This can be really addictive and you might find yourself spending hours making different patterns.

9-16

ABOUT THIS PHOTO *The color change in this pattern was all done in the camera — or more accurately, in front of the camera — by using colored gels over the front of the lens. I used a red gel, then quickly changed it to a yellow gel, and then removed the gel altogether at the end. Taken at 47 seconds, f/10, and ISO 100.*

9-17

ABOUT THIS PHOTO *This pattern is actually two separate patterns in one exposure. The first was done with a blue gel over the lens, then the lens was covered and a new pattern was started with a red gel placed over the lens. Taken at 63 seconds, f/18, and ISO 100.*

CAMERA TOSS The camera toss is a technique where you just toss your camera in the air and see what happens when the shutter release is triggered. There is no really good reason to do this other than that the resulting images, many times just by luck, are really fun and the process is really fun. A word of warning: Don't do this with your top-of-the-line or brand-new camera that you need for work. I am pretty sure that if you send it in for repairs and you are asked what happened to your camera, the answer of "I threw it in the air and failed to catch it on the way down" will usually end up with the repair folks just laughing at you and returning the camera. But if you have a spare camera body and a relatively cheap lens, then this could be a great thing to try. Start by looking for areas with multiple colors of light to get some interesting patterns.

You will use the timer function or a long shutter speed. Press the shutter release button and toss the camera into the air. Catch the camera. View the results on the camera's LCD screen. Then, repeat as many times as you want.

In theory, this looks pretty easy, but in reality this technique requires a lot of practice and a fair amount of luck to get it right. Because the shutter will only be open for a few seconds, you should set the exposure by picking a relatively high ISO (in the 800 to 1600 range) and a wide aperture, say f/4.0 or f/5.6, and pick a subject that has some bright lights. Then press the shutter release button and toss the camera up.

Assignment

Create a light painting in your home

This assignment is to create light painting with subjects you already have around the house. The first part of this assignment is to pick a good subject, something that will be fun to experiment with and that you can light from various angles and get different patterns. Then upload the image to the website and see what others came up with.

For this assignment, I chose an orchid that I have at home and set it up on a small table with a piece of black matte foam board as a background. I wanted to use the LED flashlight because I liked the color of the light it produced, but because it is quite bright I knew I would have less time to work with it. I set the shutter sped to bulb mode, used a very small f-stop of f/22, and set the ISO to 200. The total time I had the shutter open for this exposure was 10 seconds.

My idea was to trace the orchid from the top to the bottom so that the light looked like it was coming from the top right. Keep in mind that you can vary the look by using different flashlights or even changing the background or angle of the camera.

Between every shot I checked to make sure the focus was still on the orchid and my moving around with the flashlight hadn't moved anything.

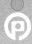 Remember to visit www.pwassignments.com after you complete the assignment and share your favorite photo! It's a community of enthusiastic photographers and a great place to view what other readers have created. You can also post comments and read encouraging suggestions and feedback.

LOW-LIGHT LANDSCAPES

PHOTOGRAPHING LANDSCAPES IN LOW LIGHT

LONG EXPOSURES

Most landscape photos are taken when there is plenty of light, giving you many options when it comes to shutter speeds, apertures, and ISO settings. When photographing in low light, there can be fewer choices, but the results can be much more dramatic.

When it comes to landscape photography, you can just wait until you get it right. The subject doesn't get up and leave or have to take a break because they are tired. Landscapes don't complain or show up late; in other words, they make great subjects for photographs.

Photographing landscapes takes patience. It might not seem as exciting as photographing concerts and sports, but when the photographs are done right, they will get viewers to stop and stare. Because I live on the West Coast of the United States, many of the landscape photography opportunities have to do with photographing at the seashore, and the combination of the different tides, structures, and sunset conditions makes for endless photographic opportunities. Each time I set up a tripod and camera at the water's edge, I am treated to a different scene depending on who or what is present. For Figure 10-1, I set up the camera before sunset and started to take photos as the sun went down, waiting until I thought I had just the right light.

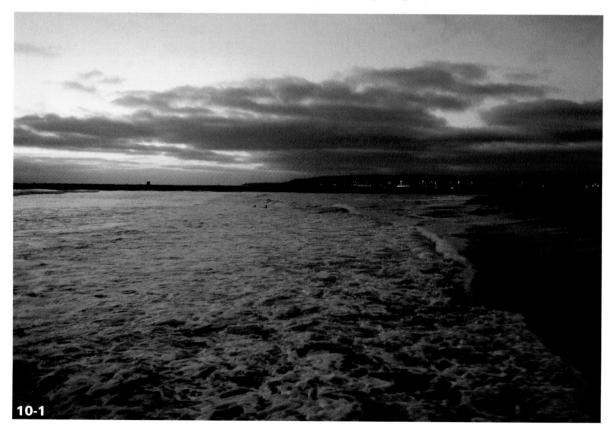

10-1

ABOUT THIS PHOTO *The water's edge makes for a great setting, especially as the sun sets. This was taken on a small jetty to get a side angle on the incoming tide. Taken at 1/30 second, f/2.8, and ISO 800.*

PHOTOGRAPHING LANDSCAPES IN LOW LIGHT

Photographing landscapes in low light does not mean that you can ignore composition. Because you usually have time to set up the photograph, there are no excuses for sloppy composition. Before tackling the exposures, here is a refresher of some guidelines and suggestions to keep in mind (they're not hard and fast rules, even though the first one is called a rule):

■ **The Rule of Thirds.** One of the most used rules in composition is the Rule of Thirds. This rule states that the best placement for the subject in your image is not in the center but instead at one of the intersecting points when you divide the frame into thirds. Imagine a tic-tac-toe board superimposed over the frame, and then place the main subject at one of the points where the lines intersect. When it comes to landscape photography, the same rule applies, but instead of placing the subject on a point, you place the horizon line one-third in from either the top or the bottom. If you place the horizon line directly in the middle of the image, then the sky and the land are both treated equally, which doesn't have the same tension as when one is given two-thirds and the other one-third of the compositional space.

When in doubt, try all three compositions, with the horizon line one-third from the bottom, then one-third from the top, and finally right in the middle. As you shoot more landscapes, you will start to see what works for you. As you can see from Figures 10-2 and 10-3, the horizon line was placed one-third of the way in from the top of the frame, which matches up to the Rule of Thirds grid.

■ **Background/foreground.** When shooting landscapes, foreground elements give the scene a sense of depth. A foreground subject gives the viewer something to focus on and will help with the composition. Although wide-angle lenses are often used for landscape photography to show the sweeping views, these lenses also tend to exaggerate the distances between the foreground and the background. You can reduce this effect by shooting from a lower angle, which can cause the middle ground to be compressed.

■ **Leading lines and curves.** If you look around, you will see that there are lines everywhere. These lines can be man-made or appear naturally, but they are there. The really great part about these lines is that you can use them in your images to lead the viewer's eye where you want it to go. You can use lines to lead the eye into the image, lead it out of the image, and to keep the viewer looking at the image. By training yourself to look for these types of lines in your images, you can improve your compositions immeasurably:

> **Straight lines.** Straight lines can run vertically and horizontally through your image. Examples of vertical lines include buildings, trees, and even people. When photographing vertical lines, adjust the angle so that you are shooting slightly upward, and the lines will seem stronger. The easiest horizontal line is the horizon, but, as described in the Rule of Thirds, you want to keep that out of the center of your image. Other horizontal lines include bridges, tops of buildings, and piers.

> **Diagonal lines.** These are lines that come from the corners into the image, and they can be some of the strongest compositional elements. Diagonal lines can draw the viewer's attention from the edge of the image into the center. The downside is that they can do the opposite as well — draw the eye from the center of the image

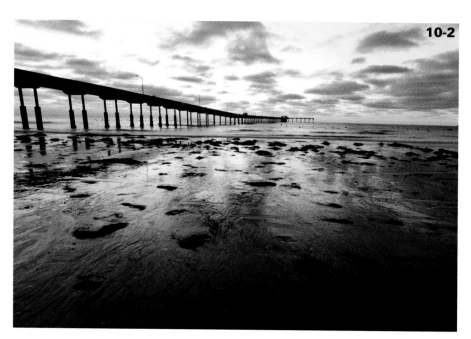

10-2

10-3

to the edge. This could include tree branches, power lines, and bridges and roads, depending on the angle of the image.

> **Curving lines.** Curving lines are a great way to keep a viewer interested in your image because they lead the eye around the image. These can include star trails and curves in a road or even the patterns the clouds or landscape makes.

■ **Framing.** Framing your image within a natural frame can add a sense of depth, but more than that, it can help to draw the viewer's eye to the main subject. For example, framing the sunset with a pier or using a doorway or window to frame the subject works great, especially when the frame is darker than the subject.

Once you have decided what to shoot, the next step is to get the correct exposure, which is explained in the next section.

EXPOSURE CONSIDERATIONS

Because you are shooting in low-light conditions, one way to deal with potential exposure problems is to use a wide aperture, which allows the most light to pass through the lens. However, for landscapes, you most often want a deep depth of field, so a wide aperture is not recommended. Going back to the basics of composition, if you want a deep depth of field, then you need a small opening; this means that you need a higher ISO or longer shutter speed to allow enough light to reach the sensor to get a proper exposure. When shooting the image in Figure 10-4 of the Golden Gate Bridge in San Francisco, the wind was incredibly strong, and so I used a wider aperture

x-ref Equivalent exposures are discussed in more detail in Chapter 2.

than I normally would so that I could use a shorter shutter speed. It still took 2.5 seconds to get the exposure, even at f/5.6.

Landscape photographs typically deal with large areas, and during the day that can mean a very big difference between the brightness of the sky and the landscape below. Once the scene becomes darker, it is actually easier to determine the correct exposure because there is not as much difference in brightness between the land and the sky. This can occur right before sunrise or right after sunset and during overcast or heavily cloudy skies, which are all great times to photograph landscapes. If you are photographing outdoors during bad weather, make sure that you have the proper clothing and protective gear for both you and your camera and lens.

So, you are now set up to photograph your landscape, and it is time to get the right exposure settings. There are two good options: the first is to use manual mode and the second is to use aperture priority mode. Both of these modes allow you to set the aperture to get the desired depth of field; the difference is that in manual mode, you can set the shutter speed as well.

In aperture priority mode, the camera uses the built-in light meter to read the light and then sets the shutter speed for you. To get the results you want, you need to make sure that the built-in light meter reads the scene correctly. The spot metering mode works well in this situation, as you can make sure that the area that is most important is the area being read by the light meter. When using aperture priority, you can bracket the exposures, which causes the camera to use a series of different shutter speeds to first underexpose and then overexpose the same scene. This

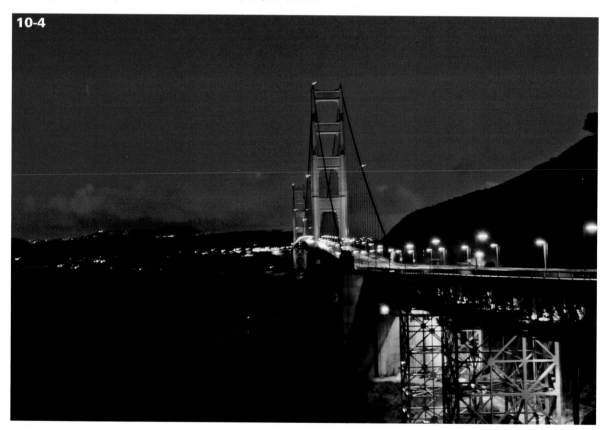

10-4

way, you can make sure that you get the desired exposure. Figure 10-5 was taken using aperture priority mode with an aperture of f/2.8. The camera metered the scene and picked a 1/5 second shutter speed at ISO 6400. When photographing in manual mode, you set the aperture and then the shutter speed using the readings from the built-in light meter, but after taking the first shot, you can use either a faster or slower shutter speed. For Figure 10-6, I used the manual mode and worked out the settings based on a meter reading using the spot meter. The exposure that I came up with was 21 seconds using f/16 and ISO 1600. This allowed the water to look a little softer, which I thought was more pleasing to the eye, but the exposures are very close to each other.

MOONLIGHT AS A MAIN LIGHT SOURCE

It is possible to shoot landscapes at night, but after the light of the sun has long faded from the horizon, it does become more difficult. While the moon is bright, especially compared to the dark sky around it, it really isn't very bright. So, when you are shooting landscapes at night, you have to allow for the moonlight to illuminate your scene, and that usually involves either very long shutter speeds, very high ISO settings, or wide open apertures — usually a combination of all three. Landscapes usually are shot with a small aperture creating a deep depth of field; landscape photography at night is no different. So that leaves you

ABOUT THIS PHOTO *The lights from the hotel spill into the bay making great lines to photograph. Taken at 1/5 seconds, f/2.8, and ISO 6400.*

ABOUT THIS PHOTO *The same scene as Figure 10-5 but this time the manual settings allowed for softer-looking water. Taken at 21 seconds, f/16, and ISO 1600.*

with the shutter speed and the ISO to adjust. The easiest way to get enough light into the scene is to just leave the shutter open for a long time; how long depends on the brightness of the moon and any other light in the scene. This works great unless the moon is actually in the scene because if you expose the scene for the landscape, then the moon will be overexposed. Also, the moon is moving, so it will no longer appear sharp. The key is to set up the shot where the moon illuminates the scene but isn't actually part of the scene.

The perfect conditions would be a light colored landscape such as a desert or sandy hill with a full moon because the light color of the landscape reflects the light the moon provides. However,

honestly, those conditions won't happen very often. One solution is to shoot with large bodies of water in the image because they can act as reflectors.

There is also a simple method for taking a landscape shot with the moon in the frame: use a piece of black board positioned so that the moon and the sky are covered and take the photo with settings that will expose the landscape. You then remove the board for the last second or two of the exposure. It isn't a perfect system, but it can work, especially if you are facing the moon. If you don't cover the moon, and the scene is exposed for longer than a few seconds, the moon will have moved and then you end up with a moon like that in Figure 10-7, a weird looking oval instead of a clear, sharp-edged moon.

10-7

ABOUT THIS PHOTO *The moon in this night scene doesn't look particularly good because the moon moved during the exposure. Taken at 79 seconds, f/16, and ISO 200.*

LONG EXPOSURES

When you leave the shutter open for a long period of time, you are compressing everything that happens into a single image. This means that items that move through the frame relatively quickly are not recorded, while things that are usually hidden by shadows can be seen. This is because the longer the shutter is open, the more light it collects. Two of the coolest effects that you can create with long shutter speeds are getting water to look silky smooth and turning night into day. First, it's important to get the sharpest image possible during these long exposures, so reducing any movement is imperative. The photo in Figure 10-8 was taken well after the sun had

set, and most of the light was provided by street lights on the pier. The exposure time was 4 minutes, and that allowed for the water to turn from surf to silky smooth.

DEALING WITH VIBRATION

The longer that you have the shutter open, the more likely it is that the camera can move during the exposure and ruin the image. To avoid this, the first thing to do is to make sure that the camera is securely locked into a tripod that can support the camera and lens weight properly. A smaller tripod might look like it is holding the weight just fine, but over time it might not be holding the camera and lens as steady as you

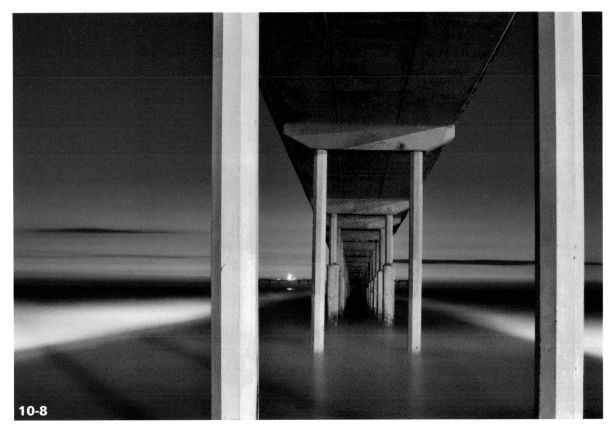

10-8

ABOUT THIS PHOTO *Setting up a tripod under the pier and exposing for 4 minutes revealed the details in the pier and turned the water to a flat, smooth expanse. The image then had the color corrected for the orange glow of the lights. Taken at 4 minutes, f/16, and ISO 200.*

think. This might not show up in a 10-, 20-, or even 30-second exposure, but when you start to leave the shutter open for 5, 10, or 15 minutes, even a little movement is noticeable.

That doesn't mean you need to buy a tripod rated to hold 40 pounds. Keep in mind that the more your tripod is rated to hold, the more it will probably weigh, and a heavy tripod is usually left behind when you are picking gear to carry. You just need to make sure that the combined weight of the gear can be supported by both the tripod and the tripod head. There is no easy way to test this other than to try it out. Go to your local camera shop and ask what they recommend, check the reviews online, and if you are really planning on buying an expensive tripod, try it out first.

> **tip** Companies like LensProToGo rent both tripods and tripod heads, which is a really good way to test the equipment before you buy it. For about $100, you can rent a good tripod and head for over a week, giving you plenty of time to try before you buy.

There are a few things that you can do to make the tripod you are using even more stable and to reduce the chances of vibration ruining your images:

- **Make sure the legs are locked into place.** No matter what type of leg-locking mechanism you are using, make sure that it is snug and not going to loosen up during the exposure.

- **Use the tripod on a firm surface.** Make sure that the tripod is placed on firm ground that isn't going to move during the exposure. I was once out taking long exposures at the beach, and the incoming tide caused the tripod legs to shift. As you can see in Figure 10-9, the image was ruined. That small movement caused everything to shake just a little.

- **Add some extra weight.** Some tripods allow you to hang a weight from the bottom of the center column. This is a great idea, as it keeps the tripod more stable. After setting everything up, I frequently attach my camera bag as the weight; just make sure that everything you need is removed because you will not be able to touch the bag after the exposure has started.

- **Stay low.** Avoid extending the center column, as it is the weakest part of the tripod in terms of stability. I also only raise the tripod as much as I absolutely need to in order to get the desired composition. The lower and wider the legs, the more stable the tripod.

- **Avoid the wind.** Try to set up the tripod and camera where it will be shielded from any wind, as all it takes is a little gust to set up a little vibration and ruin your shot. If wind can't be avoided, try to position yourself as a human shield for the camera. Every bit helps.

- **Avoid touching the camera.** I know this one seems to be obvious, but I find myself doing it all the time. It is important not to sabotage yourself by touching the camera and causing any vibration.

There are two other things that you can do to make sure you get the sharpest images; use a cable release or remote and use the mirror lockup feature if your camera has one. They have to do with what happens when you press the shutter release button. There are a series of actions that happen when you take a photograph:

1. You press the shutter release button.

2. The mirror moves up and out of the way, allowing the light entering the lens to reach the shutter.

3. The aperture changes from wide open to whatever setting you are using.

10-9

4. The shutter moves out of the way of the sensor for the amount of time indicated by the shutter speed setting.

5. The shutter closes.

6. The aperture is set to the widest point.

7. The mirror returns to the position so that the light entering the lens is now focused on the eyepiece, allowing the through-the-lens view on the camera.

There have been tests done using a laser pointer that show how much vibration is caused when you physically press the shutter release button on a camera. It's a lot, take my word for it. The solution is to use a remote control or cable release, which I cover earlier in this book.

Another situation where there are vibrations is when the mirror is moved up out of the way so that the light can reach the sensor. This only happens on dSLR cameras because of the way they work. In the camera, there is a mirror that takes the view through the lens and angles it up toward the eyepiece so that when you look through the viewfinder, you are seeing the exact scene that the camera will record. This makes it really easy to see how the different focal lengths are affecting your composition, and this helps you determine exactly what to focus on. The problem is that this mirror needs to be moved up and out of the way before you can take any photos. When the mirror is moved, it can cause slight vibrations that affect the sharpness of your image, especially at longer shutter speeds.

To counteract the vibrations created by the mirror moving, camera manufacturers have come up with a solution called mirror lockup. This feature allows the camera to move the mirror out of the way before the photo is taken to minimize vibrations. Check your manual to see if your camera has this feature. The way it usually works is that the mirror moves out of the way the first time you press the shutter release button, and the image is taken the second time you press the button.

For cameras that offer a live view feature, the mirror is locked up already, so using live view might actually be a better option. Using live view allows you to compose the image without having to put your eye to the viewfinder and inadvertently touching the camera as the image appears on the LCD. For Figure 10-10, I made sure that the tripod was set securely and I used the mirror lockup feature to make sure there was no blur at all.

One last note about vibration, and specifically vibration reduction technology: Vibration reduction or image stabilization technology is meant to be used when handholding the camera and lens, not when it is set in a tripod. Some lenses can detect when they are mounted on a tripod, and they turn off the vibration reduction automatically. As a result, when the camera and lens are mounted in a tripod, you need to turn the vibration reduction or image stabilization feature off.

FLOWING WATER

Many photographers love the look of silky-smooth flowing water, and so they use neutral density filters to be able to use long shutter speeds during the day to get this effect. A neutral density filter goes over the front of your lens to reduce the amount of light by a specific amount, usually measured in stops. For example, a 3-stop neutral density filter reduces the amount of light by 3 stops and the 6-stop filter reduces the light by 6 stops, as shown in Figure 10-11.

The general idea is to use a shutter speed that blurs the motion of the water enough that you stop seeing the water's details, but instead see the water as a bigger moving object. The actual shutter speed that you need depends on how much the water is moving.

When it comes to photographing the ocean, remember that the tide is either coming in or going out. So when you set up the shot, know

10-10

ABOUT THIS PHOTO *Photographing the pier on a moonless night resulted in a darker sky, and most of the illumination came from the lights on the pier. This is the same scene as in Figure 10-9 but here I set the tripod farther up the beach away from the incoming tide. Taken at 5 minutes and 30 seconds, f/16, and ISO 200.*

that the water will either be coming in toward you or going out away from you, and adjust the composition accordingly. For example, if the water is going away from you, make sure that you are not left with just sand, unless that's the look you are going for. If the tide is coming in, you want to give yourself a little space so that you don't end up in the water.

When photographing along the coast, the best times to shoot are at dawn or dusk when the sun is below the horizon but there are still traces of light in the sky. This also depends on which coast you are photographing. Generally the East Coast has better light before sunrise, while the West Coast has better light right after sunset. With

that being said, just being on the West Coast doesn't mean that there will be a great sunset every night, nor does it mean that every sunrise on the East Coast will produce a great image, but the odds are in your favor.

When composing for coastline photographs, try not to just point the camera out to sea and hope for the best. These images can appear really boring unless there is a stunning sunrise or sunset to hold the viewer's attention. Look for areas where there is an interesting subject, like pier pilings, rocks, driftwood, and even the patterns in the sand. These are great compositional elements that you can use in conjunction with the smooth look of the water that is captured with a long

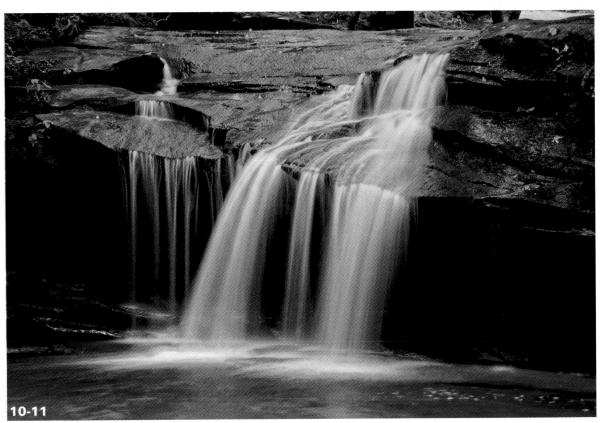

10-11

ABOUT THIS PHOTO *This image was shot with a longer shutter speed to get the water to flow, but because of the amount of light present, a 6-stop neutral density filter was needed. The 2 second exposure time really managed to smooth out the fast-moving water. Taken at 2 seconds, f/11, and ISO 200. © Ken Toney*

shutter speed. The same effect can be used at lakes, streams, and ponds, with streams being the easiest as the water is usually visibly moving. With ponds and lakes, you have to judge how long to leave the shutter open — a little (or a lot) longer to get a smooth look depending on the water's movement.

To use a long enough exposure to smooth out the water, start with a shutter speed of 1 second or longer. To get the proper settings, just do the following:

1. **Set the camera in a tripod.**

2. **Compose the scene.**

3. **Set the camera to aperture priority mode.**

4. **Pick the aperture that gives you the desired depth of field.**

5. **Set the ISO to 400.**

6. **Use spot metering mode and set the focus point on the critical subject in the scene.**

7. **Press the shutter release button halfway down to get a light meter reading, and make a note of the shutter speed.**

 > If the shutter speed is 1 second or longer, go ahead and take the photo.

 > If the shutter speed is less than 1 second, decrease the ISO and repeat steps 6 and 7.

8. **If the ISO is at the lowest setting available on your camera and the shutter speed is still faster than 1 second, then you have to either make the aperture smaller or wait until there is less light.**

This is not an exact science because the amount of blur in the water will be influenced by how fast the water is moving and where in the tide cycle it is if there is a tide. For example, the water in Figure 10-12 was moving very slowly, needing a shutter speed of more than 2 minutes to get the right amount of blur. Make sure that you keep your gear dry, and if your tripod does get wet, rinse the affected areas with clean fresh water, and dry and lubricate as necessary.

TURNING NIGHT INTO DAY

If you leave the shutter open long enough, then enough light is collected to create the illusion of turning night into day. It might seem like all you have to do is leave the camera shutter open for a long time, but there is a little more to it than that.

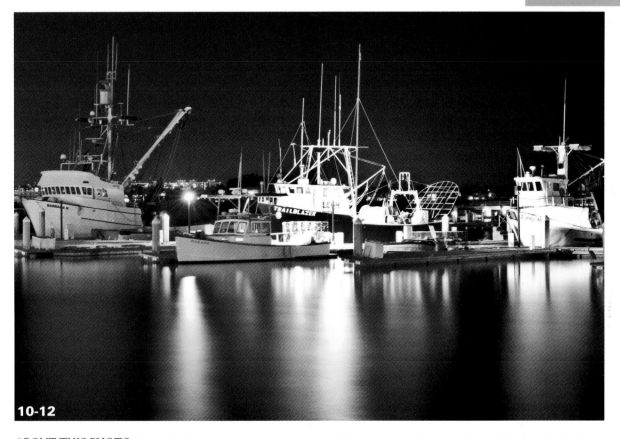

10-12

ABOUT THIS PHOTO *The tuna boats were docked, and thanks to a very still night, they could be captured in low light without the boats moving. Taken at 131 seconds, f/22, and ISO 400.*

You can use equivalent exposures to determine what your setting should be by first setting your camera to get the shot in as little time as possible. Then you can adjust the exposure settings to get the final values, and take the photo with a little more confidence that it will come out as you want it to. I have always loved photographing at the beach, even at night. This lifeguard hut in Figure 10-13 sits unused, as this image was taken at 9:30 pm on a moonless night, even though the color and exposure make it look like it was taken in the morning hours. The image was color corrected to make the sand look natural.

There is still a fair amount of guesswork to be done because there is no reliable way to meter a scene to get this result. The idea here is to make sure that the night sky no longer looks like the night sky. Settings will change as the moon waxes and wanes and with the amount of light pollution in the image. The steps to get an approximate exposure are as follows:

1. **Set the aperture as wide as possible.**

2. **Set the ISO as high as possible.**

10-13

ABOUT THIS PHOTO *The empty lifeguard hut waits for daytime when the beach will be crowded. Taken at 20 minutes, f/10, and ISO 200.*

3. **Take a photograph at any shutter speed.** I use 1/30 second as my starting point.

4. **Check the image and adjust the shutter speed.**

5. **Create the equivalent shutter speed setting using the aperture and ISO you want.**

6. **Take the photograph.**

For example, if the original test shot is taken with ISO 3200 and an aperture of f/2.8, then you need to work out the equivalent settings: 3200 goes to 200, so you have to adjust the aperture by 4 full stops.

To create the effect that the image was taken during the day, I have found that the image needs to be either correctly exposed or overexposed by a stop (or more). The light of the moon and the illumination it provides are really variable and change from one night to the next. Sometimes you might have to take the same shot numerous times to get the one you want.

Above all, have fun and experiment.

Assignment

Use a very long shutter speed to capture a night scene

Preparation is key to getting great photos when capturing long exposures at night, which is exactly what you need to do to complete this assignment. One of the most important parts of this preparation is getting the right location and composition before it's too dark. That way, you can see where you are setting up the tripod as well as what will be in your scene. At times you will have to visualize what the scene will be like after the sun has set. For this image I wanted to capture the clouds over the ocean with the lit up pier in the background. I used a 118-second exposure at f/10 and ISO 200 to get the look I wanted. The clouds are slightly blurred showing the movement during the 118 second exposure.

There are some basic guidelines that apply to all landscape photography, not just photos that are taken in low light or at night:

- **Make sure you have a subject.** Just taking a photo at night doesn't make it great, so make sure that there is a clear subject.

- **Consider the sky, even at night.** Most of the time, a clear sky is a boring sky. When you have a bland, boring sky, change the focus of the image and make the foreground the focus by placing the horizon line one-third down from the top of the frame.

- **Change the point of view.** This could mean getting lower and shooting across the scene or getting a different vantage point and shooting down on the scene.

- **Shoot using the RAW file type.** Using the RAW file type makes it easier to correct any unwanted colorcasts in postproduction.

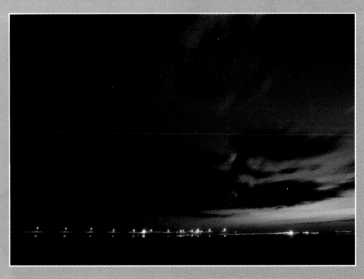

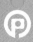 Remember to visit www.pwassignments.com after you complete the assignment and share your favorite photo! It's a community of enthusiastic photographers and a great place to view what other readers have created. You can also post comments and read encouraging suggestions and feedback.

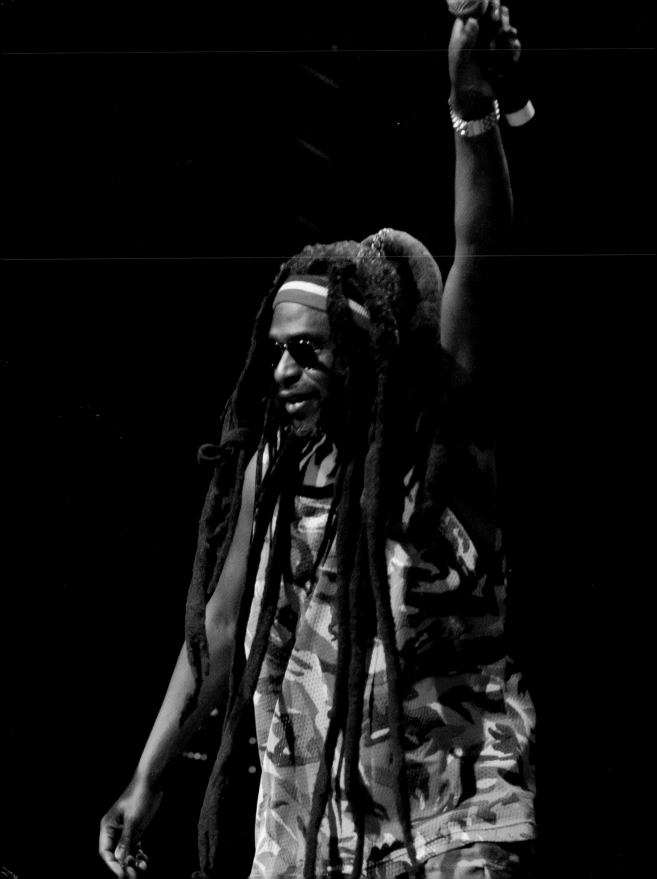

DIGITAL POSTPRODUCTION

There are many different types of file formats used in digital imaging, the two main ones being the JPEG file type and the RAW file type. The first decision that you have to make is what format you use in the camera and why. Both the JPEG and RAW file types have their plusses and minuses and that first choice can make your life easier later on. Once the files are loaded from your camera into your computer, you can really start to enhance the images. The first thing to do is to use software to reduce the noise caused by shooting at high ISOs and when using long shutter speeds. Another postproduction fix that digital photography makes really easy is to adjust the white balance so that the colors in the image match the colors that were in the scene, at least perceptually. It is also possible to easily adjust for color and exposure in postproduction, which allows certain latitude when actually shooting the image. That is not to say that every photo problem can be solved on the computer, but there are a lot of things that can now be done in less time and at a lower cost than ever before.

SOFTWARE OPTIONS

The traditional darkroom filled with chemicals and enlargers and red light bulbs has been replaced in digital photography by computer monitors and printers. This change means that no longer are images developed in chemical baths; they are now developed on the computer, and the adjustments are now made in image-editing software. The biggest and most complete image-editing application is Adobe Photoshop, but the cost is just as large as the application, and it can actually cost more than your camera. The full version of Adobe Photoshop Extended retails for $999,

while the standard version goes for $699; that is a lot of money in anyone's book. There are two other options for photographers, both of which are covered in this book. The first is Adobe Photoshop Elements, and the second is called Adobe Photoshop Lightroom (although from now on, I will just call them Elements and Lightroom). Elements is a cut-down version of the full-blown Photoshop application. Elements was created for the casual user who doesn't need the pixel editing power of the full version. The interface is easier to understand and not as complicated as the full version and the tools that most people need to edit their images are available. That is not to say that the program is underpowered or just meant for amateurs; it just doesn't have everything the full version does but it also costs a whole lot less. Right now, the current version ships for $99, and Adobe allows you to try the application for 30 days before buying it.

Lightroom is an application created specifically for photographers to import, sort, edit, and export their images. Lightroom doesn't actually make any changes to your image until you output the image. Instead, it keeps track of the changes you want to make in a XMP file that is attached to the image file. This allows you to come back to the original file later and possibly process the image a second, third, or fourth time. This is very helpful, especially as technology moves forward and the software developers create better noise reduction and image enhancements. The image in Figure 11-1 was processed in both Elements and Lightroom. It has had the noise reduced, the white balance adjusted, and the color and exposure tweaked so that I could create the best possible image.

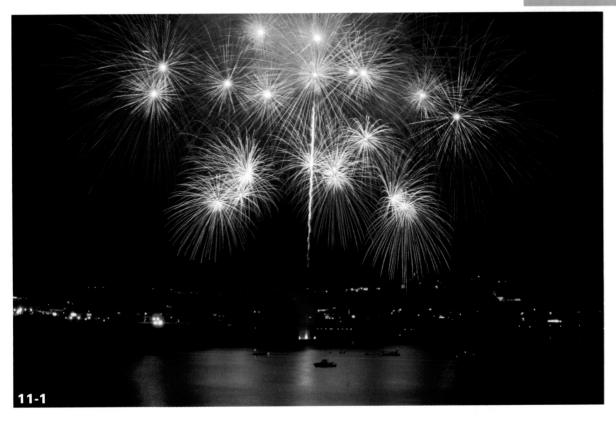

11-1

ABOUT THIS PHOTO *The fireworks reflected in San Diego Bay were photographed from the side of the road on the bridge going over the bay. Taken at 5.4 seconds, f/16, and ISO 400.*

FILE TYPES

There are many different types of digital image files. Two of the most common for digital photography are JPEG and RAW. All dSLR cameras can record images using the RAW file type.

Most dSLRs allow you to save the image as both a RAW and a JPEG file at the same time. If you set your camera to save both types of files for each image, know that it will take up more space on the memory card and it will take longer for the camera to be ready to take the next photo. This

can be a problem when shooting sports or any other subject where you need to take a lot of images in a short amount of time.

JPEG

The JPEG file type is actually based on a form of image compression created by the Joint Photographic Experts Group back in 1992. This is the most common image file type, and every digital camera has the ability to save an image as a JPEG file. The real advantages of the JPEG file

type are that it is practically a universal file format and can be viewed, printed, and shared just about anywhere, and also that it doesn't take up as much space as an uncompressed file of the same image. So if you want an image to be e-mailed, or used on the Internet or printed, and you don't want to have to edit the image on a computer, then you will want to use a JPEG file. When you use the JPEG file type to save the images you take, the camera applies all the in-camera settings directly to the file. This includes the white balance, which makes it a little more difficult to adjust later. The different adjustments for your camera will be detailed in your camera manual, so check there for what is available.

There is a downside to using the JPEG file type beyond it just being more difficult to adjust the color, and this is that the JPEG file from your camera has already been compressed. If you open and edit it in editing software, and then save the file as a JPEG again, the file starts to lose quality, and each successive time the file is edited and saved, the quality is degraded. If you are going to shoot using JPEG, I recommend that you use the highest quality and size available in your camera so that when editing, there is as much information available as possible.

RAW

The RAW file type differs between camera manufacturers and can even differ between different camera models. The RAW file type is very much like a digital negative, and like a negative, it can't really be used until it has been developed or rendered in computer talk. This development is done using computer software such as the Adobe Camera Raw module in Photoshop and Elements,

Lightroom Develop mode, or the software that came with your camera. The advantage to using the RAW file is that all the information that the sensor captured is recorded in the file. That gives you the largest amount of image data and allows for more latitude when post-processing. The following file extensions represent the different types of RAW files:

- NEF, NRW – Nikon
- ARW, SRF, SR2 – Sony
- CRW, CR2 – Canon
- PTX, PEF – Pentax
- RAW, RW1 – Panasonic

One of the main problems is that, because each manufacturer has its own proprietary (and often undocumented) RAW format, it makes it very difficult to use the RAW file. Many times you have to wait for the software companies to reverse engineer the RAW format before it can be used with anything other than the software supplied with the camera. For example, if you purchase a new camera that has a slightly new implementation of the RAW file, then you will have to wait until Adobe updates the Camera Raw software to use the RAW files from the new camera in Photoshop or Lightroom. If you have an Apple computer, you will also have to wait until Apple updates the RAW profiles before the previews of that file will be available. One solution is to convert the RAW image files to the Adobe DNG file type.

Some cameras even allow your images to be edited right in the camera, converting the RAW file to a JPEG and thus allowing you to easily get a JPEG image from the RAW image as needed.

THE ADOBE DNG FORMAT Back in 2004, Adobe Systems came out with a Digital Negative, or DNG, format that they hoped would be the answer to the multiple RAW formats created by the different camera manufacturers. A real concern for photographers is that as camera manufacturers keep improving their cameras and the RAW file format, support for the older file types will disappear, meaning that the RAW files will be useless. It would be like waking up one day and finding all your older images gone. Some camera manufacturers have taken Adobe up on its offer to build support for the DNG file type right into the camera; for example, the Pentax K20D camera offers the choice of PEF or DNG when saving the image files and Leica cameras shoot directly in DNG.

Sadly, there are not more camera manufacturers doing the same thing, but that doesn't mean you can't use the DNG format. Adobe has released a DNG converter that will convert your RAW file to a DNG, and this utility is updated as Adobe updates the Adobe Camera Raw utility. You can get the Adobe DNG Converter at www.adobe.com; search for DNG to get the latest information and download sites. The DNG Converter can take your RAW files and turn them into DNG files, and, if needed, you can turn them back into the original RAW files. You do this by clicking the Convert button to create the DNG and the Extract button to get the original back.

To convert your images and keep the original RAW file available, open the Adobe DNG Converter and, before converting the images, click the Change Preferences button and make sure the Embed Original Raw File option is checked.

One complaint from photographers when they start to use the RAW file type is that the image doesn't look the way it did on their camera's LCD. That is because the image preview on the back of the camera is actually showing an embedded version of the file with the in-camera adjustments applied. When you view the RAW file on your computer, those adjustments are not there and so the file can look muddy and not very appealing. To match the look of the JPEG file, Adobe has created a Camera Calibration setting that is used when converting the RAW file in Adobe Camera Raw or Lightroom. This allows you to choose from a variety of different settings and will get the camera's LCD image much closer to what the JPEG file will look like.

PICKING THE RIGHT FORMAT AT THE START

It is important to pick the right file format before taking any actual photos because, while you can turn a RAW file into a JPEG, you cannot take a JPEG file and add the data back in to make it a RAW file. As I mentioned earlier, many cameras actually allow you to save each image as both a RAW and JPEG at the same, giving you two image files for each photo. This is a great idea for people who are nervous using RAW files and don't want to have to process each photo in the computer before being able to use it. The downside is that this method takes up more space and takes longer to save, so it isn't very good when

you really need to save space or shoot at a fast rate. In addition, you now have to deal with two of everything when it comes to image editing and storage.

There are times when it is a good idea to shoot JPEG alone, but when shooting in low light, there are not many. One of the places where I will use the JPEG format alone is when shooting sports because I want to be able to take as many photos as possible, especially when there is a peak in the action. The camera has a buffer, which is a small piece of memory where the images are saved before being written to the memory card. When the buffer fills up, the camera needs to wait until the images have been written to the memory card and the buffer has space again for the next images. Because the RAW file type is so much bigger than the JPEG file type, the buffer fills up much faster when shooting RAW. This means that you can miss shots waiting for the buffer to empty, so to make sure I have enough buffer space to shoot, I will use the smaller JPEG file type.

When it comes to photographing at night and in low light, I prefer to use the RAW file type. Because a RAW file has more data, it allows me a lot more latitude when I need to adjust the image using software in postproduction.

The most important thing to keep in mind is that the JPEG image can be used directly from the camera, while the RAW image will need to be processed using a software application.

NOISE REDUCTION

Photographing at high ISOs or when using long shutter speeds causes digital noise to be introduced into the image. This noise can be a real distraction and can make your images look terrible,

so one of the main post-processing goals is to reduce the amount of noise. Adobe and other software manufacturers have really improved on the noise reduction available to photographers in the latest versions of their software programs. First, look at the two different types of noise, and then how to reduce the noise in Elements and Lightroom. These two types of noise are present in every image to some extent:

- **Luminance Noise.** This is also known as contrast noise and appears as variations in the brightness of the scene. This noise makes the image look like it has a rough texture, especially in areas of continuous tone.

- **Color Noise.** This appears as blotches of unwanted color. This type of noise is more detrimental than the luminance noise to the overall image quality.

The drawback to reducing the noise is that it can cause the image to lose data, and you end up with items that have no texture or detail. All the noise reduction software discussed gives you options to balance the noise reduction with preserving the details in the image.

REDUCING NOISE IN ADOBE PHOTOSHOP ELEMENTS

There are two ways to deal with digital noise reduction in Elements: the first is when you open a RAW file using the Adobe Camera Raw (ACR) module, and the second is when you use the noise reduction filter.

The ACR module is the program that converts RAW image file types into something that the image-editing application can actually use. The ACR program can do a whole lot more than just noise reduction; it can also adjust the white balance and do some basic image editing. ACR is used in Elements, Photoshop, and Lightroom.

note
If you look at ACR and compare it to the Develop module in Lightroom, you will see that they are the same. They are developed at the same time, and when one is updated, so is the other. That means that the noise reduction feature in ACR is also the same as the one in Lightroom.

To apply noise reduction in Elements, just follow these steps:

1. **Open the image in Elements.**

2. **Choose Filter ⇨ Noise ⇨ Reduce Noise.** The Reduce Noise window opens, as shown in Figure 11-2.

3. **Apply the noise reduction to the image by adjusting the three sliders or just entering the percentage you want to apply into the corresponding entry box.** There is also a check box you can select to help remove JPEG artifacts.

> **Strength.** This controls how much noise reduction is applied to the image. The trade-off is that as you increase the strength of the noise reduction, you can start to lose detail.

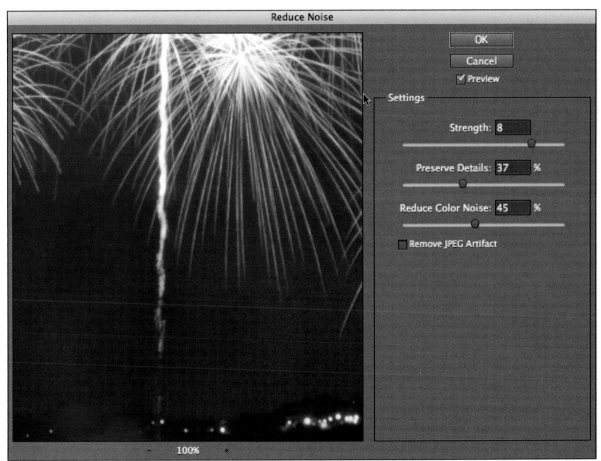

11-2

ABOUT THIS FIGURE *The Reduce Noise window in Elements. This is where you can adjust the noise reduction by just moving the sliders and watching the changes in the preview window.*

> **Preserve Details.** This setting helps to limit how much the noise reduction affects the details in your image. You can adjust the detail by moving this slider.

> **Reduce Color Noise.** This slider reduces color noise only and is usually the first slider I adjust.

> **Remove JPEG Artifact.** If you are working on JPEG images, it helps to turn this option on to remove blocky artifacts and halos from JPEG images.

You can see how the changes in the Reduce Noise window affect your image in the 100 percent preview window right next to the controls. You can move the preview around so that you see the critical parts of your image.

It is also a good idea to add sharpening to your image. In the Lightroom interface, the sharpening and noise reduction tools are in the same menu, but in Elements the sharpening tool is in the Enhance menu under the heading Adjust Sharpness. Clicking this menu opens the Adjust Sharpness window, shown in Figure 11-3, which gives you a lot of control over the sharpness of your image.

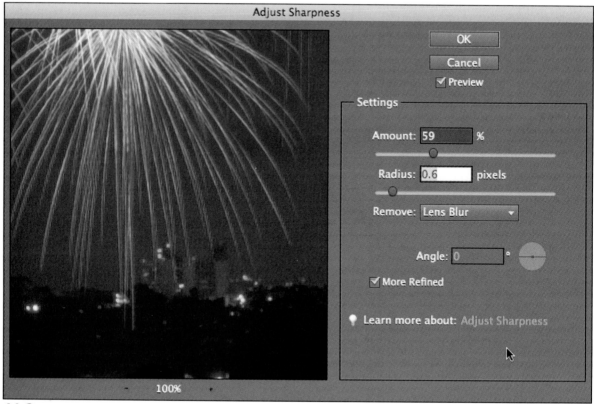

11-3

ABOUT THIS FIGURE *The Adjust Sharpness window allows you to control the edge sharpness in your image, which can be useful if you need to bring back detail that was lost in the noise reduction process.*

In the Adjust Sharpness window, you can adjust the following:

- **Amount.** This is where you specify how much you want to sharpen your image. Dragging the slider to the right increases the contrast between the edge pixels, which in turn can make the image look more in focus. Keep an eye on the 100 percent preview window, as a little sharpening can go a long way.

- **Radius.** The radius determines how big an area around the edges to adjust. The bigger the radius setting, the more obvious the sharpening is.

- **Remove.** This drop-down menu lets you choose what type of sharpening to use. For most of my images, I use the lens blur setting, but try all three and see which one works best for your image.

- **Angle.** This sets the angle when the Remove setting is set to Motion Blur.

- **More Refined.** Checking this box gives you better results but takes longer. I suggest that you check it and not worry about the slightly longer processing time.

As I mentioned earlier, a little sharpening can go a long way, and as you increase the sharpening, you can also increase the visibility of the digital noise in the image. There is also an Auto Sharpen function in Elements, but as with all the auto functions, you don't get to control the settings or the outcome. You should stick with the Adjust Sharpness setting because it gives you more control, which is a good thing.

REDUCING NOISE IN ADOBE LIGHTROOM

You can apply noise reduction right inside the Lightroom Develop module in the Detail panel, which is shown in Figure 11-4. The Detail panel can be a little intimidating for first-time users because it has nine different sliders and not only deals with noise reduction but also with image sharpening. The reason these controls are grouped together is because they work together to get the best detail with the lowest noise in an image. The panel is actually divided into two sections.

The first section is Sharpening, which has the following sliders:

- **Amount.** This setting adjusts the edge definition in your images. If you set this slider to 0, then no sharpening is applied. As you move this slider to the right, Lightroom looks at pixels that are different from the surrounding pixels and increases the contrast to make the edges stand out. This can make the images look sharper and more in focus.

- **Radius.** Changing the radius changes the size of the area affected by the Amount slider. The bigger the radius, the more of the edge area is affected. If the image has very fine details, then this setting needs to be set lower; if the details in your images are larger, then it needs to be set higher.

- **Detail.** This slider controls how much the sharpening affects the edge detail. Lower settings mostly sharpen the edges to remove blurring, while higher settings cause the textures in the image to become more pronounced.

- **Masking.** This slider controls what in the image is sharpened. The lower the setting, the more of the image is sharpened; as the masking is applied, the sharpening is restricted to the areas with the strongest edges.

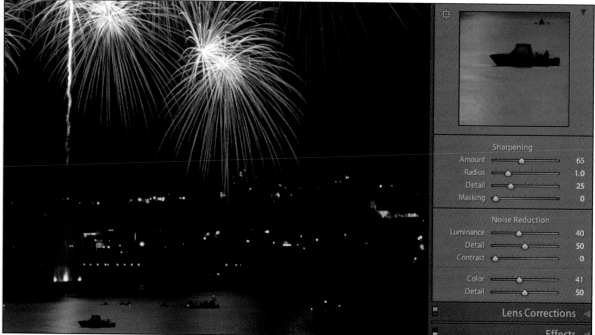

11-4

ABOUT THIS FIGURE *The Detail window in Lightroom with the sharpening and noise reduction sliders set to the values that I want for this particular image.*

The second section has the Noise Reduction controls. There are two different kinds of noise: luminance noise and color noise. The controls for reducing noise in Lightroom deal with these types separately. The controls are broken down by the type of noise they help reduce; the first three affect the luminance noise while the fourth and fifth affect the color noise.

- **Luminance.** This slider reduces the luminance noise. You must be careful not to reduce it too much or all the detail will be lost and the image will look very processed and not natural.

- **Detail.** Adjusting the Detail slider controls what the Luminance slider above it works on. The more the detail effect is applied, the more

the original detail remains; this reduces the amount of luminance noise reduction but keeps the image looking more natural.

- **Contrast.** This slider controls how much of the luminance contrast is allowed to remain. The higher the value, the more contrast remains, and the noisier but more natural the image looks.

- **Color.** This setting controls the color noise present in the image. The more the slider is moved to the right, the more the color noise is reduced.

- **Detail.** This setting controls how much detail is allowed to remain in the image. The higher the detail level, the more the thin edges are

242

allowed to remain (although you will see more color spots), while the lower the detail level, the more the colors might bleed into each other.

Just because theses sliders are in this order doesn't mean that you have to use them in this order. When I apply noise reduction in Lightroom, I usually start by reducing the color noise in the image, then I adjust the luminance noise, and then I adjust the sharpening slider to bring back the detail that might have been lost when applying the noise reduction. There is no point in giving you an exact set of numbers because they change with each image. What matters is that you view the image at the 1:1 ratio (which is 100 percent view) so that you can actually see what the sliders are affecting and adjust them to your liking. Some people like to remove a lot of noise and don't mind the very smooth-looking results, while others find this looks too fake and prefer to keep some of the noise in the image.

NOISE REDUCTION PLUG-INS

Noise reduction has always been one of those things that digital photographers have both wanted and needed. Many software programs have been developed to meet this need. Many of these programs work with image-editing software and are therefore considered plug-in applications and not stand-alone programs. In other words, they need an application like Lightroom or Photoshop to work.

■ **Dfine by Nik Software.** Dfine was created by Nik software for the sole purpose of reducing noise in your images. Where it differs from the noise reduction feature in Elements or Lightroom is that it has the ability to measure

the noise in your image and apply selective noise reduction. There are two different methods used to measure the noise in your image: the first is the automatic method and the second is a manual method that gives you more control over how the noise is measured.

Regardless of the method you use to measure the noise, the real power is in the removal of the noise, and Dfine has plenty of noise reduction capability. You can remove the luminance or contrast noise and the color noise, and Dfine also allows you to remove the JPEG artifacts, as you can see from the controls in Figure 11-5. One other feature of this software application is its ability to brush noise reduction into your image when you use the software in Photoshop and Photoshop Elements. These brushes are very cool because they target specific noise types:

> **Background.** This brush helps to reduce noise that appears in a background.

> **Hot Pixels.** This brush helps to get rid of those unwanted pixels that become visible as bright dots, most often appearing in dark areas of the image.

> **Fine Structures.** This brush reduces dominant color noise and reduces luminance noise. It tries to balance the detail and noise in components such as hair that normally would be negatively affected by noise reduction.

> **Skin.** This brush reduces both luminance and color noise but tries to leave any fine detail, especially in the skin tones.

> **Sky.** This brush removes the noise that is most often found in the sky areas of images.

> **Shadows.** This brush tries to remove the noise in shadows and low-light areas while trying to keep the detail.

> **Strong Noise.** This brush reduces noise while keeping as much detail as possible. This is the brush for those really high ISO images.

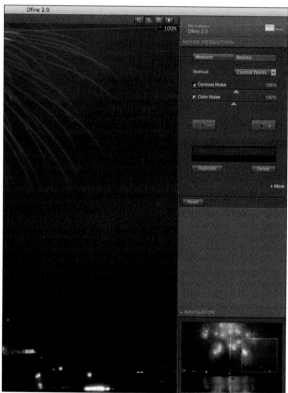

11-5

ABOUT THIS FIGURE *Here, you see the Nik Dfine window portion showing the after view of the noise reduction. The window is split with the pre-sharpening tools on the left and the post-sharpening tools on the right.*

If you shoot a lot of images that are susceptible to noise, then this is a great product to invest in for $99.

■ **Noise Ninja by PictureCode.** Used by many newspapers, this noise reduction application is aimed at photographers who want to get the noise reduction done fast and done well. The folks that make Noise Ninja have made this program extremely fast and effective by creating different profiles for different cameras. If a profile doesn't exist for your camera, you can have the automatic profiler determine the noise characteristics of your image and apply the best noise reduction. The Noise Ninja software also has a batch-processing mode that can automatically apply the noise reduction to multiple images, freeing you up from this step of the post-processing workflow. The main window of Noise Ninja allows you to adjust the luminance and color noise reduction separately, and you get to see a 100 percent and full image preview at the same time, as you can see in Figure 11-6. Noise Ninja comes in a variety of packages and price points, from $34.95 for the basic home version to $79.95 for the Pro Bundle.

■ **DeNoise by Topaz.** This noise reduction application cleans up luminance or contrast noise and color noise, but it also deals with banding noise. It tries to do it in a way that doesn't destroy any of the detail in the image. Banding noise occurs when you can see parallel stripes of noise that run vertically or horizontally in your image. This type of noise is actually just regular luminance and color noise, but it falls into this pattern. Our eyes pick up on this type of pattern very easily, and it can be really distracting when trying to view an image that is affected by banding. Another adjustment in DeNoise that can

really improve on the noise reduction in your images is Shadow Tone Restoration. The dark areas, especially large areas of dark tones, can start to look hazy when the heavy noise is reduced. This is because the luminance and color noise is averaged out with the areas around it, and this can change the color, if only slightly. The Shadow Tone Restoration feature is a way to remove these color spots and still keep the original tone. DeNoise retails for $79.99.

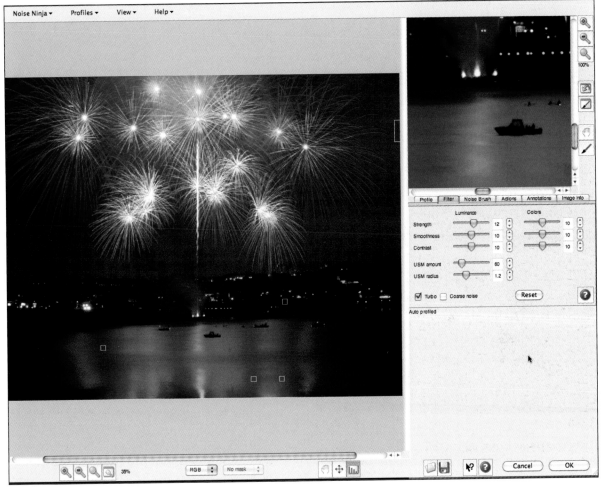

11-6

ABOUT THIS FIGURE *The Noise Ninja interface with the Luminance and Color noise reduction sliders to the right, under a 100 percent preview window.*

ADJUSTING THE WHITE BALANCE

The white balance is one of the most powerful controls that you have for correcting or adjusting the color of your images. The white balance is set in the camera to adjust for the color temperature of the light source that is illuminating your image. Until recently, you could only adjust the white balance in post-processing if you shot using the camera's RAW file type. This was because the RAW file type didn't apply the camera's white balance permanently; it just kept a note of what was used when the image was taken, and then it applied this white balance when the image was processed and converted into a useable file type, such as JPEG. It is now possible to adjust the white balance on a JPEG or TIFF file type, but it is still easier to do so to a RAW file. This is one of the main reasons I use the RAW file type for most of my images, especially those in which the color of the light is very difficult to measure.

ADJUSTING WHITE BALANCE IN ELEMENTS

The white balance adjustment in Elements is not done in the actual program but in the Adobe Camera Raw (ACR) module that opens automatically when you open a RAW file in Elements. This is the same ACR module that is in the full version of Photoshop and the same module that the Lightroom Develop module is based on, with

a few differences. The ACR module in Elements doesn't have all the tools that are available in the full Photoshop version, but the good news is that it does have the white balance tools. When you open a RAW file, the main ACR window opens. There are two separate places to adjust the white balance. The first is on the right, at the top of the Basic panel; the second is a color picker on the top of the window, above the image.

The White Balance control is located at the top of the Basic panel, as you can see in Figure 11-7, and is the first thing I correct or adjust when editing an image. Sometimes it doesn't need any adjustments; other times it takes a lot of adjusting. The initial White Balance settings are those that were present when the image was taken, but they can be easily changed. The drop-down menu gives you the following list of presets: As Shot, Auto, Daylight, Cloudy, Shade, Tungsten, Fluorescent, Flash, and Custom.

You will notice that there is no menu choice for cloudy, diffused moonlight mixed with security lights, so a one-click fix is not going to be available for most night shots. The best idea is to get close with a preset and then do some fine-tuning with the Temperature and Tint sliders. As you can see in Figure 11-8, I picked the Tungsten preset. The colors have shifted toward the left edge of the Temperature slider, and the sky now looks closer to how I remember it being; dark gray and slightly miserable. I can now adjust the sliders to get the colors closer, if needed.

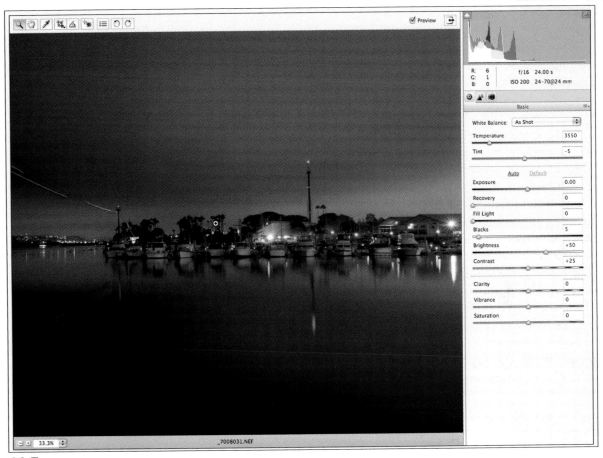

11-7

ABOUT THIS FIGURE *The Adobe Camera Raw window before adjustments shows the white balance as it was set in the camera.*

There is another way to set the white balance, and that is to use the White Balance Selector tool; it looks like an eyedropper and is the third icon from the left on the top of the screen. The idea behind the White Balance Selector tool is that you just pick a spot in your image that is

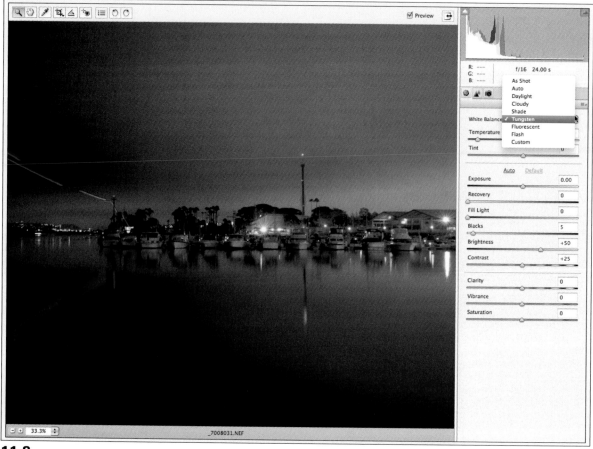

11-8

ABOUT THIS FIGURE *Picking the Tungsten white balance setting dramatically changed the color of the whole image and got it much closer to what I remember seeing that night.*

neutral, and the software uses that information to determine what the correct white balance should be. As you can see in Figure 11-9, I picked a spot in the clouds above the marina that I remember as being dark gray, and the software picked a white balance that was close to the Tungsten white balance in Figure 11-8. You can keep picking new spots in your image to get the right one, making this a really easy way to get the right color.

You can also use the White Balance feature to add a creative edge to the image and get colors that might not have been there but still look good to you. I would not suggest this if you are working for a newspaper or magazine, but if this is a creative image, then feel free to experiment. I was feeling rather frustrated when I took the image used in this series of examples because the weather kept changing on me, and instead of the

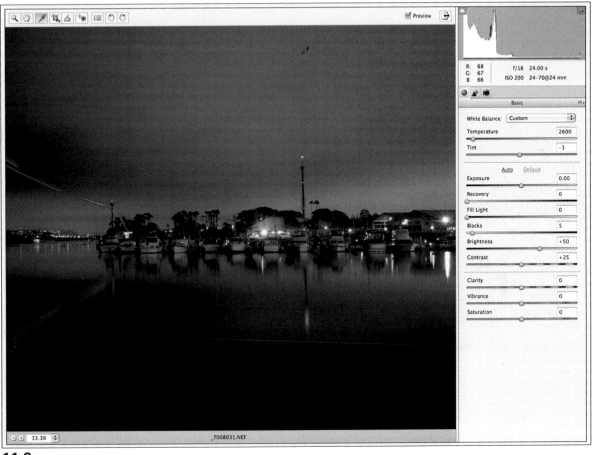

11-9

ABOUT THIS FIGURE *Using the eyedropper to pick the neutral point in the clouds rendered the scene closer to the actual colors.*

nice clear sky I was expecting, I ended up with an overcast evening. When editing the image, I started to really play with the white balance and ended up cooling down the temperature and increasing the magenta, thus creating a purple night, as you can see in Figure 11-10. You may find that just about every image you take at night or in low light needs to have the white balance adjusted; how realistically or artistically is up to you.

ADJUSTING WHITE BALANCE IN LIGHTROOM

Adjusting the white balance of an image in Lightroom is really simple. What's more, you can adjust the white balance of any image file type in Lightroom, including RAW files, JPEG files, and TIFF files. Lightroom doesn't actually care what file type it is. The only difference is that when you edit the white balance on RAW files, you get a few more preset options.

11-10

ABOUT THIS FIGURE *Experimenting with the white balance can give you some very cool results. For this image, the temperature was reduced and the magenta increased to give the clouds a purple glow.*

The white balance controls are in the Basic panel when using the Develop module. Actually, they appear at the top of the Basic panel. The white balance controls consist of an eyedropper icon, a drop-down menu of presets, and two sliders, one for the color temperature and the other for the tint.

The eyedropper tool (White Balance Selector tool) allows you to set the white balance of any image by clicking an area that you know should be a light gray. To do this, follow these steps:

1. Select the White Balance Selector tool from the Basic panel in the Develop module.

2. The eyedropper icon replaces the mouse cursor and can be positioned over any part of the image.

3. Move the eyedropper to an area of the image that is a neutral gray, and click to set the white balance. Avoid using areas that are 100 percent white.

When you select the White Balance Selector tool, a set of options appear in the toolbar right below the image, allowing you to configure the tool to your liking. The choices are:

- **Auto Dismiss.** When this is selected, the White Balance Selector tool is automatically dismissed after you click an area in the image. When this is unselected, you can keep picking spots until you find the perfect one, but you will need to either click the Done button or just pick another tool to use.

- **Show Loupe.** This shows a close-up view of the pixels under the eyedropper, along with the actual RGB values, allowing you to pick the perfect spot to use as the neutral spot.

- **Scale.** This sets the zoom level in the loupe view.

- **Done.** This sets the current white balance.

One of the coolest things when setting the white balance in Lightroom is that as you move the White Balance Selector tool over your image, the preview window in the top-left corner changes to show a live preview of the white balance. This can really make it easy to see the right spot to set the white balance, as you can see in Figure 11-11.

ABOUT THIS FIGURE
I knew that the horse was white and that picking a spot that looked neutral to me got the colors back to normal and rendered the scene as I remembered it.

11-11

Another way to set the white balance is to use the drop-down menu that gives you a basic set of white balance presets. If you are adjusting a RAW image file, then you will get more options than when adjusting a JPEG or TIFF file. The list contains the following options: As Shot, Auto, Daylight, Cloudy, Shade, Tungsten, Fluorescent, Flash, and Custom. The list of options for changing the white balance when editing a JPEG or TIFF file is much shorter, only giving you Auto and Custom, and possibly As Shot. When you use one of the presets (or the White Balance Selector tool), you see that the Temp and Tint sliders move to show the new setting. You can also use these sliders by themselves to set the white balance, or more commonly to fine-tune the white balance.

The Temp slider uses the Kelvin scale to set the white balance. Moving the slider to the right warms up the image by making it more orange and red, while moving the slider to the left cools the photo down by removing the red and orange and adding more blue. You can also set the color temperature directly using the box to the right of the Temp slider. If you are adjusting a JPEG or TIFF, the Temp slider goes from –100 to 100 and allows you to adjust the color on a relative scale.

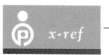

| x-ref | Kelvin is covered in more detail in Chapter 2. |

The Tint slider allows you to adjust the amount of green or magenta tint in the image. When you slide the Tint slider to the right, you add magenta; when you slide it to the left, you add green. These tools make it really easy to set the white balance on any of your images.

ADJUSTING FOR COLOR AND EXPOSURE

Photo-editing software is really powerful and there isn't a magazine cover, advertisement poster, or press shot that hasn't had a little (or a lot of) editing done to it. Adobe Photoshop is so well known that it has been used as a descriptive term ("Oh, that's been Photoshopped.") or as a request ("Could you please Photoshop that?"). And then there is the worst of all, "Don't worry; he will fix it in Photoshop." The truth of the matter is that you really can do amazing things using the image-editing software, but it shouldn't be a crutch for fixing sloppy work with your camera.

With that being said, there are times when you want to, and might need to, enhance an image using software—I do it all the time.

ADJUSTING THE LIGHTING AND COLOR IN ELEMENTS

There is a full set of exposure controls in the Adobe Camera Raw module in Elements, but because those controls are the same as the ones in the Develop module of Lightroom, they are covered a little later in this chapter. This section is about the option that Elements gives you under the Enhance menu, specifically, the Adjust Lighting menu and the Adjust Color menu choices.

The Adjust Lighting menu gives you three choices, but remember that these adjustments will be on the selected layer, so if you want to be able to go back to the original, you will need to first duplicate the layer. You can do this by right-clicking the layer and choosing Duplicate Layer from the choices shown. The three menu choices are:

■ **Shadows / Highlights.** This color adjustment allows you to lighten the shadows, darken the highlights, and/or adjust the midtone contrast. The Lighten Shadow slider lightens up the shadow areas in your image and reveals the details that might be hidden if the shadows are too dark. The Darken Highlights slider reveals detail in the lightest parts of the image. Adjusting the midtone contrast changes the way the midtones in your image look.

■ **Brightness / Contrast.** These are two simple controls that can really help you adjust the look of your image. There are two sliders: a

Brightness slider that can be set from –150 to +150, and a Contrast slider that can be set from –50 to +100. Just adjust the sliders until the image looks the way you want.

■ **Levels.** The levels adjustment can easily make your image look better by adjusting the shadow values, the middle values, and the highlight values for any or all of the color channels. As you will see when you open the Levels window, there is a graph of the tones in your image with the shadow on the left and the highlight on the right (Figure 11-12). Under the graph are three little arrows; the one on the left represents the dark values, the

11-12

ABOUT THIS FIGURE
The Levels adjustment window showing the tonal range of the image.

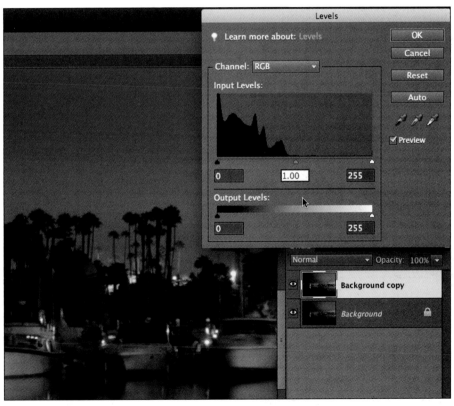

one in the middle represents the middle values, and the one on the right represents the highlight values. You can adjust any of these settings by either moving the arrows or just entering numerical values into the boxes. You can also control the output by adjusting the output levels. Slide the shadow slider to the right, and the image becomes darker as the black value is pushed right. Slide the highlight slider to the left, and the image gets lighter as the highlight value is pushed left.

The Adjust Color menu gives you eight separate controls to deal with the color. These menus are:

■ **Remove Color Cast.** This menu just offers a different way to set the white balance of the image. When you pick this menu choice, the cursor becomes an eyedropper and all you have to do is pick a part of the image that is supposed to be black, white, or neutral. This is a very helpful tool if the white balance tool doesn't give you good results.

■ **Adjust Hue / Saturation.** This menu adjusts the color (hue) and the saturation of the entire image.

■ **Remove Color.** This is a one-click trick to turn the image black and white. It removes all the color from the image.

■ **Replace Color.** This is one of those menus that seem like magic to me. This tool lets you adjust a specific color in your image. The first thing to do is to pick the color you want to adjust. You do this by using the first eyedropper tool to pick a spot in your image; you can then add to that color selection by using the additive eyedropper (the one with the plus sign below it). If you add too much color, you can use the subtractive eyedropper to remove a color (it is the eyedropper with the negative sign below it). You can also adjust the color selected with the Fuzziness slider. You can see the hue that you have selected in the color panel right above the Fuzziness slider, and it is this color that is affected by the settings in the Replacement section on the bottom half of the menu. In that section, you can adjust the hue, saturation, and lightness of the selected color. Just adjust the color with the sliders, as shown in Figure 11-13.

■ **Adjust Color Curves.** Curves are one of the most powerful ways to adjust the colors in your image, and the Elements interface makes this feature really easy to use. To start with, the menu shows you a live before-and-after window so that any changes you make are immediately seen and can be compared to the original. There are two different ways to adjust the curves, and they can both be used together to get the exact effect you want. You can use the style box or you can adjust the sliders, and with both, you will see the changes on the graph and on the after image. I find it is easier to adjust one of the four sliders to get the desired effect. The sliders are Adjust Highlights, Midtone Brightness, Midtone Contrast, and Adjust Shadows.

11-13

ABOUT THIS FIGURE
Using the Replace Color menu, I changed the color of the sky in the image by adjusting the hue, saturation, and lightness.

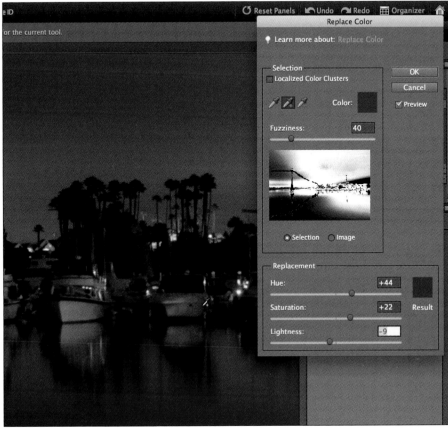

■ **Adjust Color for Skin Tone.** This is a great tool for portrait photographers or for those who just like taking pictures of people. Just click the eyedropper somewhere on the skin tone, and the program adjusts the color to make it look as natural as possible. You can help it by adjusting the tan and blush of a person's skin.

■ **Defringe Layer.** Sometimes when an object is cut from one layer and pasted on another layer, the selection may not be perfect. When this happens, you need to deal with the fringes of the selection. All you do is pick a value for the width of the defringe algorithm. When the selection is made, there are times when a little of the surrounding area is still present. Defringing helps to remove this.

■ **Color Variations.** This is a fun way to adjust the color in your image. The first step is to pick the area that you want to adjust. You can choose from Midtones, Shadows, Highlights, or Saturation. The next step is to adjust the color intensity, and then you can click the thumbnails to pick the image you think looks best. For the first three choices, you can increase or decrease the Red, the Blue, or the Green, and you can lighten or darken that area. For the Saturation adjustment, you can decrease or increase the saturation. As you can tell in Figure 11-14, the adjustments are cumulative and the preview window allows you to see the changes in real time.

These editing tools are just a small part of what you can do with Elements, and while this is not a book on image editing, photographing at night and in low light usually produces images that could use a little color editing. These are the tools that will help you get the best-looking image.

USING LAYERS, LAYER MASKS, AND BLEND MODES IN ELEMENTS

A key component to image editing is the use of layers, layer masks, and blend modes. These are the powerful tools that really allow you to enhance your images. The idea behind layers and blend modes is pretty simple: You can stack

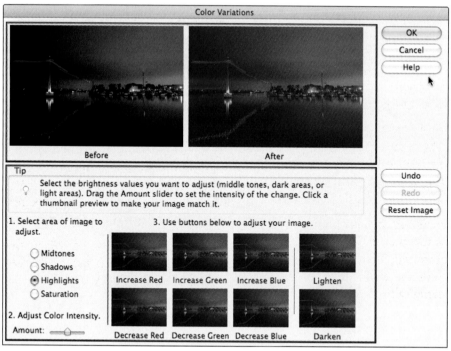

11-14

ABOUT THIS FIGURE
The Color Variations menu in Elements allows you to adjust the image without using any math; instead, you can make the adjustments based on the appearance of the image.

images on top of each other and, depending on the blend mode and opacity, the top layer affects the layer or layers below it. Let's break this down and look at a simple example. If you have a photo and place another photo on top of it, you won't be able to see the photo on the bottom. If you start to lower the opacity of the top image, the bottom image starts to come through. Now imagine that you can change the way that the top image interacts with the bottom image and that the mode of the top image (or layer) can help enhance the bottom image (or layer). This is pretty powerful stuff. Here are some uses for the blend modes:

- **You can brighten an entire image.** Open the document and make a duplicate of the Background layer. Then change the blend mode by using the drop-down menu in the Layers palette to either Lighten or Screen. You can then adjust the opacity of the top layer until the image looks good.

- **You can darken an entire image.** Open the document and make a duplicate of the Background layer. Then change the blending mode to Darken or Multiply and adjust the opacity until it looks right.

There is another use for layers, and this is to use parts of different images all together in the same composite image. Say, for example, that you had a great sky in one image and some cool buildings in another, or you took a series of shots and want to use different parts of each one in a single image. You can use a layer mask to accomplish this. The layer mask works by allowing you to selectively remove parts of one layer to reveal what is on the layer below. The cool part is that the layer mask is editable so you can adjust what is seen. Give this a shot:

1. **Open an image in Elements.**

2. **Duplicate the Background layer.**

3. **Choose Enhance ⇨ Adjust Color ⇨ Remove Color.** The top layer is now a black-and-white version of the Background layer.

4. **Click the Add Layer Mask icon on the bottom of the Layers palette.** You see a white square appear next to the thumbnail in the layers list. This is the layer mask. Anything that is white is opaque, and nothing from the underlying layer is seen, while anything that is black allows the underlying layer to show through. To get the bottom layer to show through on the top layer, you can just use the Brush tool with the color black.

5. **Paint the parts you want in color with the black paintbrush.** Any areas that are inadvertently transparent can be turned opaque by painting with white on the layer mask.

This technique allows you to create an image that consists of many images, which is sometimes the best way to go, as shown in Figure 11-15.

11-15

ABOUT THIS FIGURE *I created this image by following the steps for creating an image that is part black-and-white and part color. The possibilities are really endless.*

ADJUSTING THE COLOR AND EXPOSURE IN LIGHTROOM

Lightroom is a very powerful program that can be used to adjust the color and exposure of your images, all from the Develop module. The main controls that adjust your image are the same controls that are found in the Adobe Camera Raw

module in the full version of Photoshop. This allows you to adjust the exposure using the following sliders shown in Figure 11-16:

■ **Exposure.** The Exposure slider controls the overall brightness of the image. The more you slide it over to the right, the brighter the image appears. Move the slider to the left, and

the image gets darker. The amount of exposure change is measured in stops, and the exposure can be changed from –4 to +4 stops from the original exposure value.

- **Recovery.** This slider reduces the highlights and tries to recover some of the detail that can be lost in the overexposed areas of the image. This is very useful if you move the exposure slider to the right to brighten the overall image, but you need to recover some of the details that become lost when the brightest parts of the photo become overexposed.

- **Fill Light.** This slider lightens up the darker areas and tries to get back some detail in the deep shadows, while trying to maintain the blacks. Be very careful using this feature because it can really highlight any noise that is present in your images.

- **Blacks.** When you slide this setting over to the right, more of the image becomes black. This setting applies more to the darker areas of the image than to the midtones or the highlights.

11-16

ABOUT THIS FIGURE *This image didn't need a lot of adjustments, but they all helped. The adjustments are shown in the panels to the right.*

■ **Brightness.** This setting adjusts the brightness of the midtones in your image.

■ **Contrast.** This increases or decreases the overall image contrast.

■ **Clarity.** This increases the contrast at the edges of the subjects. When using this slider, zoom in so that you see the 100 percent preview of the image, and then move the slider to the right. If you start to see halos appear at the edges, you will want to move the slider back to the left.

■ **Vibrance.** This adjusts the saturation of the colors that have low saturation to start with. It doesn't adjust the colors with high saturation in your image, and it avoids pushing the skin tones too much.

■ **Saturation.** This adjusts the overall saturation in your image from –100, which removes all color, all the way to +100, which doubles the saturation. This is one slider where a little really goes a long way.

When adjusting my images, I usually start on the top of the panel and work my way down. But here is the great part of Lightroom: All the adjustments are nondestructive, so you can go in and adjust these settings in any order you want, and the image isn't changed until you export the file. Even then, it is the exported file that is adjusted, not the original.

Assignment

Show noise reduction in use

This assignment is all about reducing the noise in your images. A little noise reduction can go a long way, so when you are done, upload your image to the website.

When I am working with a noisy image, the first thing I do is to look at the noise in the image and decide which of the applications I am going to use to try and reduce it. Many times, if the noise isn't too bad, I just use the built-in Noise Reduction feature in the Adobe Camera Raw application, which does a fantastic job. If I feel that there is still significant noise in the image, then I use the Nik Dfine application.

After the first pass through the software, I examined the image closely and thought that maybe I had lost too much information and would reduce the amount of noise reduction. Running the program again, but using slightly less noise reduction, the results looked good to me. The original image was taken at 1/60 second, f/3.2, and ISO 1250.

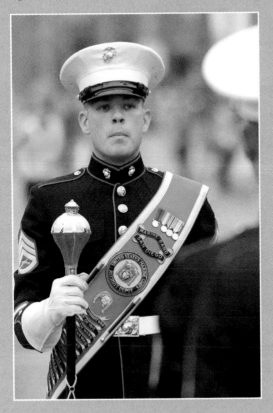
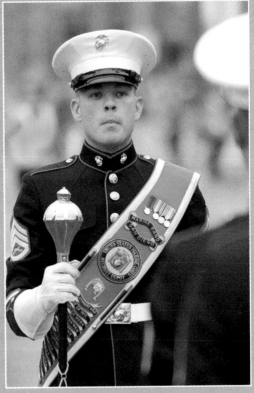

Remember to visit www.pwassignments.com after you complete the assignment and share your favorite photo! It's a community of enthusiastic photographers and a great place to view what other readers have created. You can also post comments and read encouraging suggestions and feedback.

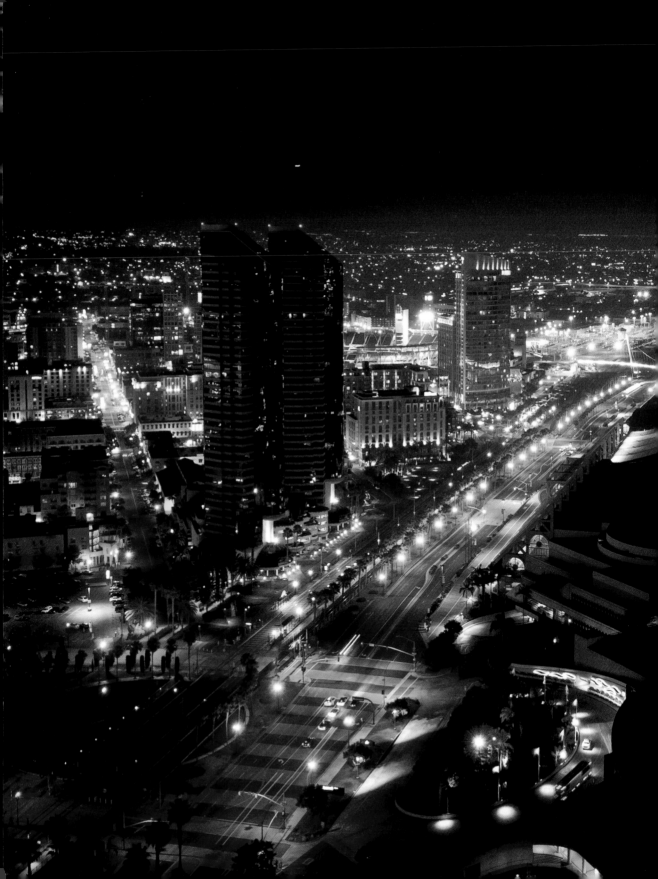

GLOSSARY

Adobe RGB A color space created by Adobe Systems Inc. to more closely match the output of inkjet printing devices. See also *color space* and *sRGB*.

ambient light The natural light in the scene, also referred to as available light.

angle of view The amount of the scene in front of the camera that a specific lens sees.

aperture The variable size lens opening in the lens that the light passes through before reaching the sensor in the camera. You can adjust the aperture by changing the f-stop, which controls the diaphragm. Aperture is expressed as an f/ number — for example, f/5.6.

aperture priority mode A mode that allows you to set the aperture while the camera sets the shutter speed, also called Av or A.

autofocus A camera mode that automatically adjusts the focus, depending on which focus point you select. The autofocus on most digital cameras is engaged by pressing the shutter release button halfway down.

backlighting A method of lighting where the main light is placed behind the subject. See also *silhouette*.

bounce light Light that is bounced off a surface before hitting the subject to create a more flattering light source. This is used mainly with a dedicated flash unit that can be aimed at a wall or ceiling.

bracket A method in which multiple exposures of the same scene are taken, some below and some above the recommended exposure value.

buffer The camera's built-in memory that is used as temporary storage before the image data is written to the memory card.

bulb A shutter speed setting that keeps the shutter open as long as the shutter release button is held down. This allows the shutter to remain open longer than a camera's built-in time limit, which is usually 30 seconds.

cable release A cable with a button on the end that you can attach to your camera, and which allows you to trigger the shutter release without having to press the shutter release button on the camera.

camera shake The small movements of the camera that can cause blurring, especially when the camera is being handheld. Slower shutter speeds and long focal lengths can contribute to this problem.

CCD Charged Coupled Device. A type of sensor found in some digital cameras.

center-weighted metering A metering mode on a camera's built-in light meter. With center-weighted metering, the entire scene is metered, but a greater emphasis is placed on the center area.

CMOS Complementary Metal Oxide Semiconductor. A type of image sensor found in some dSLRs. See also *dSLR*.

color space A description of the range of colors that can be displayed or recorded accurately by the current device. See also *Adobe RGB* and *sRGB*.

color temperature A method of measuring the color of light using the Kelvin scale. See also *Kelvin*.

colored gel filters Colored light modifiers that, when placed between the light source and the subject, change the color of the light hitting the subject. It is also possible to put the colored gel between the subject and the camera which would color the whole scene being recorded by the camera.

compression Reducing image file size when saving the image by either removing information (lossy compression) or writing the information in a form that can be re-created without any quality loss (lossless compression). See also *lossless* and *lossy*.

contrast The difference between the highlights and the shadows of a scene.

cool A descriptive term for an image or scene that has a bluish cast.

crop To trim the edges of an image; this is usually done in postproduction.

dedicated flash A flash unit that works with the camera either in the camera's hot shoe or as an external flash triggered by the camera.

depth of field (DOF) The area of acceptably sharp focus in front of and behind the focus point. A shallow depth of field means that the area in acceptable focus is rather small, while a deep depth of field means that the area in acceptable focus is larger.

diaphragm An adjustable opening in the lens that controls the amount of light reaching the sensor. Opening and closing the diaphragm changes the aperture. See also *f-stop*.

diffused lighting Light that has been scattered and spread out by being bounced off a wall or ceiling or shot through a semi-opaque material, creating a softer, more even light. Diffused lighting can also take the form of sunlight shining through the clouds.

digital noise See *noise*.

dSLR A digital Single Lens Reflex camera uses a mechanical mirror to show the scene that is visible through the lens attached to the camera. This allows you to compose the scene exactly as it is going to be captured.

equivalent exposures Images that have the same exposure value but use a different combination of shutter speed, aperture, and ISO settings. See also *exposure* and *exposure value*.

equivalent focal length The focal length of lenses attached to cropped sensors needs to be translated from the 35mm standard due to their reduced size. The quick way to determine the equivalent focal length of a lens when attached to a cropped sensor camera is to multiply the focal length by 1.5 or 1.6 depending on the camera.

exposure The amount of light that reaches the camera sensor. See also *proper exposure*.

exposure compensation A method of adjusting the exposure so it differs from the metered reading.

exposure metering Using the light meter built into the camera to determine the proper exposure. See also *metering modes*.

exposure value A numerical value describing the exposure. A value of 0 is for proper exposures, while positive numbers describe an exposure that is overexposed and negative numbers describe an underexposed image. See also *proper exposure*.

fast A description referring to the maximum aperture of a lens. Lenses with apertures of f/2.8 and higher are considered fast lenses. See also *slow*.

fill flash A method where the flash is used to reveal details in shadow areas that would usually be lost.

filter A glass, plastic, or gel piece that goes in front of the lens. Filters can be used to alter the color and intensity of light, add special effects like soft focus, and protect the front elements of the lens.

flash A device that produces a short, bright burst of artificial light. The word *flash* can be used to describe the unit producing the light or the actual light.

flash exposure compensation An adjustment that changes the amount of light produced by a flash, independent of the exposure settings.

flash sync The method by which the flash is fired at the moment the camera shutter is opened.

flat A description of an image or scene that has very little difference between the light values and the dark values. This also describes an image or scene with low contrast.

focal length The distance from the optical center of the lens when it is focused at infinity to its focal plane (sensor), described in millimeters (mm).

focal plane The area in the camera where the light passing through the lens is focused. In digital cameras, this is the image sensor.

focus The adjustment of the lens to create a distinct and clear image.

front lighting A method of lighting where the main light is placed directly in front of the subject.

f-stop A measure of the opening in the diaphragm that controls the amount of light traveling through the lens. See also *diaphragm*.

HDR High Dynamic Range photography is a method of combining differently exposed images of the same scene to create a single image with a greater tonal range than a regular photograph.

high contrast A description of an image or scene where the highlights and shadows are at the extreme differences in brightness.

high key A description of a photograph with a light overall tone.

histogram A basic bar graph that shows the number of pixels that fall into each of the shades from pure black to pure white. The histogram view on most digital cameras shows the values of the red, green, and blue color channels as well as the overall tone of the image.

hot shoe The camera mount on top of the camera viewfinder that accepts flash accessories. Each camera manufacturer produces different flash accessories, and those that are made for one brand of camera usually do not work on another camera brand's body.

interval timer A device that triggers the shutter release at predetermined intervals, allowing for multiple images to be taken automatically over a period of time. These timers are especially useful in time-lapse photography where you need a series of images to be taken over a set length of time.

ISO International Organization for Standardization. An international body that sets standards for film speeds. The standard is also known as ISO 5800:1987 and is a mathematical representation for measuring film speeds. The ISO setting on the dSLR describes the sensitivity to light; the higher the number the more the signal is amplified and the more sensitive to light the sensor appears.

ISO sensitivity A rating that measures the light sensitivity of image sensors in digital cameras, using the standards set for film. Each doubling of the ISO makes the sensor twice as sensitive to light, meaning that for practical purposes, an ISO rating of 200 needs twice as much light as a rating of ISO 400.

JPEG Joint Photographic Experts Group. The most commonly used and universally accepted method for image file compression. JPEG is a lossy form of compression, meaning that information is lost during the compression when the file is saved. JPEG files have a .jpeg or .jpg file extension. See also *lossy*.

Kelvin (K) A scale used to measure color temperature. The Kelvin scale used in photography is based on the color changes that occur when a theoretical black body is heated to different temperatures. High Kelvin has a blue cast while low Kelvin has a red cast.

LCD Liquid Crystal Display. The type of display used on the back of most digital cameras to preview photos and display menus and shooting data.

light meter A device used to measure the amount of light in a scene. The readings from the light meter can be used to determine what settings produce a proper exposure. All digital cameras have a built-in light meter that reads the intensity of the light being reflected back from whatever is in the scene.

lossless A form of computer file compression applied when saving a file that allows the original data to be reconstructed without losing any of the information. This is useful when you want to ensure that no changes are made to the information. See also *compression* and *TIFF*.

lossy A form of computer file compression that reduces the file size by removing data when the image is saved. The file is not an exact match to the original file, but close enough to be of use. This form of compression suffers from generation loss. Repeatedly compressing the same file results in progressive data loss and image degradation. See also *compression* and *JPEG*.

low key A description of a photograph with a dark overall tone.

manual exposure mode A camera mode where the photographer determines the exposure by setting both the shutter speed and the aperture.

metering modes The method the camera uses to determine what light to use in the metering process. See also *center-weighted metering*, *scene metering*, and *spot metering*.

middle gray A tone that represents 18 percent reflectance in visible light. All reflective light meters, including the one in your camera, are calibrated to give an average reading of 18 percent gray.

monopod A device with a single leg that helps to steady a camera.

noise Extra unwanted pixels of random color in places where only smooth color should be. Noise is created when the signal from the image sensor is amplified to get those high ISO settings. The higher the ISO in a digital camera, the more noise is created.

noise reduction Software or hardware used to reduce unwanted noise in digital images. See also *noise*.

normal lens A lens that produces images in a perspective close to that of the human eye.

overexposure A condition that allows more than the recommended amount of light to reach the sensor, causing the image to appear too light and with less detail in the highlights.

panning A method that involves moving the camera in the same direction and speed that the subject is moving, resulting in an image where the subject is in acceptable focus while the background is blurred.

prime lens A lens with a single focal length, which is incapable of zooming to different lengths.

program auto mode A mode in which the camera sets the shutter speed and aperture to achieve the correct exposure. You can adjust these settings to give you a higher level of control over the exposure.

proper exposure Using a combination of shutter speed, aperture, and ISO that allows enough light to reach a sensor so that the image recorded is not too bright or too dark.

RAW A file type that stores the image data without any in-camera processing. Every camera manufacturer has a different RAW file format. RAW files need to be processed before they can be used.

rear-curtain sync The ability to fire the flash at the end of the exposure instead of at the beginning. This freezes the action at the end of the exposure.

red eye A condition that occurs when photographing people with a flash that is too close to the lens (the built-in flash). The light is reflected from the person's retina (which is covered with tiny blood vessels, thus the red) back toward the camera's lens.

red-eye reduction A flash mode that fires a short burst of light right before the photograph is taken, in hopes of causing the subject's pupils to contract, lessening the amount of light that can be reflected back.

reflector Any surface that can be used to redirect light. Specialty reflectors for photography come in different sizes, shapes, and colors and are designed to reflect light onto the subject.

scene metering A metering mode that takes the whole scene into account. Each camera manufacturer has a different method for metering. Check your manual for the method used in your camera. See also *center-weighted metering*, *metering modes*, and *spot metering*.

self-timer A camera feature that allows it to take an exposure after a predetermined amount of time when you have pressed the shutter release button.

sharp A term to describe a well-focused image.

shutter A movable cover that controls the amount of light that is allowed to reach the camera sensor, by opening for a specific length of time designated by the shutter speed.

shutter release button The button that is used to move the shutter out of the way so a photograph can be taken.

shutter speed The amount of time that the shutter is open and letting light reach the image sensor in a camera.

shutter speed priority mode A mode where the photographer sets the shutter speed and the camera sets the aperture.

side lighting A method of lighting where the main light source is to the side of the subject.

silhouette An image or scene where the subject appears as a solid black object against a lighter background. See also *backlighting*.

slow A description referring to the maximum aperture of a lens. Lenses with a maximum aperture of f/8 are considered very slow. See also *fast*.

spot metering A metering mode where the only area that the camera uses to meter the light is a small area in the center of the scene.

sRGB A color space created by Hewlett Packard and Microsoft to more closely match display devices. See also *Adobe RGB* and *color space*.

stop A term of measurement in photography that refers to any adjustment in the exposure. When stop is used to describe shutter speed, a one-stop increase doubles the shutter speed, and a one-stop decrease halves the shutter speed. When stop is used to describe aperture, a one-stop increase doubles the amount of light reaching the sensor, and a one-stop decrease halves the light reaching the sensor.

telephoto lens A lens with a focal length longer than that of a normal lens.

TIFF Tagged Image File Format. A lossless file format for images that is universally acceptable by image-editing software. See also *lossless*.

tonal range The shades of gray that exist between solid black and solid white.

top lighting A method of lighting where the main light is placed above the subject.

tripod A device with three legs that is used to hold a camera steady.

tungsten light A light source that produces light with a color temperature of approximately 3200K. See also *Kelvin*.

underexposure A condition that allows less than the recommended amount of light to reach the sensor, causing the image to appear too dark and a loss of detail in the shadows.

variable-aperture lens A lens that changes the maximum aperture, depending on the focal length.

warm A descriptive term for an image or scene that has an orange or red cast.

white balance An adjustment to the colors that the camera records to match the lighting of the scene.

wide-angle lens A lens description that refers to lenses with shorter-than-normal focal lengths.

zoom lens A lens that has a range of focal lengths.

F

continued

continued

Develop your talent.

Go behind the lens with Wiley's Photo Workshop series, and learn how to shoot great photos from the start! Each full-color book provides clear instructions, sample photos, and end-of-chapter assignments that you can upload to pwassignments.com for input from others.

978-0-470-42193-2

978-1-118-02454-6

978-0-470-53491-5

978-0-470-41299-2

978-1-118-01411-0

978-0-470-14785-6

978-1-118-02453-9

978-0-470-11876-4

978-0-470-11436-0

978-0-470-11433-9

978-0-470-40521-5

978-0-470-11955-6

For a complete list of Photo Workshop books, visit photoworkshop.com — the online resource committed to providing an education in photography, where the quest for knowledge is fueled by inspiration.

Available wherever books are sold.

WILEY
Now you know.